Higher Education Under Fire

Higher Education Under Fire

Politics, Economics, and the Crisis of the Humanities

edited by

Michael Bérubé

Cary Nelson

Routledge

New York London

Published in 1995

Routledge
29 West 35th Street
New York, NY 10001

Published in Great Britain by

Routledge
11 New Fetter Lane
London EC4P 4EE

Library of Congress Cataloging-in-Publication Data

Higher education under fire : politics, economics, and the crisis of
 the humanities / edited by Michael Bérubé and Cary Nelson.
 p. cm.
 Papers from a conference held Apr. 1993 at the University of
Illinois.
 Includes bibliographical references.
 ISBN 0-415-90805-1 (hb) — ISBN 0-415-90806-X (pb)
 1. Education, Higher—United States—Aims and objectives—
Congresses. 2. Education, Higher—Political aspects—United
States—Congresses. 3. Humanities—Study and teaching (Higher)—
United States—Congresses. 4. Education, Higher—Social aspects—
United States—Congresses. 5. College teachers—United States—
Congresses. I. Bérubé, Michael. II. Nelson, Cary.
LA227.4.H544 1994
378.73—dc20 94-17598
 CIP

British Library Cataloguing-in-publication data also available.

Contents

II PEDAGOGY AND POPULATIONS

Preface

This book grew out of an April 1993 conference held at the University of Illinois and sponsored by the Unit for Criticism and Interpretive Theory. Although it is not quite a complete tool kit for higher education in the 1990s, it does attempt to give academics some of the resources they will need to deal effectively with the future they face. It is also an effort to correct some prevalent misconceptions about academic life, misconceptions that, in some cases, have force both on campus and elsewhere. Thus those, for example, who would like to know how faculty members can actually have an impact on state politicians will welcome Linda Pratt's essay. Those who believe our financial problems are likely to be easily resolved, on the other hand, might do well to read Ernst Benjamin. Those who are willing to undertake a serious critique of undergraduate education can consult, among others, Linda Brodkey's essay. Throughout the book, we have deliberately mixed longer essays with short and hard-hitting polemical pieces, in an effort to give people what we and our collaborators believe they need and want. Thus we include not only a long and complex debate about problems of identity and race on campus but also Troy Duster's concise rejoinder to a series of myths the political right has disseminated about the subject. We have worked, in other words, to mix theoretical reflection with practical advice.

The 1993 conference, organized by the editors, could not have been held without help from a great number of people. Lee Furey and Jill Leonard headed the administrative staff. Financial support came from the Unit for Criticism and Interpretive Theory, the College of Liberal Arts and Sciences, the Vice Chancellor for Academic Affairs, the Graduate College, the College of Education, the College of Communication, the School of Social Work, the School of Library and Information Sciences, the Institute for Communications Research, and the following departments or programs: Program for the Study of Cultural Values and Ethics, Afro-American Studies and Research, Women's Studies, English, French, Philosophy, Political Science, History, Comparative Literature, Classics, Germanic Languages and Literatures, and Spanish, Italian, and Portuguese.

Special thanks go to Peter Garrett, the director of the Unit for Criticism and Interpretive Theory, and to the Program for the Study of Cultural Values and Ethics, which gave us the time to edit the book. A section of our introduction was published in the March 23, 1994, issue of the *Chronicle of Higher Education*.

Introduction:
A Report From the Front

CARY NELSON AND MICHAEL BÉRUBÉ

Updating the Crisis

Imagine the following scene. A public research university announces in 1995 that its Nobel Prize-winning holder of the Albert Einstein Chair of Physics has amended the General Theory of Relativity—revolutionizing, in the process, everything from "superstring theory" in particle physics to cosmologists' accounts of the evolution of the universe. The reporters' hands go up. First question: "Is it true, Professor, that you never teach undergraduates?"

The 1990s have not been kind to American institutions of higher education. Academy-bashing is now among the fastest-growing of major U.S. industries, and the charges are as numerous as the bashers themselves: teachers don't teach; scholars fritter away their time and your tax dollars on studies of music videos; campus regulations thwart free speech; the Western cultural heritage is beseiged by tenured radicals; heterosexual white men are under attack from feminist, multiculturalist, and gay and lesbian groups; universities are buying luxury yachts with federal research dollars; academic standards of all kinds are in tatters; undergraduates lack both reading skills and moral foundations; and, in the midst of all this, to add financial insult to intellectual injury, college tuitions are skyrocketing.

Many of these charges stem from the media scare over so-called "political correctness" on American campuses, and they have taken on a new, surreal life amidst recent demands that universities deliver more services for less money. In early December 1993, for instance, the *New York Times* published an article by William H. Honan under the headline,

1

"Report Says U.S. Colleges Are Failing to Educate." The article reported the findings of "a group of 16 leading educators, business leaders, foundation executives, and others," led by William E. Brock, former Republican senator from Tennessee and Secretary of Labor under Ronald Reagan. The report itself is called "An American Imperative: Higher Expectations for Higher Education." It addresses three central areas of concern, the first of which has to do with "values": what universities need to do, according to this panel, (known as the Wingspread group), is to find ways to enable college graduates to be "more civil in their habits of thought, speech, and action."[1] This will, no doubt, come as something of a surprise to all those academics who were being told only yesterday that they were guilty of trying to indoctrinate their students into "politically correct" attitudes of civility and tolerance. But such is the image of higher education in the current public debate: it has abandoned its mission by arrogantly seeking to shape students' moral and civic lives, *and*, worse still, it has abandoned its mission to shape students' moral and civic lives.[2]

Let us pause over the *Times* headline: "Report Says U.S. Colleges Are Failing to Educate." Only a week earlier, the same newspaper—and the same reporter—had found yet another crisis in higher education. "Luring Faculty Stars to Teach More," read the headline, and underneath ran a story about how Nobel Prize-winning scientists and famous novelists like Saul Bellow were inaccessible to undergraduates.[3] Picking up the myth of a "flight from teaching" in academe, a myth first promulgated by right-wing journalist Charles Sykes (who is quoted favorably in the article), the *Times* painted a lurid picture of remote, selfish faculty and their intrepid opponents, "imaginative university administrators [who] are finding ways to tempt the distinguished professors out of their ivory towers" (A10). Earlier the same autumn, on September 3, the *Times* had opened the new school year with a remarkably witless attack on academic critics of Shakespeare; in an editorial titled "Shakespeare for Mere Mortals," the *Times* lambasted academics for *interpreting* the Bard rather than inducing students to memorize his works.[4] The next week, an op-ed appeared in the *Wall Street Journal,* under the headline, "College Teachers, The New Leisure Class," charging that university teachers work six-to-eight hour weeks with four-month vacations, and are overpaid for their time.[5]

The fall of 1993, it seems, was a very good time for college teachers, most of whom did little or no teaching. Some faculty did make an appearance in the classroom, but they taught the wrong things in the wrong way. Thankfully, a few administrators tricked academe's world-famous Rapunzels into letting down their hair, and yanked them out of their towers and back into the real world of real work—undergraduate instruction. Taxpayers and tuition-paying parents were thereby spared the in-

dignity of having to support the research and graduate instruction conducted by American Nobel laureates and their ilk.

Higher education, as our title declares, is under fire. What's more, it's under fire from every ideological hiding place, from critics inside as well as outside the groves of academe. The alarmist and tendentious accounts of Dinesh D'Souza, Lynne Cheney, Martin Anderson, Charles Sykes, and Roger Kimball have gotten a great deal of press; but lest complacent academics dismiss these New Right standard-bearers as mere "outsiders," there are now numerous "insider" critiques of American universities, penned by such diverse commentators as David Bromwich, Bruce Wilshire, Page Smith, Ernest Boyer, and John Searle. If cultural and political conservatives have been most active in this assault, liberals and leftists have not been silent either. In California, for instance, one state legislator has declared that the state can no longer afford to support world-class public research universities such as Berkeley; that state legislator was Assemblyman Tom Hayden, late of Students for a Democratic Society.[6]

We cannot say that higher education has come under fire for entirely spurious reasons; in what follows, indeed, we will agree in spirit and substance with many of the diagnoses lately offered for American universities and colleges. But it is crucial to note at the outset that the current climate of debate is such that rational assessments of university life are very difficult to come by; and even when they are voiced, they are rarely heeded. A notable case in point is the lucid and impeccably well-informed essay by Francis Oakley, "Against Nostalgia: Reflections on Our Present Discontents in American Higher Education." The essay concludes a notably underrated collection of essays, *The Politics of Liberal Education,* edited by Darryl J. Gless and Barbara Herrnstein Smith, and it contains a wealth of information and analysis useful for any aspiring critic of the universities. Demolishing the myth that college teachers have fled from teaching, for instance, Oakley notes statistics from the 1989 survey of the Carnegie Foundation for the Advancement of Teaching that decisively counter the popular impression that faculty constitute a leisure class of pampered researchers:

> [T]he story that I believe should be told goes something like this. . . .
> [I]n response to the 1989 Carnegie survey, no less than 70 percent of
> faculty overall indicated that their primary interest lay in teaching
> rather than research. And if you break that global figure down by
> institutional sector, while it is hardly surprising that 93 percent of
> faculty at two-year colleges indicated that primary interest, it is quite
> startling that 33 percent of those at the research universities said the
> same and 55 percent of those at the doctorate-granting universities. . . .

Thirty-four percent overall reported in 1989 that they were not currently engaged in any scholarly project; 56 percent had never published or edited a book or monograph alone or in collaboration; 59 percent had published a lifetime cumulative total of five articles or fewer in the professional journals; 26 percent had published none; while a small group of compulsive recidivists—maybe 20 percent in all—were publishing up a storm.[7]

Oakley also conducts a painstaking investigation of the alleged decline in enrollments in the humanities. Degrees in the humanities have gradually declined since the Second World War as a percentage of all degrees awarded, but Oakley introduces a long-overdue complexity into the analysis of why this might be so. Noting the rise of preprofessional studies, the demographic (and gender) shifts in student populations between 1950 and 1990, and the uneven developments in the humanities in different institutions, Oakley concludes that the humanities are thriving precisely where Cheney and Company have declared them dead:

> At Ball State University in Indiana the share of degrees awarded in the arts and sciences rose between 1954 and 1970 from 2.5 percent to almost 30 percent, and then declined by 1986 to about 13 percent. At Cornell, on the other hand, the comparable figures for 1954 and 1986 were 49.3 percent and 47.1 percent. . . . Moreover, there seems to be no good ground for postulating a connection, whether direct or indirect, between the decline in humanities enrollments and the phenomena which recent critics like to finger as the culprits: high tuition charges, the waning of the Western civilization approach to general education, the assault on the canon of great books of the Western tradition, the politicization of the curriculum, the ravages of deconstruction, the growth of cultural relativism, and so on. After all, to the degree to which these phenomena are present they are present most powerfully in the highly selective colleges and universities where, as the authors of the ACLS report [*Speaking for the Humanities*] rightly argue, the humanities are alive and well. (279, 281)

We await the analysis of trends in higher education that gives Oakley's essay the prominent place it deserves, but we will not hold our breath waiting. To gauge by recent newspaper articles, in fact, it is more likely that American media will continue to speak of the academy's "flight from teaching" and the "ravages of deconstruction" just as if Oakley's findings did not exist. And in the public mind, therefore, they will not exist.

In 1990, Berkeley philosopher John Searle opened his important essay, "The Storm over the University," with the words, "I recall no time when American education was not in crisis."[8] Searle had not yet had the chance to review Oakley's findings, of course, but nonetheless, Searle's

essay, devoted as it is to rallying the forces of metaphysical realism against recent trends in philosophy and interpretive theory, touches on few of the issues enumerated above; and even his subsequent essays, written as his own institution undergoes increasingly severe fiscal retrenchment, barely mention the economic ruin threatening American higher education.[9] That's not because Searle isn't a serious critic or a responsible citizen; rather, we believe, it's because financial, pedagogical, and political criticisms of higher education have mostly proceeded along different paths, advanced by different writers, for various (and often isolated) audiences. Since the larger fiscal picture for American higher education is rarely any one researcher's "field," assessments of it are usually left to administrators, and rarely linked to intellectually substantive discussions of undergraduate education, campus policies, or innovative research in the humanities and social sciences. Likewise, analyses by writers in the humanities, whether taken from Searle's perspective, Bromwich's, or Wilshire's, seldom, if ever, gesture toward the economic factors that are now shaping lives and livelihoods in the universities.

This collection of essays seeks to orchestrate these perspectives, to articulate the discourses of fiscal policy to the discourses of pedagogy, politics, and the production of knowledge. For we are convinced that many of the obstacles universities and colleges now face are systemic, and will not disappear in our lifetimes: flush times will not return with the next business cycle, and the legitimation crises provoked both by the advent of "theory" and by conservative attacks will have structural and ideological consequences for some time to come.

Those who are disinclined to take stock of these legitimation crises, and who believe the end of this (or the next) recession will replenish the empty coffers of colleges and universities, might give some thought to the priority of higher education in relation to other social goods and services. First, many of these have larger constituencies, among them the health care system and an elementary and secondary education system that is, in some areas, near collapse. Second, a decaying national infrastructure will make increasing demands on both state and federal revenues. Third and finally, the postwar boom in higher education was fueled in part by the Cold War (one of us, incredibly enough, had his doctoral training at the end of the 1960s funded by the National Defense Education Act). With the end of the Cold War, the distinctive anxiety that helped to fund education, countering long American traditions of anti-intellectualism, has dissipated. We can expect any number of new economic anxieties on the national scene, but they are not likely to do higher education any good. On the contrary, the end of the Cold War has freed legions of erstwhile

cold warriors to redirect their robust paranoia toward salient areas of domestic unrest, like education.

This conjunction of crises—political, fiscal, intellectual—has its roots in the late 1960s, when the transformation of American higher education coincided with legitimation crises in numerous American institutions; but its modern manifestation is a quite recent phenomenon, picking up steam only in the last few years. If we were publishing this book even a few years ago, during the 1990–91 season of public attacks on universities, we would primarily be countering charges of "political correctness," rather than addressing matters of fiscal and curricular policy. Of course, the criticism of "PC" has not gone away; conservative writers continue to pummel American higher education on a regular basis, decrying everything from affirmative action to the past two decades of research in the humanities.[10] By and large, however, the terrain of debate has shifted. Failing to convince a sufficient fraction of the American public that their children are being taught by radical Marxist multiculturalists, the university's critics are now trying to convince the American public that their children aren't being taught at all, and that their tax dollars are being misspent on faculty whose only concerns are research and professional self-advancement.

Working at a public research institution such as the University of Illinois, we have sometimes seen these attacks directed specifically at us. In May 1992, the University of Illinois was treated to a five-part series in the *Chicago Tribune,* which sought to document the "failure of American higher education" and charged Illinois with defrauding undergraduates of a quality education by overemphasizing research.[11] On one hand, the series went about its task incompetently, trying to drum up public outrage that the inventor of nuclear magnetic resonance imaging (MRI), a University of Illinois faculty member, was not teaching undergraduate surveys. A clearer case for a reduced teaching load could hardly be found; the technology enables diagnoses—and saves lives—every day of the year. Regardless of whether he teaches undergraduates, the inventor of MRI teaches graduate students who carry on his work.[12] But on the other hand, the series was as savvy as savvy could be, timing its appearance for the crucial closing week of budget deliberations in the state capital at Springfield. Rarely has a major American newspaper so deliberately sought to defund a major American university; in the years to come, however, such a media event may not be rare at all.

Despite the ignorance and ineptitude with which these criticisms are sometimes made, we believe they are important, and that they may have more devastating implications for the future of higher education in this country than did the media scare over PC. Where the PC wars may

have helped to delegitimate colleges and universities as sites of left-liberal social criticism and protest, the fiscal crises of universities threaten to cut much deeper, and to cut across ideological lines as well. Liberals, conservatives, radicals, and moderates—from Tom Hayden to Rush Limbaugh—can all be equally alarmed at the idea that their money is being thrown away on leisure-laden faculty; parents of every political stripe can be disturbed to hear that their ever-increasing tuition dollars are not being spent on their children's education. The reasons for this public skittishness are not obscure. The earnings gap between college graduates and nongraduates is significant in itself, in that a college degree often means the difference between gaining or losing ground each year in the national economy; but as Secretary of Labor Robert Reich has repeatedly told the press, that gap is widening, creating a "two-tier work force."[13] Parents, students, legislators, and commentators from left, right, center, up, and down on the political spectrum therefore have every good reason to resist fiscal and educational trends that work to degrade the quality of—or restrict access to—higher education. Some segments of the public seem genuinely concerned about PC in higher education; but most of our constituents seem to care little about the PC content of the curriculum so long as the credentializing functions of education continue to work properly, and these groups should by no means be written off by university faculty and administrators.

We do not claim a direct and immediate causal link between attacks on higher education and reduced state funding, but we do claim that these attacks have established a climate in which universities are vulnerable and in which public resistance to cuts is almost nonexistent. There is a consensus in many states that we are no longer a high priority. It is also clear that some legislators believe there is political capital to be gained in attacking us; anti-academic rhetoric is what they believe their electorate will be glad to hear. There is nothing odd about this. Among the various constituencies competing for state funds in tough times, higher education has every reason to expect a dwindling share of a dwindling pie. However, as Paul Lauter's contribution to this collection demonstrates, recent statistics suggest that higher education is faring especially badly, even by the standards of other social services, from welfare to legal aid. And what most people don't know is that one particularly opportunistic politician can do a great deal of damage in an astonishingly short time. The former Democratic governor of Virginia, L. Douglas Wilder, for example, considered universities so low a political priority that in only three years, his cuts moved Virginia from 29th to 43rd among states in support for higher education. Because Virginia governors cannot serve more than one term

in office, Wilder had to move quickly, reducing state support by twenty-two percent between 1989 and 1992.[14]

For both the best and worst of reasons, therefore, the criticisms of higher education must be taken seriously. What's more, they deserve serious responses in part because everything is *not* well with American universities. One may say generally, for instance, that American higher education does extremely well at providing stimulating opportunities for students who are well-motivated, culturally literate, and eager to be intellectually challenged. Curiously enough, it is not only the best schools that do this well, but hundreds of little-known, unsung colleges across the country. Where American higher education does *not* do well—and probably cannot do well in the current dispensation—is in reaching those students who have little or no intellectual curiosity, and regard college simply as a four-year social ritual or as a vehicle for narrow vocational or preprofessional training. Many colleges and universities also do poorly at policing students who do mediocre work in a series of courses carefully chosen for their pain-free requirements. The simplest way of putting this is to say that we do well at educating those students who are well prepared for college; we often do badly at compensating for deficiencies in secondary education. What would it take to change this pattern? Gerald Graff has argued that if we are to appeal to a broader segment of the student body, we need to make a coherent curriculum out of our intellectual conflicts, the better to explain to ourselves and our students what's at stake in these disputes.[15] Like all meritorious but cost-free proposals, though, this one will only take us so far. Another way to answer this question is to ask what resources would be necessary to ensure that an introductory chemistry course that now serves a thousand students in one room guarantee close faculty-student contact. There aren't enough hours in the day for that one faculty member to teach such a course in groups of thirty-five or fewer students; unfortunately, if people really want the kind of student-faculty contact they are demanding, nothing short of a major financial investment in higher education will suffice. And if they want more students to be fully prepared for college, an even larger investment in elementary and secondary education will be necessary.

On the other hand, some of the public outcry against large classes is misplaced; as any engineer will tell you, it makes little sense to conduct introductory classes in mechanical engineering as if they were creative writing workshops, in which small groups of twelve or fifteen students get together and talk about how they feel about surface tension or heat transfer. Sometimes, keeping enrollments high in such basic courses, where "instruction" consists of little more than memorizing the fundamental principles and equations relevant to the field, is the best way to allocate

one's educational resources. Ironically, what can happen when colleges place all their emphasis on putting senior faculty into smaller introductory courses is that they are left with fewer faculty to teach the advanced undergraduates who can actually benefit from the disciplinary expertise offered by "specialists" in their field. It is also important for the public to understand that undergraduate instruction need not always involve extensive class discussion, as if all college courses should reproduce the prep-school atmosphere of *Dead Poets Society*. Lecture courses have their place even in the humanities. Both of us were just as often inspired by the experience of hearing eloquent, well-organized lectures by faculty members deeply committed to their subjects. Such examples of the intellectual life, indeed, drew us to careers in the humanities every bit as much as did the experience of stimulating seminars and provocative class discussions.

At least two conclusions follow from this line of argument: first, achieving the proper mix of large lecture courses and small seminars with more faculty contact will cost more than many commentators are willing to admit; second, it would not be a bad idea for universities to stop rewarding departments which offer popular but intellectually worthless courses that chiefly serve the purpose of inflating enrollments. If faculty are going to play an important role in reforming undergraduate instruction, rather than leaving the matter to politicians and administrators, then they will have to be willing to undertake systematic internal reviews of other programs (and their own)—and to streamline that review process as well. But the educational terrain in American colleges and universities is uneven, and no one approach to improving the quality of instruction will suffice. We cannot, therefore, simply defend the university unilaterally from unprincipled attackers comfortably housed in right-wing think tanks. Now we must undertake a more hazardous enterprise, criticizing specific university policies and practices from within—while continuing to defend it both from misdirected critique within and unprincipled attack without.

The Humanities and the Sciences

We have subtitled this volume "Politics, Economics, and the Crisis of the Humanities," and have collected essays from scholars in English, education, history, sociology, and philosophy. Physicists are not represented here, nor are economists, landscape architects, accounting professors, or researchers in veterinary medicine. While we recognize that this prevents us or our contributors from speaking for every constituency within the university, we believe our emphasis on the humanities is both justified and salutary.

Because we work in a humanities department in a state-supported research university, we find the humanities especially vulnerable to the criticism that research universities undervalue teaching and reward "useless" faculty research. Our colleagues in the sciences, drawing on a long and illustrious tradition of research with tangible consequences, find it relatively easy to defend their teaching loads and their costly research centers; the humanities will never have the same option, largely because most of the public does not understand that knowledge in the humanities also must be produced as well as transmitted. This is one reason why the Cheney-Bennett rhetoric of "preserving the cultural heritage" resonates even with audiences who do not otherwise share the ideological commitments of the New Right: while there is at least some public understanding that science evolves in response to new research findings, one finds little awareness that the humanities must evolve and change as well, both because the objects we study have to be reinterpreted for new cultural contexts and because forgotten elements of the past are continually being rediscovered.

Because research is easier to justify in the sciences even when it is nearly impossible to explain, there is a decisive slippage in most public arguments against research and in favor of teaching: to fuel general indignation at cushy faculty working conditions, these complaints begin by citing teaching loads of one or two courses per year, which are typical of the experimental sciences but not of the humanities, social sciences, or nonexperimental sciences (like math), whose faculty at research universities generally teach at least four courses a year. All too often, the indignation generated by teaching loads in the experimental sciences is then transferred to (if not indeed blamed on) research produced in the humanities, for the authors of these outcries rarely, if ever, distinguish between patterns from discipline to discipline. Public misrepresentation of teaching loads, like public misrepresentation of research, is made immensely easier by widespread ignorance about what constitutes faculty "work"; yet that ignorance, surprisingly enough, begins on campuses themselves, where humanities and science faculty generally have no notion of one another's responsibilities. This ignorance then extends to legislators, parents, and alumni, very few of whom are informed about discipline-based teaching loads.

The general pattern at research universities is this: a chemist or a physicist probably teaches one course per semester. He or she usually runs a lab as well, a labor-intensive form of teaching, administration, and fundraising that involves daily responsibilities. Interestingly enough, a *biochemist*, anatomist, microbiologist, or cell and structural biologist most likely runs a comparable lab but only teaches one course per year. Why does a

biochemist teach half as much as a chemist? The answer has to do with history, power, and money. Or, to put it another way: the folks who bring you American health care also bring you, indirectly, the teaching loads for the biological sciences. Medical schools sometimes feature teaching loads as low as one course every three years. In order to compete successfully with medical schools in recruiting and retaining faculty in the life sciences, research campus departments must therefore offer a teaching load of no more than one course per year. Changing this pattern would require taking on the entire establishment of academic medicine. For what it is worth in the real world of power and money, we point out that a departmental teaching load of one course per year (or less) insults the public and endangers the entire research mission at public universities.

When other disciplines are brought into the picture, the teaching picture gets still more complicated. A key field is agriculture, among the least productive fields nationally in instruction and a field where (unlike the sciences and humanities) even the basic facts about faculty work load are difficult to establish. Finding out how much an agriculture professor teaches would probably require a military takeover. Barring that, we might simply note that, at our own institution, the average professor of liberal arts and sciences generates more than four times the instructional units per year of a professor of agriculture. "Extension work" with the surrounding farms in the state, an activity difficult to document and still more difficult to justify in an age of computerized and video communication, but an activity with ruthless advocates in the legislature, still rules in agriculture.

Perhaps the most revealing piece of information is the instructional fate of so-called "unproductive" scientists, who no longer run labs or do any major research. They might teach two or three courses a year—that is, one course less than any teacher in the humanities with the exception of holders of endowed chairs (who usually teach two or three courses themselves). Researchers in the sciences often deserve low teaching loads, since they do daily teaching and student supervision in their labs; but it is not clear why universities should release tenured faculty—in any discipline—for research when they do not *do* any research. The fact that *nonresearchers* among university scientists can land themselves a 2/1 teaching load (two courses one semester, one course the next) bespeaks an arrogance born of the enormous cultural power of "science." There is no good reason why an unproductive biochemist should teach less than an unproductive (or productive) philosopher. At the very least, we would argue that it is time for everyone on campus to be informed about these disparities and to begin discussing them frankly.

The same slippage obtains in regard to public criticism of universities' overuse of teaching assistants (TAs); overwhelmingly, the primary public complaint against TAs is not that they are deplorably underpaid, but that they are not native speakers of English and therefore hard for undergraduates to understand. The TAs under (sometimes xenophobic) attack here, of course, are employed largely in the sciences. But because the sciences are not likely to scale back their use of TAs in order to put more of their researchers in the classroom, the TAs who wind up as the targets of such public criticism are, ironically, graduate students in the humanities and social sciences, many of whom are excellent teachers and some of whom are themselves doing more innovative and provocative work than their supervisors among the faculty. Thus, criticism of faculty research generally starts with outrage over 1/0 and 1/1 teaching loads in the experimental sciences, only to turn and place the blame for the quality of undergraduate instruction on "useless" research and concomitant overuse of TAs in the humanities or social sciences. At research universities, teachers in the humanities and speculative social sciences are therefore particularly susceptible to attack, and uniquely defenseless—unless they can show that their research will yield breakthroughs and innovations of great service to business, industry, and mad-as-hell taxpayers.

Again, however, the attack on faculty research is usually narrowly conceived—and, as Francis Oakley argues, irrelevant to a great deal of what actually goes on in American higher education. For among the things increasingly lost in this debate is public awareness of the institutional diversity of colleges and universities. Most public and private institutions—both large and small—remain dedicated almost exclusively to undergraduate education, and have teaching loads of three or four courses per semester. Media coverage of academe has persuaded many that research is higher education's primary concern, whereas, in fact, research consumes major faculty time and effort in only a tiny percentage of colleges or universities. Most faculty members only rarely engage in research activities that "divert" them from the classroom, and many of those research activities have practical and pedagogical applications. This is a message the public must hear.

Nevertheless, we need to point out—and try to change—the market logic that now induces large research universities to divert funds from undergraduate instruction. The logic is not hard to follow. When state support for higher education declines, large universities find it attractive to invest their resources in short- and long-term projects that will garner support from the federal government and private industry. Not surprisingly, these projects tend to be clustered in the sciences. What's less well-known about these projects, though, is that even when they are generously

funded by the federal government or private industry, in times of declining resources they tend to siphon off funds from elsewhere as well: state funds, allocations to other departments, and student tuition and fees.[16]

To put this issue simply, universities cannot and should not fund additional high-tech research projects from state revenues and tuition increases. We intend this proposition not as a judgment about the quality or value of such projects, but about their cost and their impact on everything else the university does. In the past ten years, for example, the University of Illinois has created two impressive new research units: the Beckman Center for Advanced Science and Technology, and the National Center for Supercomputing Applications. Both bring in substantial grants, but in a time of declining resources both have also had to draw heavily on the state budget. Ten years ago, neither existed. Now, together, they require a total of nearly seven and a half million dollars in state funds. This money has come from reallocation within the university, and that reallocation has helped strip hundreds of thousands of dollars from undergraduate education. In the 1993–94 academic year, Illinois' College of Liberal Arts and Sciences did half a million dollars of undergraduate teaching with borrowed money. This we cannot tolerate. We object neither to the existence nor to the purpose of these large projects; we object only to the claim that these projects have had no negative impact on our teaching mission.

It is all very well, then, for citizens' groups or governmental agencies to call for greater attention to undergraduate instruction; we join them in that call. But what we have witnessed at Illinois is a legislative call for higher teaching loads, coupled with a heightened commitment to high-tech science, amidst a decade and more of declining state support. In these conditions, we are impelled to point out that the interests of undergraduates are not well served by decreases in state funding and state-mandated increases in teaching loads: what will undoubtedly happen, if such legislative appeals are heeded, is that undergraduates in the humanities and social sciences will wind up paying still higher tuition for still less faculty contact, while disciplines in the experimental sciences continue their current practices heedless of legislative initiatives. We have seen the unintended results of well-meaning administrative oversight before: because the Illinois Board of Higher Education (IBHE) tends to assess individual departments largely in terms of instructional units, IBHE reviews focus not on quality of instruction but on the number of warm bodies processed by a department in the course of a semester. Inadvertently, in other words, an agency like the IBHE rewards departments for offering "gut" classes in which a thousand students or more can sign up for an easy "A." We

cannot see any beneficiary of this arrangement—other than cynical departments and equally cynical administrators.

One argument for increased teaching loads is that they will likely make it easier for undergraduates to obtain the required courses they need for graduation. If one believes that the unavailability of required courses is the primary factor in lengthening the time it takes for undergraduates to receive a B.A., then higher teaching loads might seem defensible; but, as the essays of Paul Lauter and Ernst Benjamin show, the crucial factor in undergraduate degree completion is financial rather than administrative. Even when students can get all the courses they need to graduate, they will not graduate in four years if they are working fifteen or twenty hours a week in part-time jobs to defray tuition costs. And, needless to say, the availability of required courses would not be an issue at all if universities were not shrinking their faculties by failing to replace retirees.

Still, whatever remedy an individual university decides to adopt in order to re-emphasize undergraduate instruction, we propose that the solution be substantive, and that it be conceived as a long-term resolution rather than as a quick fix. Because undergraduates unhappy with the education they are receiving at large public research universities now represent a significant political force, better undergraduate instruction is ultimately in the best interest of universities as well as their students. Ten years ago, before tuition costs rose precipitously, some of these students would have been attending small liberal arts colleges that emphasize small classes and close contact with faculty; as certainly some of their parents did. As a result, these students and their parents often have expectations about their education that large institutions find it difficult or impossible to meet. But they also have genuine and often fair complaints about class size, lack of contact with faculty members, and the availability of courses. Although we must do a better job of educating the public about what we are and are not capable of providing at our current level of funding, we also must give students more of what they want, not just try to persuade them they should want something else. We need to do so not only because of the inherent merit of some these complaints, but also because their public airing has considerable potential to do harm to universities as a whole and to their research mission specifically. If we are to recognize, as we must, that our institutions are serving a student population with different needs and expectations from those we faced thirty years ago, then we need to redefine our *own* expectations about the size and the nature of our investment in undergraduate education.

Differential teaching loads keyed to research productivity may be the only way to protect our research mission while meeting instructional demand. As we noted in regard to "unproductive" scientists, it makes little

sense to maintain teaching loads that facilitate research for faculty who are not doing research. On the other hand, differential teaching loads must not be seen as a punishment. The only way to avoid this is to reward those who teach more. We believe it is time to open up a teaching track for *tenured* faculty whose scholarly efforts have become marginal; offer them increased teaching loads for a significant salary increase, perhaps ten thousand dollars a year, or 25 percent of their current salary, in exchange for a substantial increase in teaching. At the same time, make it clear that faculty members must stay current with their fields. Our cautionary warning to tenured faculty would be not "publish or perish" but "read or perish." In other words, faculty members who are not intellectually committed teachers—who pass on the discipline as though it had not changed in twenty or thirty years—are usually performing no good service to their students, and should not enjoy the same privileges and responsibilities as their more responsible and professional colleagues. We are not demanding that every scholar in the humanities immerse himself or herself in every critical or theoretical essay that comes down the pike; we are only asking that tenured faculty stay sufficiently current with their fields to offer, at minimum, informed disagreement with methodological and theoretical innovations relevant to the work of their students and colleagues. At the very least, faculty members need to care enough about their discipline to want to debate the merits of current scholarship in their classes.

This is no idle suggestion; faculty stagnation is not the same thing as the so-called "deadwood" problem, but it is a serious matter all the same, and can lead a university into ludicrous impasses. We know of a graduate student in art history who, having completed a feminist and "theoretical" dissertation on a major modern painter, could find not a single faculty member in her department willing or able to read her work, since her study did not conform to the "life and works" model her mentors expected. Her dissertation was by no means outlandish, but to a man, her faculty told her that they were either incapable of judging her work or too busy to do the interdisciplinary reading that would give them the intellectual context they needed to understand her thesis.

It is this problem of stagnation, with all the problems it poses for undergraduate majors, graduate students, and junior scholars, that leads Robert and Jon Solomon, in *Up the University,* to advocate the abolition of tenure. As they see it, eradicating tenure will not only keep the senior faculty honest, but free up-and-coming scholars from the tyranny of constant review—and constant threats of unemployment: "when it comes to job security," they write, "the real need is not protection from dismissal for cause but protection from the sometimes psychotic, intolerant, and narrow prejudices of one's fellow academics."[17] We agree in part with the

Solomons' critique, since there are certainly corrupt, anti-intellectual, or downright malicious departments here and there across the country, but doing away with tenure will not heal those programs.[18] Moreover, the elimination of tenure will only submit faculty to still more capricious trials by the sometimes intolerant and narrow prejudices of politicians and the general public. When we tell ourselves that we are far too enlightened and freedom-loving to repeat the abuses of the McCarthy period, we should remember that Americans in the 1950s thought themselves rather enlightened and freedom-loving as well. Abolishing tenure would threaten academic freedom and remove crucial safeguards for unpopular but innovative research. That is why we suggest differential teaching loads instead, since it would ensure the appropriate use of faculty less committed to research.

The alternatives to differential teaching loads are much worse. They include relying heavily on part-time teachers, as so many institutions now do, or creating a special class of permanent, non-tenure-track teaching faculty. Some schools already have differential teaching loads, and manage them without serious breakdowns in collegiality. At many schools, to be sure, the process of creating differential teaching loads will be difficult and painful, since no one wants to bell the cat, and upset a system long in place; but if this subject is not broached honestly and soon, we will only exacerbate, by ignoring, the severe—and grossly unfair—structural strains under which many disciplines (including English) now find themselves operating.

Our own institution does not rely heavily on part-time faculty. But nationwide, as schools find themselves unable or unwilling to replace their retiring faculty, most institutions are relying more and more on part-time teachers, who earn five to twenty thousand dollars a year or less and receive no health or insurance benefits. In fact, college professors, far from being a "leisure class," are now more likely to be part-timers than ever before: as Ernst Benjamin points out in his contribution to this volume, fully thirty-nine percent of our profession consists of part-time employees.[19] No other profession in this country would stand for that kind of systemic abuse of personnel and resources; no profession should have to.

For the program we recommend to be successful, we also need to defetishize research. The idea that a faculty member who publishes an unremarkable essay every two or three years is somehow a more respectable citizen than one who delivers good teaching is absurd. The fetishization of research also affects what we expect young faculty to produce for tenure. Over the past few decades requirements for tenure at research universities have gradually risen; for the most part this has meant merely that more schools are now honoring their officially stated policies, policies that were

more often honored in the breach in the 1960s and early 1970s. But in the past few years a few research universities have begun demanding, for a tenured associate professorship, what was through the 1980s demanded for a full professorship in the humanities—two published books. Demanding two published books within five years amounts to insisting that faculty members devote as little time as possible to their teaching, all so that they can make two "substantial" contributions to a field they have only recently entered. It is a prescription for poor teaching, and sloppy research to boot. Private universities presumably can get away with this kind of nonsense, though we recommend they desist from doing so; public institutions practice such a policy at their extreme peril.

English Departments, "Theory," and Graduate Studies

In many ways this is both the best and the worst of times to be in the humanities. Which way it feels depends in part on how secure your job is, and where you stand in relation to the disciplinary ferment of the past twenty years. Intellectually, humanities disciplines could hardly be more engaging: "theory" has made us far more self-critical about our intellectual assumptions; a vastly expanded canon has made hundreds of forgotten texts available for interpretation; and after a series of rapid-fire critical revolutions, a diverse intellectual scene, with space for many different kinds of work, has finally settled in. Those who have been part of these debates feel empowered by them; those who have avoided them are by now wholly alienated. And those who do not have tenure-track jobs are often torn between intense intellectual excitement and equally powerful expectations of professional failure. This is the landscape so drastically flattened out by media depictions of the humanities, which render intellectual upheaval as nothing more than a succession of passing fads, whereby each theoretical innovation obliterates its predecessors. Academe—and especially English—certainly has had its share of "fads" in the past quarter century, but describing the academic scene in this way leaves nonacademics no way of understanding how Bakhtin, deconstruction, cultural studies, historicism, feminism, postmodern ethnography, neo-Marxism, and pragmatism can possibly coexist in such a way as to inspire further interdisciplinary work.

We want to look at this contradictory scene briefly from the vantage point of our own discipline, English. It is in many ways at once the perfectly representative humanities discipline and the most extreme instance of the humanities in crisis, in part because its size and visibility mark it with every fault and virtue. It is also a particular focus of media attention, becoming one of the most controversial and oft-ridiculed disciplines in the humanities. That attention has given English a further

significance, one little noticed to date: a *structural* role in the multiple crises of the humanities.

We have mentioned one such role already: the humanities, departments of literary study among them, take the heat for low teaching loads in other disciplines. Within the humanities, English is increasingly cited as the part that ruins the whole, the bad apple infecting the rest of the humanities barrel. It is true that English is still widely regarded as an integral part of "general education"; as Evan Watkins has pointed out, it is one of the few disciplines with which *every* high school student and college undergraduate interacts.[20] Hence English—particularly the teaching of rhetoric and composition—retains an important function in the "sorting" of the student body. This is one reason why English is the largest, most influential, and most often criticized of the disciplines in the humanities; it is also one reason why English so often presumes to speak for "education" as a whole. But as English has become increasingly associated with political correctness and doctrinaire, leftist radicalism, it has been either marginalized as a source of social critique, or worse, taken to stand for the degeneracy of the humanities *in toto*. The response from English, therefore, must be directed both at "the public" (students, parents, high school teachers, legislators, trustees, "general readers") *and* at other constituencies in the university. For just as English has become, by default, one of the disciplinary locations from which the stakes of the PC wars can be seen most clearly, so too has it become, by virtue of its size and influence, among the humanities disciplines most likely to be targeted for "downsizing."

At Illinois as across the nation, humanities departments find that they cannot even replace their retiring faculty. Meanwhile, the depressed job market means our graduate students cannot find jobs elsewhere. It doesn't take a Ph.D. in math to tell you what happens when undergraduate enrollments go up and the size of the faculty goes down—class size rises, and students receive less individual attention. Since 1980, the number of undergraduate English majors at Illinois has grown from 460 to 816, and the total number of students enrolled in English department courses annually has increased by 7,800, while the number of English department faculty positions has dropped by fifteen percent. Meanwhile, the near elimination of extensive required writing from most other areas of the undergraduate curriculum leaves English departments on their own to police grammar, syntax, and writing in general. Unfortunately, the devaluation of writing reflects not only the low priority given to student essays outside literature departments, in everything from advertising to zoology, but also the limited value this culture places on articulate public discourse. Where writing *has* managed to flourish in recent years, it is

usually pegged to some instrumentalist sense of communication: either to "writing across the curriculum" programs that compensate for departments' widespread neglect of student writing, or to the enterprise of "business and technical writing," which largely enables students to write better memos, presentations, and letters of introduction. While this is a worthy enterprise, it remains true that too much of the university either doesn't care whether its students are able to express themselves eloquently in a prose essay, or is unable to imagine taking any action beyond complaining about the English department's failure to guarantee universal eloquence.

Finally, as a discipline clearly marked by generational conflicts over theory and methodology, English provides a good location from which to assess the consequences of "theory" that have been so widely debated and so widely misunderstood. As loyal, card-carrying members of the academic left, we are familiar with the role that English has played in the PC wars so far; each of us has written about PC ourselves.[21] And as loyal, card-carrying members of the Theory Posse that is reputed to have corrupted and politicized education in the humanities, we are also well aware of how "theory" has been deployed as an umbrella term either to justify or to delegitimate the new forms of knowledge and critique generated in English and allied disciplines in the past twenty-five years; it has also been blamed for demographic changes having nothing to do with theory.

In the mid- to late 1980s, for example, prospective devotees of literary study entered graduate school in record numbers, disproving the right-wing canard that "theory" has driven students away from careers in the humanities.[22] The appeal of graduate study in English has been both theoretical and practical: literary study since the early 1980s has promised to offer graduate students not only a grounding in traditional literary history, but also wide exposure to an array of discourses linking the "literary" to the "social," whether by means of feminism, Marxism, New Historicism, ethnic studies, cultural studies, or gay/lesbian studies. Thus the rapidity with which English, compared to other disciplines, made feminism central to its enterprise helped attract women to the field through the 1980s. At the same time, media reports and academic advising led many prospective graduate students to believe there would be a nationwide faculty shortage in the early to mid-1990s, and that jobs in the humanities would be plentiful for the first time since the late 1960s.

So "theory" recruited for the discipline with unprecedented success, while "practice" promised the recruits jobs at the end of their six to ten years of graduate training and underpaid labor. We now know how cruel a joke the academic economy has played on these students, very few of whom have any hope of stable academic employment. Thanks to the structural collapse in the job market in English, some graduate students

and newly-minted Ph.D.s now working in the discipline have taught over thirty classes at two or three institutions, and published several articles in refereed journals, *before* they earn their first tenure-track position (if they do this at all). In the 1960s, by contrast, jobs were plentiful and tenure was granted with a lavish hand, often for nothing more than adequate but uninspired teaching; toward the end of the decade the requirement of publishing a few indifferent essays was often added. When one of us was hired in 1970, indeed, he was actually told to be "publicatious—but not *too* publicatious." This standard in teaching and research did not change at many research universities until the mid-70s. Now our graduate students must do more teaching and publish more research for their first job—or even for a temporary adjunct position—than their senior colleagues did to win lifetime tenure.

It is time to say, bluntly, that graduate education is losing its moral foundation. For many years graduate students served not only as colleagues of lesser status but also as apprentices. The economic tradition in which "apprentices" are underpaid and overworked is older than capitalism itself; but throughout its historical transformations, the apprentice tradition typically held out eventual full-time employment with better working conditions as its delayed compensation. With the collapse of the academic job market, the guarantee of a job at the end of a long apprenticeship is more than a long shot; it's often an impossibility. This leaves us in the position of promoting not apprenticeship but exploitation. We overwork graduate teaching assistants for seven years or so, then cast them aside. The money we pay them each school year is often not enough to live on in the summer. Their health benefits are often marginal, their retirement benefits nonexistent.

All this is well known to anyone in the field, but its implications have not yet been faced squarely. At institutions with large graduate programs, *all* faculty members benefit from the work graduate students do. Faculty members are freed for intellectually specialized teaching by assigning graduate students to teach introductory courses—from basic language instruction to introductory calculus, from rhetoric and composition to introductory logic. Faculty members who devote no energy to graduate training have a relation to graduate employment that is almost wholly parasitic: their own salaries and privileges are sustained by exploiting teaching assistants.

We need to recognize these injustices, to admit that the long-term collapse of the job market is making the logic of graduate apprenticeship morally corrupt. There are difficult questions we need to confront: What does it mean to face an academic future in which many graduate students will have none? What are the ethics of training students for jobs that few

of them will ever have? Faculty reluctance to face these issues is due not merely to a sense of helplessness, to an inability to think of solutions to the employment crisis in academe, but also to a lack of concern, since the job market does not directly threaten tenured faculty members' careers. In fact it is new Ph.D.s, as a class, who are the most numerous and most serious victims of economic retrenchment in higher education. We offer, therefore, a number of preliminary suggestions about how we should respond:

- Many graduate programs should reduce the number of students they admit, especially those programs that maintained their size through the 70s and 80s. The 1990–91 MLA survey reported that one-fifth of graduate programs in English had "definite plans" (44) to *expand* in coming years; needless to say, we find such plans ill-considered. Instead of planning further overproduction of Ph.D.s, some programs should *reduce* admissions by as much as a third or a half; others should strengthen the gatekeeping function of the Master's degree, reducing admissions to Ph.D. programs while keeping their Master's admissions near current levels. Marginal programs should be closed. Professional associations need to become involved in making those tough recommendations, since neither departments nor their own institutions can be counted on to do so.

 The rationale for reducing programs is clear: We must be able to offer permanent employment to a higher percentage of the Ph.D.s we train. Though some faculty would have fewer graduate students to teach, they could certainly teach undergraduates—even in introductory courses. No one is well served by overproduction that cheapens the value of the Ph.D.

- Institutions should devise legally sound early-retirement packages for those faculty members who are neither effective teachers nor productive scholars. In some departments ten percent or more of the faculty would fail both tests. In particularly severe cases, retirement offers might include both rewards for acceptance and disincentives for refusal, the latter to include restrictions on salary growth. Again, we are not suggesting that tenure be abolished, but we are recommending periodic reviews for all faculty members, so that departments have plausible data to show who is performing responsibly and who is not. For we need to confront the fact

that we are driving talented new teachers and scholars out of the profession while retaining some incompetent faculty members with tenure. Yet some low-paid faculty earn so little they cannot afford to retire. Carefully negotiated retirement agreements could help to address all these problems. And such agreements should generally include the offer to teach one course a year after retirement.

- Professional associations must find better ways of monitoring hiring practices and must investigate deceptive job searches— that is, cases when a national search is conducted even when a department already knows whom it intends to hire. Likewise, institutions must be discouraged from converting permanent openings to temporary positions. When new Ph.Ds. are offered probationary "one-year" jobs with the promise of tenure-track appointments to follow, colleges are effectively creating a new *pre*-probationary period in which to scrutinize junior faculty. Many of those jobs, of course, never become tenure-track positions at all. More generally, we need better statistics, by discipline, comparing the numbers of degrees granted with the number of actual tenure-track hires each year.

- To lessen exploitation of graduate students, institutions should increase their wages and benefits. Those who teach throughout the academic year should earn enough, for example, to have their summers free to devote to their intellectual work. Graduate students who teach for five years or more might be given some retirement benefits and unemployment insurance. Universities should offer more extensive child care for all employees; graduate students with children would particularly benefit.

- Graduate programs should offer serious career counseling, so that students can be advised at a suitably early stage about their prospects for non-academic employment. In a bleak market, we must encourage current students to consider career changes before they have invested the better part of a decade in training for academic employment. Since few programs are now equipped for effective career counseling, national professional organizations might well help in gathering, evaluating, and distributing information about alternative careers.

- Universities should refocus graduate education to emphasize both its intellectual rewards and its marketable skills. Specific

suggestions here will vary widely from discipline to discipline, but in the humanities and social sciences, at least, graduate programs need to give advanced graduate students the right to design and teach their own courses so they are better prepared for teaching jobs at non-research colleges and universities. Teacher training and experience now varies widely from discipline to discipline, even within the same university. Most English graduate students at Illinois teach fifteen to twenty sections of several courses over six years; psychology graduate students teach only one section of one class.

• Faculty members must be required to do their best for students in the current bleak job market. Those who carry out their responsibilities indifferently—who, for example, write sexist, lazy, or trivializing letters of recommendation—should be confronted about their behavior by department heads. Even if graduate study is to be an end in itself for some students, and not a means to an end, it needs to be fulfilling in those terms. This is a particularly difficult challenge—and we are far from certain what it entails. At the very least, however, it means being able to leave graduate study with a sense of intellectual work that is coherent and complete.

These suggestions will not suffice to relieve the crisis, but they represent a beginning. Many graduate programs now offer a year or two of postdoctoral employment, a practice that helps some students but ignores the larger problem. Other than that, to date a number of graduate programs have responded to the logjam with only one stringent, short-term solution: moving up deadlines and cutting off financial support in the hope of hastening students out the door without addressing the structural problems of academic training and employment. But decreasing "time to degree," even by the most draconian methods, will accomplish nothing if the degree in question turns out to be nothing more than a ticket to part-time employment of indefinite duration. If we don't address this issue aggressively, the current "crisis" may become permanent, as we gradually forget that times were once much better for new Ph.D.s.

The employment prospects for new Ph.D.s highlight what makes the intellectual "boom" in our field so bitterly ironic: that it is occurring at a time of severe financial retrenchment. The university English department is thus a multiply conflicted site from which to assess the state of higher education and the state of the humanities. It houses a large, omnibus, and ill-defined discipline, and it is under heavy attack from right-wing think tanks; it is generationally and ideologically riven by "theory,"

and it is strangled by a nightmarish job market and a systemic but un-addressed faculty downsizing; it is a crucial component of undergraduate education even for those students who never open a literary text, and it is extraordinarily vulnerable to charges that universities reward research at the expense of teaching. These are some of the reasons why English has played a major role in discussions of the future of American higher education—and why English, in all its contradictions and ferment, is increasingly the site where the fate of the humanities as a whole is being debated.

Analysis and Activism

The foregoing exhortations and proposals should be read in the light of two important imperatives for higher education. The first is that faculty, administrations, legislatures, and the concerned public must realize that American higher education has undergone a sweeping and largely beneficial transformation in the past fifty years. In 1946, the so-called Harvard *Redbook,* "General Education in a Free Society," defined higher education as a compensation for democracy. Democracy, argued the *Redbook,* could not be counted on to find and train the next generation of leaders; higher education would compensate by winnowing out the best and brightest, and giving them the training and credentials to take the helm.[23] In 1946, needless to say, the "best and brightest" would have been almost exclusively white, male, and privileged. But the GI bill in the 1940s and then the opening of the universities in the 1960s gave higher education a quite different function: compensating for capitalism. Where college was once seen as a device for creating tomorrow's leaders, it is now seen also as a device for combatting socioeconomic inequities. Contemporary college education, like compulsory primary and secondary education, is charged not only with training leaders but also with finding students of merit whose social disadvantages prevent them from realizing their potential. Only for one generation, then, have American universities truly attempted to serve all the public. That experiment offers a promise we cannot now betray. Thus we cannot allow higher education to follow the market logic that gave us our tiered health care system—the best services in the world for those who can afford them, tolerable services at inflated prices for the moderately comfortable, and whatever can be patched together, or nothing at all, for everybody else, all based on the criterion of ability to pay.

The second imperative is this: faculty members must find an effective voice as a constituency, both within the university and outside it. Over the past few years, we have tried to engage our own faculty in the project of acting collectively to win back public support, to speak up on the issues

pertaining to our campus and to higher education in general. We have so far met with little success. Our colleagues are largely disinclined to organize and act, even when they perceive that organization and action may be in their interest. Some of them, we surmise, think that all will be well as long as we throw a few radicals to the wolves. Others believe the crisis of the universities will not affect them at all—that they can simply go ahead, finish their next project, design their next course, and everything will basically be all right once the nation's fiscal condition improves. But we will not be able to publish our way out of this one, nor will we be able to dodge the budget ax simply by protesting that we're only doing things the way we've always done them.

If we have compiled this collection of essays for anything, it is to inform our colleagues and our nonacademic readers that the crisis of American higher education affects us all and will continue to do so. Some of the initiatives we need to take largely involve the interests of the academic and cultural left; but many others, from refocusing on undergraduate education to relieving the pressure on graduate students in the humanities, should certainly have wide and nonpartisan appeal. Yet whatever our intellectual or political commitments, many more of us need to be involved in debating the issues and seeking solutions.

For decades American universities have fostered a kind of *idiot savant* academic culture. Faculty members maintain expertise in their disciplines but remain mostly ignorant about how the university works. About public higher education's relation to the state's culture, politics, and economy they are even less well informed; the dean and the president, they believe, will take care of such things. But as Linda Pratt argues in this volume, in "Going Public: Political Discourse and the Faculty Voice," the best efforts of the dean and the president are no longer going to be enough. Faculty members and graduate students are going to have to become knowledgeable about the institutions in which they work and about the larger social and political formations in which those institutions are embedded. Graduate training, in fact, will need to build such issues into the curriculum.[24] Then all of us will have to build relationships with relevant constituencies. For if, as concerned faculty, students, and citizens, we do not take our stand collectively, and take our stand now, we will soon be left without a leg to stand on.

We have put this book together to give people some of the materials they might need to move from passivity to action. But as Henry Giroux cautions us in the conclusion to his essay in this volume, "Beyond the Ivory Tower: Public Intellectuals and the Crisis of Higher Education," we need to take a stand without "standing still." This requires a larger understanding of how economics and politics are interrelated. Taken to-

gether, the essays here by Michael Apple, Ernst Benjamin, Paul Lauter, Linda Pratt, and Carol Stabile provide both a handbook of political and economic analysis and a series of challenges for the future. They help clarify the current forces operating on higher education and the historical changes since the Second World War that have produced the educational environment of the present; and in various ways, they all also suggest what we in the academy need to do differently if higher education in America is to survive in a form worthy of our commitment.

The tensions in higher education, of course, are not only a result of external pressures but also a result of internal changes over the past two decades. New interpretive perspectives and broader historical awareness in the humanities and social sciences have combined with more diverse student and faculty constituencies to turn colleges and universities into laboratories for the negotiation of social conflict. We do not claim to represent all these developments here, but we have tried to offer clear position papers on a number of them. Notable in this regard, among others, are the essays by Troy Duster, Michael Dyson, Todd Gitlin, Cameron McCarthy, Joan Scott, Michael Warner, and Jerry Watts, all of whom relate the intellectual debates of the past generation to the challenges posed by the latest generation of college students. Where these essays focus on the myriad theoretical and practical implications of defining a campus "community," the essays of Linda Brodkey, Judy Frank, Henry Giroux, and Gerald Graff and Gregory Jay turn directly to the question of pedagogy. Whether they write to defend or to criticize the "pedagogy of the oppressed," to redefine the role of introductory writing courses, or to address the function of pedagogy in the American imagination, all of these critics argue, with good cause, that the national debate over higher education has thus far been scandalously inattentive to what professors actually try to do in the classroom.

Although this collection is weighted heavily toward left perspectives on higher education, partly because left perspectives do not often get a hearing in public discussions of the academy, we have not put this volume together in order that our contributors might speak with a unified voice in support of a specific program of analysis and activism. Much of this volume, indeed, testifies to the diversity of opinion among the so-called "cultural left," and two of our contributors, Barry Gross and Jeffrey Herf, are members of the generally conservative National Association of Scholars. Their presence in this book provides it with a particularly valuable corrective, both for their individual contributions and for their reminders that the ills of higher education are not the property or responsibility of one party alone: as Gross and Herf serve to demonstrate, liberal and leftist

academics are not blameless participant-observers in the culture wars, and need to get beyond conducting debate by preaching to the choir.

Yet the balance we have aimed for is not numerical or ideological but intellectual, and it has produced a book which offers not only broad terms for reconceiving the crises of higher education but also a unique exemplum of rational but impassioned debate. This is particularly evident in the long and often remarkable discussions that conclude each of the book's two sections. Drawn from several days of recorded meetings held at the University of Illinois in April of 1993, these two sections of conversation and argument represent a rare opportunity to overhear university faculty with different political and disciplinary agendas discuss present and future issues in higher education. Anyone who reads these discussions carefully is bound to feel dissatisfied with the simplistic "positions" and "alternatives" fostered by media coverage of issues like affirmative action and identity politics. As the participants challenge each other, and clarify and renegotiate their own positions, they offer a model of the sort of careful, deliberative negotiation that is sometimes possible at colleges and universities. If politically committed academics enter into this kind of discussion, the end product, it appears, may not be ultimate victory for one side or the other but rather the creation of new intellectual positions and coalitions whose shape cannot be altogether predicted from the character of current conflicts.

The public debates about higher education over the past several years have suffered badly from the tendency—in both the media and the academy—to package every issue in terms of irreconcilable opposing positions. Yet however much academics struggle against these reductive oppositions, they often end up reproducing them as a way of gaining access to the public sphere. We hope *Higher Education Under Fire* shows that neither the left nor the right on campus actually possesses the sort of unanimity that makes for the most dramatic and confrontational news coverage. We also hope it shows, most immediately, that teachers and scholars in institutions of higher education must try to regain control of their own representation. Along with the essays we are publishing, the two discussion sessions here— the first ranging over issues such as objectivity in educational standards and the relation between "standards" and a democratic commitment to educational access, the second interrogating the struggles over identity politics that have swept across so many campuses—suggest how we might take control of our future again.

NOTES

1. Quoted in William H. Honan, "Report Says U.S. Colleges Are Failing to Educate," *New York Times*, December 5, 1993, p. 25.

2. Allow us to secure this point by way of an example. In *Politics By Other Means: Higher Education and Group Thinking* (New Haven: Yale University Press, 1992), David Bromwich derides progressive and reformist teachers for trying to turn the university into "a superior social adjustment agency, in the business of granting degrees that mean: 'Your son or daughter has turned out correct. Politically, morally, socially correct, at least by this year's standards' " (46). For Bromwich, as for many liberal and conservative commentators on "political correctness," turning out students who are "more civil in their habits of thought, speech, and action" is the *last* thing a university should be trying to do.

3. William H. Honan, "Luring Faculty Stars to Teach More," *New York Times,* November 29, 1993, p. A10.

4. Editorial, "Shakespeare for Mere Mortals," *New York Times,* September 3, 1993, p. A22.

5. Gene I. Maeroff, "College Teachers, the New Leisure Class," *Wall Street Journal,* September 13, 1993, p. A16. Maeroff is a member of the Carnegie Foundation for the Advancement of Teaching, and wrote to protest the priority given to undergraduate instruction—not only in research universities, remarkably, but in all institutions.

6. Tom Hayden's antagonism toward Berkeley's research mission received some national publicity when he was interviewed on the Public Broadcast System's MacNeil-Lehrer News Hour on November 12, 1993. For the other university-bashing critiques to which we refer, see Martin Anderson, *Imposters in the Temple: The Decline of the American University* (New York: Simon and Schuster, 1992); Lynne V. Cheney, *Telling the Truth: A Report on the State of the Humanities in Higher Education* (Washington, D.C.: National Endowment for the Humanities, 1992); Dinesh D'Souza, *Illiberal Education: The Politics of Race and Sex on Campus* (New York: Free Press, 1991); Roger Kimball, *Tenured Radicals: How Politics Has Corrupted Higher Education* (New York: HarperCollins, 1990); and Charles Sykes, *ProfScam: Professors and the Demise of Higher Education* (Washington, D.C.: Regnery Gateway, 1988). For the "insider" critiques, see Bromwich, *Politics By Other Means*; Ernest L. Boyer et al., *Scholarship Reconsidered: Priorities of the Professoriate* (Princeton: Princeton University Press, 1990); Page Smith, *Killing the Spirit: Higher Education in America* (New York: Viking Penguin, 1990); Bruce Wilshire, *The Moral Collapse of the University: Professionalism, Purity, and Alienation* (Albany: State University of New York Press, 1989), and the articles by John Searle cited in notes 8 and 9 below.

7. Francis Oakley, "Against Nostalgia: Reflections on Our Present Discontents in American Higher Education," *The Politics of Liberal Education,* ed. Darryl J. Gless and Barbara Herrnstein Smith (Durham, NC: Duke University Press, 1992), p. 275; hereafter cited in the text.

8. John Searle, "The Storm over the University." *New York Review of Books,* December 6, 1990; reprinted in Paul Berman, ed., *Debating P.C.: The Controversy over Political Correctness on College Campuses* (New York: Dell, 1992), pp. 86–124.

9. See John Searle, "Is There a Crisis in American Higher Education?" *Partisan Review* 60.4 (1993), pp. 693–709; "Rationality and Realism, What is at Stake?" *Daedalus: Journal of the American Academy of Arts and Sciences* 122.4 (1993),

pp. 55–83. In the *Partisan Review* essay, an earlier version of which was published in the Bulletin of the American Academy of Arts and Sciences, Searle does indeed admit in his third paragraph that "there is not enough money" in American higher education (694) before proceeding to defend metaphysical realism. That paragraph also contains the astonishing sentence, "Another problem seldom remarked on is that many universities in the United States practice certain forms of discrimination against white males" (694). Regardless of the merit of this claim (and it is not without merit), one wonders in what sense anyone can plausibly say it is a claim "seldom remarked on." As in the *New York Review of Books* essay, Searle's more recent work suffers from his tendency to treat his critics' arguments only in caricature—as, for instance, when he argues that "it doesn't in any way discredit the works of . . . Descartes or Shakespeare that they happen to have been white males" ("Crisis," 705), as if any serious cultural leftist has held that it does, or when he paraphrases postmodernists' understanding of Kuhn in the most reductive possible terms: "scientists are an irrational bunch who run from one paradigm to another, for reasons with no real connection to finding objective truths" ("Crisis," 703). Searle continually complains about the low intellectual level of his adversaries; we note that it is easy for him to do so, since he so deliberately makes them sound ridiculous.

Yet even in his central argument about the irrefutability of what he calls "the Western Rationalistic Tradition," Searle sometimes relies on arguments that fall short of the rational standard he otherwise seeks to uphold. The "attacks on the Western Rationalistic Tradition are peculiar in several respects," writes Searle ("Rationality," 76), the first of which is that they have "little influence in American Philosophy departments" (77); Richard Rorty and Jacques Derrida, specifically, "are much more influential in departments of literature than they are in philosophy departments" (77). For Searle, it apparently follows from this that the "attacks" cannot be philosophically substantial; he does not entertain the possibility that American philosophy's cultivated inattention to pragmatists and twentieth-century Continental philosophers might actually be evidence of American philosophy's parochialism as a discipline. Searle assumes, of course, that poststructuralists and pragmatists lack influence in American philosophy because they are not good philosophers, but he presents his evidence the other way around, inviting his readers to infer that his opponents are not good philosophers because they lack influence. Certainly it is worth noting that Searle relies here on the argument from authority, which, in the Western Rationalistic Tradition, is normally considered a logical fallacy.

10. In "Time to Retire a Cliché," a December 5, 1993, editorial, the *New York Times* calls on people to stop referring to political correctness, since the charge "seeks to reduce all differences of opinion to a contest between a rigidly defined liberalism and a rigidly defined conservatism, with the conservative side laying exclusive claim to all that is good and true" (p. 20, sec. 4). Unfortunately, that is not likely to happen. The arguments about political correctness have entered the culture with enough force to have some staying power. Their future, as a result, is inherently unpredictable, for they are now available to be rearticulated to new discontents and new political projects of delegitimation. One use we should be

prepared to counteract—a use implicit in Kimball's and D'Souza's work—is that of dismissing progressive humanities research as "merely PC." This would be an excellent way to drive a further wedge between the humanities and the sciences, and defund research only in the former. In 1993, for example, a faculty member at a research university was denied funding for a project on the Harlem Renaissance because an administrator assumed all research on minority writers was "just PC."

11. Ron Grossman, Carol Jouzaitis, and Charles Leroux, "Degrees of Neglect," *Chicago Tribune*, June 21–25, 1993.

12. The researcher in question is Paul Lauterbur, who was told he would not have to teach undergraduate classes at the University of Illinois. The *Tribune*'s complaint about Illinois' hiring negotiations with Lauterbur was then picked up, seventeen months later, by the *New York Times* for its article on "Luring Faculty Stars to Teach More." The *Times* account not only claimed that the negotiations "came to light recently," as if they were matter for an exposé; worse, it treated Lauterbur as if he were a symptom of a national trend, calling his recruitment "a typical case of faculty raiders using the promise of an exemption from undergraduate teaching." Two paragraphs later, however, the *Times* admitted that Lauterbur does teach undergraduates after all, in "a course called Special Topics in Biophysics that highly qualified undergraduates may take by special arrangement" (A10). The other example they use as evidence of a national trend is the tragic story of a recent University of Chicago undergraduate who found Saul Bellow inaccessible. Neither the undergraduate nor the *Times* paused to reflect that faculty members over 75 years of age are not expected to hold office hours.

13. See, e.g., "The Labor Secretary Speaks Out on Training and the Two-tier Work Force," *Fortune*, March 8, 1993, p. 11.

14. James D. Koch, "From the President's Office to the Faculty of Old Dominion University," September 4, 1993. According to Koch, statewide tuition increases offset some of these cuts, yielding a 13.5% net reduction for the period; but because public resistance to tuition increases is greater than public resistance to funding cuts, Wilder has left a legacy as potentially damaging as was his term as governor: tuition caps have now become a populist rallying point in Virginia politics, and it is not likely that Virginia schools will recoup their economic losses in the legislature.

15. Gerald Graff, *Beyond the Culture Wars: How Teaching the Conflicts Can Revitalize American Education*. New York: W. W. Norton, 1992.

16. See Elliott Negin, "Why College Tuitions Are So High," *Atlantic Monthly*, March 1993, pp. 32, 34, 43–44.

17. Robert and Jon Solomon, *Up the University: Re-Creating Higher Education in America* (Reading, Mass.: Addison-Wesley, 1993), p. 248.

18. Perhaps it is worth putting on record one example of how a rogue department behaves. One of us knows an instance of a department that, on several occasions since 1970, adopted a special way of denying tenure to faculty members whose work it found politically objectionable, particularly feminists and scholars on the Left. The department head directed his assistant to go through the faculty member's publications and make a list of the names of scholars he or she criticized or attacked. The head then wrote to *only those scholars* for outside evaluations of

the tenure candidate's work. Of course this practice required the collusion of the department's entire tenured faculty (who would eventually see the letters) if it were to succeed. Meanwhile, confidentiality insured that the candidate would never learn who had evaluated his or her work.

19. National news media have generally been as reluctant to report this statistic as they have been eager to publish criticisms of faculty research. For two exceptions to the general rule, see Dennis Kelly, "Colleges Rely on Part-time Faculty," *USA Today*, November 13, 1992, p. D1, and Tony Horwitz, "Class Struggle: Young Professors Find Life in Academia Isn't What It Used to Be," *Wall Street Journal*, February 15, 1994, pp. A1, A8. Also see Patricia Kean, "Temps Perdus: The Woes of the Part-Time Professoriate," *Lingua Franca* (March/ April 1994), pp. 49–53. The Horwitz article should be given to all students applying to graduate school. The Kean article is a timely warning about the price *all* faculty pay for excessive reliance on part-time teachers. In that context, it is worth offering a warning about another potential two-tier faculty structure: hiring special teaching faculty who would teach four courses per semester, have no expectations for research, *and* receive drastically reduced salaries. Those faculty would often have to work in the summer and would have considerable difficulty remaining current with their disciplines. Small colleges without research traditions are already beginning to test the low end of the salary scale for new Ph.D.s; some research universities may soon do the same. In fact, in the present job market, new Ph.D.s could easily be hired for such jobs at $20,000 a year, perhaps less. The overproduction of Ph.Ds. amounts to an almost irresistible temptation to invent new forms of exploitation.

20. Evan Watkins, *Work Time: English Departments and the Circulation of Cultural Value* (Stanford: Stanford University Press, 1989).

21. See Michael Bérubé, "Public Image Limited: Political Correctness and the Media's Big Lie," *Village Voice*, June 18, 1991, 31–37, and *Public Access: Literary Theory and American Cultural Politics* (London: Verso, 1994), and Cary Nelson, "Canon Fodder: An Evening With William Bennett, Lynne Cheney, and Dinesh D'Souza," *Works and Days: Essays in the Socio-Historical Dimensions of Literature and the Arts*, No. 18 (Fall 1991), 39–54, and "Hate Speech and Political Correctness," *University of Illinois Law Review* 1992, No. 4, 1085–1094.

22. Conservative complaints about the degeneracy of the humanities usually concentrate on the number of undergraduate degrees awarded in each discipline; but, of course, any assessment of the popularity of *careers* in the humanities should focus instead on *graduate* applications and enrollments. The reason conservative polemicists ignore graduate enrollments is that the numbers contradict the polemicists' case so decisively: recent statistics clearly show that in the late 1980s, literary study experienced a stunning surge in popularity. According to the latest MLA survey of doctoral programs—a 1990–91 survey to which 88 percent of all programs responded—the average program witnessed an amazing 50 percent jump in the number of applicants, from 120 to 181; 77 percent of programs which responded to the survey reported that their applicants were better qualified for graduate study in 1990 than in 1985 (only 2 percent reported a drop in applicants' qualifications); and many programs expanded their size in order to accommodate

the flood of talented applicants. From these figures it would appear that cultural conservatives will have to forsake their claim that theory has corrupted the humanities, and revert to the more broadly philistine position that theory has corrupted the youth. See "Highlights of the MLA's 1990 Survey" and Bettina Huber, "Recent and Anticipated Growth in English Doctoral Programs: Findings from the MLA's 1990 Survey," *ADE Bulletin* No. 106 (1993), pp. 44, 45–63.

23. For a discussion of the *Redbook*'s emphasis on selection mechanisms whereby "the best people would be sorted out to assume the authority" of "the knowledge necessary to the proper functioning of the social system," see Watkins, *Work Time*, p. 97. Just after the *Redbook* appeared, however, President Truman appointed a Commission on Higher Education, whose report, according to Ernest Boyer, "dramatically redefined" this conception of higher education. "In its landmark report," writes Boyer, "this panel of prominent citizens concluded that America's colleges and universities should no longer be 'merely the instrument for producing an intellectual elite.' Rather, the report stated, higher education must become 'the means by which every citizen, youth, and adult, is enabled and encouraged to carry his [sic] education, formal and informal, as far as his native capacities permit.' " As Boyer puts it, "higher education, once viewed as a privilege, was now accepted as a right"—although, we add, that "acceptance" was by no means complete in 1947 and remains highly contested today. See, for example, the opening pages of the "Money, Merit, and Democracy" exchange in the present volume. Ernest Boyer, *Scholarship Reconsidered: Priorities of the Professoriate* (Princeton, NJ: Carnegie Foundation for the Advancement of Learning, 1990), p. 11.

24. One reason why a focus on socially aware graduate education is important is that many current faculty are simply incapable of dealing with the public realm. Take, for instance, the recent example of Geoffrey Hartman, one of our most distinguished literary critics, in an essay called "Higher Education in the 1990s," given pride of place as the opening piece in the fall 1993 issue of *New Literary History*. In a miasmic meditation, Hartman at one point imagines that higher education can get its bearings again if it only rethinks its relation to the sublime. He concludes the point with a particularly puzzling reference to popular culture: "As late Romantics—and progressive critics—we are attempting the impossible: instead of acknowledging a tension between art and social forms, we pretend we can normalize or instrumentalize art's charisma, transgression, wildness, innovation; we bestow an apriori [sic] acceptance on these qualities, and insist on a focus so broadly emphatic, so open on principle, that the sublime becomes an abstract and spasmodic technique, a routinized ecstasy, a mere flicker of itself like the photographically distorted grimacings of MTV's perpetual *danse macabre.*" Hartman, "Higher Education in the 1990s," *New Literary History* 24.4 (1993), p. 637. Ignorant of what this passage means, we can only guess what fraction of the state legislature will find it a persuasive rationale for re-funding our enterprise.

I

Professors and Politics

Going Public:
Political Discourse and the Faculty Voice

Linda Ray Pratt

Despite the revolution in discourse analysis that has yielded new levels of sophistication about the use of language, faculty efforts to turn theory into praxis often seem to stop at the classroom door. Critics such as Lynne V. Cheney, former chair of the National Endowment for the Humanities, have accused professors of putting "teaching and learning . . . into the service of politics" (6), but from another perspective, faculty have been remarkably unwilling or unable to translate learning into a politically effective public discourse. Amid a national debate about the structure and purpose of higher education, and a local debate in every state about funding, professors have seldom emerged as among the most influential voices. The public dialogue about higher education has been dominated by political partisans outside the academy, angry parents who feel cheated by high tuition for graduate assistant instructors, and a gaggle of disgruntled academics who berate the profession from the fringes. When a handful of professors in the humanities recently began to write in more popularizing language for commercial magazines, it was such a departure from the ordinary that the *Chronicle of Higher Education* considered it a news event ("Humanists Renew Public Intellectual Tradition, Answer Criticism," April 7, 1993, p. A6).

The degree of public credibility won by those who fail to understand what happens in a college classroom—or why research is related to teaching, or how the curriculum always changes as new ideas redefine knowledge—is alarming. In order to grasp what it means that faculty have so little voice in the debate over the shape and future of higher education,

try to imagine a public discussion about reforming the courts in which
the judges and lawyers were hardly consulted, had few political friends
watching out for their interest, and had no organized lobby. Or imagine
politicians designing a national health care system without being advised—
or shadowed—by well-organized and well-funded American physicians.
Both of these scenarios are impossible to conceive, even though polls tell
us that lawyers are the most mistrusted professionals, and medical costs
are bankrupting us. In contrast to most other professions that have one
central organization, faculty in higher education are largely scattered into
disciplinary organizations, each of which has only a limited national po-
litical agenda. Less than one fourth of faculty in higher education are in
unions, unlike the K-12 teachers, who are thoroughly organized in every
state, and function as a union in those states which permit public employees
to bargain. My own organization, the American Association of University
Professors (AAUP), is the only interdisciplinary professional organization
devoted exclusively to protecting the rights of faculty in higher education,
but on many campuses, only a small cadre of campus leaders are active in
the AAUP. On some campuses, there is no AAUP chapter. Lack of co-
herent organization thus mutes the impact of the faculty voice, but perhaps
equally critical to our faltering credibility is our failure to realize that our
professional discourse cannot persuade a public that doesn't understand it.

The New Public Faculty

If American faculty have been reluctant to assume a public role, and are
often ineffective as public spokespersons, they have in their defense the
lack of a historical model for such a role. It was only in the 1960s that
higher education became predominantly a state-funded affair. The growth
of multicampus state universities, state colleges, and community colleges
opened the doors to a wider public than had ever before thought of itself
as college-bound. The democratizing of college which began with the GI
bill after the Second World War continued throughout the 1970s until
almost every community had a publicly funded college or a university
where tuition was inexpensive and admission standards were permissive
for resident high school graduates. On the plus side was the most open
and accessible system of higher education we had ever had; on the negative
side was the increasing dependency of these institutions—and their fac-
ulty—on the mood of taxpayers and legislators.

As long as higher education was for the elite, and the division be-
tween intellectual education for its own sake and technical education for
economy's sake was sharply defined, the credibility of the professor resided
in his (rarely her) intellectual otherness. To be a college student was to

have elite status; to be the college student's professor was a hieratic position. The stereotype of the absentminded professor in an ivory tower was an affectionately comic image that revered as much as it mocked the superiority of mind that wasn't much fit for the exigencies of daily living. Such professors would have lost their standing if they were seen arguing for salary raises or analyzing a budget. The faculty's voice had real authority only as long as it spoke in ringing iambic accents or on the mysteries of $E = mc^2$.

Hence the distaste many faculty members express today about taking an active role in determining their economic status, in joining unions, and in lobbying the statehouse is both historical and practical. Academic culture accorded professors their status on the basis of values opposite from those that pervaded the capitalist economy, which nevertheless fed the large endowments sustaining private colleges and universities. Academic work required a mental disengagement from the bump and rub of the business world. Academic freedom protected the professor's work in terms of the priestly task of seeking the truth. I recall a faculty member in a state university declining to join the campus union with the explanation that to join would be to say to the governor, "I am your employee." Though he was about to become a zero-percent-pay-raise employee of the state, his image of himself as free of the muck of money and politics was more valuable to him than the actualities of his job.

Changing the Academic Narrative

Jean-François Lyotard discusses the changing definitions of higher education and its altered relationship to society in terms of revisions in the narratives on which we model ourselves and our institutions. The traditional model was based on "emancipationist humanism" which trained an elite in ideals that could sustain the emancipation narrative of social development (48–49). Lyotard's description of this historical function of education is perhaps more familiar to us in terms of the "idea of the university" we inherited from John Henry Newman and John Stuart Mill. Education was valued for its own sake, and the professor's role was to enlighten the minds and hearts of those who would interpret truth and justice for their society. But Lyotard's report on the condition of knowledge in the postmodern world discovers a new narrative that has displaced emancipationist humanism. The postmodern narrative for higher education is predicated on the "performativity of the supposed social system," and its goal is to teach and create functional skills (48). Its success is measured by its ability to enhance world competition and to preserve the social cohesion necessary to an efficient economy.

The pattern of the development of higher education in the last twenty-five years and the language of the current debate over its future structure and purpose support Lyotard's general thesis about the narrative of performativity. To the extent that this analysis is true, it has profound implications for faculty in terms of our status in the institutions and in society as a whole; it also dramatically affects the academic values by which we define our professional standards, and the conditions which are likely to determine the nature of our work. If we are to influence this development and exercise any control over the terms and conditions under which we work, the faculty must develop a new narrative of our own and find ways to carry it to the public. If the narrative of education for its own sake has become only a tangent in a new system of education for efficiency, the traditional authority vested in professors as seekers of the truth cannot address the issues in a public discourse concerned with accountability in cost efficiency and skills performance.

To date, the faculty's public discourse has been largely what Lyotard calls "reactional countermoves" (16). When the legislature says the faculty doesn't teach enough, we essentially respond by saying, "We do, too." Of course we have work load surveys that supply data showing that we work fifty to sixty hours a week. But these counters accept the terms of the opponent without introducing new ones that might change the assumptions in the discourse. Lyotard explains that reactional countermoves play into the hands of the opponent's strategy, "and thus have no effect on the balance of power" (16). If the administration's defense will present "an overly 'reifying' view of what is institutionalized" (17), then the only voices within higher education that can hope to shift the balance of power belong to the faculty and the students.

Yet precisely because the traditional authority of the faculty lies in its scholarly image, any practical political move faculty make into the public arena has the potential to get beyond the reactional counter that only reinforces the terms of the existing discourse. New theories about the nature of language and its contextual life offer a potential tool in achieving a more effective political discourse. Applying our theoretical understanding of such forces as the social contextualizing of a text, the cultural representation in narratives, or the dialogic imperative in heteroglossic societies may help us find new strategies in formulating our public voice.

Too often leaders in higher education defend the academy in the language and value systems used to rationalize other kinds of interests, such as business and industry. But a discourse that accepts the value-laden language of another community may do little more than reinforce those values, a tactic that results in a "reactional countermove" that cannot

change the structure of power. One of the most common but hazardous strategies for justifying higher education has been adopting the rationales of the business world. Research is good because it produces new products; the university brings x dollars into the local economy; writing labs help future employees prepare better reports; foreign languages are necessary if we are to trade with the world. It's not that these arguments are untrue, but that they are too narrow in scope to protect universities as we know them. Once we cast education in the metaphors of business, research that does not yield new products winds up seeming even more irrelevant than before, and courses that don't feed job skills are frills. When the business model is appropriated by academe to defend itself, the public university becomes subject to the other standards applicable to business: work load efficiency, downsizing in personnel, elimination of program duplication, teaching more students with fewer faculty, replacing inefficient classroom contact with high-tech "distance learning" through television, "TQM" as the management model. Funding is seen as an investment decision based on short-term production goals.

When education becomes essentially a component in the efficiency of a performance-measured economy, the question of who is worth the investment also becomes sharper, and meaner. The use of community colleges to train the mass of skilled workers, and the restriction of university enrollments to these workers' future managers and directors, makes good business sense. Education programmed in this way will inevitably favor the white economic elites and result in aggregating nonwhites in second-tier institutions that prepare them to fill jobs that others will supervise. Such controls on access to knowledge serve one conception of social cohesion. Educating the elite for leadership was the traditional function of higher education, and dividing institutions and students into distinct tiers preserves the class division while pretending to make education more democratic. The logic of the discourse of business is clearly one that the public and the politicians are prepared to understand and endorse, but when university officials adopted it, they yielded their own authority to define higher education and surrendered the institutions to the laws of the market economy. One clear sign of how pervasive the change in values has been is the phenomenon of tenure and promotion recommendations based on how much outside grant money the professor has brought into the institution.

The consequences of appropriating the discourse of business illustrate how important it is to know what we want to say and to be conscious of the implications in the language we use. Yet the forums are few indeed in which faculty as a whole, or a campus community in particular, debate the future of higher education or chart a course of action for themselves.

Often this is due to the lack of a specific imperative that requires faculty action. Invariably, faculty on campuses which have collective bargaining are much more informed and astute about the operations of their institution, its political relationships, its budgetary possibilities, and its comparative peer standing. For them the negotiating table and the contract are imperatives that drive the acquisition of faculty expertise. For many others, only a crisis atmosphere provides the impetus for finding a faculty voice with which to address the public. The three case studies that follow are diverse examples in which faculty action in a public arena proved effective.

Three Case Studies

The University of Nebraska-Lincoln

In the University of Nebraska system, the campuses at Omaha and Kearney have collective bargaining; the "flagship" campus at Lincoln does not.[1] Each campus has a chancellor, but a president and central office govern the broad concerns of the university system. A Board of Regents presides over the whole. Since campus-level administrators are not officially permitted to lobby independently for their campus, the official lobbying was done for the system, and the interests of the Lincoln faculty could only be openly represented as part of the overall package that the system's office was advancing. Many on the UNL faculty also felt that the faculty's interests had been bargained away in the legislature for other items that were on the University administration's agenda. The unionized faculty at UNO (AAUP) and UNK (NEA), for their part, had each hired lobbyists in the statehouse to advance their campus faculty interests. A collective bargaining campaign at Lincoln had failed in 1983 ("flagship" faculty are especially reluctant to be "employees"), but faculty leaders in the local AAUP chapter felt it was essential that UNL faculty find some new way to have a voice in the legislature.

In 1987 the Lincoln chapter initiated a plan to solicit funds from the faculty to hire an independent faculty lobbyist. The first question was how faculty would pay for a lobbyist; the next question was what the lobbyist would be asked to do. Both of these questions were important in establishing a faculty community that might come together in a new kind of alliance and in determining what they would want a lobbyist to advance on their behalf. The AAUP first got sound advice about how to employ a lobbyist—and who to hire—from a handful of legislators who strongly supported the Lincoln campus. About six months after the AAUP had hired a lobbyist, the UNL Academic Senate followed its lead and also

hired one. The leadership in the AAUP and the senate, a group with significant overlap, worked together to make sure the two efforts were complementary. Faculty could contribute to either or both funds, or to a general AAUP fund that helped defray costs other than the salary of the lobbyist. Many faculty members who would not run for the senate or join the AAUP were willing to contribute money to hire a lobbyist under these conditions. Since its inception in 1987, the appeal has collected the necessary funds with a request that each faculty member contribute one dollar for every one-thousand dollars in annual salary.[2]

The one specific item that had been part of the appeal was faculty salaries, but when the issue of faculty salary enters the political arena, it does so as part of a broader budget package. A faculty lobby and a budget bill provide the occasion for faculty to talk with legislators about their own set of priorities for the university. Faculty priorities are almost certain to be centered on academic programs, even when these are framed around the issue of faculty salary. These priorities may be different from those of the administration, but even when they are not substantially different, they may be advanced much more concretely in terms of student needs, classroom situations, and real working conditions. Faculty are likely to be accorded considerable credibility when approaching legislators personally for three reasons: faculty speak from direct experience with students; few faculty have political interests or ambitions that might compromise the candor of our assessment; and faculty are largely free of the baggage of con games and manipulation that many legislators have learned to expect from the administration.

Faculty in the legislative halls give a human face to the university that can be a refreshing alternative to the dressed-for-success administrators with their briefcases full of reports. For some lawmakers, meeting with faculty provides an opportunity to find the part of the university they want to see. Politicians want to believe that the money they appropriate actually educates people, and faculty and student contact brings that reality home. Some of the contact between faculty and policymakers will result in unexpected insights. One legislator's public complaints that university faculty were spending all their time on research stopped after he had lunch with professors who talked about what they were doing in their writing classes. In another case, a faculty member casually joked that cutbacks in university maintenance meant her office got cleaned about twice a year. The senator was a lawyer accustomed to elegant offices that were cleaned nightly by an invisible service. A university so strangled by budget cuts that professional people were working in dirty offices was a vivid image that translated more concretely than data about enrollment swells and program cuts. Some faculty may find it disturbing that votes are sometimes

decided by brief impressions or emotional reactions, but people in power
are as subject to human factors as anyone else. People in power are also
invariably courted by many others with valid interests who make demands
on the public largesse. Faculty were sometimes confronted with the naiveté
of their claims on the state budget, and some had to admit to the essential
bigotry of their presumption that most politicians are stupid.

Faculty in the halls of the state capitol can make a different statement
about themselves from the ones the media present or administrators rep-
resent, and those differences often matter. Although the UNL lobbying
plan was designed to give the faculty a voice in the state capitol, it also
heightened the credibility of the AAUP and the senate with faculty, and
became part of the base for sustained cooperative efforts between the two
groups. With campus administrators hamstrung by the system's office, the
faculty could say publicly what campus administrators could not. The
faculty's move to political action also took them out of a passive role, and
opened the way for a more cooperative relationship between faculty and
administration. Above all, a faculty that moves into the public arena asserts
to all interested parties that it will not be taken for granted, and that it
is prepared to make a public and political fight for what is most important
to it.

In the last five years that the University of Nebraska faculties have
been lobbying the legislature, four two-year budgets have been approved.
The first two of those budgets brought UNL 10.5 and 11 percent pay
raises as part of a major salary initiative that produced a 34 percent salary
increase over three years.[3] From 1990 to 1992, although many institutions
were facing zero increases, UNL sustained their salary improvement with
4.5 percent raises in each of the two years. Only in 1993, when growing
health costs in the state constrained appropriations, were deep budget cuts
and zero percent salary increases threatened. However, the final cuts did
not require program elimination or dismissal of tenure-track faculty, and
the salary package provided about three percent over two years. In addition,
in 1992–93 a threatened legislative bill, requiring a minimum teaching
work load for faculty, did not get out of committee. When an ill-conceived
administration plan to cut two departments on the Lincoln campus was
announced in the summer of 1991, the faculty alliance that had previously
worked together for better salaries was highly visible in the media and
on campus in the successful effort to rescind the plan. Within the power
structure that had controlled the flow of information and contact with the
legislature, the faculty, by taking their case to the legislature, had made
a new "move," one that could affect power relations instead of merely
reacting to them.

Oregon's Measure 9

The statehouse is where budgets are approved, but higher education's greatest threats often grow out of the lack of public support and understanding. In two notable examples, one in Oregon and one in Connecticut, faculty took their case to the public via the media. In Oregon, Ballot Measure 9 would have restricted the use of state funds for anything that promoted behavior deemed "abnormal" and "unnatural," or acts of "sadism" or "masochism." It expressly stated that the State Department of Education and the public schools must "assist the government in labeling homosexuality as abnormal and perverse." This proposed legislation was not only offensive to many faculty members in its discriminatory intention; it was also an infringement on academic freedom since it would have required teachers to promote the state's "truth" in the classroom. It would also have prohibited publicly funded libraries from purchasing books that might be considered in violation of the statute, and forced them to remove books on the shelves that discussed homosexuality as anything other than an abnormal and perverse act.

Indications were that the vote would be close, and the Oregon Conference of the AAUP felt it was important to defeat the measure. The AAUP commissioned a poll of the legislative districts to determine in which ones the outcome was uncertain. Those districts were then targeted for a radio ad campaign designed to swing the vote against Proposition 9. Questions about strategy and potential audience were critical. The radio ad was carefully considered, but the ad campaign was not without its critics. An analysis of this venture of the faculty into the political arena may illustrate both the political strategizing required when taking one's case to the public, and the conflicts that may arise when the highly nuanced and politically coded discourse characteristic of professors is translated for a wider public. The text of the radio spot was as follows:

> Since the days of the Oregon trail, brave men and women carved out Oregon with grit and independence. That same spirit still lives today making Oregon's public schools and universities among the best in America. Why? Because parents, our elected school boards, and the teachers we hire all work together to decide what our children should learn. Here in Oregon we call that local control, and it has served us well. But the backers of Ballot Measure 9 want to take that right away and push their own political agenda on our kids. They want to tell us who we can hire in our schools and universities, and what those educators can say. In the land of the free, that's not the way we do things. The American Association of University Professors believes every parent should take an active role in deciding what their children learn. We urge you to protect your right to run our local schools and

insure academic freedom in University classrooms. Vote "No" on Measure 9 and keep local control of our schools. Authorized and paid for by the American Association of University Professors. (Transcript from tape, AAUP archives)

The basic message in this ad is "Don't let people with political agendas tell us what to do in our schools." Its strong secondary point is that the business of deciding what goes on in schools is the responsibility of parents, teachers, and duly elected school boards, all of whom constitute "local control." The reference to "the teachers *we hire*" deepens the right of local control by parents and officials. The message is contextualized with the appeal to the pioneer heritage: *brave* men and women who could *carve* Oregon *with grit and independence* don't let people push them around. The connection of that "spirit" with building fine schools and universities places the education system within the context of the pioneer achievement. Now that legacy, that spirit, is being threatened by ideologues who do not understand the American way ("In the land of the free, that's not the way we do things"). "Academic freedom in university classrooms" is specifically mentioned only once at the end of the ad, but the references to freedom, independence, and the right to speak which appear throughout the text carry the message in language that connects to the larger public's values.

Among academics, the very fact that the AAUP was sponsoring the ad was a powerful argument for the dangers to the academy if Measure 9 was approved. But if the measure was to be defeated, a much wider group would need to be reached. The ad was designed to appeal to those voters in the mainstream who were *not yet convinced* of the danger in approving Measure 9. Its job was to find the points where academic freedom could translate as something that was of benefit to the general public. Measure 9's provisions also attacked the freedom of schools to control their own curriculum. The ad's references to teachers, schools, parents, and citizens sought to define a community with a common interest. Geoffrey Johnson of Johnson and Associates, the firm that created the ad campaign, assessed the Oregon public as one that was skeptical and "conservative with a little 'c' " (interview with Johnson). Radio was chosen because radio stations can both blanket an area and target particular audiences more effectively for lower costs than other media.[4]

When the votes were counted, the AAUP ad campaign was apparently a success, as Measure 9 was defeated in all the targeted legislative districts. In determining its best strategy, the AAUP had several options. One was joining its efforts with those of the broader union movement. The advantage of that strategy would have been to strengthen an important coalition that might have other reciprocal relations; the disadvantage was

that it would have lost the major point on which the AAUP can speak with undisputed authority—the concern for academic freedom. The other major choice in the radio strategy was not addressing directly the issue of discrimination against gays. In general press releases and stories written for its own publications, the national AAUP did raise these issues, saying things like, "Measure 9 is about superstition and bigotry. We cannot allow government to censor education and discriminate against those it deems 'abnormal, wrong, unnatural, and perverse,' " and that AAUP policy "condemns discrimination in colleges and universities on the basis of sexual or affectional preference' " ("AAUP Opposes Measure 9 On Oregon Ballot," national press release, fall 1992). A letter campaign also discussed the issues of Measure 9 more fully than the radio spot. Although Measure 9 was unquestionably aimed at suppressing gays, the provisions whereby the policy would be carried out raised other issues about requiring teachers to advance the state's idea of "truth" and censoring the selection of educational materials. The choice again came down to matters of credibility: as professors we had something unique and powerful to say about freedom in the schools, something on which we could be the voice of authority.

One critic faulted the radio ad because it did not include gays among those interested in and sharing responsibility for the schools (the ad had argued, "parents, our elected school boards, and the teachers we hire all work together to decide what our children should learn"). His point was that gays are as interested in issues of education as others, and that the ad's focus on parents tended to exclude gays from the concerned community. In some ways this criticism reflects the way in which academics often model our public discourse on the assumptions that govern our academic discourse. Within liberal and progressive political communities, a self-conscious verbal inclusiveness of women, minorities, and gays signals one's peers of one's politics, but an effective public discourse may require a different language because it aspires to address a community with significantly different values and cultural experiences. A radio ad that included gays among those concerned with our schools might indeed have affirmed gays as caring citizens, but gays were not, of course, among the groups the ad hoped to convince to vote against Measure 9. Effective political action must be targeted to specific issues and specific power groups. The larger principle at stake here is quite significant: if our public discourse aims at making "them" understand "us," we will wind up mainly talking to ourselves. The goal is to find what "they" believe or want that we can make resonate with what is important to "us."

University of Connecticut

The Northeast area has been one of the hardest hit by recession for several years now. In what were unquestionably tough times for the state, the

University of Connecticut had taken five years of bone-deep cuts. From 1987 to 1992 the University of Connecticut's general fund budget had been cut by 33.5 million dollars; tuition for in-state students had risen 82 percent. In 1991–92 alone the University's general fund budget was cut by 19 million dollars (figures from material prepared by University of Connecticut AAUP). In 1992, when Governor Lowell P. Weicker, Jr. announced a plan to match 200 million dollars in state money with 800 million dollars of bank money to create new business investment in the state, the state's indifference to the welfare of its university system became more intolerable.

The University of Connecticut AAUP is one of the largest collective bargaining units in higher education. The range of strategies it could put together to take its case to the public almost certainly could not be matched by a faculty lacking a union, but the thoroughness and imagination of the UConn campaign are worthy of study even by those campuses which have more limited resources and experience. For several years now the University of Connecticut has been taking its case to the public. During the 1992 legislative session the UConn-AAUP ran ads and mailings around the theme that the university budget had already been cut to the bone. The 1992 theme was carried out in printed materials and radio ads. One pamphlet declared "UConn's budget already has been cut to the bone," and accompanied it with a nine-by-twelve inch photograph of a skeleton dressed in UConn track clothes and wearing a mortarboard. The profound damage of more cuts was also powerfully visualized in other material that pictured well-dressed male and female students who were headless. The image was labeled, "this is one cut Connecticut cannot afford." Radio ads echoed the theme of being slashed to the bone by interlacing lyrics from the song "Dem Bones" with commentary about the university's budget woes. The ad ended with the sound of bones falling to the floor and a door slamming. The language of budget cuts was, in effect, "fleshed out" with images that made clichés ("cut to the bone") visually graphic and immediately comprehensible. When Governor Weicker angrily reacted to the radio ads by charging that professors shouldn't be doing such things, the media covered his response and thus added to the growing sense that much was at stake.

In 1993, the year the union would be negotiating a three-year contract, the UConn-AAUP built a strategy around Governor Weicker's announced plan to promote business in the state. Unlike the Oregon campaign, where voters would decide an issue on a given election day, the University of Connecticut faculty needed to organize a group of supporters to initiate specific action on their behalf. Although radio ads throughout the state could build the public's consciousness about the UConn budget,

a more direct and personal approach was necessary to stir people to contact their legislators. A mail campaign directed primarily at 75,000 alumni drew a surprising fifteen percent return rate (Johnson interview). A series of brochures with photographs that visualized the effects of budget cuts at UConn included a card addressed to the governor or to legislators. The card had a printed message stating that the budget cuts were too severe and asking that the legislature make higher education a priority, and it included a space for personal comments. The signed cards bore a return address to the UConn Chapter of the AAUP. The local chapter in turn presented the cards to the lawmakers from each zip code area. In this way the AAUP knew how many cards were coming in from which areas, and they had the advantage of choosing how and when the cards would be used.

Radio spots picked up the governor's theme of investing in business in Connecticut:

> Name a business that isn't leaving Connecticut . . . ever. Last year, this business brought nearly a hundred million dollars into the state, and introduced thousands of trained employees into the work force. Over a thousand of its staff have doctorates.
> What thriving enterprise is this?
> It's the University of Connecticut.
> ("Staying in Connecticut," recorded February 23, 1993)

The ad continued by mentioning the $88 million dollars in research grants the University attained in 1992 and noted that Connecticut ranked 45th in state support as a percent of per capita income.

The UConn-AAUP strategy included a wide range of activities designed to create public awareness and to bring pressure to bear on legislators. One issue of the newsletter in 1993 listed the following as among the activities the chapter was pursuing:

- Active lobbying in Hartford.
- A public relations effort which includes mailings to known supporters, the business community across the state, and constituents in many legislative districts.
- Radio time highlighting the need for UConn support. . . .
- Coalition activity with colleagues at CSU and the Community Colleges to build political and public support for public higher education as part of the answer for Connecticut.
- Intensive legal analysis of contract, By-Laws, and statutory options of protecting members and the University at large.

- Obtaining records used by or relevant to the PRC [Program Review Committee, the UConn committee charged with making recommendations to the Provost about the elimination, reduction, or consolidation of programs].
- Work with each of the units currently at risk from the PRC reports. (from the UConn Chapter *AAUP Newsletter,* February 19, 1993)

In addition to promoting the agenda indicated on the list, the AAUP leadership visited the governor, and invited Senator Christopher Dodd to campus to meet with faculty and students. Moreover, their regular newsletter and periodic bulletins kept faculty informed of what was happening.

The UConn-AAUP's campaign gained effectiveness because it targeted a constituency, and provided them with a convenient way in which to act on behalf of their alma mater. The language used tied into the public discourse of the governor and state officials, and the campaign concentrated on a few themes that were repeated in a related set of visual and auditory messages. The radio ads were aimed at two audiences: the general public, and the lawmakers. Ads seeking the widest coverage were placed on the most popular stations for morning listening on the way to work. The ads aimed at key legislators were placed on local stations in their districts.

In the end, the 1993 Connecticut legislature added back to the university's budget 8 million dollars in the first year and 9.5 million dollars in the second year. Faculty, who had been threatened by program cuts that meant layoffs, won a contract that brought greater stability to the campus by protecting against immediate layoffs, notices of layoff, or involuntary furloughs. Salary increases were staggered: three percent in July, 1993; another three percent in August, 1994; another three percent in January, 1995; and a wage reopener clause for July, 1995. The AAUP's efforts made a convincing case that further damage to the University of Connecticut would hinder the general economic recovery and limit the state's future.[5]

The UConn-AAUP recognized the value of a sustained effort over several years to build the case with the public about the desperate conditions at the university. In 1993, when contract negotiations were at hand, the union's efforts focused on creating pressure on the legislature to appropriate money that could fund salary increases over the next three years. The UConn-AAUP radio ads also remind us of the way in which ads in the public media may be used to deliver messages other than the one in the script. We do not normally think of a radio ad having only a few key people as its target, but numerous faculty groups have used such

ads to signal public officials or administrators that the faculty is ready for a full-scale public campaign. At another institution in a midwestern state, the faculty union ran ads supporting a bond issue in order to signal campus officials that they had the money and the know-how to use the media if necessary in an upcoming contract dispute. In general, institutions do not like their business discussed in the public arena, and especially not by faculty groups which the school cannot control. A faculty which signals its willingness to take its case to the public may win the ear of the administration without launching a full-scale media campaign.

Where to Go From Here?

The fiscal future will almost surely bring increasing requests for public funding that will outrun the willingness of the public to raise taxes. Since most of higher education is state-supported, our institutions face continuing economic struggles and public demands for accountability. How our society will pay for higher education will remain an issue in the political arena. Too often, politics is power, not wisdom; it involves the use of information, not knowledge; it rewards speaking effectively, not truthfully. Few of us are willing to forego wisdom, knowledge, and truth, and for us the dilemma is finding a middle ground that is both true to our beliefs and capable of communicating to a broader public. The three cases discussed above represent successful efforts by faculty that combine the integrity of their beliefs about education with strategies that can influence the political players that may control their futures. The examples of the University of Nebraska and the University of Connecticut also remind us how basic state funding is to the structure of the university, and not just to the economic welfare of faculty.

The most frequently discussed plans for restructuring the universities always call for doing more with less. "Distance learning" seeks to make a virtue out of not being in a classroom, and high-tech delivery of courses aims at massive reductions in the number of faculty needed in higher education. The importance of research is downgraded by those who wish to cut budgets by increasing teaching loads. Those of us who have classrooms and know what the role of research is in a university must take our case to the public if we are to hold on to our ideals of education as a dynamic process between students and teachers.

Little in our academic culture prepares us for the role we need to play. We need to organize, but the model of the high-status faculty member is that of individual entrepreneurship. We need seriously to tend to our academic house, but faculty governance is demeaned as low-status "service." We need to talk to the public about the values we potentially

share, but faculty are trained to "instruct" those who do not know. We need to take greater responsibility for our employment conditions, but we are reluctant to think of ourselves as "employees." We need to address our local politics, but our affiliations are with national and international disciplinary organizations. We need to explain why a multicultural curriculum benefits society, but too often we resort to defensiveness when questions arise. We need to stand together and face our public, but we often dissipate our energy and anger in internal controversies.

The idea that education's role is to deliver performative skills at efficient costs is a public consensus which most practitioners of the profession do not accept. Yet the traditional academic consensus is as broken internally as it is externally. Our problem is how to be sufficiently organized to influence the public consensus and sufficiently united to find a coherent alternative to it. Our best hope for a coherent internal strategy is in uniting around those few standards that are critical to almost all of us. Most of us believe in the value of the teacher in the classroom, and the need to protect academic freedom, in the necessity of economic stability for the profession, and in a diverse curriculum in an open system of democratic education. We also know that learning is not always a matter of performance, and that the most promising students may not fit the statistical profiles. We understand that education must always be out on the edge of what is known, and that being on the edge inevitably brings controversy and misunderstanding. These are precisely the things least clear to the public, and a faculty that could unite around these beliefs would have the basis for a purposeful internal organization that could direct its energies outward.

If the values that most nearly unite us are in fact the values least understood by the public, it follows that we must devise public strategies that challenge the consensus, not reinforce it. This may mean doing what professors aren't expected to do, making what Lyotard calls a "new move" that destabilizes the existing power. This may mean exposing the contradictions in a confused public attitude that both demands quality in education for its investment and wants to believe that one college credit is as good as any other.[6] Clearly it means organizing to address local situations, lobby legislatures, build coalitions with students, parents, and alumni, and utilize the structure of faculty governance to speak effectively within our systems. Political expertise comes with experience and concrete knowledge of the local topography of power. Some of what we do may be inept and misguided, but if the profession fails to influence the public voices that increasingly control higher education, our own ideas of a university will surely be silenced.

NOTES

1. A fourth campus in the NU system, the Medical Center, with a faculty of medical professionals, is not sufficiently comparable to the other campuses to illuminate this discussion.

2. I wish to express my appreciation to Professor William J. ("Jim") Lewis, Professor and Chair of the Department of Mathematics and Statistics at University of Nebraska-Lincoln, for reviewing for me the events under discussion. Professor Lewis was president of the UNL Academic Senate and later the UNL-AAUP chapter during these years.

3. Since the Omaha and Kearney campuses are represented by different unions, their contracts have sometimes had different salary agreements. The Medical Center and the Lincoln campus salaries are determined by the Board of Regents which follows the legislature's guidelines closely.

4. The AAUP's booklet, "Building an External Communications Program," provides information faculty groups need to use media effectively.

5. I wish to thank Edward C. Marth, Executive Director of the University of Connecticut Chapter of the American Association of University Professors, for supplying written documents and providing information and commentary on the events at UConn.

6. As I write this, the morning paper has four different stories which suggest the contradictions in the public attitudes about education. One is on the decline in quality of American teachers, and one is on the improvement in SAT scores for the second year in a row; and one is about the impossibility of attaining educational goals without more funding, and the other is on the lack of evidence that increasing funding increases performance.

WORKS CITED

Cheney, Lynne V. *Telling the Truth. A Report on the State of the Humanities in Higher Education.* Washington, D.C.: National Endowment for the Humanities, 1992.

"Humanists Renew Public Intellectual Tradition." *Chronicle of Higher Education.* April 7, 1993, pp. A6–A7, A12–A13.

Lyotard, Jean-François. *The Postmodern Condition: A Report on Knowledge,* trans. Geoff Bennington and Brian Massumi. Minneapolis: University of Minnesota Press, 1984.

A Faculty Response
to the Fiscal Crisis:
From Defense to Offense

ERNST BENJAMIN

The current decline in state funding for higher education did not originate in the recent recession. Rather, the decline results from a long-term economic weakening of the public sector, and the consequent erosion of public support for higher education. That is why we have felt the recession more deeply and its campus impact more severely than is generally supposed.

What we have experienced is not only the cumulative effect of recurrent recessions (1970, 1974, 1980–82, 1990–92) but a fiscal crisis particularly harmful to public institutions. Government has been unable or unwilling to generate and allocate the funds necessary to resolve widely recognized social problems. Moreover, federal efforts to improve the fiscal situation have relied on measures which diminished the earnings and quality of life of the majority of citizens and thereby diminished support for federal activities in general. Accordingly, I propose to review our national fiscal policy, explore its campus impact, and consider what we can do to improve the policy and the academy.

The link between the long-term fiscal crisis and the decline in public support for higher education will be most evident as we explore the sharp shift between campus growth in the 1960s and erosion in the 1970s. The erosion has not been uninterrupted. As we will see, by some measures campus resources and quality ceased to decline—or even showed modest improvement—from the mid-1980s to the 1990–92 recession. But the overall pattern of decline demonstrably has its foundation in the nation's continuing fiscal crises. Hence, we need to seek solutions to campus prob-

lems not only through adjustments in campus policy, but through organized efforts to change state and national fiscal policy.

The Fiscal Crisis

The fiscal crisis is the result of policies intended to increase the nation's economic "competitiveness." In the postwar era of the 1950s and 1960s, the United States dominated world trade, and the dollar provided the foundation of the international monetary system. By the 1970s the growth of international competition and inflationary domestic policies had forced the government to "float the dollar" and adopt fiscal "austerity." The dollar did not so much float as sink; that is, its value declined against such currencies as the mark and the yen. This increased the cost of imports and of everyday life.

The federal government responded with fiscal policies intended to increase "competitiveness" by reducing private consumption, public spending, and taxes on corporations and wealthy individuals thought likely to invest. Reduced domestic consumption diminished the growth of domestic demand and, thereby, diminished the growth of jobs, wages, and taxable income. This policy has not, therefore, produced commensurate investment in new industry and technology. Nor have exports increased sufficiently to stimulate increased rates of domestic investment. Investment has all too often been concentrated in foreign plants, equipment, and jobs, or in inefficient and obsolete defense industries, or in domestic financial speculation. Consequently, for an increasing number of Americans, the real meaning of "competitiveness" has been "austerity."

Diminished public spending (in real dollars), which includes cuts in educational spending, has worked in tandem with lower corporate taxes and production costs to increase the short-term competitiveness of individual firms. But the costs of this policy are never immediately apparent. When legislatures constrain educational spending, the impact on productivity may not be felt for a generation; in the meantime, the consequences for educational quality can be concealed from the public by maintaining access to programs whose lower quality is not publicly perceived. Such a policy may be prolonged to the point at which firms can no longer hire essential skilled employees. Yet even then, firms may cover for the shortage of skilled labor by designing production around the increasingly abundant low-skilled, low-waged labor pool here and abroad. Prolonged fiscal crisis in education, then, can produce social effects that are no more visible than the movement of glaciers—but which transform the national landscape all the same.

Secretary of Labor Robert Reich has long emphasized this danger. In a recent interview he observed that the U.S. has, since 1974, created jobs more successfully than our European counterparts, but not good jobs:

> "The average wages of America's production workers continue to slide," he said. "Adjusted for inflation they're the lowest they've been since 1967. . . . No other nation's industrial workers have lost so much income." . . . Reich insists the trade-off between good jobs and more jobs is not inevitable. But he said it can't be avoided without a change in government policies, and the key is education.[1]

As long as we continue to design production around a decline in educational investment and diminished worker productivity, we further reduce the competitiveness of high-wage firms dependent on educated employees. This accelerates our descent on the downward slope toward a low-skill, low-wage economy.[2]

Yet in the current fiscal perspective, education is most often viewed, erroneously, as a form of private consumption rather than as a public investment. Individual educational expenditures are considered consumption rather than saving despite the fact that a B.A. degree is an investment in future productivity which increases earning capacity relative to a high school diploma by 20 to 40 percent.[3] Public educational expenditures are considered part of "tax-and-spend" government rather than investments in human capital. Accordingly, the Reagan "recovery" did not include an increase, but rather a substantial reduction, in federal student aid. Between 1981 and 1986, federal aid declined by 14 percent in constant dollars. Despite increases in cost of attendance well above the rate of inflation and a substantial shift of federal aid from grants to loans, federal aid in 1991–92 had not quite attained the 1991 level.[4] State and private institutions made up the federal shortfall from their own funds. This meant increasing tuition, state assistance, and state taxes to help pay for student aid.

Other reductions in federal contributions to the states have diminished the ability of the states to fund education. In 1992 the National Conference of State Legislatures reported that "Federal mandates to expand Medicaid and other welfare programs, state court orders to equalize school funding and federal court orders to reduce prison overcrowding have imposed tremendous costs."[5] Moreover, the unresolved social problems exacerbated by diminished public services have themselves further increased the costs of these programs. Consequently, "despite strong sentiments around the nation to avoid tax increases (some states enacted deep budget cuts to avoid them), two-thirds of the states enacted net tax increases for fiscal year 1992."[6] These pressures on the state tax systems have, predictably enough, only heightened public resistance to federal taxes.

Since U.S. fiscal policy has sought to encourage austerity, government is less willing to make countercyclic investments in domestic programs. The first such effort since the early Carter Presidency, President Clinton's proposed "stimulus" package, was inadequate even as proposed, and died due to a Republican filibuster. Of course, the Reagan recovery did reflect the stimulus of increased government defense spending. It benefitted also from the decline in inflation and interest rates resulting from the weakening of the oil cartel. But, following the massive growth of the deficit and the national debt due to the Reagan defense buildup, the savings and loan bailout, and the Gulf War, government is even more fearful of increasing domestic spending to alleviate the impact of, or stimulate recovery from, recessions.

On the one hand, then, the fiscal policies underlying the recessions of the mid-1970s, early 1980s and early 1990s have diminished the living standards of the middle class and sharpened income differentials between rich and poor. Many other households have had to increase the number of wage earners and work longer hours simply to maintain—or minimize erosion of—their standards of living. On the other hand, the loss of perceived benefits from government expenditures fuels the tax revolt, which in turn exacerbates the deficit and further diminishes the capacity of government to alleviate problems.

Campus Impact

Consequently, the states and higher education have suffered increasingly severe economic difficulties. In 1991 almost two-thirds of state colleges surveyed reported midyear budget cuts.[7] Thirty-six states had lower appropriations (adjusted for inflation) for 1992–93 than for 1990–91.[8] For the very first time, higher education appropriations were lower, in nominal as well as constant dollars, than in the year before.[9] Moreover, the pattern of support is changing. Community college funding increased by 13 percent, compared to a 3 percent increase in funding of four-year schools in the 34 states which provide separate data.[10] These figures indicate legislators' desire to provide access at the lowest public cost—and, more broadly, the increased short-term outlook and vocationalism of an austerity-based policy.

Although the absolute decline in funding is new, funding for education has been inadequate to sustain the quality of growth since the early 1970s. The commitment to educational quality eroded under the pressures of fiscal constraint, and has not been restored. Enrollments have increased, but the quality of opportunity has diminished. Excellent teaching and research remain available for some, but overall we have witnessed a sys-

tematic decline in student and faculty "involvement in learning."[11] This decline is not due, as is often alleged, to a decline in the quality of curriculum or individual instruction. Neither the curriculum nor individual teachers' pedagogical practices have changed that substantially in the last twenty years. What has changed is the underlying pattern of student-faculty interaction. As enrollments and institutions have grown larger, a diminishing proportion of students benefit from full-time interaction with full-time faculty in a campus environment which offers the intellectual resources and community essential to effective learning.

The decline in the quality of instruction is neither universal nor uniform. Most universities and four-year colleges have retained policies, such as those recommended by AAUP, which protect the quality of the full-time faculty. The tenure system in higher education, unlike that in the schools, protects faculty from routine layoffs due to funding shortages. It also requires faculty in most four-year institutions to meet increasingly demanding performance standards both to complete a lengthy probationary period, typically of seven years, and to achieve promotion and salary advancement thereafter. Those students who can afford full-time attendance at well-supported institutions which rely primarily on such faculty, and whose economic needs do not cause their employment obligations to interfere with their learning, may still experience educational excellence.

Unfortunately, economic pressures on institutions and students alike have diminished the proportion of students who benefit from quality higher education. Three interrelated changes are especially responsible for the decline in quality education for an increasing proportion of students. First, there has been a vast increase in part-time participation by both faculty and students. Second, there has been a substantial and disproportionate growth of community colleges, which has changed the meaning of access to higher education. Third, universities have substantially increased in size. This search for economies of scale has generally meant larger classes and less student-faculty interaction. It has also meant increased specialization, so that lower-division students often work with non-tenure-track faculty and student service personnel rather than with the core faculty.

These changes are more easily recognized when viewed in the perspective of the general development of higher education following the Second World War, summarized in Table I. Between 1949 and 1989 the number of students in higher education increased five times, the number of faculty three times, and the number of institutions only twice. The student-faculty ratio increased from 10.8:1 to 16.4:1. The number of students per institution increased two and a half times from 1,437 to 3,798. These numbers might be used to suggest substantial improvements in

TABLE I

The Expansion of Higher Education 1949–1989

	Institutions	Students	Faculty	Students:Faculty
1949	1851	2,659,021	246,722	10.8:1
1959	2008	3,639,847	380,554	9.6:1
1969	2525	8,004,660	450,000	17.8:1
1979	3152	11,569,899	675,000	17.1:1
1989	3565	13,538,560	824,220	16.4:1
Comparative Increase:				
1989/1949	1.9	5.1	3.3	

Prepared on the basis of data from the National Center for Education Statistics, *Digest of Education Statistics, 1992*, p. 171.

faculty productivity and institutional efficiency. Unfortunately, they are better understood as the source of student, parental, and political dissatisfaction with the students' learning experience.

Although the problem is rooted in the vast and rapid increase in enrollment between 1960 and 1970, it was only in the 1970s that higher education became financially unable to cope. It is true that the great increase in the number of students per faculty member occurred in the 1960s, when the student-faculty ratio increased from 9.6:1 to an all-time high of 17.8:1, and that the ratio thereafter declined to 16.4:1. But in the 1960s universities' efforts to increase faculty size to match the increase in enrollments fell behind, in part due to the inadequate supply of Ph.D. faculty. In the 1970s, by contrast, many disciplines experienced a Ph.D. glut, as universities shifted to hiring part-time faculty—and community colleges, based substantially on part-time faculty without terminal degrees, expanded far more rapidly than four-year institutions.

Table II provides a closer look at the changes in faculty and student composition between 1970 and 1989. Only 22 percent of faculty held part-time positions in 1970, compared to 34 percent in 1980 and 36 percent in 1989. The growth of part-time faculty paralleled a similar transformation of students, from 32 percent in 1970 to 41 percent in 1980 and 43 percent in 1990. Much of this growth in part-time education occurred in community colleges, where more than a half of all students and faculty attend part-time. Between 1970 and 1989, community college enrollments increased by 122 percent, while four-year college enrollments increased by only 34 percent. By 1989, 38 percent of all students in higher education attended community colleges.

TABLE II

The Growth of Part-Time and Two Year Higher Education 1970–89*

	1970			1980			1989		
	All	PT	2Yr	All	PT	2Yr	All	PT	2Yr
Faculty—n	474	104	92	686	236	192	824	300	241
%		21.9	19.4		34.4	28.0		36.4	29.2
Students—n	8,581	2,765	2,319	12,097	4,999	4,526	13,539	5,878	5,151
%		32.2	27.0		41.3	37.4		43.4	38.0

*Figures represent thousands
Prepared on the basis of data from the National Center for Education Statistics, *Digest of Education Statistics, 1992*, pp. 172–173.

Students are going to community colleges and attending school part-time because it costs them less and affords them time in which to earn more. Students increasingly attend relatively low-tuition regional universities, and some urban private colleges with convenient evening and extension programs, for similar reasons. Tuition, which has increased far more rapidly than living costs at four-year institutions, is a primary factor in such decisions. Financial aid, which has failed to keep pace with both tuition and living costs, has also caused more students to find it necessary to work, to live at home, to earn their own way and to take longer to complete their training. By 1989–90, about 80 percent of students worked—and about half worked while attending classes. As Laura Greene Knapp has pointed out, even the decreasing "proportion of students within the 'traditionally' aged student population (those aged 16 to 24) who worked increased from 42 percent in 1972 to 54 percent in 1988."[12]

Most working students attend the country's less expensive institutions. These schools cost less not because they attract less-well-prepared, part-time, and working students—many of whom need more rather than less assistance in learning—but because they spend less per student on instruction and support. The full-time faculty in community colleges have excessive teaching loads, and more faculty teach part-time at community colleges than at four-year institutions. There is more emphasis on inexpensive skills training and less support for libraries, research activities, and the comprehensive intellectual experiences available at universities. Many community college faculty are good teachers but lack the opportunities for professional development available to faculty at four-year institutions. Moreover, community colleges have held down costs by not recruiting Ph.D. faculty or supporting faculty training or scholarship. In the 1970s and 1980s, when there were "no jobs" for new Ph.D.s in history, English, and languages, community colleges were continuing to expand. But fewer than 20 percent of community college faculty have doctoral or professional degrees.[13]

The problem is not, of course, confined to community colleges. The growth of community colleges is merely the often-overlooked aspect of the public's general dissatisfaction with the quality of undergraduate instruction. Influential parents and legislatures worry about the diminishing quality of instruction in the universities, while universities cheapen undergraduate education by relying on large classes, non-tenure-track and part-time faculty, and graduate assistants. Again, these are often competent individuals; what's more, graduate assistants and their future students benefit from their experience as teaching assistants. They are often both able and particularly enthusiastic teachers. But the pressures of their own studies, and the competing demands placed on their faculty supervisors, create

conditions under which graduate assistants also often lack the preparation, time, and support essential to high-quality university instruction.

Colleges and universities bear some institutional responsibility for these problems. In particular, there has been an excessive increase in expenditures on administration relative to instruction. Between 1974 and 1981 instructional costs increased 9.9 percent and administrative costs 21.8 percent. From 1975 through the late 1980s the number of students increased 10 percent, the number of faculty increased 6 percent and the number of administrators increased by 45 percent.[14] Some of this administrative growth was necessary: larger universities with fewer well-prepared students needed more counselors and advisors, and government regulation required increased supervision and reporting. But on the whole, the growth in the number of administrators and their salaries exceeded these needs.[15]

The variations in institutional expenditure shown in Table III offer further confirmation of the tendency toward excessive administrative growth. The data show that administrative expenditures increased more rapidly than overall expenditures and at two to three times the rate of instructional expenditures from the mid-1970s to the mid-1980s. But Table III also illuminates more fundamental problems. Spending, and spending increases, have varied substantially by type and control of institution. Community colleges not only spend less per student overall, as might be expected, but less per student on instruction. They spend less than universities with expensive programs of graduate instruction, but what's really notable is that they spend only half as much as all four-year schools combined. Community college library expenditures compare even less favorably with the outlays of their four-year counterparts, and their research expenditures are negligible. Moreover, the disparity between two-year and four-year schools has increased in every category.

The public universities, which provide the best educational opportunity available to the vast majority of students, spend substantially less per student than their private counterparts, and are slipping further behind. Instructional expenditures for public universities were only about two-thirds of those for private universities in the mid-1970s; that is, just under $4,000 per student compared to just under $6,000 per student. But the gap in instructional expenditure widened further over the next ten years, as public universities increased instructional expenditures 10 percent compared to 20 percent for private universities. Public four-year colleges compare more favorably to their independent counterparts, but the independent four-year schools range much more widely in expenditures and quality than the public institutions. The elite independents spend substantially

TABLE III

Total and Selected Expenditures Per Full-Time-Equivalent Student 1976–77 and 1985–86 for Public and Independent Institutions in Constant 1985–86 Dollars

Type of Institution Year & % Change	Total		Instruction		Administration		Research		Libraries		Scholarships & Fellowships	
	Pub.	Ind.	Pub.	Ind.	Pub.	Ind.	Pub.	Ind.	Pub.	Ind.	Pub.	Ind.
University												
1976–77	$ 9,944	15,394	3,877	5,853	1,658	2,552	1,825	3,242	350	640	399	1,249
1985–86	$11,320	18,779	4,206	7,093	1,991	3,539	2,227	3,471	366	655	426	1,713
% Change	14%	22	10	21	20	39	22	7	4	2	7	37
Other 4-Year												
1976–77	$ 7,251	7,589	3,363	2,834	1,626	2,110	507	383	284	297	283	756
1985–86	$ 8,243	9,130	3,713	3,201	2,031	2,740	672	443	296	317	237	1,053
% Change	14%	20	10	13	25	30	32	15	4	7	-16	39
Two-Year												
1976–77	$ 3,908	4,790	1,996	1,693	1,036	1,679	13	21	137	162	114	366
1985–86	$ 4,223	5,272	2,107	1,792	1,253	2,046	4	1	122	140	93	487
% Change	8%	10	6	6	21	22	-77	-96	-11	-13	-9	33

Source: Based on data derived from U.S. Department of Education, Office of Education Research and Improvement, *Higher Education Administrative Costs: Continuing the Study*, by Thomas P. Snyder and Eva C. Galambos (Washington, D.C.: Government Printing Office, January 1988), pp. 18–23.

more, and the less prestigious independents substantially less, than similar public institutions.

In their effort to preserve faculty quality, public universities increased their research expenditures per student by 22 percent compared to only 7 percent in private universities. This is a major reason why the public tends to blame the diminished quality of undergraduate instruction on research. Despite that increase, though, private university research expenditures remained more than 50 percent greater than outlays in public universities. Although directly comparable data are not available for more recent years, the research-expenditure disparity between public and private institutions is undoubtedly worsening: for example, over the decade from 1982–83 to 1992–93, faculty salaries in public institutions increased by 63 percent while those in independent institutions increased 75 percent and church-related institutions 70 percent.[16]

We need to consider the impact of the fiscal squeeze not only on the institutions but on student enrollment and completion patterns. The ratio of low-income to high-income enrollment by white students in the early to mid-1970s was about 6:10, but in 1983 had declined to less than 5:10. For black students, the low-to-high-income ratio changed from 7:10 to less than 4:10 over the same period.[17] These numbers are especially significant because students whose circumstances require them to depend on public education are also less likely to achieve four-year degrees.

Fewer than 25 percent of community college students transfer to four-year colleges and complete their degrees.[18] In states which rely more heavily on community colleges, still lower proportions of students complete four-year degrees. Moreover, "in states that have numerous community colleges, minority enrollment was predominantly at community colleges [and] minority bachelor's degree attainment rates were less."[19] Public university students also fare less well in terms of degree completion. Where 71 percent of students who entered private universities in 1984 had graduated by 1989, only 43 percent of public university students had graduated in the same time period.[20] Students in public institutions are working to support themselves, and stopping or dropping out when they cannot. But instead of legislating the financial support and institutional funding these students need, politicians propose legislation to "assess" students and "speed up" faculty productivity.

The fiscal crisis has deeply affected both national and local discussions of higher education reform as well. The 1984 report of the Study Group on the Conditions of Excellence in American Higher Education, *Involvement in Learning,* recommended many measures to improve the quality of student learning by reversing the erosion of the 1970s. These included: increasing the resources devoted to first- and second-year instruction; more

small, interactive classes and more general, interdisciplinary learning; five-year degrees to permit preprofessional students to acquire sufficient preparation in the liberal arts; consolidation of part-time faculty into full-time; and increased full-time attendance by students.[21] Resources have not been found to bring about these improvements. On the contrary, reliance on part-time faculty and part-time study have increased. The only widely adopted recommendation of the 1984 report is outcomes assessment. This will, at best, confirm the results of diminished involvement in learning, but contributes little to improved learning. The newest proposals, ironically, suggest shortening the four-year degree to three, and increasing the quantity, not the quality, of instruction.

The quality of involvement in learning does matter. In their comprehensive survey of research on higher education, *How College Affects Students,* Ernest Pascarella and Patrick Terenzini include the following findings in their summary of the impact of various factors on student learning:

> It is clear that where one begins one's collegiate experience has an influence on educational attainment independent of one's precollege abilities, socioeconomic status, or aspirations. . . . Net of precollege differences, attending a four-year (versus a two-year) college appears to increase one's probability of attaining a bachelor's degree within a specified time period by 15%, perhaps even more. . . . [N]et of student precollege characteristics, attending a private or a small college tends to have positive effects on educational attainment. . . . Specifically, attendance at a small college rather than a large one tends to facilitate social involvement with faculty and peers that in turn positively influences persistence, college graduation, and graduate school enrollment.[22]

They also find that "college quality (and particularly selectivity) has a small positive direct effect on earnings" which they attribute primarily to the effect of social screening rather than intellectual quality.[23]

Similarly, Zelda Gamson, reviewing the findings of Alexander Astin's recent comprehensive study, *What Matters in College? Four Critical Years Revisited,* reports that the average socioeconomic status of other students had "*the* most significant impact on student outcomes":

> The higher the socioeconomic status of the student body, the more positive the change on almost every indicator of satisfaction, perceptions of the faculty, interpersonal skills, commitment to liberal programs and social change, test scores, academic confidence and skills, and entry to graduate school. (Like all of the other analyses reported in the book, the effects of socioeconomic status are measured after

ability, academic preparation, and other input characteristics have been controlled.)

Hence, although Astin himself tends to attribute deficiencies in learning especially to institutional size and faculty emphasis on research, Gamson considers that Astin's finding of the positive effects of intensive student-faculty involvement points especially to the need to make coherent and well-supported learning communities available to all students.[24]

Pascarella and Terenzini do find that larger and more research-oriented institutions have a positive influence on earnings.[25] As we have seen above, however, completion rates at public universities are substantially lower than those at private universities. This may reflect the greater probability that public university students commute and work off-campus, both of which factors have significant negative effects on student persistence and degree completion.[26] Gamson suggests that large institutions do provide the opportunity for multiple learning communities which can provide cultural support for diverse types of students.[27] Unfortunately, many of the experimental subcolleges she promotes have been victims of the budgetary pressures and competition characteristic of large public universities. All too often, large public institutions provide arenas for cultural confrontation and conflict rather than cultural growth and exchange.

The fiscal crisis, in diminishing educational opportunity and quality, increases economic stratification as well as social and cultural conflict. Well-to-do students, and a declining number of talented scholarship students, benefit from substantially greater educational opportunity. The fact that their well-informed parents have been willing to spend three to four times as much for elite education than the cost of basic public education confirms, on the basis of the market system, the findings of the research cited above: private and more expensive, selective, public universities provide an advantage to those with financial access to them. On the other hand, the increased competition for educational opportunity and the declining support for educational community exacerbate social and cultural conflict, especially for those students in large, public institutions. The current curricular debate over multiculturalism is not only a dispute about the content of the canon but, at bottom, a debate over access to the supportive educational community which is so important to educational success.

Campus, State, and National Responses

What can we do to arrest this decline in the quality of educational opportunity? Since the problem is due in substantial part to the national fiscal crisis, a solution requires not only changes in campus policy but

political efforts at the state and, especially, national levels. Most faculty, other than those dependent upon federal research grants, rarely focus on the connection between national politics and the campus. I think it is time that all faculty do so. But an effective response must begin at the campus level. Moreover, it must begin with policies which not only aim at preserving the quality of educational opportunity, but which help overcome the divisions within the campus—and between the campus and the community—which have been exacerbated by the fiscal squeeze.

Preserving full-time faculty positions and base salaries is a sound policy which is sometimes erroneously viewed as an obstacle to coalition-building. Elimination of tenure, though often advanced as a way to create new opportunities for younger faculty, will not increase the number of available positions. The increase in non-tenure-track and part-time positions, which has already occurred, has itself increased job insecurity and created a stratum of disadvantaged faculty, all too often women and minorities. The better quality institutions, by any of the measures discussed above, remain those with strong tenure systems and fully qualified, full-time faculty who have met reasonable requirements for tenure and advancement. Diminishing professional standards are part of the problem, not part of the solution.

Fewer of the best university graduates seek to become faculty members; they enter the other professions and business because those pay better. We need, therefore, to recruit a new generation of scholars.[28] We will further weaken our economy if we make university careers even more insecure and less well paid relative to other careers. Recruiting the best also means assuring genuine equality of opportunity for faculty careers. This not only means increasing graduate opportunities for women and minorities, but affording greater opportunities for employment and fair consideration for advancement for all faculty. Although many faculty believe that affirmative action has been pursued to excess, the data clearly, and disappointingly, show little gain in black, Latino, or Native American participation; moreover, the increase in female faculty has been disproportionately in the lower ranks.[29] In the current competitive situation, quality and diversity are too often rhetorically counterposed. But a sound educational policy requires a faculty that is both qualified and diverse; and only an alliance of such faculty can provide the leadership essential to bring this about.

Economic adversity is alarming and divisive. It can lead to injudicious decision-making and to an undermining of the alliances essential to an effective response by educators. For example, it is often suggested that short-term budget cutbacks should be based on the elimination of allegedly peripheral programs rather than across-the-board reductions. Experience

with such cutbacks suggests that they are frequently as academically questionable as they are divisive.[30] Certainly universities should engage in recurrent program evaluation with a view to phasing out some programs and enhancing others. But universities do not do this fairly or soundly at moments of crisis. Better decision-making—and the cooperation essential to guiding universities through difficult times—are more likely when unavoidable short-term cutbacks are accomplished through shared sacrifice. Relatively less damaging temporary measures include across-the-board freezes or marginal reductions, and deferred hiring, expenditures, and compensation increases.

We do need, even in these difficult times, to recognize and work to correct genuine academic deficiencies. This means not only the kind of recurrent program review necessary to eliminate superfluous programs, which is often referred to as "restructuring" or, more accurately, as "downsizing"; it also means improving the effectiveness of academic programs. This might best be termed "renewal," as it seeks to restore colleges' and universities' commitment to academic excellence, and to reverse the decline in quality which has resulted from the inadequately supported expansion of access over the last thirty years. We must, especially, put more time, energy and resources into improving first- and second-year education. I think there is something fundamentally inappropriate about a curricular structure in which we have small classes and relatively intensive faculty involvement for juniors and seniors, who should have been enabled to learn more independently, and huge lecture classes for freshmen and sophomores, many of whom lack adequate preparation for university education. We are dismayed when our juniors and seniors resist writing papers and essay exams because they have not done them before, but we maintain a curricular structure which offers lower-division students few opportunities to practice writing or interactive learning.

We also need to approach this problem very seriously because dissatisfaction with lower-division instruction is quite widespread and provides the principal fuel for public criticism of higher education. This problem particularly affects the large research universities. Community colleges, regional colleges, and private colleges which do not suffer from large lecture classes may also deny students adequate involvement with faculty through excessive teaching loads and overuse of part-time faculty. Our declining public image derives most, however, from the increasing numbers of middle-class students who are attending the state research universities because they cannot afford the elite private institutions, but who often seek the quality of learning offered by the latter.

Improving lower-division instruction should not mean attacking scholarship and research. There is a fundamental misunderstanding about

this issue. Although any individual institution may make trade-offs between research and teaching, if we return to the data in Table III on overall expenditures, we find that spending on instruction and research vary directly according to type of institution, and not inversely. In other words, the universities and colleges most in demand—and rightly so—are generally those which support a scholarly faculty actively involved in research.

Research is essential both to the instructional programs that make us the world leader in higher education and to preserving our position as the world leader in basic research. These are the areas in which we successfully compete in the international market, and we do so in a fashion that prepares students for high-skilled, high-paid jobs. If we sacrifice the long-term contribution of the university research culture to short-term economic advantage, we will diminish competitiveness and exacerbate the fiscal crisis.

Nor can we improve teaching by increasing teaching loads, as many legislators and some reformers propose. The schools with the higher teaching loads are not the ones students compete to enter. If we increase teaching loads at the expense of the research culture at the large public institutions, we will further the transfer of the best faculty and programs to the private institutions. More than half of the students in public higher education already attend community colleges. If we destroy the research culture at the public universities attended by the majority of four-year students, only a small minority of mostly well-to-do students will have access to "state-of-the-art" programs and faculty. The vast majority of college students will attend institutions as constrained by social problems and economic inadequacies as are the public schools.

But we can improve instruction by devoting more full-time, interactive instruction to first- and second-year students. Some instructional resources may be redistributed between graduate and undergraduate or upper- and lower-division instruction. Some faculty may increase their emphasis on teaching at some stages of their scholarly careers. Of course, the only fundamental solution would be to provide public university and college students with both the quality of faculty and the student-faculty ratios found in selective, independent universities. We may take at least a small step in this direction by developing fair and efficient internal reallocation strategies. We can reduce nonacademic expenditures and, in particular, the administrative expenditures which have increased so rapidly over the last twenty years. We are not likely, however, to succeed in reducing administrative costs by increasing the administrative controls which have produced the administrative excess.

Yet many administrators and legislators seek to respond to dissatisfaction with our educational "output" not by restoring necessary "inputs," but by introducing new and costly managerial controls. This substitution of top-down management for necessary investment and cooperative work arrangements has failed American industry. Industry has recognized that the key to efficient production is not monitoring individual effort or quality assessment at the end of the line. Rather, productivity depends on investing in improved methods of work.

We know that student learning occurs most successfully in institutions that provide coherent and intensive student-faculty learning communities. We know that true higher education requires a culture grounded in disciplined scholarship and research. We must find ways to explain this to the public and to legislators. But we need this public recognition not merely for our own resource requirements but, more importantly, because we need to inform legislators, parents, and media about what really needs to be done to improve teaching and learning in different campus settings.

The same principle holds true for the social aspects of campus life. Managerial control will be no more effective in resolving the increasing social and cultural conflicts on our campuses than it would be in overcoming fiscal constraints. Campus conflicts of race, gender, culture, and class reflect those of the larger society, just as they are exacerbated by the economic problems of that society. Yet we have seen that a coherent campus community is important to student perseverance, learning, and achievement. How can schools achieve such community without "imposing" it from the top down? Public universities cannot provide the homogeneous learning environment available at some small, selective colleges and universities. They certainly cannot provide the socioeconomic selectivity which is itself important to preparing a fortunate few scholarship students for worldly success. Nonetheless, public universities can offer a diversity of learning communities and cultures which enable each student to find the supportive environment essential to persistence and learning. This is the social and cultural foundation for the intellectual dispute regarding multicultural curricula and programs.

The undergraduate curriculum has always been shaped by the need to acculturate as well as to educate. In a society as diverse as ours has become, this means encouraging not only tolerance but active appreciation of diverse cultures. Managerial responses, such as speech codes and compulsory orientation programs, tend to breed cynicism, resistance, and conflict. Successful multiculturalism depends rather on the fundamental structure of the curriculum, on living arrangements, and on comprehensive extracurricular programs that have been the historical source of "collegiate" culture. Our increasingly diverse students will not return to the

"melting pot" or to a false pluralism which presupposes the superiority of previously prevailing values. The campus and the curriculum, therefore, need to manifest opportunity and respect for cultural difference as well as an appreciation of the common intellectual standards integral to academic life.

Of course, the prevailing culture has not been homogeneous, self-contained or unself-critical. Those students who feel excluded may, in part, lack understanding and appreciation of the diversity within the prevailing curricula and campus culture. But these students are no less able than those who benefit from the accident of a superficial acculturation in the prevailing values through their previous upbringing and schooling. If Western culture is historically diverse and self-critical, and the university properly a "marketplace of ideas," then a multicultural curriculum is surely intellectually and educationally appropriate to Western societies such as ours.

This argument should not, however, be taken to legitimize managerial promotion of a merely "tolerant" multiculturalism which exempts various cultures from critique. Such an arrangement would subject neither prevailing nor contesting perspectives to the rigorous intellectual examination essential to the university. The cohesion of the university community should derive not from enforced tolerance but from intellectual rigor. Precisely because such rigor may challenge the most basic values, students also require supportive social and cultural subcommunities to assist them to integrate new values and learning into their lives without sacrificing their cultural independence or integrity. Unfortunately, our resources are insufficient to the task.

Public universities have achieved some economies of scale at the cost of diminishing the supportive community previously available in the collegiate social environment. They have brought together more students, more disparate students, and less-well-prepared students, in a period of increasing competition for economic and social advantage. The fiscal crisis, which has undermined the financial foundation for student involvement in learning, also denies us the resources essential to develop the social and curricular support to aid students in this difficult time. Meanwhile, politicians, unable to cope with fiscal problems, accuse the universities and their faculties of failing to use their resources and carry out their duties responsibly. We need to explain our actual situation more effectively, but even this is not enough. We need to alter the terms of the debate, and even more the shape of the political battle, by building public recognition and support for sound fiscal policies in academe and out.

If we are going to achieve public support, we need strong campus-based faculty organizations as well as persuasive policy proposals. Faculty

have more easily attained effective state organizations where there is col-
lective bargaining. This opportunity is denied to faculty in public uni-
versities in many states where faculty organization is most needed, and
denied faculty in most private universities. But the key is not bargaining;
it is the commitment and organization of faculty time and resources.
Faculty need to support statewide efforts to educate higher education
boards, legislators, and the media.

This means building broad organizational and financial support, but
this, too, is not enough. Coalition efforts are crucial. It is particularly
important to involve students. This requires more readiness to respond to
students' educational needs and avoidance of overdependence on tuition
increases. It need not, however, imply a sacrifice of academic standards
and priorities. Students have a stake in the quality of their education and
the value of their degrees—and students, and their parents, do influence
legislatures.

Coalitions based on a shared commitment to access to quality ed-
ucation are both possible and essential. In several states faculty and students
have cooperated and formed effective coalitions with unions and civic
groups to promote adequate support for quality education.[31] If we can
convince students, parents, and the public, through our work to improve
lower-division instruction, as well as through our rhetorical and organi-
zational efforts, that we are genuinely concerned about the quality of the
student's educational experience, then I think that it will be possible to
expand this support effectively.

Such coalitions can also contribute to the essential effort to increase
federal support of higher education. Yet assuring adequate funding of
federal student aid and research programs, though necessary, is not suf-
ficient. We must revise fiscal policy to assure restoration of public funding
of essential public programs. If states are to be empowered to restore
support to public higher education, they need a federal government able
and willing to restore federal revenue sharing and federal spending in
support of federally mandated state obligations.

We must also respond to the issue of national health care. Until this
is resolved medical costs will displace university expenditures in state and
federal budgets. Universities themselves are devoting increased portions
of shrinking compensation budgets to health care. So we have to begin
thinking of health care not only as an important social issue, but as a
problem whose solution is vital to the future of higher education.

Finally, we have to confront the fundamental issue of federal fiscal
policy. We must have a fair and adequate tax system. We are currently
among the least taxed, and least fairly taxed, of advanced industrial so-
cieties. As long as this continues, there is no fair solution to the problem

of funding higher education. If we cut tuition, the middle class is subsidized by the working poor, who pay taxes but cannot afford higher education. If we raise tuition without providing more financial aid, we price many more students out of the educational market. Either way, the solution is national and systemic: the possibility of more funding, like the possibility of more aid, first requires a solution to the country's larger fiscal crisis.

Support for this effort requires recognition that higher education is an investment in economic development—an investment which promotes better jobs and living standards for all. It also depends on overcoming the public resistance to taxes, not only by building confidence in how the taxes will be spent, but by creating a system in which taxes are apportioned and collected fairly. We can achieve adequate funding to meet the needs of a sound system of higher education if, and only if, we build and support a broad-based program to resolve the fiscal crisis.

NOTES

1. Frank Swoboda, "U.S., Others Struggle With the Choice of Creating More Jobs or Good Jobs," *Washington Post,* July 11, 1993, p. H2.

2. Jeff Faux, "Economic Competitiveness and the Human-Capital Investment Gap," publication of Investment 21, December 1992.

3. Ernest T. Pascarella and Patrick T. Terenzini, *How College Affects Students: Findings and Insights from Twenty Years of Research* (San Francisco: Jossey-Bass, 1991), p. 529.

4. The College Board, *Trends in Student Aid: 1982 to 1992,* September 1992, pp. 5, 12.

5. National Conference of State Legislators, *NCSL State Issues,* 1992, p. 64.

6. *Ibid.,* p. 65.

7. American Council on Education, *Higher Education & National Affairs,* August 12, 1991, p. 1.

8. *Chronicle of Higher Education,* October 21, 1992, p. A21.

9. *Chronicle of Higher Education,* November 6, 1991.

10. *Ibid.,* p. 38.

11. *Involvement in Learning: Realizing the Potential of American Higher Education,* final report of the Study Group on the Conditions of Excellence in American Higher Education, October 1984.

12. Laura Greene Knapp, "Students Who Worked During 1989–1990," *Washington Research Report,* May 1993, p. 1.

13. National Center for Education Statistics, *Digest of Education Statistics 1992,* p. 225.

14. W. Bruce Bassett, "Cost Control in Higher Education," in *The Crisis in Higher Education,* ed. Joseph Froomkin (New York: Academy of Political Science, 1983), p. 140; and Jay A. Halfond, "Too Many Administrators: How It Happened and How to Respond," *AAHE Bulletin,* March 1991, p. 7.

15. Barbara R. Bergmann, "Bloated Administration, Blighted Campuses," *Academe*, November-December 1991, pp. 12–16.

16. "Treading Water: The Annual Report on the Economic Status of the Profession," *Academe*, March-April 1993, p. 10.

17. Michael S. McPherson and Morton Owen Schapiro, "The Student Finance System for Undergraduate Education: How Well Does It Work?" *Change*, May-June 1991, pp. 16–22.

18. *Chronicle of Higher Education*, July 21, 1993, p. A15.

19. Faith G. Paul, "State Higher Education Systems and Bachelor's Degree Attainment," *Transfer:* National Center for Academic Achievement and Transfer Working Papers, April 1993, p. 2.

20. *Chronicle of Higher Education*, March 27, 1991, p. A41.

21. *Involvement in Learning*, pp. 8.

22. Pascarella and Terenzini, pp. 416–17.

23. *Ibid.*, pp. 530–31.

24. Zelda F. Gamson, "The College Experience: New Data on How and Why Students Change," *Change*, May-June 1993, pp. 64–68.

25. Pascarella and Terenzini, p. 531.

26. *Ibid.*, pp. 419–20.

27. Gamson, pp. 67–68.

28. Howard R. Bowen and Jack H. Schuster, *American Professors: A National Resource Imperiled* (New York: Oxford University Press, 1986).

29. Cecilia Ottinger and Robin Sikula, "Women in Higher Education: Where Do We Stand?" *Research Briefs,* vol. 4, No. 2; and Deborah J. Carter and Eileen M. O'Brien, "Employment and Hiring Patterns for Faculty of Color," forthcoming in same series.

30. Sheila Slaughter, "Retrenchment in the 1980s: The Politics of Prestige and Gender," *Journal of Higher Education*, May-June 1993, pp. 250–82.

31. *Chronicle of Higher Education*, January 28, 1992, p. A25.

"Political Correctness" and the Attack on American Colleges

Paul Lauter

The main news Americans were taught about colleges during the last few Bush years was that they had been infected with a galloping moral disease, "Political Correctness." Talking with academics across the country and visiting over twenty campuses in the last year, I came to think that the charges of PC were fundamentally a smoke screen designed to discredit higher education. Behind that screen, conservatives have implemented a well-orchestrated and financed campaign to cut budgets, downsize universities, and thus sharply restrict access to higher education. This process has particularly hurt the "new" student populations which began to arrive on campus late in the 1960s. More broadly, I think that higher education in the United States is undergoing a revolution in structure and function as profound as that which, earlier in this century, converted it from the province primarily of a tiny group of white gentlemen into a broad-based institution of social inclusion.

The construction of the monster PC depends upon highly partisan and often remarkably ignorant interpretations of a series of campus events.[1] On the other hand, the extraordinary cutbacks in higher education can be documented in painful detail. The State University of New York (SUNY) suffered 60 million dollars in cuts in 1991–92; 1150 faculty and staff jobs were lost, and over 30 academic programs were closed. Meanwhile, tuition for New York State residents soared from $1350 in 1990–91 to $2650 in 1991–92, still a bargain compared with tuition at the state's private institutions, but a major strain on the budgets even of middle-class families.[2] The City University of New York (CUNY), where enrollments have grown by about five percent since 1970–71, has suffered a cut of some 350 million dollars, or 33.5 percent, in state and city funding

73

during this period—that is to say, the costs of CUNY have been privatized.[3] The University of Connecticut has absorbed cuts of 47.5 million dollars in four years with the consequent loss of about six hundred jobs—and, of course, few pay raises for employees. Tuition, which in 1988–89 was $2293, went up by 42 percent to $3902 in 1991–92; in fact, with additional fees, higher room and board, and other expenses, the rise in costs to students was about double. With the imposition of a new state income tax, such increases have priced the university out of the range of many theoretically "middle-class" students.[4]

Nowhere, perhaps, have the cuts been more dramatic than in California. In 1992–93, the University of California system lost 224 million dollars, or 10.6 percent of its total state appropriation, leading in May of 1993 to an across-the-board pay *cut* of five percent. Meanwhile, the California State University system, largest in the nation, lost 125 million dollars, or 7.6 percent of its 1991–92 budget—totals more damaging to the four-year colleges than to the UC system, because the state universities are far more dependent on state funds, whereas institutions like Berkeley and UCLA receive under 20 percent of their funding from the California budget. According to an April, 1993, draft report for the California Assembly Committee on Higher Education:

> In only the past two years, the state has withdrawn more than $550 million from its $6.5 billion in annual support for higher education. The workforce of the two public universities has shrunk by 6,800 faculty and staff (or 7.2 percent of the total)—the only sector of state government employment to have declined—in the last ten years. (p. 2)

Similarly, the California Community College budget faced a 29 percent cut in 1992, which was offset by raising fees per credit hour from $6.00 to $10.00 (a current proposal calls for a further increase to $30) and by a set of budgetary devices—like charging $15 per term for parking.[5] For those who already hold a degree, but who wish to return to community college for retraining, the cost has climbed to about $50 a unit. Similarly, UC undergraduate fees have more than doubled, from approximately $1,820 a year to $4,039 in 1993–94; and State University tuition has in three years gone from $780 to $1,788.

The impact of such cuts has been most striking at institutions like San Diego State and San Jose State. At San Diego, where state funding was down 16.2 percent in two years, enrollments have been cut by 17 percent. Whole departments, such as Sociology, were threatened with elimination, and only a strenuous organizing campaign prevented professors with up to twenty years of seniority from being laid off. Still, some six hundred jobs have been lost, most part-time and many untenured fac-

ulty have been dropped, and students have found it often impossible to enroll even in courses required for graduation—like basic English—or for their majors.[6] San Jose, which has eliminated virtually all part-timers and even teaching by early retirees, reduced its student ceiling by 15 percent; still, even classes at 7:30 A.M. are overenrolled. Statewide, Cal State officials project the elimination of some 10,000 students from the university rolls. Meanwhile, in the community college system, "over 100,000 potential students, most seeking job retraining, were unable to obtain courses" they needed in the fall of 1991, because classes were filled or eliminated, and at least an equal number were, in 1992, unable to pursue their courses of study at their local colleges.[7] California Community Colleges are, for the first time, actually turning students away from their doors.[8]

Viewed nationally, the picture is equally grim. In 1990, state funding showed "the lowest two-year growth since the figures were first collected in 1958."[9] In seventeen states, including Florida, Illinois, and Ohio, apart from New York and California, appropriations were actually lower than two years before. Overall 1990 totals, including states which were then increasing funding, were about one percent less than in 1988.[10] Since 1990, things have gotten worse: funds for higher education have been "cut in 30 states, affecting two-thirds of all public colleges and universities."[11] Despite some modest increases projected for 1993–94, most state systems are still reeling from at least four years of major cutbacks.[12]

What is particularly striking about these figures is, perhaps, not the size of the cuts, the rapid rise of public tuitions and fees, or even the laying off and speeding up of faculty and staff. Rather, I think, the most significant detail concerns the *disproportionate* cutbacks that have hit higher education. In Ohio, for example, the 1992–93 budget called for a cut of 170 million dollars in the overall 1.8-billion-dollar university budget—a harsh measure, to say the best of it. What catches my attention, however, is the fact that 54 percent of Republican Governor Voinovich's budget cuts come from higher education, although higher education accounts for only 12 percent of the overall state budget.[13] Ohio's Republican governor is by no means distinctive in using higher education as the fall guy for state budget cuts. C. Peter Magrath, president of the National Association of State Universities and Land-Grant Colleges, asserts that "State support for higher education is deteriorating. . . . In a lot of states, where 10 years ago 18 percent of the state budget was going to higher education, now it's down to 14 percent."[14] In California, education funding is down from 15.5 percent of the state budget seven years ago to 12.4 percent. In Illinois, colleges received 23.5 percent of state funds in 1968, 18.3 percent in

1990.[15] In Colorado, "higher education receives 19.2 percent of the state general fund budget, down from 23.5 percent ten years ago."[16]

Like most states, the federal government has also *dis*invested in higher education. During the 1980s, funding for student aid programs rose to some extent, although the basic Pell grants have never been funded at their authorized levels. Indeed, in the last Bush year, drawdowns on Pell grants put the fund 1.4 billion dollars in arrears; part of the dispute over President Clinton's stimulus package concerned the appropriation of funds for this program. More and more students have turned to such grants as states like New York have ended long-established programs like the Regents Scholarships, which helped generations of students through both public and private institutions. And, as the federal government has sought funds for other programs, it has depleted monies available for programs like work-study—on which many middle-income students depend.[17] Similarly, for better or for worse, federal support for university research programs has eroded. While it is no doubt true that a few research universities ripped off taxpayers through excessive indirect cost procedures, the effect of recent changes has been to cut budgets even further, especially at less prestigious (and wealthy) institutions.

If you feel stunned by reading these details—and they could be multiplied with particulars from states from Oregon and Washington to Florida[18]—imagine their direct impact on students. While many faculty members have gone without raises, and thus fallen further and further behind economically, and while significant numbers especially of part-time employees (and thus usually of women) have lost their jobs, the greatest impact of these cuts and the consequent sharp raises in state college tuitions has been felt by students. In forty states, public institution tuitions rose at a rate faster than personal income.[19] Many showed two straight years of double-digit raises in tuition, a rate three times that of inflation.[20] According to *Business Week,* private college tuitions have been rising faster than medical costs, with public colleges not far behind; in fact, "college costs as a share of median family income jumped from 26.6% to 39.9% for a student at a private school and from 12.1% to 15.9% at a public one."[21]

Virtually every story in the popular press or in higher education trade journals tells some variation of a now-familiar tale: monster sections, like an eleven-hundred-student introduction to Political Science at the University of Illinois; students sitting on the steps of packed auditoriums; library hours cut back and acquisitions curtailed; students unable to get into English 101 after five terms of trying (last year, in fact, twelve hundred San Diego State students failed to get into *any* of the classes for which they had registered)[22]; major requirements taught only every second or

even third year; planned elimination of programs like aerospace engineering at San Diego, and threatened deep cutbacks of traditional departments like Sociology, even at Yale. SUNY/Old Westbury tried to retrench one of the nation's few African-American music programs—at a college which is half minority and to which a significant number of students came to study music. One statistic captures the impact of this process: in 1976 it took students an average of 4.6 years to graduate with a bachelor's degree; in 1992 it takes an average of 5.5 years.

These are not the only means by which *access* is being curtailed. The Minnesota system has closed a campus; the University of Massachusetts (where state funds have been cut thirty percent in three years) shut the accessible downtown Boston campus; CUNY's chancellor wishes to "consolidate" certain departments so that not every campus will offer all traditional subjects, like Philosophy. At the same time, faculty are being told to be "more productive"—that is, to process larger and larger numbers of students by increasing class size, teaching additional sections, or shortening terms. In brief, higher education is becoming less available to students as well as more costly, and it is also being cheapened as a "product."

What has been less evident is the process one might describe, in a term borrowed from industrial union contracts, as "bumping." As private institutions have become increasingly expensive, upper-middle-class students not eligible for aid have turned in large numbers to the flagship institutions of state systems, which remain significantly cheaper than privates. "Since there are only a limited number of slots at the flagships," Arthur M. Hauptman points out, "the wealthier kids from suburban schools with better grades and better test scores squeeze out poorer kids, who then go to a state college or a community college or the regional, private liberal arts college that will offer them $5,000 in aid. Or they don't go to college at all." That, Hauptman claims, "undermines the mission of public schools: to broaden access to higher education by subsidizing colleges with taxpayers' money."[23] Such a "bumping" process not only limits the life-chances of many middle- and working-class students, but it undermines opportunities for poor and particularly minority students even to attend college. *Business Week* concludes that "Middle- and working-class students are being squeezed out of the nation's best, most expensive schools to compete for slots at public colleges—where prices are also rising year after year."[24]

Furthermore, as costs have risen and aid packages have increasingly been limited, students who do stick it out emerge from college with enormous debts. It is not unusual for a student to complete a B.A. with a debt of $20,000 or more; in fact, median debt has more than doubled since 1977, from about $2,000 to $4,800.[25] What has been occurring here

is not only the undermining of the mission of public institutions, but the privatization of the costs of attending college.[26] For an increasing number of students, moreover, the combination of increased costs, the difficulty of getting courses they need, and the problem of finding a job that will enable them to attend college even part-time leads to a decision to drop out—indebted, discouraged, and bitter.

The American education system has always, in part, been a means for stratifying society. Schools used to sort students, primarily on the basis of class characteristics, into variously named tracks—college-bound, general, or commercial—or into "ability" groups. Now, colleges are being made to play an increasing role in such class stratification.[27] Since the 1970s the proportion of students from high-income families who attend four-year colleges has risen from 54 to 60 percent. Among lower-income families the proportion has remained at a constant 27 percent.[28] Another study indicates that among households in the upper half of income, 26 percent of students took a four-year college degree in 1979; that figure is up to 31 percent today. But among students from the lower-income half, the proportion completing a degree has fallen from 14 percent to 13 percent.[29] In other words, the gap between upper-income and lower-income educational levels is steadily, if slowly, increasing.

Even these discouraging figures do not tell the full story, however. The University of Arizona has been relatively less affected by cuts than some; its budget was up about one percent in 1992. Yet its administration tried to cancel remedial math and language classes for the forty percent of incoming students who needed them. Many of these are Latino, first-generation-to-college students. The plan was to "allow" them to take such courses off-campus, where their costs would not be covered by financial aid packages. In this instance, the proposal was beaten back, but similar schemes are on virtually every administrative drawing board.[30] Such measures are often posed as desirable efforts to raise academic "standards," but so long as schools, shattered communities and families, and a drifting economy fail to prepare many students to do academic work at the college level, these measures will in fact sharply restrict access to higher education, especially for poor and minority students. Indeed, the Chancellor of the California State University, as reported in the *Wall Street Journal,* feared that the impact of current policies, particularly as they are applied to public, four-year colleges, will be to "shut the door just as people of color are reaching to open it."[31]

In sum, colleges and universities, especially in the public sector, have suffered unprecedented budget cuts, even as they are being asked to accommodate larger numbers of students ("doing more with less" is the administrative rubric). At the same time, students and parents are being

forced to take on a larger proportion of increased educational costs, even as wage levels have stagnated or, for some, declined. In fact, then, educational consumers are paying more for less (fewer and larger classes, busier professors, decaying campuses and services). Downsizing, privatizing, speeding up, cheapening the product—the university as model American industry.

One might argue, of course, that the plight of higher education is indeed sad, but that, after all, things are tough all over, from Sears to Boeing. But as I have pointed out, public institutions of higher education have taken a disproportionate hit. Furthermore, it is simply not the case that public funds are *not* available for some projects, even for some connected with colleges and universities. The State of New York managed to build a new stadium at the University in Buffalo for the World University Games. Other institutions making cuts in programs have installed astroturf on their football fields or draperies in the homes of their presidents. At a Colorado campus, the salary of the football coach is reported to be some $360,000 a year, far more than the president, and somewhat more than the grunts in the freshman English trenches. UCLA bought memberships in a fancy club for some of its elite staff. A number of universities have hired expensive Washington lobbyists to help them at the federal trough.[32] Moreover, of all college costs, those for administration have increased by far the most rapidly.[33] The Department of Education reports that between 1975 and 1985 nonteaching professional staff expanded by 61%, whereas the faculty grew by only 6%.[34] And all of this says nothing about federal and state funds which continue to be poured into the S&L and other banking scandals, not to speak of Star Wars, stealth bombers, and prisons[35]—forget the cabinet jaunts that marked the last days of the Bushies. It is *not* simply the invisible hand of the market which has decreed such outrageous cuts in higher education. On the contrary, spending choices have been made by people carrying out definable projects: that is, the cuts in higher education I have chronicled reflect *political* decisions.

To argue in this direction is, of course, to raise a question: what political goals can possibly be pursued by cutting higher education? We may begin answering that question by examining a postelection op-ed article from the *New York Times* by Charles Murray, a fellow at the right-wing American Enterprise Institute. In the article, Murray offered advice on educational policy to the new President and his Secretary of Education, Richard W. Riley:

> *Giving qualified students a chance at college is something we already do well.* More than three-quarters of the nation's top students already

go to four-year colleges. The number of top students who don't go
to college because of lack of money is miniscule. It is fine to make it
possible for every qualified student to go to college, but there is not
much room for improvement. If Mr. Clinton's loan plan succeeds in
significantly expanding enrollment, it may well damage university
education: campuses will be flooded with still more students who are
not ready for college-level material. That this view is elitist does not
make it wrong.

I need to set some facts against Murray's use of slippery, subjective terms
like "qualified" and "top." About 80 percent of American young people
now graduate from high school. "Fewer than 30 percent receive bachelor's
degrees and/or continue on to graduate school."[36] Thirty percent fewer
kids in the economically poorest quartile graduate from high school than
in the richest quartile. The gap in the college participation rate is 32
percent; the same gap obtained in the rates of graduation from college.
And this final set of figures has not changed over the last 20 years.[37] Such
numbers cast Murray's assertions in a different light: the issue is not that
they are elitist but that they are profoundly simpleminded as well as dan-
gerously undemocratic. The assumption underlying Murray's argument is
that standards of qualification for college work are known, agreed upon,
and universally objective—a notion undermined by the rather differing
weights given to a variety of factors (like wealth, athletic skills, geography,
relationship to alumni) by college admissions officers.[38] Moreover, such
"qualification" is by no means a constant, essential quality of some young
people; the ability to succeed in college changes in individuals over time,
in relation to particular institutional environments, and in significant mea-
sure in relation to external factors like the availability of funding. Hidden
under Murray's bland assertions is a Thatcherite vision of an American
education system designed more systematically than ever to channel young
people into levels of the work force for which they are "appropriately"
prepared. Indeed, what the figures I have cited strongly suggest is that
colleges and universities have replaced secondary schools as primary mech-
anisms for sorting people on the basis, mainly, of their class origins.

The Thatcherite vision has, unfortunately, been bought into by
many even well-meaning higher education administrators as well. Chan-
cellor Sheila Kaplan of the University of Wisconsin's Parkside campus
writes, in a model of administrativese as follows:

> In the face of limited resources, we must consider the possibility
> of reducing enrollments and thus preserving the quality of our en-
> terprise by bringing the number of students served into closer con-
> gruence with our available resources.

Kaplan goes on to quote the Wisconsin system president, Kenneth A. Shaw:

> "The University of Wisconsin System is committed to providing qual-
> ity in teaching, in research, and in public service. The University of
> Wisconsin System is also committed to providing access to its quality
> programs and resources. . . . However, when faced with a choice be-
> tween maintaining educational quality and decreasing access to its
> programs and resources, the University of Wisconsin System must
> choose to maintain quality. For if academic programs, research, and
> public service are not first rate, access to the institutions will be of
> little value."

"Enrollment management," Kaplan continues, "requires that choices be made and that students with the best chance of success be admitted to the university."[39] In short, Kaplan and Shaw pose "access" against "quality" in an artificial binary bound to be lost by "access."[40]

What these arguments come down to politically is this: access to colleges and universities was opened to an unprecedented degree in the 1960s. Politically, it is as impossible to return to a policy of much more limited access as it would be to abrogate other universal "entitlements" put into place during those bad old days. Access can *only* be restricted if one can successfully argue that restriction is a function of economic forces beyond our control, and if one can somehow make colleges politically suspect.

Such arguments play nicely into the overall conservative agenda, which emphasizes downsizing of government (in education as in other areas), privatization (of costs as well as services), and letting the "market" operate rather than using government to level the playing field. Moreover, for those committed to the future outlined in the North American Free Trade Agreement, "excessive" access to higher education is an impedi-ment. After all, NAFTA envisages a decline in living standards for many—if not most—American workers, which is surely the only way Americans will be able to staunch the outflow of jobs to lower-paying and lower-cost Mexican plants.[41] The problem with education, from this perspective, especially college and university education, and most particularly "liberal arts" education, is that it raises expectations far too high. It encourages workers to aspire beyond what the shrinking job market can offer, to think and imagine beyond what labor discipline must impose. An "overeducated" work force is, to this kind of thinking, as "destabilizing" to the United States as it once was to the state of Kerala in India.

The problem for conservatives then becomes, as Max Sawicky has put it, "not how to devise a better way to deliver services, but how to

overcome the political obstacles to cutting public spending."[42] The idea is not to devise means for offering more and better educational services. Rather, as Sawicky quotes right-wing maven Stuart Butler, "There is one missing ingredient in the campaign for a smaller and more efficient government sector—a political strategy that works."[43]

Enter "Political Correctness"

The construction of the PC Monster was one of the major preoccupations of cultural conservatives, especially during the last days of George II. I use the term "construction" with care, for it rather resembles the way in which the Piltdown Man was produced. One particularly notorious but exemplary instance is provided by the so-called "Thernstrom case" at Harvard. It is cited as a prime instance of PC not only in the right-wing bible of academic condemnation, Dinesh D'Souza's *Illiberal Education,* but in Lynne Cheney's valedictory pamphlet, which was given the Pickwickian title of "Telling the Truth."[44] Cheney's account nicely illustrates the self-referential process by which tales of political correctness were inflated like Macy's parade balloons. To support her account of the heinous attacks on poor Thernstrom's academic freedom, she cites D'Souza, a strikingly primitive article in *New York Magazine,*[45] which offered no independent evidence of anything, and Thernstrom himself, in that journal of scholarly objectivity, *Academic Questions.*[46] But she does not cite an article by Jon Wiener,[47] which effectively dismantles D'Souza's initial account by reporting on Wiener's own interviews with the undergraduates supposedly guilty of harrassing Thernstrom, with Thernstrom and other Harvard faculty, and with the Harvard administrators who, according to Thernstrom, did not support him. Wiener's conclusion, to which there has been no substantive response from the right, is that "almost every element of the story D'Souza tells is erroneous" (p. 384), and that therefore the accounts spread by right-wing mockingbirds like Cheney are equally fallacious; that, indeed, there was no "Thernstrom case."

But of course, it was not only right-wing flacks like D'Souza and Cheney, marginal at best to the academy, who have spread such poison through the body politic. Indeed, I suspect that the most damage has been done by liberals within academe, like C. Vann Woodward. Many readers will recall an essentially laudatory review of D'Souza's book published by Woodward in the *New York Review of Books.* You may also recall how, in that article, Woodward regales *NYRB*'s many readers with an uncritical summary of D'Souza's account of how poor Thernstrom was "silenced" and "forced" to stop teaching the class in question. What many of you

will not recall—nor, in fact, even have seen—is Woodward's recanting of what he wrote about Thernstrom in that article. For his recantation emerges only in the collection edited by Pat Aufderheide called *Beyond PC* and published by Graywolf Press in St. Paul. In that article Woodward admits that he "and others were misled by D'Souza's account."[48] He does not say how many people might have read him in the widely circulated *New York Review of Books* and how many might have come upon his retraction in the Graywolf Press volume.

My point is not, of course, that political correctness, self-righteousness, and lousy scholarship do not exist. Of course they do, as Lynne Cheney's pamphlet nicely illustrates, and as any of us who have struggled with the more vapid forms of identity politics can testify. The academy has always had its share of charlatans, lowlifes, and scurvy reprobates: they produced an Aryanized version of the classics, faked twin-studies which have so corrupted the understanding of intelligence, American literary history without black writers, and my favorite bit of academic nonsense, the "end of ideology"—not to speak of NCAA Division One athletics.[49] But they are no more—well, maybe a little more—symptomatic of the American academy as a whole than, say, Leonard Jeffries's ideas about "ice people" and "sun people." For every abuse of "affirmative action"—and there have been some, to be sure—I can tell many a story of academic favoritism, incompetence, and silliness. Indeed, I don't have to tell, for they're set out in hilarious detail in a book of a quarter century ago called *The Academic Marketplace*, long before "affirmative action" or anything like it had been thought up as an effort to right the previous obliquity of segregated schooling. For every instance of preferential admission by gender or race, I will be glad to cite the multiplying thousands of instances in which preferences like those for alumni children became *de facto* tools for sustaining segregation and privilege. For every instance in which students of color have chosen to gather among themselves, you can cite hundreds of instances in which they have been segregated by regulations, threats, and the legacy of racism with which we all live.

I can excuse D'Souza his ignorance; he, after all, was not around when Karl Shapiro wrote of the University of Virginia in those good old 1940s days:

> To hurt the Negro and avoid the Jew
> Is the curriculum.

I can excuse D'Souza. But not people like the former dean of Yale College, who proclaimed that the climate in his and other universities was worse than it had been in those good old days of black exclusion, Jewish quotas,

and McCarthyite firings of big, bad Commies. Those good old 1950s when the barber at Indiana University's Union claimed he "just didn't know how to cut a Nigra's hair" and the subtitle of the Western Civilization course I once taught—and loved—had the distinctly unideological rubric "The Origins of Christian Civilization." Those were good days, all right, when Yale's eighteenth-century English literature program produced recruits for the CIA—including its director of counterintelligence—not to speak of the methodological base for the CIA's gathering and deployment of information, and also the intellectual grounding of its Cold-War ideology.[50] I can regard these people who have gone round the country talking about "tenured radicals," the left-wing takeover of the university, and the rest of the PC line—I can regard them as little other than a fifth column. For the practical effects of the attacks on the university, and particularly from those within it, have been to threaten our colleagues' jobs, our students' access to education, and the usefulness of learning to the future of this country. And to support the worst know-nothings hanging on in statehouses across the country.

But all of this has come to seem to me, as perhaps to you, ancient history, B.C., so to speak. It is *boring,* like most right-wing scholarship. And without its promotion from the White House, the PC Monster seems to be deflating, like the Snoopy balloon the day after Thanksgiving. It may still be useful to understand how political correctness has been deployed, to use Stuart Butler's language, as the "missing ingredient in the campaign for a smaller . . . government sector—a political strategy that works." It may be useful to show how precisely those individuals—like William Simon—and organizations—like the Olin, Scaife, and Coors Foundations—which have promoted the conservative agenda have also been the major financial sources for those talking up the PC threat.[51] It may also be useful to point to other factors which have helped produce the constriction of college budgets. To cite just three: an aging population which no longer wishes to pay for other people's education, the narrowing of states' discretionary choices about where to spend money (a narrowing produced by Reagan-Bush mandates to carry on programs shifted to localities from the federal budget), and the push for international "competitiveness"—shared by Reaganites and Clintonites alike—which has led to efforts to decrease domestic consumption, and thus wages and public spending.[52] No doubt it would also be useful to think about ways in which university education can be made more cost-effective. But I want to suggest that our primary problem is at least as much to organize as to analyze.

Those of us who are committed to broadening educational access and who believe in the value of multiculturalism and sex and gender equity need, I believe, to persuade Americans, as we have not successfully done,

of the value of what we and our students do in colleges and universities. Many people have become skeptical of that enterprise, and indeed, in traditional American fashion, of intellectual work generally. In fact, one might argue that the real crisis of higher education has to do with the sharp decline of its authority, most particularly its cultural authority. To an increasing number of Americans, including our students, universities mean little more than a stamp on one's life passport—important but not all that serious. For them, the flickering screen, the boom-box, the Boss and the Dead—not to say the Pistols, the Michaels, Madonna, Chuck D, Ice-T, the Nike ads, and (God save the mark) Roseanne—define the shape of culture. And the color of money. This is not altogether bad, given the imperial versions of culture that, until recently, predominated in colleges and universities. Yet we need to stop to consider what it might mean for youthful values to be increasingly established by the media, by a network of print, video, advertising, organized primarily around considerations of profit.

Some of the findings in Alexander Astin's recent book *What Matters in College?* are strikingly relevant here. Astin reports that "student acceptance of the idea that the chief benefit of a college education is to increase one's earning power is positively affected by . . . living at home, majoring in engineering, and a peer environment characterized by a lack of student community." Such student attitudes are further associated with the number of hours spent watching television, "a particularly interesting effect," Astin comments, "given the great emphasis on acquisitiveness and materialism that one finds in most commercial television programming."[53] By contrast, an institution's "humanities orientation" negatively affects such attitudes; also negatively associated with this set of beliefs are the number of hours spent talking with faculty outside of class, the number of courses a student takes which emphasize writing, and similar factors. Astin's statistics illuminate a common wisdom about collegiate experience: that definable factors can influence students' political, social, and cultural outlooks. We might, then, argue that current fiscal policies in higher education, especially in public education, are decisively eroding precisely those features of academic life that foster humane values alternative to those of "acquisitiveness" and "materialism," and that the erosion of contemporary academic cultural authority is no accidental by-product of financial cutbacks and culture wars but one of their objectives. And further, that such a shift is a mark not of rational economic progress but of social ill-health.

It is because I have a certain faith in the value of intellectual work and in the academy that I have helped begin an organization called—perversely it seems to some—the Union of Democratic Intellectuals. It

would be hard to cram more conflicted words into a title, but the main reason for the name Union of Democratic Intellectuals is not linguistic perversity, however appealing that has often seemed to be to academics. The reason is located precisely in the union of intellectual work with a democratic polity. Our responsibility—and especially those of us well situated in universities—is to sustain, to nourish, to develop that union. The responsibility of intellectuals, after all, does not cease with the final footnote. It takes us into communities, into politics; into organizing, in short.

The "crisis" of the university we face may, in fact, prove an opportunity. It can be an opportunity not only to help renew the struggle for broadened access, but to debate the question of access *to what*. It should be an opportunity not only to reassert the value of diversity in curriculum, students, and staff, but to discuss how we can press for concrete measures to insure that real diversity, at every level, begins to be realized, as it never has been. Certainly, it is an opportunity to extricate ourselves from the defensive postures into which many of us twisted in this last twisted decade, and to take up the tasks of shaping the debate, rather than being defined by other peoples' sound bites, like PC. Above all, it must become an opportunity to define alternative directions for college education; precisely because we can no longer assume that jobs will continue—or departments, or even institutions—intellectuals must rethink the work we do in universities and colleges, and the work such institutions do in the rapidly underdeveloping economy of the United States. Will universities be ever more elaborate mechanisms for sorting and dividing Americans—and foreign elites as well—or can they become instruments for democratizing society and culture? The answers are not foreclosed, but depend upon our imagination, energy, and willingness to organize.

NOTES

Earlier versions of this article appeared in Politics and Culture *and in* Radical Teacher. *I wish to thank my colleagues at Trinity College, and especially Jan Cohn, for their helpful criticisms. This paper also benefited from the suggestions of Richard Ohmann, Louis Kampf, and Saul Slapikoff of the* Radical Teacher *editorial board, from a number of comrades in the Union of Democratic Intellectuals, and especially from the support and criticism of Ann Fitzgerald.*

1. See below on the Thernstrom "case" at Harvard for an illustrative example.

2. Andrew L. Yarrow, "At UConn Costs Squeeze Its Students," *New York Times,* August 16, 1992, p. 42.

3. Jeannie Cross, "Higher Education Under Attack," *Empire State Reports* 18, August, 1992, p. 31.

4. Yarrow, "At UConn, Costs Squeeze Its Students," pp. 37, 42. Yarrow's subhead conveys the essence of his story: "Many in Middle Class Face Crisis Over Fees."

5. Kit Lively, "California Colleges Worry About How to Live With Deep State Cuts," *Chronicle of Higher Education,* September 9, 1992, p. A25.

6. Sonia L. Nazario, "Funding Cuts Take a Toll at University," *Wall Street Journal,* October 5, 1992, pp. B1, B11.

7. "Important Trends for California Community Colleges, 1992," report prepared for the Board of Governors' Retreat, April 23–25, 1992. See also Lively, p. A25.

8. Anthony DePalma, "Community Colleges Forced to Restrict Access, and Goals," *New York Times,* November 11, 1992, p. 1.

9. Edward Hines, *State Tax Funds for Operating Expenses of Higher Education* (Washington, D.C.: National Association of State Universities and Land-Grant Colleges, 1990), as cited by Arthur M. Hauptman, "Meeting the Challenge: Doing More With Le$$ in the 1990s," *Educational Record* 72, Spring, 1991, p. 8.

10. Mary H. Cooper, "Paying for College," *CQ Researcher* 2, November 20, 1992, p. 1003. Robert M. Sweeney, "Report of the States: 1992 Annual Budget and Fiscal Survey of the AASCU Council of State Representatives," American Association of State Colleges and Universities (1992).

11. Sonia L. Nazario, "Funding Cuts Take a Toll at University," *Wall Street Journal,* October 5, 1992, p. B1.

12. See, for example, Kit Lively, "Most University Systems Are Still Playing Catch-Up Despite Some Increases in Appropriations for 1993–94," *Chronicle of Higher Education,* July 14, 1993, p. A20.

13. Joye Mercer, "Drop in State Support Leaves Ohio Colleges Wondering How Much Farther They Can Fall," *Chronicle of Higher Education,* September 9, 1992, p. A23.

14. Quoted in Cooper, "Paying for College," p. 1013.

15. Nazario, "Funding Cuts," *Wall Street Journal,* p. B1.

16. The figures are those of the *Denver Post,* quoted in the *AAUP College and University Fiscal Crisis Update* 1, No. 2, March 1993, p. 5.

17. Thomas J. DeLoughry, "Recession Takes Toll on U.S. Student Aid," *Chronicle of Higher Education,* June 10, 1992, pp. A1, A20–21.

18. See, for example, Kit Lively's examination of the impact of extraordinarily deep cuts on Oregon campuses: 5 percent state appropriation cut in 1991–93, with the consequent disappearance of seventy academic programs; 18.3 percent in cuts for the 1993–95 biennium, and an additional 20 percent cut projected for 1995–97. *Chronicle of Higher Education,* June 9, 1993, pp. A19–21.

19. Gordon Van de Water, "Public Tuition and State Expenditures for Higher Education, 1984–1988," NCSL (October 1991).

20. Mary H. Cooper, "Paying for College," *CQ Researcher* 2, November 20, 1992, p. 1003.

21. *Business Week,* May 24, 1993, p. 112.

22. Sonia L. Nazario, *Wall Street Journal,* p. B11.

23. Quoted in Mary H. Cooper, "Paying for College," p. 1004.

24. *Business Week,* May 24, 1993, p. 154.

25. See Mary H. Cooper, "Paying for College," p. 1007.

26. As Rita Rodin, a spokesperson for CUNY, pointed out, the City University, long free, began to charge tuition in 1976 and raised its tuition by a total of $53 million for this year. "The upshot is that 'a greater portion of the burden [of financing CUNY] is falling on students. . . .'" Quoted by Jeannie Cross, "Higher Education Under Attack," *Empire State Report,* pp. 34–35.

27. This is not a new development, but the extension of a role colleges have increasingly played since a significant proportion of American youth began attending after the First World War, and especially since very large numbers of Americans began attending after the Second World War. For useful earlier analyses of the sorting functions of higher education see Ivar E. Berg, *Education and Jobs: The Great Training Robbery* (New York: Praeger, 1970); Samuel Bowles and Herbert Gintis, *Schooling In Capitalist America: Educational Reform and the Contradictions of Economic Life* (New York: Basic Books, 1976); Christopher Jencks and David Riesman, *The Academic Revolution* (Garden City: Doubleday, 1968); Paul Taubman and Terence Wales, *Higher Education and Earnings: College as an Investment and a Screening Device* (New York: McGraw-Hill, 1974).

28. Charles F. Manski, *Parental Income and College Opportunity,* Democratic Study Center, August 26, 1992; quoted in Cooper, "Paying for College," pp. 1004–5.

29. U.S. Census Bureau figures cited by Nazario, *Wall Street Journal,* p. B1.

30. See, for example, "The Battle for City University," *Lingua Franca* 3, January–February, 1993, pp. 1, 24–31, 62.

31. Nazario, "Funding Cuts," p. B1.

32. *New York Times,* October 12, 1993.

33. "College Education: Paying More and Getting Less," staff report to the Select Committee on Children, Youth, and Families, presented at hearings on September 14, 1992, p. 3. To be sure, many of these administrative expenses, such as those for security and utilities, are quite legitimate. On the other hand, it would be hard, in my judgment, to maintain that many huge presidential salaries and burgeoning administrative staffs are uniformly necessary. At the same time that the president of San Diego State initially announced layoffs for hundreds of faculty, he gave himself a five-figure raise—just a small instance of how the greedy culture of the 1980s has infected educational institutions.

34. Cited in *Business Week,* May 24, 1993, p. 113.

35. A recent newsletter from State Senator Franz S. Leichter of New York mentioned that, in real dollars, New York spending for jails has increased by 270 percent in the last ten years, whereas higher education spending has actually decreased by about 8 percent.

36. Peter Smith, "Beyond Budgets: Changing for the Better," *Educational Record* 72, Spring, 1991, p. 27.

37. *Ibid.*

38. Amy Lang of Emory University informed me about a decision at the Massachusetts Institute of Technology to increase the weight given to verbal scores on the Scholastic Aptitude Test. That adjustment alone moved the proportion of women in the entering class upward by about twenty percent. It was, I should note, motivated less by the institute's desire to diversify its student population than

by the fact that computer science had been overwhelmed by student enrollments; women, however, seldom went into computer science and so an increase in the female population served to relieve enrollment pressures without "lowering standards."

39. "Maintaining Quality in the 1990s: How Will We Pay?" *Educational Record* 72, Spring, 1991, p. 17.

40. Both Kaplan and Arthur M. Hauptman, in an article elsewhere in the same issue of *Educational Record,* note the danger to minority enrollments of the cuts they cite. But neither presents any concrete plan or, indeed, more than vague hopes that such cuts will not roll back previous gains, such as they have been.

An equally grim "Discussion Paper" from the Acting President of Simon Fraser University in Vancouver, Canada—where a similar process, mandating that the university "expand our services without any prospect of incremental funding," is underway—frames the issue differently: ". . . only fundamental change will allow us to manage the coming years without significant loss of quality" (p. 2). The proposals put forward here are not comforting, I hasten to add, although some of them, like expanded use of electronic media, seem sensible. But at least the initial outlook does not counterpose access to quality.

41. As a leaflet issued by the Jobs With Justice Fair Trade Committee of Boston puts it, "Economists at Skidmore College and the University of Massachusetts have estimated that by the year 2000 investment in Mexico would reach over $50 billion costing the US more than 450,000 jobs and a 2.3% decline in wages."

42. Max Sawicky, "What's NEWP? A Guiding Theory of the New Right," *Social Policy* 22, Winter, 1992, p. 9.

43. *Ibid.*

44. Washington: National Endowment for the Humanities, 1992.

45. John Taylor, "Are You Politically Correct?" January 21, 1991, pp. 32–40.

46. Stephan Thernstrom, "McCarthyism Then and Now," *Academic Questions* 4.1 (1990–91), pp. 14–16.

47. "What Happened at Harvard," *The Nation* 253, September 30, 1991, pp. 384–388; reprinted in Patricia Aufderheide, ed., *Beyond PC: Toward a Politics of Understanding* (St. Paul: Graywolf Press, 1992), pp. 97–106. A number of other articles in this volume cut the ground from under many of the more notorious "cases" of PC.

48. p. 43. To his credit, Woodward acknowledged and accepted some of the criticisms directed at him in *NYRB's* letters column. But the Thernstrom case remains a source of conflict. I might add that I find it hard to understand why a teacher would not use student inquiries—or even complaints—about the content of his course as a basis for discussing and clarifying his objectives.

49. See, for example, Tom Foster Digby, "Political Correctness and the Fear of Feminism," *The Humanist* 52, March–April 1992, pp. 7–9, 34, particularly his analysis of the vicious "irresponsibility and lack of seriousness" with which another right-wing academic, Christina Hoff Sommers, attacks her subjects.

50. See a wonderful essay by William H. Epstein, "Counter-Intelligence: Cold-War Criticism and Eighteenth-Century Studies," *ELH* 57, 1990, pp. 63–99.

51. See, for details, Scott Henson and Tom Philpott, "The Right Declares a Culture War," *The Humanist* 52, March–April 1992, pp. 10–16, 46.

52. The most useful analysis of the economic relationships between national economic policies and the fiscal crisis of higher education is Ernst Benjamin's essay in the present volume.

53. Alexander W. Astin, *What Matters in College?* (San Francisco: Jossey-Bass, 1992), pp. 153–4.

Cultural Capital and Official Knowledge

MICHAEL W. APPLE

Introduction

Everyone stared at the department chair in amazement. Jaws simply dropped. Soon the room was filled with a nearly chaotic mixture of sounds of anger and disbelief. It wasn't the first time she had informed us about what was "coming down from on high." Similar things had occurred before. After all, this was just another brick that was being removed. Yet, to each and every one of us in that room, it was clear from that moment on that for all of our struggles to protect education from being totally integrated into the rightist project of economic competitiveness and rationalization, we were losing.

It was hard to bring order to the meeting. But, slowly, we got our emotions under control long enough to hear what the State Department of Public Instruction and the Legislature had determined was best for all of the students in Wisconsin—from kindergarten to the university. Starting the next year, all undergraduate students who wished to become teachers would have to take a course on Education for Employment, in essence a course on the "benefits of the free enterprise system." At the same time, all school curricula at the elementary and secondary levels—from five-year-olds on up—would have to integrate within their teaching a coherent program of education for employment as well. After all, you can't start too young, can you? Education was simply the supplier of "human capital" for the private sector, after all.

I begin with this story because I think it is often better to start in our guts so to speak, to start with our experiences as teachers and students in this time of conservatism. I begin here as well because, even though there is a new administration in Washington which may rein in some of

91

the excesses of the rightist social agenda, the terms of debate and the existing economic and social conditions have been transformed remarkably in a conservative direction (Apple 1993). We should not be romantic about what will happen at our schools and universities, especially given the fiscal crisis of the state and the acceptance of major aspects of the conservative social and economic agenda within both political parties. The story I told a moment ago can serve as a metaphor for what is happening to so much of educational life at universities and elsewhere.

Let me situate this story within the larger transformations in education and the wider society that the conservative alliance has attempted.

Between Neoconservatism and Neoliberalism

Conservatism by its very name announces one interpretation of its agenda. It conserves. Other interpretations are possible, of course. One could say, somewhat more wryly, that conservatism believes that nothing should be done for the first time (Honderich 1990, 1). Yet in many ways, in the current situation this is deceptive. For with the right now in ascendancy in many nations, we are witnessing a much more activist project. Conservative politics now are very much the politics of alteration—not always, but clearly the idea of "Do nothing for the first time" is not a sufficient explanation of what is going on either in education or elsewhere (Honderich 1990, 4).

Conservatism has in fact meant different things at different times and places. At times, it will involve defensive actions; at other times, it will involve taking initiative against the status quo (Honderich 1990, 15). Today, we are witnessing both.

Because of this, it is important that I set out the larger social context in which the current politics of official knowledge operates. There has been a breakdown in the accord that has guided a good deal of educational policy since the Second World War. Powerful groups within government and the economy, and within "authoritarian populist" social movements, have been able to redefine—often in very retrogressive ways—the terms of debate in education, social welfare, and other areas of the common good. What education is for is being transformed (Apple 1993). No longer is education seen as part of a social alliance which combined many "minority"[1] groups, women, teachers, community activists, progressive legislators and government officials, and others who acted together to propose (limited) social democratic policies for schools (for example, expanding educational opportunities, limited attempts at equalizing outcomes, developing special programs in bilingual and multicultural education, and so on). A new alliance has been formed, one that has increasing

power in educational and social policy. This power bloc combines business with the New Right and with neoconservative intellectuals. Its interests lie not in increasing the life-chances of women, people of color, or labor (these groups are obviously not mutually exclusive); rather it aims at providing the educational conditions believed necessary both for increasing international competitiveness, profit, and discipline, and for returning us to a romanticized past of the "ideal" home, family, and school (Apple 1993). There is no need to control the White House for this agenda to continue to have a major effect.

The power of this alliance can be seen in a number of educational policies and proposals not only at the university but in schooling in general. (In fact, it is *essential* that we see this broader picture. Without it, we cannot fully understand what is happening to institutions of higher education.) These include: 1) programs for "choice," such as voucher plans and tax credits, to make schools like the thoroughly idealized free-market economy; 2) the movement at national and state levels throughout the country to "raise standards" and mandate both teacher and student "competencies" and basic curricular goals and knowledge, increasingly, now, through the implementation of statewide and national testing; 3) the increasingly effective attacks on the school curriculum for its antifamily and anti-free-enterprise "bias," its secular humanism, its lack of patriotism, and its supposed neglect of the knowledge and values of the "Western Tradition" and of "real knowledge"; and 4) the growing pressure to make the perceived needs of business and industry into the primary goals of education at all levels (Apple 1988; Apple 1993; Apple forthcoming). The effects of all this—the culture wars, the immensity of the fiscal crisis in education, the attacks on "political correctness," and so on—are being painfully felt in the university as well.

In essence, the new alliance in favor of the conservative restoration has integrated education into a wider set of ideological commitments. The objectives in education are the same as those which serve as a guide to its economic and social welfare goals. These include the expansion of the "free market," the drastic reduction of government responsibility for social needs (though the Clinton Administration will mediate this in not very extensive—and not very expensive—ways), the reinforcement of intensely competitive structures of mobility, the lowering of people's expectations for economic security, and the popularization of what is clearly a form of Social Darwinist thinking (Bastian, Fruchter, Gittell, Greer, and Haskins 1986).

As I have argued at length elsewhere, the political right in the United States has been very successful in mobilizing support *against* the educational system and its employees, often exporting the crisis in the economy into

the schools. Thus, one of its major achievements has been to shift the blame for unemployment and underemployment, for the loss of economic competitiveness, and for the supposed breakdown of "traditional" values and standards in the family, in education, and in paid and unpaid work-places *from* the economic, cultural, and social policies and effects of dominant groups *to* the school and other public agencies. "Public" now is the center of all evil; "private" is the center of all that is good (Apple 1985).

In essence, then, four trends have characterized the conservative restoration both in the United States and Britain—privatization, centralization, vocationalization, and differentiation (Green 1991, 27). These are actually largely the results of differences within the most powerful wings of this tense alliance—neoliberalism and neoconservatism.

Neoliberalism has a vision of the weak state. A society that lets the "invisible hand" of the free market guide *all* aspects of its forms of social interaction is seen as both efficient and democratic. On the other hand, neoconservatism is guided by a vision of the strong state in certain areas, especially over the politics of the body and gender and race relations, over standards, values, and conduct, and over what knowledge should be passed on to future generations (Hunter 1988).[2] While these are no more than ideal types, those two positions do not easily sit side by side in the conservative coalition.

Thus the rightist movement is contradictory. Is there not something paradoxical about linking all of the feelings of loss and nostalgia to the unpredictability of the market, "in replacing loss by sheer flux"? (Johnson 1991, 40).

At the elementary and secondary school level, the contradictions between neoconservative and neoliberal elements in the rightist coalition are "solved" through a policy of what Roger Dale has called *conservative modernization*. Such a policy is engaged in:

> simultaneously "freeing" individuals for economic purposes while controlling them for social purposes; indeed, in so far as economic "freedom" increases inequalities, it is likely to increase the need for social control. A "small, strong state" limits the range of its activities by transferring to the market, which it defends and legitimizes, as much welfare [and other activities] as possible. In education, the new reliance on competition and choice is not all pervasive; instead, "what is intended is a dual system, polarized between . . . market schools and minimum schools." (Dale quoted in Edwards, Gewirtz, and Whitty forthcoming, 22)

That is, there will be a relatively less regulated and increasingly privatized sector for the children of the better-off. For the rest—and the

economic status and racial composition in, say, our urban areas of the people who attend these minimum schools will be thoroughly predictable—the schools will be tightly controlled and policed, and will continue to be underfunded and unlinked to decent, paid employment.

One of the major effects of the combination of marketization and the strong state is "to remove educational policies from public debate." That is, the choice is left up to individual parents and "the hidden hand of unintended consequences does the rest." In the process, the very idea of education being part of a *public* political sphere—in which its means and ends are publicly debated—atrophies (Education Group II 1991, 268).

There are major differences between democratic attempts at enhancing people's rights over the policies and practices of schooling and the neoliberal emphasis on marketization and privatization. The goal of the former is to *extend politics,* to "revivify democratic practice by devising ways of enhancing public discussion, debate, and negotiation." It is inherently based on a vision of democracy that sees it as an educative practice. The latter, on the other hand, seeks to *contain politics.* It wants to *reduce all politics to economics,* to an ethic of "choice" and "consumption" (Johnson 1991, 68). The world, in essence, becomes a vast supermarket (Apple 1993).

Enlarging the private sector so that buying and selling—in a word competition—is the dominant ethic of society involves a set of closely related propositions. It assumes that more individuals are motivated to work harder under these conditions. After all, we "already know" that public servants are inefficient and slothful while private enterprises are efficient and energetic. It assumes that self-interest and competitiveness are the engines of creativity. More knowledge, more experimentation, is created and used to alter what we have now. In the process, less waste is created. Supply and demand stay in a kind of equilibrium. A more efficient machine is thus created, one which minimizes administrative costs and ultimately distributes resources more widely (Honderich 1990, 104).

This is of course not meant simply to privilege the few. However, it is the equivalent of saying that everyone has the right to climb the north face of the Eiger or scale Mount Everest without exception, providing of course that you are very good at mountain climbing and have the institutional and financial resources to do it (Honderich 1990, 99–100).

Thus, in a conservative society, access to a society's private resources (and, remember, the attempt is to make nearly *all* of society's resources private) is largely dependent on one's ability to pay. And this is dependent on one's being a person of an *entrepreneurial or efficiently acquisitive class type.* On the other hand, society's public resources (that rapidly decreasing

segment) are dependent on need (Honderich 1990, 89). In a conservative society, the former is to be maximized, the latter is to be minimized.

However, most forms of conservatism do not merely depend in a large portion of their arguments and policies on a particular view of human nature—a view of human nature as primarily self-interested. They have gone further; they have set out to degrade that human nature, to force all people to conform to what at first could only be pretended to be true. Unfortunately, in no small measure they have succeeded. Perhaps blinded by their own absolutist and reductive vision of what it means to be human, many of our political "leaders" do not seem to be capable of recognizing what they have done. They have set out, aggressively, to drag down the character of a people (Honderich 1991, 81), while at the same time attacking the poor and the disenfranchised for their supposed lack of values and character.

But I digress here, and some of my anger begins to show. You will forgive me, I trust; but if we cannot allow ourselves to be angry about the lives of our children, what can we be angry about?

What Postmodernists Forget

Important elements of the neoconservative and especially the neoliberal agendas are increasingly dominating the university. The growing class and race polarization surrounding *which* universities one gets to go to (or doesn't get to go to), the funding cuts for "unproductive" (a truly revealing metaphor), humanistic, and/or critically oriented programs, the increased pressure towards "efficiency" and raising standards, the calls for a return to a "common culture," and above all the growing integration of university teaching, research, funding, and many of its other functions into the industrial project—all of these and more are indicative of the effects of both strands of the complex restructuring of our daily lives.

Unfortunately, major elements of this restructuring are hardly on the agenda of discussions of some of the groups within the critical and "progressive" communities within higher education itself. This is especially the case if we examine what kind of knowledge is now more and more being given the official imprimatur of the institution.

While the conflict over postmodern and poststructural forms continues to rage—in part because of some of the overstatements by what are affectionately known by some of my colleagues as the "posties," as well as because of the aggressive attacks coming from movements associated with the conservative restoration (Apple 1993)—too little focus has been placed on the political economy of what knowledge is considered high status in this and similar societies. Thus, while the humanities and the

social sciences are engaged in clever rhetorical and cultural "battles" (please excuse the masculinist and militarist turn of phrase; the word is not mine) over what counts as "appropriate" knowledge and what counts as "appropriate" forms of teaching and knowing ("the culture wars"), what are commonsensically known as the sciences and technology—what I have called (following the lead of Walter Feinberg) technical/administrative knowledge—are receiving even more emphasis at schools at all levels in terms of time in the curriculum, funding, prestige, support from the apparatuses of the state (Apple 1985), and a new administration in Washington that is committed to technical solutions and technical knowledge.

What I shall say here is still rather tentative, but it responds to some of my intuitions that a good deal of the storm and fury over the politics of one form of textual analysis over another, or even over whether we should see the world as a text, as discursively constructed, for example, is at least partly beside the point, and that "we" may be losing some of the most important insights generated by, say, the neo-Marxist tradition in education and elsewhere.

In what I say here, I hope I do not sound like an unreconstructed Stalinoid (after all, I have spent all too much of my life writing and speaking about the reductive tendencies within the Marxist traditions). I simply want us to remember the utterly essential—not essentialist—understandings of the relationships (admittedly very complex) between what knowledge is considered high status and some of the relations of power we need to consider but seem to have forgotten a bit too readily. I shall not only refer to relations of power at the university, but to emerging and crucial transformations that are occurring in elementary and secondary schools that educate (or don't educate) students who ultimately go (or don't go) to institutions of higher education.

The growth of the multiple positions associated with postmodernism and poststructuralism is indicative of the transformation of our discourse and understandings of the relationship between culture and power. The rejection of the comforting illusion that there can (and must) be one grand narrative under which all relations of domination can be subsumed, the focus on the "microlevel" as a site of the political, the illumination of the utter complexity of the power-knowledge nexus, the extension of our political concerns well beyond the "holy trinity" of class, gender, and race, the idea of the decentered subject where identity is both nonfixed and a site of political struggle, the focus on the politics and practices of consumption, not only production—all of this has been important, though not totally unproblematic to say the least (Clarke 1991; Best and Kellner 1991).

With the growth of postmodern and poststructural literature in critical educational and cultural studies, however, we have tended to move too quickly away from traditions that continue to be filled with vitality and provide essential insights into the nature of the curriculum and pedagogy that dominate schools at all levels. Thus, for example, the mere fact that class does not explain all can be used as an excuse to deny its power. This would be a serious error. Class is, of course, an analytic construct as well as a set of relations that have an existence outside of our minds. Thus what we mean by it and how it is mobilized as a category need to be continually deconstructed and rethought. Thus we must be very careful when and how it is used, with due recognition of the multiple ways in which people are formed. Even given this, however, it would be wrong to assume that, since many people do not identify with or act on what we might expect from theories that link, say, identity and ideology with one's class position, this means that class has gone away (Apple 1992).

The same must be said about the economy. Capitalism may be being transformed, but it still exists as a massive structuring force. Many people may not think and act in ways predicted by class essentializing theories, but this does *not* mean the racial, sexual, and class divisions of paid and unpaid labor have disappeared; nor does it mean that relations of production (both economic *and* cultural, since how we think about these two may be different) can be ignored if we do it in nonessentializing ways (Apple 1992).

I say all this because of very real dangers that now exist in critical educational studies. One is our loss of collective memory. While there is currently great and necessary vitality at the "level" of theory, a considerable portion of critical research has often been faddish. It moves from theory to theory rapidly, often seemingly assuming that the harder something is to understand or the more it rests on European cultural theory (preferably French) the better it is. The rapidity of its movement and its partial capture by an upwardly mobile fraction of the new middle class within the academy—so intent on mobilizing its cultural resources within the status hierarchies of the university that it has often lost any but the most rhetorical connections with the multiple struggles against domination and subordination at the university and elsewhere—has as one of its effects the denial of gains that have been made in other traditions, or the restating of them in new garb (Apple 1992). Or it may actually move backwards, as in the reappropriation of, say, Foucault into just another (but somewhat more elegant) theorist of social control, a discredited and ahistorical concept that denies the power of social movements and historical agents.

Both the power of conservative social movements and the structural crisis into which they intervene concern me here.

In our rush toward poststructuralism, we may have forgotten how very powerful the structural dynamics are in which we participate. In recognition of this, I want to focus on some of the dynamics of knowledge at the university, especially on the continued reconstruction of the role of the university towards the complex and contradictory economic and cultural "needs" of economic rationalization, national and international competitiveness, and its associated agendas. In order to go further we need to think about the process of commodification, especially about the ways in which knowledge and institutions are reified so that they can be employed to extract surplus value. Oddly enough, I too must commodify knowledge in order to understand how it fits into the flow of capital.

The Political Economy of Cultural Capital

What I propose is somewhat dangerous. We have spent years trying to *dereify* knowledge, trying to show it as both a process of meaning construction and the embodiment of past constructions. To treat knowledge once again as a thing risks losing those gains. However, such a move is essential if we are to understand the continuing transformations that are going on in higher education. In making this case, I need to recapitulate a number of arguments I made in *Education and Power* (Apple 1985).

I want us to think of knowledge as a form of capital. Just as economic institutions are organized (and sometimes disorganized) so that particular classes and class fractions increase their share of economic capital, cultural institutions such as universities seem to do the same things. They play a fundamental role in the accumulation of cultural capital.

Now I am using the idea of cultural capital in a particular way, one that is different from that of, say, Bourdieu. For Bourdieu, for instance, the style, language, cultural dispositions, and even the bodies—the hexus and habitus—of dominant groups are the cultural capital that, through a complicated process of conversion strategies, is cashed in so that the dominance of these dominant groups is preserved. Thus, students from dominant groups (and for Bourdieu these center largely around class) get ahead because of their "possession" of this cultural capital (Bourdieu 1977; Bourdieu 1984).

There is some strength to such a conception of cultural capital. However, it assumes that the fundamental role of educational institutions is the *distribution* of knowledge to students, some of whom are more "able" to acquire it because of cultural gifts that come "naturally" from their class or race or gender position. Yet such a theory fails to catch the university's role in the production of a particular kind of cultural capital, *technical/administrative* knowledge. The production of this "commodity"

is what many universities are increasingly about, though many of the
debates over the corpus of knowledge that should be taught at the uni-
versity, over what is to count as "tradition," still seem to assume that the
only role the universities play is distributing knowledge (preferably after
deconstructing and then reconstructing it with students) (Apple 1985;
Apple 1990). This misses the structural point.

An advanced corporate economy requires the production of high
levels of technical/administrative knowledge because of national and in-
ternational economic competition, and to become more sophisticated in
the maximization of opportunities for economic expansion, for commu-
nicative and cultural control and rationalization, and so forth. Within
certain limits, what is actually required is *not* the widespread distribution
of this kind of high-status knowledge to the populace in general. What
is needed is to maximize its production (Apple 1985).

Thus there is a complex relationship between the accumulation of
economic and cultural capital. This means that it is *not* essential that
everyone have sophisticated technical/administrative knowledge in their
heads, so to speak. Thus whether you or I or considerable numbers of our
students have it is less important than having high levels of increasingly
sophisticated forms of this knowledge *available for use.*

Broadly speaking, technical/administrative knowledge is essential in
advanced industrial economies. The *way* it is employed in ours, though,
is the critical factor. Given the enormous growth in the volume of pro-
duction and the transformations in its organization and control, there has
been a concomitant need for a rapid increase in the amount and kinds of
technical and administrative information. This is coupled with the con-
tinued increase in the need for "market research" and human relations
research, which each firm requires to increase the rate of accumulation
and workplace control. All of this necessitates the machine production of
information (and the production of more efficient machines as well). These
products—the commodity of knowledge—may be nonmaterial in the tra-
ditional sense of that term, but there can be no doubt that they are eco-
nomically essential products. When one adds to this the immense role
that defense-related industries have played in corporate accumulation, the
increasing role of agribusiness in the corporate monopolization of food
industries and technologies, and so forth, the importance of this kind of
cultural capital increases.

In his analysis of the history of the relationship among science,
technology, educational institutions, and industry, David Noble (1977)
once argued that the control of the production of technical cultural capital
was an essential part of industrial strategy. Capital needed control not

simply of markets and productive plants and equipment, but of science as well:

> Initially this monopoly over science took the form of patent control—that is the control over the *products* of scientific technology. It then became control over the *process* of scientific production itself, by means of organized and regulated industrial research. Finally, it came to include command over the social prerequisites of this process: the development of institutions necessary for the production of both scientific knowledge and knowledgeable people, and the integration of these institutions within the corporate system of science-based industry. "The scientific-technical revolution," as Harry Braverman has explained, "cannot be understood in terms of specific innovations. . . ." Rather it "must be understood in its totality as a mode of production in which science and exhaustive engineering have been integrated as part of ordinary functioning. Thereby innovation is not to be found in chemistry, [biogenetics], electronics, automatic machinery . . . or any of the products of these science-technologies, but rather in the transformation of science itself into capital. (Noble 1977, 6)

Thus, as I have developed at greater length elsewhere, as industry tied itself more and more to the division, control, and replacement of labor, and to technical innovations, if it were to expand its markets, products, and consumption it needed to guarantee a relatively constant accumulation of two kinds of capital, economic and cultural. These needs required much larger influence in the place where both agents and knowledge were produced—the university (Apple 1985).

Noble's previous statement about the importance of patent control illuminates a critical point, for it is here that one can see an area where the accumulation of technical knowledge plays a significant economic role. Controlling the production of technical knowledge was important for systematic patent production and the monopolization of a market. While a primary aim of a good deal of, say, industrial research was to find technical solutions to immediate production problems, the larger issue of the organization and control of knowledge production was essential if one was to "anticipate inventive trends and take out patents to keep open the road of technical progress and business expansion" (Noble 1977, 128). The control of major aspects of science and technical knowledge was accomplished by use of patent monopolies and the organization and reorganization of university life (and especially its curricula and research). Thus, as Noble again shows, industry and the ideologies it has spawned played and continue to play an exceptionally important role in setting structural limits on (*not* determining) the kinds of curricula and pedagogical practices deemed appropriate for a significant portion of university

and technical institute life. Given the economic crisis we currently face, one should expect an even greater influence of the (multiple and sometimes contradictory, of course) interests of capital in the future as well, especially given the Clinton Administration's neoliberal construction of a national industrial policy in which many aspects of the state and capital (as well as other aspects of civil society) should be integrated into rational planning models for achieving a "restructured and more competitive economy for the 21st century."

Thus, with the Clinton Administration's move toward a corporatist model of industrial policy, we shall undoubtedly see more of an integration between universities and larger economic goals. The effects of this on what knowledge is considered to be of most worth, if I may paraphrase Spencer, will be momentous.

Henry Louis Gates, Jr. puts it rather succinctly in the following passage, where he points out who some of the losers of these policies will be:

> The struggle to obtain funding for research, for buildings, and for new and better programs caused the university to increasingly adapt to the priorities of corporations, foundations, government, and other elite donors. A new union emerged with business, industry, and the federal government as the principal partners of the university. At the local level, this meant that resources, human and material, were poured into programs that did research and provided services for the corporate elite. Indeed, on most campuses the resources devoted to such programs would dwarf the resources that go to programs devoted to grappling with the problems of distressed central city neighborhoods. This is also a reflection of the fact that money available for research on social issues of concern to business and industry is much greater than the money available for research on local issues of concern to blacks, Hispanics and working-class whites. (Gates 1992, 21)

Noble's and Gates' points are, of course, relatively economistic and essentializing. They capture neither the relatively autonomous activities of universities nor the micropolitics of science and its practitioners. They ignore the struggles that have been going on "on the ground," so to speak, as well. Yet they do provide an essential insight into the process by which high-status knowledge is produced in a time of economic crisis and the fiscal crisis of the state.

They do help us recognize that universities are caught in a structural contradiction between the task of distributing knowledge and maximizing its production. As the institutional logic surrounding the commodification process recuperates more and more of the daily teaching and research activities at universities within its orbit, the emphasis tilts toward the latter,

while at the same time attempting to limit the former to only that knowledge which is economically "essential" or to move other, more critical, forms of discourse to the margins. They, collectively, slowly become the institutionalized "Other."

Thus, increasingly, in the process what is *perceived* as economically useful knowledge is given the institutional imprimatur. Anything else is nice work if you can get it, but increasingly beside the point. (The neoconservatives, however, know better. They realize that the struggle over culture and consciousness is essential. This is why the issue of language, collective memory, and how we should "name the world" is seen by them to be so important) (Apple 1993).

I am, of course, speaking very generally here. This is not a smooth and rational process. There are struggles over this—over what counts as high-status knowledge, over the state's role in supporting its production, and within institutions of higher education both over why these particular forms of knowledge should gain the most resources and power and over the relatively autonomous status hierarchies within the social field of the academy, hierarchies about which Bourdieu, for instance, has been so perceptive (Bourdieu 1988). Rather, I am pointing to general tendencies, tendencies I am certain have an impact on each of us in varying ways— on funding for research, fellowships, and scholarships, on the distribution of new faculty positions, and more than a little occasionally on tenure decisions and on layoffs of faculty and administrative staff.

Will Our Future Students Know Better?

So far I have given an outline of my intuitions about the contradictions and dynamics surrounding the political economy of high-status knowledge in the academy during a period of economic crisis. The concomitant cultural relations and authority have their own, partly independent, dynamics and struggles, of course, as we witness every day in the culture wars in our institutions. I have discussed these latter issues, concerning the cultural politics of what counts as official knowledge in history, language, literature, "the arts," and so forth, at much greater length elsewhere, and do not want to rehearse them again here (Apple 1993; Apple forthcoming). Rather, I now want to briefly turn to parts of the reconstruction that is occurring at the level of the elementary, middle, and secondary schools throughout this country, and what this means to what students will actually expect from their higher education.

As we witness the steady transformation of what knowledge will be converted into capital at the university—the complex conversion of cultural capital into economic capital[3]—there are similar things occurring at other

levels of our educational institutions. These may have major effects on our
students. Among the most important will be whether a large portion of
our future students in institutions of higher education will see anything
wrong with the commodification of knowledge for private gain. This is
a complicated issue involving the formation of subjectivity(ies) among
students. But perhaps some examples of what is happening at, say, our
middle and high schools can illuminate some of the dangers we are facing.

I turn to this because one of the most crucial issues we will face will
be what our students will be like—what they will know, what values they
will have—when they arrive. Because of this, it is utterly essential that we
focus on elementary and secondary schools, as well as our institutions of
higher education.

At the level of our elementary and secondary schools, the most or-
ganized and well-funded curriculum reform efforts are being developed
around proposed national curricula in mathematics and science. And even
though the Clinton Administration has proposed making the arts the equal
of more "basic" subjects such as science and mathematics, this will have
mostly rhetorical weight, not the weight of policy, especially since many
large school districts such as Los Angeles are having to eliminate art in-
struction and lay off art teachers at all levels. Similar things are occurring
in other, "less essential," curricular areas as well.

To take but one other example, in history it is Diane Ravitch and
her relatively conservative colleagues who have provided the outline for
the social studies textbooks in California. Thus, because of the dominance
of the textbook as the official curriculum in American schools, and because
nearly all publishers will *only* publish what will sell in states such as
California and Texas because these states are in essence the largest guar-
anteed markets, the perspectives on history that the vast majority of stu-
dents will receive will be a narrative of relatively self-congratulatory prog-
ress seen largely through the eyes of dominant groups (Apple 1988; Apple
1993; Apple and Christian-Smith 1991).

Yet the cuts in particular humanities programs and the reassertion
of certain narratives, while important, do not even begin to cover the
entire range of transformations we are witnessing. Let me give what I
believe is the best example.

There is a new generation of "cooperative relations" between ed-
ucation and industry now being built. Among the most "interesting" is
something many of you may not know much about. It is called "Channel
One." Channel One is a commercially produced television news program
that is now broadcast to thousands of schools in the United States. A
description of it is overtly simple: ten minutes of international and national
"news" *and* two minutes of commercials produced very slickly by Whittle

Communications—one of the largest publishers of material for "captive audiences" in the world—and broadcast directly into classrooms.

In return for the use of a satellite dish (which can only receive Channel One), two VCRs, and television monitors for each classroom, schools sign a contract that, over a three-to-five-year period, ninety percent of all students will watch the broadcast in schools ninety percent of the time. Compliance is monitored. For many chronically poor school districts, and an increasing number of seemingly more affluent ones, the fiscal crisis is so severe that textbooks are used until they literally fall apart. Basements, closets, gymnasiums, and any "available" spaces are used for instruction. Teachers are being laid off, as are counselors and support staff. Art, music, and foreign language programs are being dropped. In some towns and cities, the economic problems are such that it will be impossible for schools to remain open for the full academic year. In the context of such a financial crisis, and in the context of a rhetorical strategy used by Whittle that knowledge of the world will assist students in getting jobs and in making our nation more competitive internationally (commercials for Channel One, for instance, point out that some students think that Chernobyl was Cher's original name or that silicon chips are a kind of snack food), schools throughout the nation have seen Channel One as a way of both teaching "important knowledge" and as helping to solve their budget problems.

In *Official Knowledge* (Apple 1993), I have analyzed the strategies Whittle has employed as a rhetoric of justification, the ways Channel One enters into classrooms, the contradictions in its content and organization of the "news"—its linguistic codes, its constructions of the Other, and so on—and what teachers and students actually do with it. What is important here, however, is that for between thirty-five and forty percent of all middle and high school students in the nation, we have *sold* our children as a captive audience to advertisers. The students themselves are positioned as consumers, and commodified and purchased as a captive audience by corporations willing to spend the money for commercials on Channel One.

Now students and teachers sometimes engage in "carnival" with material on Channel One, especially with the commercials. They ignore the news and pay attention to—and sometimes play with—the advertisements in a manner Bakhtin might enjoy. Yet, once again, our educational institutions are being reconstructed as a site for the generation of profit. For years, students will be members of that captive audience. Their daily experience—their common sense—will have been formed around the transformation of knowledge (and themselves) into a site for the production of profit. What would seem so strange for the same to be justifiable at universities? Why should we be surprised that particular definitions of

economically useful knowledge increasingly dominate many institutions of higher education, when we are even now selling students in our middle and secondary schools?

Conclusion

I could say considerably more here, for I have only touched the surface of the emerging trends toward commodification and privatization that education is currently facing. My major point, though, is to caution us, to correct a tendency among our "more advanced theorists" to marginalize concerns surrounding political economy and class relations. It is not to ask us to revivify previous grand narratives, whose "will to know" was itself more than a little problematic, that I raise these points. It is to remind us that this *is* still capitalism, and that makes a difference to our daily lives, and to the lives not only of those students who are at our universities now, but also to the lives of people who may venture into those buildings later on. Ignoring the complex relations between cultural capital and economic capital will not make the situation any easier. The world may be text, but some groups seem to be able to write their lines on our lives more easily than others.

NOTES

1. I put the word "minority" in inverted commas here to remind us that the vast majority of the world's population is composed of persons of color. It would be wholly salutary for our ideas about culture and education to remember this fact.

2. Neoliberalism does not ignore the idea of a strong state, but it wants to limit it to specific areas (e.g., defense of markets).

3. I do not want to romanticize the history of this. Universities did not have a mythical "golden age" when they were cut off from the interests of business and industry or other elites. Indeed, exactly the opposite is the case. See, for example, Barrow (1990).

WORKS CITED

Apple, Michael W. 1985. *Education and Power.* New York: Routledge.
———. 1988. *Teachers and Texts: A Political Economy of Class and Gender Relations in Education.* New York: Routledge.
———. 1990. *Ideology and Curriculum,* 2nd. edition. New York: Routledge.
———. 1992. "Education, Culture and Class Power." *Educational Theory* 42, Spring, pp. 127–145.
———. 1993. *Official Knowledge: Democratic Education in a Conservative Age.* New York: Routledge.

————. "The Politics of Official Knowledge: Does a National Curriculum Make Sense?" *Teachers College Record,* forthcoming.

————., and Christian-Smith, Linda, eds. 1991. *The Politics of the Textbook.* New York: Routledge.

Barrow, Clyde. 1990. *Universities and the Capitalist State.* Madison: University of Wisconsin Press.

Bastian, Ann, Norm Fruchter, Marilyn Gittell, Colin Greer, and Kenneth Haskins. 1986. *Choosing Equality.* Philadelphia: Temple University Press.

Best, Steven, and Kellner, Douglas. 1991. *Postmodern Theory.* London: Macmillan.

Bourdieu, Pierre. 1977. *Reproduction in Education, Society and Culture.* Beverly Hills: Sage.

————. 1984. *Distinction.* Cambridge: Harvard University Press.

————. 1988. *Homo Academicus.* Stanford: Stanford University Press.

Clarke, John. 1991. *New Times and Old Enemies.* London: HarperCollins.

Education Group II, eds. 1991. *Education Limited.* London: Unwin Hyman.

Edwards, Tony, Gewirtz, Sharon, and Whitty, Geoff. "Whose Choice of Schools?" *Sociological Perspectives on Contemporary Educational Reforms,* eds. Madeleine Arnot and Len Barton. London: Triangle Books, forthcoming.

Gates, Henry Louis, Jr. 1992. "Redefining the Relationship: The Urban University and the City in the 21st Century." *Universities and Community Schools* 3, Fall–Winter, pp. 17–22.

Green, Andy. 1991. "The Peculiarities of English Education." *Education Limited,* ed. Education Group II. London: Unwin Hyman, pp. 6–30.

Honderich, Ted. 1990. *Conservatism.* Boulder: Westview Press.

Hunter, Allen. 1988. *Children in the Service of Conservatism.* Madison: University of Wisconsin Law School, Institute for Legal Studies.

Johnson, Richard. 1991. "A New Road to Serfdom." *Education Limited,* ed. Education Group II. London: Unwin Hyman, pp. 31–86.

Noble, David. 1977. *America By Design.* New York: Alfred A. Knopf.

Another Brick in the Wall:
(Re)contextualizing the Crisis

CAROL A. STABILE

> Columbia, Slick . . . Chicago, LA, wherever—in America our seats
> of learning are surrounded by the worst, the biggest, the most
> desperate ratshit slums in the civilized world. It seems to be the
> American way. What does this mean? What is its content?
> —Martin Amis, *Money: A Suicide Note* (1986)

In an article in the *New York Times Magazine,* Brown University
president Vartan Gregorian made the provocative, if rather randomly con-
structed, observation that: "Campuses today are Athenian city-states. . . .
Laundry, concerts, parking, catering—some days I feel like Job: 'Hit me
again!' But as Harvard's president said recently, 'Where else in America
can you get hotel, health club, career advice and 1,800 courses for $90 a
day?' " (Matthews 1993, 38). Writer Anne Matthews's comment in the
same article, that "violence on urban, suburban and rural campuses has
transformed many schools into discreetly armed camps: electronic passkeys
for dormitories, cold-steel mesh on classroom windows, computer-con-
trolled cameras in stairwells, alarm strips in toilet stalls" (38) offered an
interesting complement to Gregorian's rendering of the university as Club
Med resort. Although most campus violence is perpetrated by students (as
Matthews's examples illustrate), security measures such as those listed
above, and the ongoing debates about arming campus police, do not seem
to be aimed at crime prevention. The purpose of these measures, rather,
is to police and maintain the ever-expanding wall between campus and
community, between those who belong within the academy and those
who apparently do not.

The image of the academy as armed fortress, or as an island of privilege surrounded by "the most desperate ratshit slums in the civilized world," is one that I want to keep in mind throughout this analysis, because my purpose here is to offer a context for the debates about the crisis in higher education. In so doing, I am motivated by the belief that controversies over political correctness and multiculturalism have served a metonymic function—that they have, in fact, displaced scrutiny from issues that have much broader significance for academics and nonacademics alike and that are, therefore, much more threatening to conservative forces than the media coverage of the PC monologues leads people to believe.[1] And the PC debates have proved that theories—be they poststructuralist, feminist, Marxist, or postmodernist—do travel. I want to draw attention to the ways that, as intellectuals and academics, we have thus far contributed to the containment and isolation of our arguments.

One would think that there would be more attention to the organic nature of the crisis in higher education at a time when recent doctoral students are finding it difficult—if not impossible—to obtain employment; when college graduates in both the humanities and the sciences must resort to temporary or part-time work; and when those who do not have a college education fare even worse. One would also think, in effect, that there would be some scrutiny as to just what it is that we are educating students for. While it may seem reasonable to believe that critiques of the canon formulated during the seventies and eighties were motivated by the admirable, if utopian, impulse to redress current and historical injustices, we need to understand how it was that, during the conservative restoration, efforts to work toward democratic ideals and a democratic society were systematically evacuated of wider political and cultural significance. The legacy that we have inherited from the eighties is one characterized by decontextualization and depoliticization—a legacy engineered to cement the fragmentation of intellectual life and its continuing isolation from material concerns.

The political correctness monologues played a central role in this evacuation. In a process similar to that described by Roland Barthes, the mythification of political correctness (for which multiculturalism now functions as a synonym in popular culture) was "constituted by the loss of the historical quality of things: in it, things lose the memory that they once were made" (1972, 142)—a function most vividly illustrated by the naturalization of the Western canon. Intellectuals were by no means innocent of participation in this process; thus what is of immediate concern to this paper is our failure to restore these memories and histories and to promote understandings of the political interests guiding this amnesia.

The Crisis

A situation of nascent crisis is an opportunity to discern the hidden pre-suppositions of a traditional system and the mechanisms capable of per-petuating it when the prerequisites of its functioning are no longer com-pletely fulfilled. It is when the perfect attunement between the educational system and its chosen public begins to break down that the "preestablished harmony" which upheld the system so perfectly as to exclude all inquiry into its basis is revealed (Bourdieu 1980, 99).

In the early days of the nineties, the breakdown between the edu-cational system and its chosen public was beginning to gradually seep into public consciousness. Unemployment—often of the explicitly chronic va-riety—was increasing; more women, men, and children than at any other time in U.S. history lacked housing and health care; the government had slashed funding to state governments, causing further cutbacks in areas such as social services and education; and the U.S. was generally repre-senting itself as unable to compete in the international marketplace. As Ira Shor has put it, "Blaming poor education and allegedly undereducated workers for unemployment and the economic crisis are old themes" (1986, 233). In response to the recession, conservatives resorted to a traditional rhetoric of competition and impotence: if workers could not find em-ployment, this failure was not due to any structural deficiencies or ine-qualities—it resulted from educational shortcomings on the part of workers themselves. While these shortcomings have been attributed to "bad" teachers, they are seldom, if ever, linked to structural problems within the institution of education.

If standardized testing (both for students and teachers) was proposed as a partial solution to the crisis of "undereducation" at the levels of primary and secondary education, the crisis in higher education demanded different, more novel, strategies. After all, for the post-Second World War generation, a college education was an intrinsic part of the narrative of the American Dream and its promise of class mobility. With a college education, it had long been assumed, a person could go anywhere, and even if this ideology was temporarily disrupted or resisted during the sixties, it remains a major thread in the fabric of the ever receding Amer-ican Dream. In order to explain the unemployment now confronting col-lege graduates on a massive scale, the rhetoric of crisis would have to shift somewhat.

Of the rhetorical purposes served by PC, Shor remarks, "It [the rhetoric of PC] is a communications strategy to control public perception so that the critical opposition is seen as social misfits who are ethically repulsive, intellectually shallow, and politically threatening. Through PC

campaigns, conservative spokespeople try to dominate how various dissidents are viewed in society. Conveying a negative image of social critics can isolate them from public support and put them on the defensive" (248).

Viewed as a communications strategy, it seems less than coincidental that PC entered popular vocabularies in August 1990, at virtually the same moment as the mobilization of Operation Desert Shield.[2] By pointing to this temporal conjuncture, I do not mean to imply any even or simple correlation between these two events. However, in light of the critical work on the manufacturing of consent for the Gulf War, it seems an act of incomparable naiveté to dismiss this convergence as merely coincidental.[3] As such theorists as Stuart Hall, Christopher Norris, Cynthia Enloe, Noam Chomsky, and Herbert Schiller have observed, conservatives have learned a great deal about controlling and structuring the flow of information to the media in the years since Vietnam. Tom Engelhardt has pointed out that prior to Operation Desert Shield, the Pentagon had invested a great deal of analysis in "matters of scheduling and closure—this, out of a post-Vietnam desire to create a Third-World battlefield where maximal weaponry and minimal U.S. casualties would guarantee public support" (1992, 631).

When George Bush exclaimed, "By God, we've kicked the Vietnam syndrome once and for all," he explicitly referred to the belief that the U.S. military had been restrained from exerting the full strength of its righteous military powers in Vietnam. But "kicking the Vietnam syndrome" not only entailed the media's acquiescence to the official Pentagon version of the war, it further required the management of opposition within the U.S. If "the timing of the campaign to discredit 'political correctness' coincides with that other media event calculated to wipe out the sixties and to 'kick the Vietnam syndrome': the Gulf War" (1992, 77), as Ruth Perry claims, it also was timed to manage potential resistance to U.S. military action in the Persian Gulf. While much has been written about the role that collective memories of the Vietnam War played in consolidating public support for Operations Desert Shield and Desert Storm,[4] there is another specter that haunts these narratives: the powerful presence of massive antiwar protests organized on campuses throughout the United States during the sixties and early seventies.

In short, if conservatives were to avoid repeating the Vietnam syndrome, they faced two related tasks: controlling the media and silencing or discrediting oppositional forces that might question the hegemonic media line on the conflict. During a period of economic recession and uncertainty, it seemed that whatever opposition to be mobilized might emerge most forcefully from within the academy, since in addition to the

history of campus antiwar and peace protests, students and professors could devote more time and energy to planning and organizing such demonstrations. By representing leftists in the academy as elements comprising a speech-chilling, Stalinist monolith—intent on promoting a single, undemocratic party line—conservative forces effectively closed dissenting mouths before they could speak. For those who have followed the PC monologues closely, one accusation runs through the convoluted logic of conservative arguments: radical forces in the academy are inherently undemocratic and solidly opposed to Western (read "American") values. In effect, radical intellectuals were set up as paradigms of ungrateful, unpatriotic behavior—a sin made more salient and reprehensible in the context of the call to arms then under way. Ironically, less than one month before the overt censorship and speech-chilling that accompanied the Gulf War, Newsweek's cover on the academic "Thought Police" asked: "Is this the new enlightenment—or the new McCarthyism?"

I do not think that many of us took these initial attacks on the university and its curriculum seriously enough or made any connection between Operation Desert Shield and the PC monologues in August 1990. First of all, there was a certain ludicrous air to the monologues: we knew that the left, as it existed within the academy, could barely agree on what to have for dinner, much less on the direction and shape of socialism for the nineties. In other words, claims that the academic left was developing an oppressive hegemonic bloc seemed much more like a defensive projection on the part of those who actually constitute the dominant, oppressive bloc. Second, it was difficult to foresee the manner in which our arguments and theories could be so easily and powerfully subsumed beneath an anti-intellectual, antidemocratic war machine that staged the controversy as yet further evidence of intellectual solipsism—if not autoeroticism—in the humanities.

Indeed, the PC monologues worked with and through existing commonsense attitudes toward intellectuals and intellectual activity. In lieu of any political and historical context, the PC monologues guaranteed that only the most remote and decontextualized aspects of the controversies would be presented to support the conservative case. The coverage was pastichelike in its focus on isolated paper titles and incidents, presented to readers with virtually no reference to the internecine debates and struggles that framed them. Scholarly work on race, gender, and class was routinely presented in the most insipid and distantiated terms, with the net result of making critical work on capitalism, racism, homophobia, and sexism look ridiculous.

George Will, for example, strung together this litany of literary critical absurdities: "Jane Austen's supposed serenity masks boiling fury

about male domination, expressed in the nastiness of minor characters who are 'really' not minor. In *Wuthering Heights,* Emily Brontë, a subtle subversive, has Catherine bitten by a *male* bulldog. Melville's white whale? Probably a penis. Grab a harpoon!" (1991b, 72). Two weeks later, Will further disarticulated the controversies from the political and economic climate, recounting the saga of a University of California administrator who "wants to stamp out such familiar phrases as 'a chink in his armor' or 'a nip in the air' (get it? 'chink' and 'nip' can be offensive in other contexts)" (1991a, 72). Not only did such statements reduce efforts to confront racist language and behavior in the academy to the level of the inane, they also functioned to remove debate from an analysis of education in crisis to a monologue about the silly and depoliticized nature of intellectual work. For instance, Paul Weyrich, one of the premier New Right ideologues, cited a list of such depoliticized concerns, one of which is the fact that "Students at Brown University are now banned from throwing parties with an ethnic theme after a student complained that one fraternity's 'South of the Border' party was offensive to Mexicans" (1991, 44).[5]

Despite the fact that the academic left was making the New Right more than a little nervous, the representation of the PC monologues in the media not only increased antagonisms between campuses and communities, but reinforced an anti-intellectualism that has a long history in the United States. One of the most alarming examples of this, particularly for feminists, has been the popular appeal of Camille Paglia, whose dubious charm seems to result from a combination of *épater les bourgeois* and intellectual disdain. "Who occupies faculty positions in the Ivy Leagues?" Paglia asks. Her answer: "Lily-livered, trash talking foreign junk-bond dealers. Noses in the dictionary" (1991b, 35).

While many dismissed Paglia as a fast-talking, opportunistic anomaly, her unprecedented rise to fame suggests that she had successfully tapped into a reservoir of resentment against intellectuals. Accusations like "The campus is now not an arena of ideas but a nursery-school where adulthood can be indefinitely postponed" (1992, 19) sent a highly specific message to readers. For people making enormous sacrifices to send their children to college, for taxpayers who vote on spending for education, the message that such statements send is clear: you're wasting your money on something that's trivial and irrelevant. These "tenured radicals" are not educating your children: they are brainwashing them. "Real" education, in contrast, must be intrinsically apolitical and value-free.

The ideological uses to which Paglia's diatribes were put further reinforced stereotypes of intellectual privilege and self-aggrandizement. As Teresa Ebert observed, "Paglia's popularity is a warning to feminists, especially the academic variety, who have become somewhat smug and

insular in their preoccupation with the internecine debates among femi-
nists" (1991, 13). Like Ebert, I do not want to dismiss the PC monologues
as a mere backlash phenomenon. The reasons why the PC monologues
won hearts and minds on both the right and the left merit more consid-
eration. For example, in the midst of her weirdly maniacal tirades about
academicians, Paglia often came dangerously close to revealing certain
truths about the nature of class-stratified education in the U.S. The "big
scam," she says, "is that these people are vicious, these people at the top.
They are people who have enormous salaries, I'm talking about Johns
Hopkins and Yale, they have, like, hundred-thousand-dollar salaries; the
only people they ever see in their classes are the products of prep schools.
They have no idea how removed from reality their ideas, their plan for
the future, is for the poor" (1991a, 102).

Paglia's vitriolic attacks on antiporn feminists and their alliances with
"the reactionary, antiporn far right" (1991c, 36) also contain more than
a kernel of accuracy. For many feminists (whose voices were seldom heard
during the monologues), Andrea Dworkin and Catherine MacKinnon's
claim that pornography causes violence against women was ludicrous in
the extreme. Their efforts to introduce antiporn legislation located the
problem as a matter of images, and dubious causal connections were all
too predictably removed from a material realm where restraining orders
against violent spouses or lovers are often difficult to obtain and only
haphazardly enforced.

I imagine that some would claim that the eighties' emphasis on the
discursive construction of reality was our downfall. Many intellectuals lip-
synched, along with French postmodernist social theorists such as Laclau
and Mouffe, the belief that the "real" was only a by-product of "discourse."
Baudrillard, as usual, took this one step further, claiming that the Gulf
War had never happened. In an indirect if ideologically consistent ren-
dering of this, PC monologists such as Dinesh D'Souza, Robert Kimball,
and Camille Paglia asserted that our goal consisted of nothing more (or
less) than "politically correct" language: if people could just learn to say
the right thing, doing the right thing would fall into place. Thus, in their
dependence on the divide between abstract arguments and material real-
ities, the PC monologues also worked to reinforce the distance between
intellectuals and society. In a culture where intellectual work seems to
exist outside the category of labor, the arguments presented as evidence
of PC behavior could very well appear to be silly—if, as John Clarke
remarks, "the rest of the world took it seriously" (1991, 27). Indeed, it
seems unlikely that people confronting chronic unemployment and ever
increasing rollbacks in welfare spending would find any sustenance in the
belief that shifts in discourse would effect shifts in material reality.

As Gramsci observed some sixty years ago about another crisis in education—education always appearing as scapegoat during times of economic flux—"Many people have to be persuaded that studying too is a job, and a very tiring one, with its own particular apprenticeship" (1989, 42). Although, as academics, we may understand that our work involves labor, from outside the academy—for those whose lives are ruled by time clocks and rigidly established "vacation" time—our routines appear to be much more flexible and leisurely (which, to a certain extent, they are). And within the economic context of the eighties and nineties, where skyrocketing tuitions have made university educations a luxury that increasingly few can afford, what better way to reify commonsense attitudes toward intellectuals (as cloistered, privileged ninnies, whose ineffectual attempts at authoritarianism render them only more ridiculous) than to so thoroughly trivialize and discredit their work? Add to this the perception that, in an age of technoscientific education, work in the humanities is tacitly understood to be a vestigial appendage to the corporate machinery that drives the sciences. Really, what do you need to be able to write for, or think critically for, when your job is going to consist of punching keys on a computer?[6]

The popular representation of the conflict in the university as a series of skirmishes over textuality or language solidified the belief that intellectuals had at last managed to wall themselves off from the dirty provinces of material reality. The monologues consequently coalesced around the defense of what Pierre Bourdieu has called "legitimate culture"—the training in which is "characterized by the suspension and removal of economic necessity and by subjective distance from practical urgencies, which is the basis of objective and subjective distance from groups subjected to those determinisms" (1980, 251). This focus engendered two distinct trajectories of derision and ridicule. For those equipped with the cultural capital to decipher the many literary and philosophical references, the "aesthetic disposition" ensured that those who violated the illusion of "neutralizing distance" (Bourdieu 1980, 251) would be dismissed as crazed ideologues. For those who lacked the cultural capital to interpret such allusions, those who do not possess "a generalized capacity to neutralize ordinary urgencies and to bracket off practical ends," the PC monologues served both to alienate (in the sense that the partially understood province of intellectual authority appears mystified and abstruse) as well as to legitimate the belief in "proper" forms of intellectual authority. In this way the controversies came to typify the curious contradictions of American anti-intellectualism, which at the same moment reveres and resents expertise of all kinds.

Gramsci commented that, "The starting-point of critical elaboration is the consciousness of what one really is, and is 'knowing thyself' as a

product of the historical process to date which has deposited in you an infinity of traces, without leaving an inventory" (1989, 324). In effect, our response to the PC monologues was a symptom of our lack of both self- and historical consciousness. We defended our territory vigorously, but it was—in the final analysis—only our territory that was at stake. Ironically enough, we defended the canon and legitimate culture in an insular fashion, ceding the ground of political debate for one of professional (and professorial) debate: the professional *was* the political. The central response to the monologues was one of countercanonization rather than the politically interested nature of canon formation in general. And, in the midst of this defensive posturing, few of us (if any), considered what the view of the monologues would be from outside the institution. Transformed into a "search for euphemisms [that] has become the great challenge of American university life" (Adler 1990, 54), the monologues appeared utterly meaningless to those who live and labor outside the academy, except insofar as they fuelled anti-intellectual sentiments.

Of course, there is no denying that few progressive intellectuals have access to the media to the extent that conservatives do. Nevertheless, to use this imbalance as an excuse for our lack of critical and conjunctural analysis seems an especially academic mode of disavowal. Our willed ignorance of the larger context for the PC monologues and ancillary debates over education implies a much more pernicious problem. While my argument has thus far relied on the perhaps desperate (if necessary) fiction of some progressive "we," it would be disingenuous to deny that academic life does not promote isolationist tendencies. How many academics have learned to think outside the boundaries of their own discipline, much less outside the boundaries of the academy? And as long as our classrooms, offices, and homes overlook the quad or the green rather than concrete playgrounds and decaying urban landscapes, it is far too easy (not to mention a great deal less unpleasant) to imagine that such spaces don't exist.

It may be that the PC monologues succeeded in diverting attention from a number of urgent economic issues (that have—or in the near future will have—dire consequences for higher education) because intellectuals simply didn't care enough about what goes on outside the parameters of their existence, or because we cared too much about the wrong things. Conservatives, for example, posed the conflict as one of a crisis in democracy: as an attack on the pluralistic notion of the mythic melting pot. We essentially capitulated to the terms of an argument that posed democracy only as a matter of equal access to discursive space. Perhaps it is true that certain conservative voices in university settings were being, if not silenced, then excluded from conversations. But questions as to the material exclusion of people from such dialogues—questions as to who has

access to these conversations by virtue of economic and/or cultural capital in the first place—was never posed. "Politics" (as in the currently fashionable image of the multicultural university) was isolated from "economics," and the conflict was duly transformed into struggles over language, now safely removed from larger political and economic battles.

Reading the monologues in terms of popular culture, it appeared that the politics of knowledge had absolutely no connection with disparities of wealth. In place of a direct confrontation with the Marxist concept of "the economics of untruth," we substituted what Michèle Barrett has approvingly described as "the politics of truth" (1991, 140). The fact that so many people are being systematically excluded from educational possibilities—and excluded on the basis of race and class—at the level of primary and secondary education never entered the PC picture. Jonathan Kozol has said that in terms of its public educational system, the U.S. "is at least two nations, quite methodically divided, with a fair amount of liberty for some, no liberty that justifies the word for many others, and justice—in the sense of playing on a nearly even field—only for the kids whose parents can afford to purchase it" (1991, 212). Given the routine exclusion of children from decent public education, and ever dwindling access to higher education, that we should defend the "democratic mission" of the university was not merely an ineffectual defense: it was a hypocrisy of the first order.

The Hill

Open-handed map
Awarding the world its world. And yet, for these
Children, these windows, not this world, are world,
Where all their future's painted with a fog,
A narrow street sealed in with a lead sky,
Far far from rivers, capes, and stars of words.
(Spender, 1939)

Class is for European democracies or something else—it isn't for the United States of America. We are not going to be divided by class.
George Bush, in Navarro, 1991, 1

In Providence, Rhode Island, two high schools stand side by side. Despite their proximity, the boundaries between Classical High School and Central High School are stringently maintained. From the names of the schools, it does not take much effort to deduce which one is the magnet school (which requires entrance exams) and which school is attended

primarily by students of color. For Classical students, senior year is a flurry of college applications, SATs, and excitement. For students at Central, where the dropout rate is 39.3 percent as opposed to Classical's 3.2 percent, if they make it to senior year, it is doubtful that any but the most motivated of students (whose backgrounds are no doubt exceptional in some way) will go on to college.[7]

While professors, graduate students, and undergraduates at Brown University (and elsewhere) were enraged enough to form reading groups and debate political correctness, secondary educators at Central dealt with more immediate problems. Multiculturalism is a dream on the part of some faculty there, and with no funding for new textbooks and only an old, erratic ditto-machine for copying, it seems likely that it will remain a remote possibility. One English teacher at Central told me that, as a first-year teacher, she was trying to understand the students' lack of response when she wrote on the blackboard. One day, it occurred to her to ask how many students could actually *see* the board. As it turned out, many students could not.

From this perspective, the controversies over political correctness and multiculturalism in the university seem insignificant indeed. In far too many respects, battles over educational democracy are being fought and lost at the level of public education. Kozol's *Savage Inequalities* cogently points out that the effects of the conservative restoration have been experienced most severely in the realm of primary and secondary education, where "social policy has been turned back almost one hundred years" (1991, 4) and that in no school that he saw anywhere in the United States "were nonwhite children in any large numbers truly intermingled with white children" (3).

In light of the segregated nature of public education, it seems bizarre that so many private universities are marketing themselves on the basis of their "diversity." As Hazel Carby has remarked, "Departments and programs in many private universities, for example, will proudly point to an 'integrated' curriculum while being unable to point to an integrated student body—except in photographs in their student handbooks" (1992, 191). Despite their marketing attempts, minority recruitment (such as still exists) has largely been from the suburban middle-classes and not from impoverished areas.[8] And given the financial situation of public schools, it seems unlikely that children from economically devastated areas and backgrounds will acquire the skills necessary to complete a baccalaureate curriculum, particularly since they are competing with students from more privileged backgrounds while funding for remedial programs at the university level has been drastically slashed.

Consequently, at the university level, we are dealing with the effects of such regressions rather than their causes. Truth be told, in most institutions of higher education, the students we confront are the end result of systematic screening, tracking, interpellation, and processing on the basis of class and race (which in this case seem more determinative than gender). But while we debated the merits of multiculturalism and an integrated student body at the level of the university, the New Right (having prepared the ground with the PC monologues) was working at a much more fundamental and potentially catastrophic level.

In April 1991, at a moment of renewed interest in PC, George Bush unveiled his "America 2000" plan, which focused on six "educational" goals to be met by the year 2000.[9] The pamphlet originally released to publicize this plan contained the following message (omitted in the revision of August 1991): "Operation Desert Storm was a triumph of American character, ability and technology—a victory for America and all it stands for. It helped show that our nation can do whatever it decides to do—and that our people can learn anything they need to learn" (April 1991, 5). Perhaps the most terrifying aspect of the plan is its deregulatory spirit: less government intervention in public schools, it repeatedly insists, but an enormous increase in corporate involvement. "The Business Community" the pamphlet asserts, "is also vital. It will jump start the Design Teams that will design the New American Schools ... perhaps most important, [it] will provide people and resources to help catalyze needed change in local schools, communities and state resources" (August 1991, 27).

Along with emphatic statements about standardized testing, America 2000 endorsed the concept of "choice" in public education. "Choice" also formed the framework for the plan's "populist crusade," handily defined in the "Glossary of Key Terms" as: "A national crusade led by the president—school by school, neighborhood by neighborhood, community by community—to transform American education and to spur fundamental changes in the ways we educate ourselves and our children. It also will be a restoration of what we think is important, a homecoming in sound values and community attitudes" (April 1991, 27). As Fredric Jameson has remarked, "The negative symptom of populism is very precisely the hatred and loathing of intellectuals as such (or today, of the academy that has seemed to become synonymous with them)" (1993, 40–1). As a communications strategy, the PC monologues certainly sanctioned populism and anti-intellectualism in the interests of further rollbacks in educational spending, as the references to individual communities and corporate funding made clear. The appeals to "restoration" and "sound values" further implied that a central obstacle to educating people properly lay in the

attitudes and values espoused by educators themselves—a groundwork that had been steadily developed by the PC monologues.

What ultimately guaranteed the success of this conservative position was the lack of interest academic intellectuals expressed in democracy outside the institution, as well as an associated inability to formulate broader coalitions with progressive educators.[10] The hullabaloo in the universities, in other words, concealed the increasingly antidemocratic nature of United States education. While we were debating the fallacies of PC, extolling the virtues of multiculturalism, and defending our intellectual territories, the New Right has been working effectively at the level of primary and secondary education, through national legislation and local school board elections.[11] While we defend our theory and practice from accusations of undemocratic principles, democracy is being undermined at the ground floor. How many university professors realize that African-American students are three times as likely to be tracked into special education classes as white students, while they are only half as likely to be placed in "gifted and talented" programs (if in fact these programs are funded in their school systems)? What, in short, does it mean if students confront multiculturalism through texts or images when seldom in their lives, from day care through high school, do they ever look around a classroom and see any type of heterogeneity? What does it mean to discuss "difference" and the "othering" effects of Western culture, when the "other" is once again being systematically excluded from such conversations?

At the University of Illinois' conference on the crisis in higher education, one of the participants made the claim that, from the medieval ages onward, the university has performed an elitist function in societies and that, moreover, was the role that it should continue to carry out. The content of this comment made many intellectuals in the audience apoplectic, largely because it expressed a bitter truth—that the university is based on exclusions and exclusionary practices—that few liberal educators seem willing to confront. Our defensiveness around this issue further suggests that while the terms of the PC monologues may have been set by the New Right, we tacitly accepted both the terms and the terrain. Rather than drawing attention to the fact that education—be it primary, secondary, or tertiary—is fundamentally antidemocratic, we defended the illusion that our work occurs in a setting emblematic of democratic values.

Despite postmodernist assertions to the contrary, the boundaries that separate and divide are neither as pliant nor as permeable as many imagine. As the walls continue to rise between campuses and communities, we need to acknowledge these fortifications, and develop strategies for challenging them. This first demands that we possess a more structural and less frag-

mented conceptualization of political interests. Internecine debates about which form of oppression is greater than another ultimately overshadow the structures that continue to reproduce such inequities. Thus, we have to demand answers to questions as to whose interests it serves to claim that, for example, homophobia is the single, most virulent form of oppression. What, we must ask, is the purpose of such rankings and conflations on behalf of certain groups, if not to consolidate narrow political interests and narrow demands for equal rights? How can we continue to demand equal rights on behalf of certain groups while ignoring or diminishing the claims of others?

We further need to think carefully, rigorously, and above all honestly about our position and function within the hierarchical structure of U.S. education. We must understand how and why disadvantaged students are being taught consumerism by Chris Whittle's Channel One (who is himself sponsored by Time Warner Inc. and Philips Electronics), preparing them for a life of impossible and frustrated commodity fetishism, before we make claims about the liberating potential of knowledge. In addition, we need to be able to forge connections with progressive educators at other levels of education and outside the academy in order to understand the legacies that we are inheriting, as well as to think collaboratively about strategies for combatting them.[12] Of course, the efforts necessary for such a broad-based assault hinge on intellectuals' commitment to educational democracy. It might well be argued that many academics care very little about the "desperate ratshit slums" that surround their enclaves—except when slums begin to encroach on their own territory, and then, far too frequently, they care only in reactionary ways. But at a time when many college graduates' first experience of postgrad employment is "temping" (or piecework for the educated), where graduate school in the humanities offers only an elaborate debt structure and all the allure of chronic unemployment, it may very well be that the contradictions inherent in an often self-serving academic liberalism will become too obvious to ignore or dismiss.

Like Bourdieu, I maintain a belief in the liberatory potential of education, although it may very well be true that "only a school system serving another system of external functions and, correlatively, another state of the balance of power between the classes, could make such [liberatory] pedagogic action possible" (Bourdieu and Passeron 1977, 127). However, if, as Cornel West puts it, this is "a situation that can change in the near future depending in part on what some intellectuals do" (1991, 35), it is going to require fundamental shifts in our intellectual paradigms and practices.

NOTES

1. The term "PC debates" is indicative of the very elision of inequities of power that I will return to during the course of this paper. At no point in the media coverage did anyone "debate" political correctness. Rather, the coverage was used to stage the New Right's monologic tirade against progressive education. Claiming that academic leftists were shutting down some mythic dialogue about democratic values, the New Right put intellectuals on the defensive by implying that the discursive ball was in our court. The illusion that dialogue with the New Right was possible, and desirable, further ensured that dissident responses to the controversy could only be framed defensively and within the debilitating and depoliticized terms established by conservatives. In addition, the burden of creating a space for dialogue has been placed traditionally on the shoulders of the disempowered: the claim having been made, as in the PC monologues, that the powerless were the very people who possessed the power to silence. Dialogues within leftist circles, which might have more strategically shifted the debates, were subsumed beneath the desire to effect a dialogue with the New Right in our defense. Subsequently, we gave up any possibility of an offensive, frontal assault on New Right politics in the interests of politeness.

2. This is not to say that there had been no references to PC before this date. The point is, nonetheless, that the controversy really gained massive publicity with the publication of an article in the *New York Times,* entitled "The Rising Hegemony of the Politically Correct."

3. It is worth noting here that the National Association of Scholars (NAS) was established not in response to the PC monologues, but in the mid-eighties. The NAS is privately funded by the Olin Foundation, whose president is William Simon (Richard Nixon's Treasury Secretary) and the Scaife Foundation, whose president is Richard Mellon Scaife, a close friend of Joseph Coors. Scaife and Coors, incidentally, provided funding for the Heritage Foundation. For further information on the origins of these organizations and ultra-right-wing connections, see the *Columbia Journalism Review* (July-August 1981) and Russ Bellant's *The Coors Connection: How Coors Family Philanthropy Undermines Democratic Pluralism* (Boston: South End Press, 1988).

4. See *Triumph of the Image: The Media's War in the Persian Gulf—a Global Perspective,* eds. Hamid Mowlana, George Gerbner, and Herbert I. Schiller (Boulder, CO: Westview Press, 1992); *Collateral Damage,* ed. Cynthia Peters (Boston: South End Press, 1992); and *Cultural Critique,* Fall 1991.

5. While the partiality of such accounts may appear self-evident to intellectuals, such partiality was nowhere in evidence in the media. For example, at the very moment in which Weyrich was writing, frat boys at Brown University had also been accused of videotaping sexual encounters with women (unbeknownst to them) and screening these tapes for the entertainment of brothers. Of course, the videotapes were never located, the administration having warned the fraternity early one morning that they were coming to make a search later that day.

6. At a time when "knowledge" is being quite explicitly linked to the production of surplus value, work within the humanities is going to take on more

and more the appearance of luxury items. Those of us who continue to believe in the liberatory potential of the humanities are going to have to take this grim fact into mind when constructing strategies for opposing the ongoing cuts in liberal arts programs.

7. Statistics are compiled by districts: the overall dropout rate in this particular district is 31.9 percent.

8. Recent media attention to the class backgrounds of minority candidates has fanned the predominantly anti-affirmative-action climate. Appealing to the frustrations of people of color and white people who cannot afford to send their children to college, a recent article in the *New York Times* described in excruciating detail the economic status of several candidates who were being courted at privileged institutions such as Harvard and Yale.

9. During Operation Desert Storm, coverage of PC dwindled to a smattering of articles, but in April and May 1991, as the ground war lurched toward its grim conclusion, PC once again consumed the pages of magazines and journals.

10. Lest we believe that the Clinton administration offers solutions to the crisis, the Clinton/Gore Plan contains similar proposals. In fact, its goals are virtually identical to those set forth in America 2000: "Prepare every child for school, establish tough standards, reform our schools, make our schools safe again, give every American the chance to get ahead" (1992). And, like Bush, a crucial aspect of his agenda is to "Help states develop public choice programs like Arkansas'."

11. See Donna Minkowitz's "The Religious Right Hits N.Y.C.: Wrong Side of the Rainbow" in *The Nation* (June 28, 1993) for an analysis of the tactics used by the New Right in opposing the "Children of the Rainbow" curriculum. Another example of New Right tactical shifts appears in the concept of "stealth" candidates running in local elections. These are candidates whose religious fundamentalism and reactionary conservatism is masked or concealed during their campaigns. Efforts are currently being organized in local communities to "out" these candidates at public forums or media events, generally by posing questions involving "family" values, lesbian and gay rights, educational policies, and issues that would force their ideological hand.

12. Groups like Teachers for a Democratic Culture seem ill-equipped to engage in this sort of work. First of all, there is little commitment to including primary and secondary educators in the organization. Secondly, TDC is primarily concerned with professional issues that leave scant room for the types of contextualizations for which I am arguing.

WORKS CITED

Adler, Jerry. 1990. "Taking Offense: Is This the New Enlightenment on Campus or the New McCarthyism?" *Newsweek* December 24, pp. 48–54.

America 2000. 1991. Washington, D.C.: U.S. Department of Education, April.

America 2000. 1991. Washington, D.C.: U.S. Department of Education, August.

Amis, Martin. 1986. *Money: A Suicide Note.* New York: Viking Penguin.

Barrett, Michèle. 1991. *The Politics of Truth: From Marx to Foucault.* Stanford: Stanford University Press.

Barthes, Roland. 1972. *Mythologies,* trans. Annette Lavers. New York: The Noonday Press.

Baudrillard, Jean. 1991. "The Reality Gulf." *The Guardian.* 11 January 1991.

Bernstein, Richard. 1990. "The Rising Hegemony of the Politically Correct." *New York Times.* October 28, p. 1.

Bérubé, Michael. 1992. "Public Image Limited: Political Correctness and the Media's Big Lie." *Debating P.C.,* ed. Paul Berman. New York: Dell Publishing, pp. 124–149.

Bourdieu, Pierre. 1980. "The Aristocracy of Culture." *Media, Culture and Society* 2, pp. 225–254.

———. 1984. *Distinction: A Social Critique of the Judgement of Taste,* trans. Richard Nice. Cambridge, MA: Harvard University Press.

——— and Jean-Claude Passeron. 1977. *Reproduction in Education, Society and Culture.* London: Sage Publications.

Carby, Hazel. 1992. "The Multicultural Wars." *Black Popular Culture,* ed. Gina Dent. Seattle: Bay Press, pp. 187–199.

Clarke, John. 1991. *New Times and Old Enemies: Essays on Cultural Studies and America.* London: HarperCollins Academic.

"Clinton/Gore on Education." 1992. Little Rock, Arkansas: Clinton/Gore 92 Committee.

D'Souza, Dinesh. 1991. *Illiberal Education: The Politics of Race and Sex on Campus.* New York: The Free Press.

——— and Robert MacNeil. 1992. "The Big Chill? Interview with Dinesh D'Souza." *Debating P.C.,* ed. Paul Berman. New York: Dell Publishing, pp. 29–39.

Ebert, Teresa L. 1991. "The Politics of the Outrageous." *The Women's Review of Books.* vol. IX, No. 1, October, pp. 12–13.

Engelhardt, Tom. 1992. "Pentagon-Media Presents: The Gulf War as Total Television." *The Nation,* 254(18), 11 May, p. 630–631.

Gramsci, Antonio. 1989. *Selections from the Prison Notebooks,* trans. Quintin Hoare and Geoffrey Nowell Smith. New York: International Publishers.

Gup, Ted. 1992. "What Makes This School Work?" *Time,* 140(25), December 21, pp. 63–65.

Hunter, James Davison. 1991. *Culture Wars: The Struggle to Define America.* New York: Basic Books.

Jameson, Fredric. 1993. "On 'Cultural Studies.' " *Social Text* 34, pp. 17–52.

Kellner, Douglas. 1992. *The Persian Gulf TV War.* Boulder, CO: Westview Press.

Kozol, Jonathan. 1991. *Savage Inequalities: Children in America's Schools.* New York: Harper Perennial.

Matthews, Anne. 1993. "The Campus Crime Wave: The Ivory Tower Becomes an Armed Camp." *New York Times Magazine.* March 7, pp. 38–42, 47.

Mowlana, Hamid, George Gerbner, and Herbert I. Schiller, eds. 1992. *Triumph of the Image: The Media's War in the Persian Gulf—a Global Perspective.* Boulder, CO: Westview Press.

Navarro, Vicente. 1991. "Class and Race: Life and Death Situations." *Monthly Review.* 43(4), September, pp. 1–13.

Noble, Douglas D. 1992. "Schools as 'Instructional Delivery Systems.' " *In These Times*. November 30, pp. 28–29.

Paglia, Camille. 1991a. "Antihero." *Spin Magazine*. Interview with Celia Farber. September, pp. 88–105.

————. 1991b. "Ninnies, Pedants, Tyrants and Other Academics." *New York Times Book Review*. May 5, p. 1.

————. 1991c. "The Return of Carry Nation." *Playboy Magazine*. December, pp. 36–38.

————. 1992. "The Nursery-School Campus: The Corrupting of the Humanities in the US." *Times Literary Supplement*. May 22, p. 19.

Perry, Ruth. 1992. "A Short History of the Term 'Politically Correct'." *Beyond PC: Toward a Politics of Understanding,* ed. Patricia Aufderheide. St. Paul, Minnesota: Graywolf Press, pp. 71–79.

Peters, Cynthia, ed. 1992. *Collateral Damage: The 'New World Order' At Home and Abroad*. Boston: South End Press.

Shor, Ira. 1992. *Culture Wars: School and Society in the Conservative Restoration.* Chicago: University of Chicago Press.

Smith, Page. 1991. *Killing the Spirit*. New York: Penguin Books.

Spender, Stephen. 1939. "An Elementary School Classroom in a Slum." *The Norton Introduction to Literature*. New York: W.W. Norton, 1973.

Squires, Gregory D. 1992. " 'Economic Development' is Killing Education." *In These Times*. December 28, pp. 28–29.

West, Cornel. 1991. "Theory, Pragmatism, and Politics." *Consequences of Theory,* ed. Jonathan Arac and Barbara Johnson. Baltimore: Johns Hopkins University Press, pp. 22–38.

Weyrich, Paul. 1991. "Politically Correct Fascism On Our Campuses." *New Dimensions*. June, p. 44.

Will, George. 1991a. "Curdled Politics on Campus." *Newsweek*. May 6, p. 72.

————. 1991b. "Literary Politics." *Newsweek*. April 22, p. 72.

The University and the Media:
Apologia Pro Vita Sua *with a Defense of Rationality*

BARRY R. GROSS

We must accept that much is wrong before we can even begin to think how to set it right. In his essay, Professor Lauter paints an accurately bleak picture, as have many others. But to my mind he does not put his finger on the causal factors that have made things the way they now are, nor does he discover where the fault lies, if there is fault. So I think the debate could use a bit of sharpening. I don't intend to be abusive or even abrasive myself. But do let's give two cheers for sharp talk and a bit of polite name-calling. The *Times Literary Supplement,* Parliament and *The Times* of London are all a bit more interesting than their American counterparts, in part because they will call a spade a spade or, occasionally, a trowel.

The university in America today is in a deep crisis of its own making. For the purposes of this paper I shall assume without much argument that there are real dangers to academic freedom and free speech from the politicization of the campus. For those inclined to doubt, I cite a few instances of what has come to be called political correctness. Other problems will also be mentioned. I blunt the criticism that the same instances of PC are constantly recycled by citing ones that have not, to my knowledge, appeared frequently, say, in D' Souza's book.

The first PC item is a rather delicious irony of juxtaposition. In the *Chronicle of Higher Education* (September 11, 1991) there appeared two boxed stories on the same page. One was an announcement of a conference at Ann Arbor entitled "The P.C. Frame-Up." The other was the story of a second cancellation of a talk to have been given by Linda Chavez, this

time at Arizona State. It seems some students awoke to the fact that Chavez's "stand on the issue of bilingualism and the state is so controversial among minority students. 'The minority coalition has requested that we cancel the engagement and bring other speakers whose views are more in line with their politics. . . .' "

The second instance of PC is to be found in something called *The Anti-Bias Curriculum,* published by the National Association For The Education of Young Children (*NR* August 19 & 26, 1991). Teachers are there advised to teach and to explain to young children that witches are not really evil hags but actually good women—mostly homeopaths. A third instance is Congress's attempt to regulate medical drug trials to require that for each trial there be separate cohorts of white males, white females, black males, black females, Hispanic males, Hispanic females, and so on (Wittes 1993; *Chronicle* April 7, 1993).

Consider next the bizarre attempt at defending Martin Luther King's plagiarism on his Ph.D. thesis by citing his oral African heritage, a tradition supposed to exculpate him from blame because those brought up in it are thought not to take the written word seriously (*CHE* January 20, February 10, 1993). See also the extraordinary defense of feminist philosophy in the letters to *The Proceedings and Address of the APA* (January 1993) citing the rationality, meaningfulness, and depth of commitment of that philosophical view, words never, to my knowledge, thought to have been required in the defense of any other philosophical doctrine. And there is lots more, not cited by D'Souza, like the very lukewarm response of N.E.H. Chairman, Sheldon Hackney, to the theft by black students of one *entire* run, fourteen thousand copies, of the University of Pennsylvania student newspaper, the *Daily Pennsylvanian,* because they disliked some of its contents (Hentoff 1993). I spare the reader further evidence of such shenanigans.

Like Cardinal Newman, who famously converted to Catholicism, I, too, have had a bit of a conversion, though not a religious one—hence my usurpation of his title for my paper. Like Newman, I rather approved of the idea of an insulated, ivory-tower university, and I did my best to believe universities had been and could still be so. Of course, if universities had ever been like that, the rise since the Second World War of the multiversity, so beloved of Clark Kerr, certainly put an end to it. Increased government funding at federal and state levels and the push to vocational courses ensured that the doors would be open to people who mistook further education for higher education. That open door included not only students but faculty, administrators, and government regulators. What we have ended up with are largely vocational parking lots where little learning is done and that little generally subordinated to other ends. So we should

not wonder that, when they see just how little learning our graduates have, both the public and politicians are put off spending money on us.

To what, if not Catholicism, have I converted? Well, I thought I would join the crowd and try to prise open the doors of the university too; but I want to prise them open just a teeny bit further than most others. So my task is to explain why some academics, including very much myself, are going well out of our way to attract the media in order to alert the public to just what goes on in our postsecondary institutions these days.

Here I must discharge an obligation demanded of me by the editors to say briefly why I joined the National Association of Scholars. Simply put, that reason is that the NAS was and remains the only organized attempt both to uphold academic freedom and freedom of speech while also making a principled case for standards, especially standards of evidence, argument, and general rationality.

I am not by nature a joiner. Hobbesian individualism is much more my taste. I preferred not to be identified with the decisions and actions of others. But in the early 1980s it became clear to me that universities in America were fast going downhill, and losing what small *raison d'être* remained to them. I had written and spoken out to no avail, as had prominent academics like Edward Levi of the University of Chicago and Sidney Hook, who founded an organization—University Centers for Rational Alternatives. It became clear that Hobbes was even more prescient than I thought, and some sort of surrender of individual sovereignty was going to be necessary. But the collectivity one joined had to combine the potential for significant strength with the integrity and the stomach to organize carefully and then to fight the necessary battles on principled ground. Both the AAUP and the ACLU remain very strong on speech issues, but they waffle unacceptably on standards and preferential treatment.

When the NAS came on the scene it made a creditable argument, and it was new. That meant it offered an opportunity to help shape it. And from the beginning it was broadly ecumenical, as shown by many of its prominent members (*CHE* May 7, 1993). It requires no doctrinal purity nor any litmus tests. It had only a commitment to freedom of expression, rationality, and evidence. Such issues transcend mere politics, as the case of a man like Nat Hentoff, though not himself a member, confirms. So a two-time Carter and one-time Dinkins voter, who chaired a curriculum committee that mandated a new and rigorous multicultural requirement for his college, which he helped design, and who sat on a presidential search committee that brought a black female president to his college—

though not because she was either black or female—was welcome not only to join NAS, but also to play a prominent role in the organization.

In this paper I defend a narrow piece of ground, but, like Agincourt, it is an important piece of narrow ground, so I accept that the educational system is going to hell in a handcart, pushed there both by gleeful PCers and others. The question I raise is this: If one thought things rather dreadful in a particular way in universities, what course of action should one take? This is a partly prudential question, but also a broadly philosophical one. Naturally, I have a course of action in mind, and will outline my reasoning after canvassing alternatives, and, if you think my claims about the current state of education doubtful, well, that's another paper. Suppose yourself in the following situation. For fifteen years or so you have watched, with growing unease, the schools and universities in America becoming less and less rigorously intellectual and more and more political, vocational, and anti-intellectual than even they were documented to have been in the past by two distinguished historians of intellectual life—Richard Hofstadter and Diane Ravitch. It is really worth reading or rereading Ravitch's *The Great School Wars,* and Hofstadter's magisterial *Anti-Intellectualism In American Life.*

Suppose, further, that you come to see the forces pushing the schools and universities in such directions now issuing from a rather different direction. Formerly these vectors might have been outside politicians, enraged alumni, the increased vocationalism once hailed by Clark Kerr as the triumph of the multiversity, and the general anti-intellectualism of America. But suppose now that you come to see these new forces which cut the heart out of the university actually originate within the schools and universities themselves?—perhaps pushed by some faculty idealistically desiring to use the university for noble political ends, others whoring after fashion or power, or both, some students whose conceptions of the intellectual or the aesthetic remain ill- or uninformed, and most administrators. Far too many administrators happen by mere chance to be administering universities and have little or no understanding of, much less allegiance to, the life of the mind. That has as little influence with them as the aesthetics of canning peas. They might as easily have been KGB apparatchiks.

Finding oneself in this position, there appear to be just four options:

1) Do nothing, just lay back and enjoy—or hate—it.
2) Try to rally like-minded students, faculty, and administrators.
3) Go political and try to rally legislators.
4) Go public with the media.

Now, if one feels strongly about the life of the mind and the intellectual integrity of education, one cannot do nothing. Thus the first option is no option at all. What about the second? Rallying like-minded students, faculty, and administrators to reinvigorate the curriculum and institute more rigorous intellectual standards? But consider: Just how ethical is it, from the professional point of view, to involve students in what must, at least in part, be exercises of academic politics? How wise is it to involve students in questions of knowledge and value when, by definition, they must be ignorant of the weight and range of possible answers? Should one ask them to give up time from studies and work? If we do involve them, can we later discard them? Or will they remain shadow colleagues, out of their depth? Looking over these considerations, I cannot conclude that it is either ethical or wise to enlist students in faculty academic battles.

What about faculty, then? A surprising number of them will agree with this diagnosis of decline—in private. But if they had taken a stand in the first place the university would not now be in such deep trouble. These faculty will worry about their relations with students. They will be profoundly disturbed by Genovese's "First Law Of College Teaching: Any professor who, subject to the restraints of common sense and common decency, does not seize every opportunity to offend the sensibilities of his students is insulting and cheating them, and is no college professor at all" (Genovese 1991) or by C. Vann Woodward, who wrote:

> The purpose of the university is not to make its members feel secure, content, or good about themselves, but to provide a forum for the new, the provocative, the disturbing, the unorthodox, even the shocking—all of which can be profoundly offensive to many inside as well as outside its walls.... I do not think the university is or should attempt to be a political, a philanthropist, a paternalistic, or a therapeutic institution. It is not a club or a fellowship to promote harmony and civility, important as those values are. It is a place where the unthinkable can be thought, the unmentionable can be discussed, and the unchallengeable can be challenged. (Woodward 1991)

The faculty you contact will also worry about their relations with other faculty and the administration. And the scientists have hardly been touched. They are hardly aware of Sandra Harding (1983) or Evelyn Fox Keller (1986). So you will first have to convince them that there is something amiss—no easy matter. Many faculty will be rightly concerned about their own scholarly projects and unwilling to take time out, as one very distinguished historian in New York was unwilling to do. And an Oxford philosopher with whom I am friendly said "yes, it's terrible and it's even beginning to happen here too. But really, Barry, haven't you got better things to do with your time?"

Then, too, as many careers remind us, faculty are peculiar sorts of employees. They are essentially individual entrepreneurs—a delicious irony in some cases—with all the virtues and vices of that much-maligned calling. Even were they inclined to join you, they hold views, even trivial ones, with quite astonishing tenacity, as those with experience of entrepreneurs will know. The compromises required for joint action and concerted effort sit ill with them and, even well-intentioned, they do not easily make strong allies. A well-known philosopher at a distinguished university and broadly sympathetic to the NAS told me that with him it was a Kierkegaardian imperative not to be one of a crowd, and he is an analytic philosopher!

Then, many faculty hold administrators in contempt, but *oderint, dum metuant,* said Caligula—or some Roman just as nasty: "Let them hate me so long as they fear me." And faculty are fearful, especially in times of falling enrollments and rising costs. For example, CCNY's philosophy department has fallen from approximately fifteen to eight faculty members, and my own history department from nine to three. Think what the administration would do if they really disliked you!

So the faculty who agree with you are likely to let you do the fighting—alone. And the only thing to add to what I have said about administrators is that they do not have tenure in their posts. One could form a sort of Ohms/Faraday Law of Administrators, at least heuristically; they are most likely to follow the path of least resistance.

Well, there is still option three: Why not go political? A moment's thought shows this to be a move of almost lunatic desperation. Politicians have their own agendas. Few understand or care about education. Government is already too heavily involved in education now, from budgets to tenure and admissions decisions, to antitrust activities, to wishing to fire some professors, or hire some of their friends, for the inclusion or exclusion of—you name it—Italian American Studies, Creation Science, and so on. Tom Hayden of California wants all graduating classes to be proportionately representative of California's population. Henry Hyde and Larry Craig have introduced separate anti-PC bills, the latter to stop federal funds going to colleges and universities with speech codes, and the former to apply the First Amendment to private universities. Meanwhile, both the Middle States and the West Coast accrediting associations have Haydenesque ideas about proportional representation.

Where legislation leads, the courts are sure to follow and to expand the reach of the legislation. Thanks to them, letters of recommendation and confidential files are no longer confidential. If you want to stifle the universities, political action is probably your best route. That leaves option 4. Go public. And that means going to the media.

I do agree in part with what Professor Graff writes about the media (Graff 1992). They do not understand higher education. But I cannot agree that, with better communication on our parts, they will come to understand it better. My long examination of the best of the media has convinced me that, with the general exception of the *Economist,* and the partial exception of the *Wall Street Journal,* they understand almost nothing, and do not place a high priority on getting much right. I am quite prepared to document this, but that is another paper, one on which I have dined out often.

Yet in no other way than through the media can one capture people's attention. In America this strategy has a particular advantage. For here the educated public, though it happily thumps up tens of thousands to educate Junior, is astonishingly ignorant of what goes on in its schools and universities—to a degree quite unimaginable in France or Britain. So the revelations are likely to have maximum effect on parents and alumni. And it only seems fair to let these poor souls know what their tuition and bequests buy. Even a dedicated search by a parent is unlikely to uncover what is being taught and how little of it. And universities, especially, are as adept at, shall we say, obfuscating, as are the best of politicians or business men. I will not debate the merits of preferential treatment (PT) here, but the Georgetown Law School flap is a good example, for it hid its PT admissions for years. When the unfortunate Mr. McGuire blew the whistle, the dean's initial reaction was to deny it, then, when denial was no longer possible, she claimed that GPAs and LSATs aren't everything (McGuire 1992). In this she followed the tradition of the U.C. Davis Medical School's claim at trial and oral argument before the Supreme Court that Davis's sixteen percent set-aside was not really a set-aside, because there were other indica showing that these students had the ability to do well in medical school. When challenged to state the indica, U.C. Davis was unable to do so. In this connection we must also recall preferential admissions for alumni and faculty children, as well as athletes. It is astonishing how far this rot reaches.

I know personally of a student, white in this case, with few intellectual interests and a very mediocre record at one of the country's leading prep schools, who was given *early admission* at Princeton because he is nationally ranked in a rather minor sport. However, I would argue that, pernicious and corrupt as these policies are, current race-based preferential treatment for minority candidates is worse by several orders of magnitude: because it gives rise to serious problems of racism on campus, and has spawned a costly bureaucracy which is now deeply embedded in colleges and universities (Gross 1994).

In another vein, even though I follow these things closely, it came as a shock to read in the judge's opinion in *Levin v. Harleston* (770 F Supp, 895) the laconic testimony of the CCNY chief of security to the effect that students often burned notices on the doors of professors they disliked and the college took no action against such students. So I think consumer advocates ought applaud a bit of truth in education. Why shouldn't parents and alums know that their alma mater forbids Jane and John alike from laughing in an unseemly manner at some unfortunate, telling ethnic jokes, expressing moral condemnation at some social practices, or the excessive use of the masculine pronouns (Hentoff 1992)? For the moment, I don't argue against such restrictions, but merely in favor of the consumers' right to know of them. And parents who send their kids to the best prep schools in the country expecting them to read lots of Homer, Spenser, Milton, Shakespeare, Austen, and Eliot, ought to know that they are studying instead the works of Zora Neale Hurston, Ntozake Shange, and Frantz Fanon, while learning of the amazing toleration of homosexuality among the *Iroquois* (No, I'm not making it up).

Not all complaints are about the turn to PC. People ought to know, too, just how little the university expects its students to work. A 1990 survey of college students by the Carnegie Foundation reports 30 percent of college students spending less than 6 hours a week studying outside class and only 23 percent spending 16 hours a week or more at it. Think of it. That means that 77 percent of the students spent 16 hours or less a week studying. Assume these students take 15 fifty-minute class periods a week; that is twelve and a half hours in class. Add that to the 16 hours or less spent in outside study and you get the astonishing total of twenty eight and a half hours per week or less. That means that more than three-fourths of our college students are spending a total of twenty-eight and a half hours per week or less on academic work. And that charitably assumes that all the classes are academic rather than vocational, remedial, or touchy-feely. Moreover, semesters now only run from a minimum of eleven weeks to a maximum of fourteen weeks.

The Carnegie survey also showed that 60 percent of the professors surveyed said they were teaching basic high school skills to their under-graduates (see also *CHE* February 24, 1993) while 75 percent of the presidents of liberal arts colleges and 82 percent of the research university presidents said that drugs and drunkenness were major problems on their campuses. And then there are the con-man tactics used by university admissions offices to entice students to enroll. They range from glossy and expensive multicolor brochures which extol the fun of attending, though none of the programs or work required, addressing Spanish-surnamed applicants in Spanish without a clue as to whether or not they understand

that language, and offering admissions to branches and even to two-year affiliates of themselves to which the applicant in question emphatically did not apply (Welsh 1993, personal communication to a prospective student from Emory, dated April 1, 1993). So there's a lot to know about our institutions of higher education today. Exposing them is good consumer advocacy, and well within the progressive traditions of Lincoln Steffens and Jacob Riis.

Well, what other dirty little secrets might a decent muckraker think the public ought to know? Here's one I bet most of us will agree upon: administrative bloat. According to the Department of Education, between 1976 and 1989 there were the following increases: Full Time Equivalent (FTE) students—17 percent; FTE Faculty (mostly tenure lines)—25 percent; executives and administrative managers—43 percent; nonfaculty, nonexecutive administrators—123 percent; and let us not forget that administrators require offices and staff. No wonder funds are short!

Next, the tuition scam might be of interest. We are told constantly that undergraduate tuition must rise because the cost of teaching Janey and Johnny has also risen, and parents, alums, and, until recently, legislators, are broadly sympathetic. But of course this claim is, at best, ingenuous. The cost of teaching undergraduates is part of the aggregate costs of a university. These also include teaching graduate students, paying professionals producing research, running the press, if there is one, extra curricular activities and, last but hardly least, paying administrators. There is, however, no way to discover the precise, or even the approximate cost, of one product out of the aggregate. In Sowell's apt example (1992), if it costs you five hundred dollars to raise a pig for market, there is no way to assign the separate costs of having produced the bacon, the pork chops, the ham, the belly, or the trotters. As there is no incentive for administrators to hold down costs, colleges and universities may expand functions and increase the number of administrators, assigning an arbitrary "cost" to tuition, which is whatever the market will bear.

While we are on costs, the public should also know the monetary and the intellectual costs of having roughly 30 percent of the nation's college student body take remedial courses, some of which are actually counted towards a four-year degree; and that the 30 percent figure charitably assumes that courses not labeled "remedial" are actually not remedial. On the question of graduation rates in general, I am prepared to admit openly those for CUNY in general—27 percent over nine years in the four-year colleges. CCNY, once the "Harvard of the Proletariat," is down to 15 percent, while my own college is distinguished by an 8.5 percent rate.

I have already mentioned preferential treatment. As I said, I am not concerned here with its justification or lack thereof. I am concerned with its hiddenness and its cost. If colleges are prepared to waive application fees and deadlines and accept lower standards for students and faculty of some but not other races and ethnic groups, then the public should be informed so that the debate about the justice of such practices can be joined by all interested parties and not just the platonic guardians. The public should also know the monetary costs of preferential treatment—direct and indirect—which are considerable. Finally, they should know about the graduation rates of the preferentially admitted students, which are significantly lower than those of regularly admitted students.

Bunzel (1988) reports that at Berkeley 66 percent of the white students and 61 percent of the Asian students graduate in five years, but only 41 percent of the Hispanic and 27 percent of the black students ever graduate *at all*. Sowell (1993) reports Shelby Steele's analysis that only 30 percent of the black students ever graduate at his school, San Jose State, and Oscar F. Porter's survey showing that nationwide 74 percent of black students fail to graduate in five years. Sowell blames much of this on mismatch of black students to colleges due to affirmative action pressures.

Then the public might be interested to learn just how far back some of our colleges and universities have set civil rights, with the acceptance, even encouragement of "theme houses," a euphemism for segregated dormitories, and, in some cases, dining facilities. Stories in the media occasionally make oblique references to these, but few parents or prospective freshmen seem to have heard of them (Bunzel 1992, Staples 1993). Another elite prep school student—black this time—told me with disgust last year that he had turned down admissions to Dartmouth for what I regarded as a less desirable school, after spending an entire introductory weekend at the Dartmouth campus, during which he was presented to no white students or faculty at all.

Another item on the muckrakers' list for exposure ought to be what now passes for intellectual discovery in some university circles. Before coughing up twenty thousand dollars or more per year, mommy and daddy might be interested to know that some professors attempt to fly multiengined jets, while licensed only for single-engined propellers. They no longer feel it necessary to teach the nominal subjects of their departments; subjects that they were hired to teach, subjects that the catalogue lists them as teaching, and subjects in whose research methods and professional literatures they were presumably trained. In some quarters a degree in literature is presumed to license the teaching of history, or of political and economic theory, or, alas, of philosophy, especially the philosophy of language. These subjects are treated by some as if the most casual

acquaintance with a few works, whether representative of the field or not, is sufficient background from which to teach and expound it.

I want to go slowly here because I want to be quite clear. I do not impugn the critical credentials of any of those whom I am about to mention. One may be quite brilliant and imaginative in one's field of expertise, and be quite out of one's depth in another field. One's insights may be brilliant and one's arguments unsound.

Some, but not all of these points have been made by John Searle in two *New York Review of Books* pieces (October 13, 1983; and December 6, 1990). However, they will bear repeating, especially since they seem to have passed by quite without touching those who might have benefitted most from thinking about them. First, I do not know whether she teaches philosophy in her classes, but anyone who shows as infirm a grip of that much-maligned subject as Barbara Herrnstein Smith did in her letter in reply to Searle (February 14, 1991) is best advised to keep to herself any philosophic thoughts she may have.

In reply to Searle's sketch of an argument for metaphysical realism (Searle 1990, Herrnstein Smith 1991) she writes:

> as for matters of ontology and epistemology, readers of the *New York Review of Books* will be grateful to Searle for clearing up the issue so painlessly. No problem there at all; just remember that Reality is presupposed by all language, Reason by all argument, and that to deny either is impossible. *Does* anyone "deny" either? Is it not, rather, that the nature and meaning of such concepts have been recurrently questioned and subjected to diverse formulations? But never mind—forget Kuhn, forget Kant, forget Quine, forget Protagoras. With John Searle to set us straight, we do not *need* any Great Books.

But Searle's argument was more nuanced than that. First, he nowhere claimed in that argument that anyone denied "reality" or "reason," but that there have been attacks on metaphysical realism, which there have, and that there have been demands for a proof of rationality—though in fact Paul Feyerabend (1988) appears to deny both, and the authors of "Speaking for the Humanities" seem to want to do just that. What Searle did say is that speaking a language and demanding a proof *presuppose* that the speaker accepts the existence of an objective world and of reason, so that the denial of them in such contexts is incoherent, rather along the lines of someone who asserts, literally and seriously, the words: "I am not here." All of which are points made by Aristotle against Protagoras some twenty-five hundred years ago; though what poor Protagoras, only two fragments of whose philosophic works we possess, is doing in company with Quine, Kuhn, and Kant, or what they are each doing in the company of the others, is not at all clear.

The Pyrohnean skeptics apart, I do not believe that any serious thinker meant to deny reality to the ordinary space-time world we inhabit in our ordinary daily lives; certainly not Kant, who went out of his way to say that the world necessarily would have to appear the same to all rational creatures, not just human beings. Nor did Kuhn who, despite having been much misunderstood, never claimed that whether, say, water was really H_2O was an open question depending upon what paradigms we adopted in future.

In fact, there appears to be great confusion among some between what it means to say that there are no absolute aesthetic values, what it means to say that there are no absolute moral values, and what it means to say there is no absolute reality. These are three very different claims, and arguments establishing one of them, supposing there were such, would not be likely to establish either of the other two.

The confusion is multiplied when these three latter assertions are confused with the corresponding but quite different claims that there are no objective aesthetic values, no objective moral values, and no objective reality, each of which is, of course, a claim in its own right, distinct from either of the other two. Values, for example, might not be absolute in the sense that they are written in the stars, independent of any human thought, and still be objective in the sense that the great majority of human beings are so constructed that most prefer, say, more to less complexity in plot construction, greater to lesser character development, and certain sequences of sounds to others. Thus concert-goers will know that an entire evening of pieces composed in a minor key leaves just about everyone in the audience profoundly dissatisfied, even depressed. All of this is quite compatible with the fact that by no means all would agree precisely upon which works exhibited these traits best. More about this shortly.

As John Searle pointed out (1990, 1991) the authors of the ACLS pamphlet, *Speaking For The Humanities,* don't know much about philosophy, and less about science. As Searle quotes them:

> The challenge to claims of intellectual authority alluded to in the introduction of this report issues from almost all areas of modern thought—science, psychology, feminism, linguistics, semiotics, and anthropology. As the most powerful modern philosophies and theories have been demonstrating, claims of disinterest, objectivity, and universality are not to be trusted and themselves tend to reflect local historical conditions.

Now, on their face, these claims are sophomoric rubbish. If you really think that claims to scientific objectivity are false, that they reflect merely local historical conditions, then why not try a glass of H_2SO_4

rather than a glass of H_2O, or flying an airplane with a rectangular airfoil, or curing anemia with red wine? Results like Gödel's Incompleteness Theorem, Heisenberg's Uncertainty Principle, Bohr's wave/particle duality, or special and general relativity, usually trotted out as if they refuted claims to objectivity and rationality, actually apply only in extraordinarily technical and specific scientific contexts, and have never successfully been extrapolated beyond them. Certainly even the attempt to do so would require very deep and powerful arguments which have never been sketched, much less formulated, largely because no one with the requisite technical competence in these areas has the remotest belief that it can be done.

Here are two more examples of unlicensed flying. Searle quotes Jonathan Culler attempting to illustrate a Derridadian "deconstruction" by "reversing the hierarchy" between cause and effect. But where is that hierarchy? "Cause" and "effect" are correlative terms. No event is a cause unless it produce an effect, and no event is an effect unless it has been caused. Worse, Culler writes:

> [i]f the effect is what causes the cause to become a cause, the effect, not the cause should be treated as the origin. By showing that the argument which elevates cause can be used to favor effect, one uncovers and undoes the rhetorical operation responsible for the hierarchization and produces a straightforward displacement. (in Searle 1983)

First, one wants to ask what any of this has to do with literature. Second, though "cause" and "effect" are correlative terms, their referents are temporally related. By definition, the event called "the cause" must either precede or be simultaneous with the event called "the effect." In the case of a *single causal relation,* it thus makes no sense at all to say that an effect causes its cause to be anything at all, because an effect cannot *cause* anything; if it did, it would be a cause and not an effect. An effect could no more be the cause of its cause than a wife could be a husband to her husband. Whatever is the point of this nonsense? Suppose, *per impossible,* Culler were correct? What would he have shown?

Then there is Wendell V. Harris confusing a *reductio ad absurdum* with the ancient paradox of the liar. Harris (1986) writes:

> whether anyone from Aristotle to Bertrand Russell has resolved "The Liar" is a matter logicians still debate; but the revisionist claim of the indeterminacy of texts is reducible to the same paradox. "If I write that all texts are indeterminate, either my statement cannot have determinate meaning, or it has a determinate meaning and is thus false."

First, despite sporadic articles, there has not been much of a debate about the liar paradox for some time. The paradox results from the fact that the

sentence purports to refer to itself; and its resolution consists in avoiding self-reference. Second, the final sentence quoted is a by now commonplace *reductio* run against the claim that all texts are indeterminate. Broadly, there are two classes of *reductios:* those in formal proofs in logic and mathematics and those in rhetoric.

In formal proof one uses *reductio* to prove a theorem indirectly. The technique is simple and, though the application may sometimes be technically demanding, it is usually a much shorter method of proof.

To use it, one adds to the premises of the proof the denial of the theorem or proposition to be proved, and then derives a formal contradiction of the form "both A and not-A." Roughly, we know that logic and mathematics are consistent, so that no such contradiction can be derived from premises which are themselves consistent. Therefore, if you know that your original premises are consistent, the derived contradiction must have resulted from the addition to them of the denial of the theorem you wished to prove. It follows that the original theorem must be true.

In rhetoric, a *reductio* consists in showing that accepting the premises of some argument entails a conclusion which, while not a formal contradiction, is not rationally acceptable to whoever holds those premises. In the case of Harris's argument, the conclusion which follows upon accepting the premises that all texts are indeterminate is that the text which purports to say this is, itself, indeterminate and could not be known to say what it purports to say. Since this conclusion is not rationally acceptable to anyone who makes this argument, he must hold that his premise is false. And in Harris's example, if the statement is to have any meaning at all, it must necessarily be false.

The liar paradox is entirely different. It is a formal paradox, the definition of which appears to be unknown to Harris. Paradoxes result when valid arguments lead to two contrary or contradictory propositions. In its most extreme form a paradox suggests the apparent equivalence of a proposition and its negation.

In its most famous extant form, the liar runs: "Epimenides the Cretan says 'all Cretans are liars.'" Now, if what Epimenides says is true, then what he says must be false (because he lies) and therefore it must be false that all Cretans are liars. But then, by parity of reasoning, if what Epimenides says is false, then what he says must be true and it must be true that all Cretans are liars. Thus the truth of the proposition entails its falsity and its falsity entails its truth. But by the formal definition of equivalence, if any proposition entails its own falsity *and* its falsity entails its truth, then that proposition is equivalent to its negation—in symbols, $p \equiv -p$— satisfying the definition of paradox. The difference is, then, that the rhetorical *reductio* yields only the falsity of the original premise; the paradox

of the liar yields the apparent equivalence of contradictory propositions. They cannot, therefore, be the same thing.

Lacking serious acquaintance with the field, these and other writers are bound to blunder when the air gets a bit choppy over unfamiliar territory. They make elementary errors, and they seize on what they take to be accepted results of some philosophers like Rorty or Kuhn (in his case a bad misreading). In so doing, the ACLS authors, for example, commit the same error as the creationists and other enemies of Darwin, who similarly seized on Karl Popper's incautious remark that Darwin's theory was circular (Popper 1965, Schilpp 1974) as proof that evolutionary theory could not explain the biological world. But Popper's views were by no means generally accepted, and have been subject to many attacks and refutations. The history of philosophy has not yet shown us one philosopher whose views have generally come to be accepted in their entirety. The appeal to new and controversial ones is surely ill-advised.

The ACLS authors even make the blunder of equating objectivity with positivism, a mistake that no reasonably informed philosophy undergraduate is likely to make. Objectivity, roughly, is the metaphysical view that the world is a certain definite and fixed way; while positivism, in its twentieth-century incarnation, is an epistemological thesis about how to discover knowledge and, in most forms, rules out on epistemological grounds even making such assertions as "the world is or is not objective."

But one wants to ask why these authors even raise such issues. Do they think that, if it should turn out in some unspecified, deep, metaphysical sense that, say, Heraclitus were right, that the world is in flux and nothing is, in that sense, objectively so, that would then mean they *really could* drink sulfuric acid and fly with rectangular airfoils, or that it will turn out not to have been historically true that Hitler's armies crossed the Polish-German border on September 1, 1939, or that Columbus set sail in 1492 with three ships and made three further voyages, or that Stalin starved the Ukraine? A moment's thought should expose this as nonsense.

In *de sophistica elenchi,* Aristotle catalogues many logical and material fallacies. Unfortunately, there are more forms of bad reasoning than there are names for them. And, of course, the reason to be wary of fallacies is that they make us go wrong in our arguments. And the reason to use nonfallacious reasoning is that it gets things right; that is, it works. If the fallacies are logical or material, they will make us think that our premises and conclusions are logically related when they are not. If they are statistical fallacies they will induce us to believe that evidence strongly supports a conclusion when it does not.

Among the more common fallacies we may list: *ad hominem,* both abusive and circumstantial, accident, hasty generalization, equivocation, begging the question, and *non sequitur.* From the fact that someone is alleged to be, or even is, stupid, nasty, or morally reprehensible, we may conclude nothing whatever about any particular argument he may make. For even the worst of us may argue soundly. The same holds for the fact that someone may stand to gain if his argument is accepted. For even those who argue in their own interest may make sound arguments. Equally clearly, it is incorrect either to generalize on too little information or to impute something that is generally so to a particular case without further evidence that it is so in that case: or to do the reverse and invoke as a central property of a thing that which is only ancillary to it. It should also be clear why arguments are fallacious that trade on two different meanings of a word, or which assume what they must prove, or leave an unbridged logical space between premises and conclusions.

It is disturbing to an observer of the present scene who is professionally interested in argument to see the plethora of bad arguments among the writings of colleagues. As my friend (despite or, perhaps, because of, our many disagreements) Professor Graff is a contributor, I will begin by citing two of his arguments (Graff, 1992). He writes in defense of such fields as ethnic studies, feminism, and deconstruction that

> ... virtually every major advance in humanistic scholarship over the last three decades is indebted to the movements that are widely accused of subverting scholarship: feminism, ethnic studies, post colonialism, deconstruction, and the new historicism. ... The conservatives, on the other hand, who defend scholarly values against politics, have produced little scholarship of interest, but a great many polemics.

First, it is worth pointing out one common fallacy professor Graff did not commit: the undistributed middle, though the argument might well have gone that way, and does so in much of what passes for art criticism nowadays. Here it is in one popular form:

> Great art of the past has been ridiculed and called silly.
> *These paintings have been ridiculed and called silly.*
> Therefore, these paintings are great art.

For purposes of comparison:

> A great poet, Shelley, was expelled from university.
> *My daughter was expelled from the university.*
> Therefore, my daughter is a great poet.

Professor Graff's two fallacies are begging the question and the *ad hominem,* abusive or circumstantial, depending upon how one reads his

text. He assumes, first, the very thing that is in dispute, that there have been these major advances in humanistic scholarship. He cannot, therefore, use that claim as a justification of those subjects he seeks to justify. The *ad hominem* is clear enough. Even were it true that his opponents have produced very little interesting scholarship, that imputation is irrelevant to the quality of the arguments they use to attack what Professor Graff seeks to defend.

Here is a fallacy from Stanley Fish (1992) "The Common Touch: One Size Fits All." Discussing an anonymous short review of Robert Alter's book, *The Pleasures of Reading in an Ideological Age,* Fish writes:

> The review of Alter's book ends with the double praise of the author's "lucid and moderate way" and of literature for preserving "from generation to generation" the "diversity, passions and playfulness" of "human beings." The curious—even bizarre—word in this encomium is "diversity." What does it mean? What could it mean? How do you celebrate diversity in a context that affirms the common so strongly?

Just what are we supposed to think is the problem here? A perfectly clear, natural, and obvious way to read the reviewer's claim is that what is common to us all is a range of feelings and emotions, which range encompasses diverse feelings and emotions expressed in diverse ways through diverse genres of literature. Fish's argument is just bad. One is tempted to name this sort of bad argument "the fallacy of univocation"—the inverse of the fallacy of equivocation. One equivocates by trading upon different meanings of the same word. And one univocates by making or implying or presupposing the claim that each word has only one meaning or domain of application.

Here is a fallacy of Chinua Achebe's. It is quoted by Graff (1992) with all signs of approval, so we may be excused for believing that he accepts Achebe's claim. Achebe writes: "Even the attempt to say nothing about politics is a big political statement. You are saying that everything is o.k." (Graff quotes George Orwell to this effect also). This is an example of the black/white fallacy (no pun intended); for example, it is like arguing that if Jones is not rich then he is poor. But not everyone who fails to achieve the enviable state of wealth is poor. There is a whole spectrum of other financial states between them. In this case a writer may simply be ignorant of politics, not care about them, be committed to some theory of pure poetry/literature, or simply wish to write a nonpolitical work. Suppose someone were to write a book without mentioning the astrophysical phenomenon of black holes. It hardly follows that by that act he endorses the theory which says there are such phenomena. Silence may imply consent in English common law, but it does not necessarily do so

outside it. Consider the famous example of Jane Austen. She is silent upon each of the following topics—are we supposed to think that she approves of them all?: the nature of sexual relations in general, homosexuality, toilet facilities, the slaughtering of animals, the state of medical practice, Napoleon's usurpation of power, the war with America, the war with Napoleon which precipitated it, the Congress of Vienna and its results, the Peterloo Massacre, the Cato Street Conspiracy, the assassination of August Kotzebue by Karl Sand, and Metternich's consequent unusual convocation of the Diet. One can conclude nothing from the silence of any author upon any topic and most emphatically can in no way, absent independent evidence, construe that silence as political statement.

Non sequitur is one of the most frequent fallacies. In her book, *Contingencies of Value,* Barbara Herrnstein Smith makes a very good case that there are no transcendent literary or artistic values, a case which had been made far more strongly by Hume in the eighteenth century, which is a staple of much contemporary philosophical writing (for instance, Dickie, 1989; Danto, 1983, 1986) and a case which I, myself, tend to accept. But from that case she makes a series of further claims which by no means follow from it and which would require much extended argument to be taken seriously, to wit: that there are no generally objective aesthetic values, no generally objective moral values, and even that there is no truth or objectivity at all (Levin, 1992). These further claims are, one and all, *non sequiturs,* and naive ones to boot. The failure to comprehend this is symptomatic of being a stranger in a strange land, a stranger to the thought and literature of a discipline which has developed extremely sophisticated arguments and positions on these questions in the twentieth century alone.

Let us turn finally to the question: When is something political? For the argument that literature is political is a supreme example of a bad argument. This question, happily, is the title of Chapter 8 of Professor Graff's book (1992) and to my mind is not as successful as the rest of the book, which presents a very clear and arguable position, a mistaken one I believe, though I do not have the space here to set out my reasons. There are two lines of argument running through the chapter. First, though it may not be exactly the case that *everything* is political, much is, and literature, to borrow a phrase, may well be seen as politics by other means. Second, just about everybody takes literature politically. Now if the first argument is sound, the second may be made to follow from it. If not, the second one is in grave danger of committing either the fallacy of appeal to authority or the *tu quoque* fallacy.

Is the first argument sound? Two sorts of considerations are offered. First, an impressive list of authorities, ancient and modern, of the nineteenth and early twentieth centuries, are exhibited in support. And Graff

claims that the virtues appealed to were blatantly political in the usurpation by English letters over the Greek and Latin classics that occurred in the nineteenth century. Second, Graff lists a variety of ways in which he finds politics to infect literature. Among them: some literature is about politics— Shakespeare, Plato, and Milton, for example; then, the choice of what is taught is, he thinks, a political choice; and the very division of literature into departments by language reveals political infection.

Against the first part of Graff's first consideration, one can pose three objections. 1) Appeal to authority is never an argument that can stand on its own. It must be buttressed, in this case by evidence showing that what these authorities say accords with the state of affairs. And this evidence he fails to supply. 2) As the village postman is often not the best person to draw a map of his route, nor the native speaker the best person to write a grammar of his language, so writers and critics are not necessarily in the best position to analyze their activity. Something beyond their status as practitioners, even if they are superior practitioners, of their art must be adduced before we take their second-order opinions about their subject. 3) It would not take much research to construct a list of equal length with equally eminent names on it, which represented writers who held just the opposite view, the view that literature as literature has nothing to do with politics in any central sense of that word. When this list is assembled we could not choose between the views of those in it and the views of those on Graff's list. From this point of view the issue is undecidable.

We can undermine the second part of Graff's first consideration by pointing out that people may justify some policy on one ground, and yet it may be adopted on quite another. What must be shown in this case is not merely that many people claimed patriotic and nationalistic reasons for replacing Greek and Latin by British and American literature, but that this was the actual reason for the change. Again, this Graff does not do.

If one looks at American literature, one is struck by whom we read and criticize and whom we do not. We require of our students, or at least we used to require of them, Hawthorne, Melville, and James. And we spend much time on them. But if what really counted were their *Americanness,* then we should be hard-pressed to say why we do not spend nearly so much time on, say, Jonathan Edwards, Increase Mather, and Anne Bradstreet. That is, we read our better, not our less good authors. Kenny Williams (1992) makes a useful distinction between the literature of a place and time that we read largely because it is all we have from there and then, and the literature we read because it is good; between the literature we read because it forms a context from which the best works grew, and the best works. Even if all British and American literature were celebratory, which I doubt, but defer to expertise, each of its own country,

we do not therefore treat all literary works as fungible. We pick and choose among them, and we do not pick and choose by indicia of patriotism or flag-waving.

Against Graff's second consideration—that politics infects literature—we may argue similarly that if the politics in or of a literature were of major concern, then we ought to award the highest marks for excellence to those works that exhibit the most politics. But we do not do this. Shakespeare may well celebrate order and monarchy to a certain degree, but Alan Drury, Edwin O'Connor, Robert Penn Warren, Howard Fast, and Anthony Trollope have all produced more thoroughgoing political works. Few, I imagine, would put any of them in the same league as Shakespeare. Again, many writers criticized the bourgeoisie, though, unlike Professor Graff, I do not think Proust was criticizing them, but *if* we take him to be so doing, we must first observe that his criticism is social, not political. His great novel deals with social rather than political insights. Second, it is Proust and Balzac whom we read, not Aragon or Roger Martin du Gard. But they all criticize the bourgeoisie. Why, then, do we favor the former over the latter two?

Life and courses are lamentably finite. Choices must be made, and one may make them on many criteria. What evidence is there that the choices of what and whom to read are centrally political? Let us take as examples Marx and Nietzsche. Professor Graff gives us the example of two professors, one a conservative sociologist who teaches Marx without revealing his own attitude towards his work, and the other a political scientist who would no more teach Marx than the flat earth theory. Graff says that the sociologist is committed to the view that Marx is important. Otherwise, why teach him? But, though this is not an example of political choice it would seem like one to the political scientist. But why should it? This story is compatible with the first professor having reasoned that any figure who ruined, albeit indirectly, more economies and cost more lives than lots of famines was an important figure and important figures should be taught, while the second professor might reason that any political economist who got so much analysis wrong was not worth teaching. Both pieces of reasoning are judgments, but they are empirical judgments related to the professors' pedagogical goals, and both are compatible. Neither is political. One could make the same sorts of judgments about Nietzsche. One might find his thought mawkishly adolescent, and decide him not worth teaching on that account, or one might make a point of teaching him because of the large influence he had on literature.

Another way in which Professor Graff finds political infection in literature is in the division of departments by language. He writes: "Thus it tends not to occur to us today that once we call a subject 'English' or

'French' literature we have already politicized it, for 'English' and 'French' derive from political not aesthetic categories." Perhaps Professor Graff meant this tongue in cheek; for it is an astonishingly bad argument. Compare it to this one: "once we have said that the 'Gettysburg Address' is 272 words long or that Aristotle's *Ethics* contains ten books we have mathematicized literature. For 'two hundred seventy-two,' and 'ten' derive from mathematical, not aesthetic concepts."

No doubt it is for political reasons that people in France or the Ivory Coast speak French while people in England and New Zealand speak English. But departments of literature are divided by language for two quite different and obvious reasons: first, to give notice to prospective students and faculty of the linguistic competence required to take its courses and, second, because the main connections among the works in the literature of a given language can be expected to be with other works written in that language.

Thus Graff's attempt fails to make a plausible case for the central or even important place of politics in literature and, hence, fails to justify the claim that literature is, in any but the most ancillary sense, political.

I conclude with an example of some of the things that can go wrong when political consciousness is forced on an artistic work. In 1918 Igor Stravinsky composed a septet called "L'histoire du soldat" to be played, danced, and narrated. Stravinsky had been captivated by Afanassiov's collection of Russian folk tales. His friend, the writer Ramuz, provided a libretto for one of them, concerning an age-old tale of a soldier who sells his soul to the devil. The tale is a simple one of mystic morality which casts it out of its real time and place; the music is very complex and driving. On May 6, 1993, the piece was performed in New York with the libretto "reinterpreted" by Kurt Vonnegut. Stravinsky's "naive soldier is replaced by a wisecracking deserter who is confronted" not by the devil but by a general, a military policeman, and a Red Cross girl. In his program notes, Vonnegut offers the following rationale (Kozinn, 1993):

> What the people have to say in between Stravinsky's brilliant little outbursts up to now has less than nothing to do with the gruesome and humiliating life of any soldier in any war at any time. . . . I cannot understand how Stravinsky, in exile from his native Russia but of military age when he wrote the music, could have found acceptable words which were so unresponsive to a war then going on in which 65 million persons had been mobilized and 35 million were becoming casualties.

The operative words here are "I cannot understand." Precisely. Since Vonnegut could not understand he ought not to have forced an alien

political interpretation on what is one of Stravinsky's gems. At least two things seem not to have occurred to him. First, that Stravinsky had something else on his mind than the war; second, that anyone might like the life of a soldier and not find it humiliating in the least. Indeed, in this tale Joseph, the soldier, has many adventures of a distinctly nonmilitary sort. In short, the work has nothing whatever to do with either the Great War or the ordinary life of a soldier. Only a writer obsessed with the idea that art *must* be political could have what must be described as the *chutzpah* to rewrite a masterpiece he admits to not understanding. Vonnegut has wrenched the work completely out of its orbit and made of it a grotesque parody of his own politically correct sensibilities. Incidentally, his figures of sixty-five million mobilized and thirty-five million casualties are off by roughly a factor of four in each case.

WORKS CITED

Bunzel, John H. 1988. "Affirmative Action: How it 'Works' at Berkeley." *Public Interest,* 93, Fall, pp. 111–129.

————. 1992. *Race Relations on Campus: Stanford Students Speak.* Stanford Alumni Association.

Burd, Stephen. 1992. "Scientists Oppose Diversity Rules for Clinical Trials in NIH Bill." *Chronicle of Higher Education,* April 7, p. A26.

Carnegie Foundation for the Advancement of Teaching. 1990. *Campus Life: In Search of Community.* Princeton: Princeton University Press.

Danto, Arthur C. 1986. *The Philosophical Disenfranchisement of Art.* New York: Columbia University Press.

Dickie, George. 1984. *The Art Circle: A Theory of Art.* New York: Haven.

Fish, Stanley. 1992. "The Common Touch, or One Size Fits All." *The Politics of Liberal Education,* eds. Darryl Gless and Barbara Herrnstein Smith, pp. 241–266. Durham: Duke University Press.

Genovese, Eugene. 1991. "Heresy Yes—Sensitivity No." *New Republic,* April 15, pp. 30–35.

Graff, Gerald. 1992. *Beyond The Culture Wars: How Teaching the Conflicts Can Revitalize American Education.* New York: Norton.

Gross, Barry R. "Science and the Mass Media." Unpublished lecture.

————. 1994. "The Intolerable Costs of Affirmative Action." *Reconstruction,* 2:3.

Harding, Sandra, ed. 1983. *Discovering Reality: Feminist Perspectives on Epistemology, Metaphysics, Methodology, and Philosophy of Science.* Dordrecht, Holland: D. Reidel.

Harris, Wendell V. 1986. "Towards an Ecology of Criticism." *College English* 48.2, February, pp. 116–131.

Hentoff, Nat. 1992. *Free Speech For Me—But not For Thee,* San Francisco: Harper-Collins.

Herrnstein Smith, Barbara. 1988. *Contingencies of Value: Alternate Perspectives for Critical Theory.* Cambridge, MA: Harvard University Press.

————. Letter. 1991. *New York Review of Books,* February 14, p. 48.

Hoffstadter, Richard. 1963. *Anti-Intellectualism in American Life.* New York: Knopf.

Keller, Evelyn Fox, *Reflections on Gender and Science.* New Haven: Yale University Press.

Kozinn, Allan. 1993. "Kurt Vonnegut's Reinterpretation of 'L'Histoire Du Soldat,' " *New York Times,* May 8, p. 11.

Leatherman, Courtney. 1992. "Conservative Scholars' Group Draws Increasingly Diverse Voices to Its Cause." *Chronicle of Higher Education,* April 28, pp. A15–A16.

Levin, Michael. 1991. Review of *Contingencies of Value* by Barbara Herrnstein Smith. *Academic Questions,* Summer, pp. 88–91.

Lively, Kit. 1992. "States Step Up Efforts to End Remedial Courses at Four-Year Colleges." *Chronicle of Higher Education,* February 24, p. A28.

Magner, Denise K. 1991. "Reagan Appointee's Speech Canceled After Students at Arizona State Object to Her Conservative Views." *Chronicle of Higher Education,* September 11, pp. A19–A20.

McGuire, Timothy. 1992. "My Bout with Affirmative Action." *Commentary,* pp. 50–52.

Miller, Keith Z. 1992. "Redefining Plagiarism: Martin Luther King's Use of an Oral Tradition." *Chronicle of Higher Education,* January 20, p. A60.

Searle, John R. 1990. "The Storm over the University," *New York Review of Books,* December 6, pp. 34–42.

————. 1991. "Letter." *New York Review of Books,* February 14, pp. 48–50.

————. 1983. "The World Turned Upside Down," *New York Review of Books,* October 13, pp. 74–79.

Sowell, Thomas. 1992. "The Scandal of College Tuition." *Commentary,* August, pp. 23–26.

Staples, Brent. 1993. "Editorial Notebook." *New York Times,* May 28, p. A28.

Welch, Patrick. 1993. "Dear Warm Body." *Washington Post,* April 4, p. C5.

Wittes, Benjamin, and Janet Wittes. 1993. "Group Therapy." *New Republic,* April 5, pp. 15–16.

Woodward, C. Vann. 1991. Letter. *New York Review of Books,* September 26, pp. 75–76.

How the Culture Wars Matter:
Liberal Historiography, German History, and the Jewish Catastrophe

JEFFREY HERF

Winners are seldom in the mood to reflect on the contingencies of history. Rather, they equate their own good fortune, no matter how fleeting or fragile, with the advance of humanity, reason, the revolution, or the nation. History, winners believe, advances. Despite the postmodernist themes that have surfaced in American universities in recent years, this progressive faith, and equation of one's own success with the progress of the Good, if not always the True, continues in the universities. The teleology of a popular Hegelianism appeals to those who want to believe that those they have vanquished truly deserve to be defeated, placed in history's trash can and catalogued as lost causes that got just what they deserved. In this way, the winners convince themselves that their good fortune is an unmitigated gain for humanity while their opponents' loss represents no significant loss for anyone, or for the universities and their traditions.

They are wrong. Along with a laudable growth in the complexity of our knowledge, valuable traditions have been weakened, their scholarly distinction not up to the challenge of populism and *ressentiment* directed against them. The traditions of the university contribute to the celebratory mood. The world is more complex, and knowledge, in the humanities and social sciences, as well as in the natural sciences, must meet the challenge of that complexity. "History" now rightly includes the political, economic, social, diplomatic, military, intellectual, cultural, national, racial, and gendered aspects of a society. Growing complexity in the midst of scarce resources means something has got to give, and past scholarly

149

traditions ought to be subject to critique and reinterpretation. Yet it has become clear again that might does not make right, today's losers are not necessarily less worthy than today's winners, and that precious traditions may be lost or forced into latency for long periods, thus slowing the growth of knowledge.

I am a historian of modern European and especially German political culture. In my field, knowledge has advanced, and in part because of welcome contributions of social and women's historians. Important books and articles have been written that would not have been written had there been only the old history of politics, diplomacy, and ideas, without the newer history of society, women, and nongoverning social strata. But along with this advance in knowledge, important traditions of inquiry, especially at the intersection of political, intellectual, and cultural history, have been weakened. Moreover, the weakening of these traditions is not, as the victors sometimes claim, an unqualified triumph over the dark forces of reaction. On the contrary, some of these weakened traditions are indispensable for continuing to explain developments that the current victors think ought to be on the top of the agenda—for example, race. As you know, historians of political culture are interested in the mutual impact of language and politics, in what words mean, how these meanings change, and what difference they make for political outcomes. My thesis is that a key contributing factor to the erosion of valuable traditions—and to academic freedom and diversity—has been a redefinition of the meaning of the terms "liberal" and "conservative" that took place in the 1960s and 1970s, and continues to shape our discourse. This enduring linguistic turn has given winners a good conscience, and indeed helped to bring about their victories. One purpose of my remarks is to point to the price of what is called progress, and to note that momentary losers are not, for that reason, lacking in valuable traditions which ought to be continued.

The academic left, in its modernist and postmodernist forms, has been a victor in the academy in the past two decades, and at times it has been an intolerant victor. It is far from being the only source of intolerance in American society. Indeed, the old-fashioned forms of hatred and fear of minorities, women, and homosexuals remain. Religious fundamentalists have grown in number. A populist anti-intellectualism remains an undercurrent of American democratic culture. But these forms of intolerance are rightly surrounded with a barrage of well-deserved moral condemnation. McCarthyism, the mindless and paranoid anticommunism, was discredited by the evil man who gave it its name. In the Reagan era, in the most bitter years of the last phase of the Cold War, the academic left continued to accrue jobs and tenure—and NEH Fellowships. The hoopla about the culture wars of the 1980s helped conservative critics sell books

to a general public while politically correct academics continued to gain jobs and tenure. Criticisms from conservative politicians and journalists, as well as long-standing populist anti-intellectualism, did little to limit academic freedom within the research universities.

Conservative intellectuals found a foothold in some Washington think tanks and in the federal bureaucracy, but these jobs are miniscule in number compared to those in the universities. Within the universities, in the opinion-shaping and ideology-forming departments of the humanities and social sciences, conservatives remained an increasingly marginalized group with very little power to influence the direction of the academy.

As important as its success in securing jobs and tenure were the aftereffects of the left's transformation of American political language. Liberalism ceased to be color- and gender-blind, and supported affirmative action requiring discrimination taking race and gender into account. Liberalism also ceased to be anticommunist, and supportive of an active American role in the Cold War. Those who vigorously supported the principles of judging individuals solely by the content of their character and by the quality of their achievements as determined as much as possible by objective—that is, commonly held—standards of excellence were now called conservatives, neoconservatives, right-wingers, or sometimes simply racists and sexists. To have associated the term "liberal" with policies that stood at odds with the liberal tradition was a rhetorical victory for the left, from which liberals in the old-fashioned sense of the term have never fully recovered. Nothing is as deadly to an academic career in the humanities and social sciences as to be labeled a conservative, or rather, a "right-wing" intellectual or ideologue. The key point, and one often missed in discussions of recent years, is not primarily the existence or nonexistence of a majority of left-leaning scholars in a department or discipline. Rather it is the attitude towards those to the right of what is defined as acceptable or "politically correct" opinion. The shift in the meaning of the terms "radical," "liberal," and "conservative" gave an enormous boost to the left, because it gave intolerance a good conscience. It feels different to the victors of recent years to deny employment, tenure, or promotion to a "right-winger," rather than to a liberal.

I want to explore the meaning of this linguistic shift, that is, the redefinition of liberal positions into conservative ones in the field of my own work, German and European history. A central, indeed *the* central issue of twentieth-century German history, and of Nazism, in regard to the category of race is the history and impact of anti-Semitism. It was a liberal tradition of historiography which was most responsible for bringing the issue to the fore. Neither Marxists nor conservatives thought it central.

The placement of the Jewish catastrophe in the center of modern European history was the accomplishment of German Jewish refugees. It began with the philosopher Hannah Arendt's enduring classic of 1950, *The Origins of Totalitarianism*. It continued and entered the American professional literature on German history with the publication of George Mosse's *The Crisis of German Ideology* in 1964, and Fritz Stern's *The Politics of Cultural Despair* in 1961. Arendt made the powerful argument that Europe's major political traditions—conservatism, liberalism, and Marxism—had been unable to understand, at the time and afterwards, totalitarian ideology, wedded as they were to the naively cynical view that all politics is reducible to material interests. Drawing on evidence from texts of high culture to literary hacks aiming at a mass audience, Mosse and Stern worked out the fundamental connections between anti-Semitism, German nationalism, and a cultural revolt against modernity.

Anti-Semitism, and the stereotype of the Jew as "the other," as the antitype to an idealized German, was, they argued, crucial to German national identity and nationalism. Mosse and Stern convincingly placed the question of racism and anti-Semitism at the center of German history. The centrality of anti-Semitism to the prehistory and history of Nazi Germany did not enter the German historiographical literature with full force until the publication of Karl Dietrich Bracher's great work, *Die Deutsche Diktatur (The German Dictatorship)*, in 1969.

These four scholars were bound together by two fundamental convictions. First, the question of anti-Semitism and racism was central to modern German history and national identity. This view made them uncomfortable colleagues for German historians, who would just as soon have left the question of racism and anti-Semitism to the side. One group of such historians were conservative nationalists, who sought to minimize, forget, or—as in recent years—relativize Nazism by comparison. Mosse and Stern fought against the reluctance of their colleagues to deal with such a morose and grim aspect of German history. Today, most German historians on both sides of the Atlantic would include these issues at the center of German history, something that was not the case in the 1950s.

My own work lies in this tradition as well. In *Reactionary Modernism* (Herf 1984), I addressed the tension between Nazi ideology and modern technology. Again, in opposition to the tradition of conservative cultural criticism, which would dissolve German history into a lament about modernity in general, as well as to Marxist and critical theoretical assumptions about capitalism and a dialectic of the Enlightenment, I stressed Germany's particular road to modernity. How, I asked, did the Nazis and the antidemocratic intellectual right reject the West and the Enlightenment while embracing modern technology? How did they embrace some parts of

modernity while rejecting others? How was Jew-hatred interwoven into a German hostility to capitalism and Western liberalism without, at the same time, leading to a rejection of modern technology? *Reactionary Modernism* changed the way many German historians thought about modernity, Nazism, and anti-Semitism. Like Mosse and Stern's work, it placed the issue of race and national identity at the center of the study of modern German intellectual, cultural, and political history. Liberal historiography was the presupposition, not an obstacle, to placing this aspect of the Jewish question into the main analysis of modernity, national identity, and Nazism.

Resistance to the entry of the history of racism and anti-Semitism into the central themes of German history has had a powerful intellectual and political source: Marxism. I am now working on a history of politics and memory in the two Germanies from 1945 to 1989. There was a minority tradition of left-wing Communism among German Communists who did try to grapple with the Jewish catastrophe. Paul Merker, a German Communist who escaped from Europe to Mexico City, wrote a fascinating and valuable Marxist analysis of Nazi Germany, in which the autonomous force of racial ideology was given its due (Merker 1944). But Merker fell victim to the communist attack on "cosmopolitanism" in 1950, was expelled from the party, and imprisoned from 1952 to 1956. Communist historiography of East Germany largely buried the issue of anti-Semitism under a mountain of studies of capitalism. In West Germany, the Marxist and neo-Marxist "fascism discussions" subordinated the "particular" Jewish issue to a "general" discussion of capitalism.

The finest of the postwar Marxist historians of Nazism, Timothy Mason, unintentionally pointed to the heart of the problem in a now-classic essay of 1968, "The Primacy of Politics: Politics and Economics in National Socialist Germany." Mason saw Nazism as the exception which proved the rule of Marxist class analysis, according to which politics ought to follow from economic interests. For Nazi politics did not, he recognized, follow the class interests of German capitalism, a point historians of the Second World War and the Holocaust have confirmed. That is not to say that business did not profit from Nazism. Rather, Nazism's policies were not the outcome of the class interests of capitalism. They came from somewhere else. They came, as Mason also admitted, from the Nazi's beliefs—as Arendt, Mosse, Stern, and Bracher had argued. The collapse of Communism also brought with it an end to official Marxist orthodoxy in these matters. Historians in West and East Germany are now turning their attention to how the East Germans did and did not examine the particularities of race in the communist analysis of National Socialism. Sigrid Meuschel's recent study of national identity in East German political cul-

ture has unraveled the fascinating links between Communism, nationalism, and resistance to examining the anti-Semitic continuities in German history.

I want to emphasize that it was the liberal tradition of German intellectual, cultural, and political history which was most responsible for placing anti-Semitism and the Jewish catastrophe, that is, "race," into the central political narrative of German history. Yet since the 1960s social historians have attacked this tradition as conservative, elitist, in other words, as politically incorrect. Jobs in German intellectual, cultural, and political history in this tradition became harder to come by, as more openings appeared in social history. Hence, the tradition which, more than any other, addressed the issue of race, presumably a goal of politically correct multiculturalists, has become weakened and often demoralized. Rather than view with alarm the failing health of this important tradition, or make its survival a *cause célèbre* for the advocates of multiculturalism, diversity, and understanding of the "other," its passing was welcomed as yet another part of the conservative, elitist, white, Eurocentric, male academy to hit the dust. The redefinition of liberal traditions into conservative, right-wing legacies facilitated weakening them with a clear—liberal—conscience.

I want to emphasize here that I am not repeating a traditionalist complaint about the emergence of social history and women's history. They have added enormously to our understanding of German and European history. Our understanding of history has become more complex, and this is as it should be. My point is that the story is not simply a morality tale of the defeat of the racist, sexist, reactionary, elitist history of old by the new enlightened history of the present. The old history was not uniformly conservative and naively objectivist, as it is often assumed to be. In the case of German history, one aspect of the old history was more central to grasping the category of race than its supposedly more enlightened leftist and postmodernist successors. Yet, here again, the redefinition of liberal traditions as conservative traditions allows the weakening of this important tradition to proceed with a clear or clearer conscience. If a past tradition has been humiliated with the damning labels of conservatism and elitism, there is no need to humble oneself by admitting that one is not inventing the wheel, but is standing on several distinguished shoulders.

The vogue, especially but not only in departments of literature, for a critique of Western rationality—a critique rooted in Nietzsche and Heidegger, and brought to this country via Foucault and Derrida—has been a cause of particular dismay for many modern German historians. We have looked on in amazement to see intellectual traditions central to the rise

of Nazism and fascism become an important component of supposedly critical theory in this country. As I argued in my study of reactionary modernist ideology in Germany, the antidemocratic and Nazi right wing in Weimar and the Third Reich saw a unified Germany as the alternative to a soulless modernity. Of course they resisted the idea that the problem lay not in modernity but in the illiberal manner in which Germany became modern. After 1945 it was understandable that unrepentant Nazi intellectuals like Heidegger would prefer to moan and groan about the dilemmas of modernity, displace the proper noun "Germany" from discussion of the past, and cast doubt on the possibility of establishing causality in history. After all, aside from all the intellectual issues involved, many German intellectuals after 1945 had a direct and vital interest in obscuring the possibility of fixing moral and political responsibility for Nazism's crimes.

The problem for historians of Nazism posed by deconstruction has been well stated by Jane Caplan, a German historian whose earlier work was influenced by neo-Marxism:

> To put it bluntly, what can one usefully say about National Socialism as an ideology or a political movement and regime via theories that appear to discount rationality as a mode of explanation, that resist the claims of truth, relativize and disseminate power, cannot assign responsibility clearly, and do not privilege (one) truth or morality over (multiple) interpretations? (Caplan, 1989, p. 274).

Indeed, Caplan is quite right. Reading the trial records of the Nuremberg war crimes trials, it occurred to me that postmodernist theorists of recent years would lend weight to the rejection of the trials as nothing other than "victor's justice." On the one hand, today, past liberal traditions are redefined as conservative. But on the other, traditions which contributed to the development of fascist and Nazi ideologies become part of the hip, ironic, playful—and morally irresponsible—armory of parts of the contemporary academy. Rather than being indicative of theoretical profundity, the postmodernist vogue seems to me to be a case of historical amnesia, or perhaps historical ignorance. The idea that there is a dark side to the Enlightenment is now a commonplace in social theorizing. I would like to see scholars influenced by postmodernist theories acknowledge a theme that has been far more prominent in the historiography of Nazism: the dark side of the counter-Enlightenment.

As the *Historikerstreit,* or historian's dispute, in West Germany of the mid- and late 1980s has made clear, the impulse to push the Jewish catastrophe, and anti-Semitism, out of the central themes and master-narrative of German history does not come only from the deconstructionist

and postmodernist left. From a postmodernist perspective, such master-narratives—including those presented in the opening and closing statements by the prosecutors at Nuremberg—are arbitrary impositions of power. The argument is sometimes made that there are no (or ought to be no) such master-narratives. Such arguments often assume all power is bad, yet without power, including military power, neither slavery in the South nor the Nazi regime could have been destroyed. Postmodernists, it seems, have trouble linking power and the growth of freedom. On the other hand, some West German conservative scholars, laden with *ressentiment* at the burden of German history, and angry at the Jews for reminding them of their country's dark past, have also sought to push the Jewish catastrophe out of the center of German history or to diminish its impact by comparing it to the Soviet Gulag. Or, as was more common in the postwar decade, they—in an interesting parallel to theorists of modernity and postmodernity on the left—drop the proper noun "Germany" from discussion, and wring their hands about the modern world. Saul Friedlander, during the West German *Historikerstreit,* and in response to the American reception of postmodernist theory, has pointed out how such politically opposed standpoints can lead to the similar result of obscuring the specificity and uniqueness of the Nazi Holocaust (Friedlander 1987, 1989, and 1992). But the challenge to liberal historiography of modern German history in the United States does not come primarily from such an intellectual right but from the cumulative effect of criticism from the modernist and postmodernist left. Moreover, important contributions to our understanding of Nazism and the Holocaust have come from conservative historians, including some West German military and diplomatic historians.

I want to put this as bluntly as possible. The entry of the Jewish catastrophe into the main themes of German history was a great accomplishment of Jewish and German historians, who were all deeply bound to the values of the Enlightenment liberalism and to the highest standards of scholarship. We are proud of that accomplishment, and will defend it fiercely against the idea that there is no central historical narrative or that all narratives are of equal historical significance. We will also oppose a return to a central narrative in which the Jewish catastrophe plays the subordinate role it used to play before challenges from the periphery moved it into the scholarly center. We do so both from our deepest moral convictions but also as historians, for, in Ranke's terms, this is the way it really was, not only in our imaginations, narratives, tropes, discourses, and representations but objectively, in incontrovertible fact.

I use the term "incontrovertible" intentionally to stress that, while there has been and will be debate among historians about why and how

Nazism and its crimes took place, there is no debate among them about whether these crimes occurred. That debate does not take place because we share common standards of evidence and argument, on the basis of which that argument has been settled once and for all. If postmodernist literary theory seeks to make historians conscious of the impact of the narrative and linguistic strategies which they already use, but often unconsciously; to restate old insights about the impact of our subjective standpoint on the aspects of the past that are of interest to us; or to make intellectual and cultural historians think in fresh ways about the complexities of understanding a text, then, at most in my view, it offers contemporaneous versions of some of the major traditions of history as a humanistic discipline. But it claims more, much more. As Gertrude Himmelfarb has recently argued (Himmelfarb 1992), the postmodernist blurring between fact and fiction, and its assumption that all knowledge is the product of power, weakens the discipline of history as such. The emergence of such a discipline in the nineteenth century, with more rigorous standards of evidence and argument, was a democratic challenge to those who would impose a story about the past and insist it be accepted on faith, or due to power, and in either case without evidence and sources accessible to the reader. Far from being an authoritarian development, this discipline was a challenge to unaccountable power. That all historians have not lived up to the highest standards of objectivity, or have falsely presented subjective judgement and interpretations as objective, is a commonplace observation, but not one that justifies abandoning the effort to differentiate fact and fiction and truth from error. Without such distinctions, there is no justification for departments of history in universities.

This critique of postmodernism is politically multivalent. It is not shared political opinions that link critics of postmodernist history such as Saul Friedlander (Friedlander 1989 and 1992), Gertrude Himmelfarb (Himmelfarb 1987 and 1992), Lionel Gossman (Gossman 1990), and the German philosopher of history, Jorn Rusen (Rusen 1990), but shared convictions concerning how our knowledge of the past grows, namely that we are, in spite of our disagreements, able to settle some issues in order that we may go on to others. They also, as historians, share memories, both personal and intellectual, of the dangerous implications of the counter-Enlightenment project in the recent history of this century. These memories are not only of Nazism but of Communism as well. Both of the central totalitarian ideologies of this century attacked notions of objectivity, common standards, and rules of evidence in favor of forms of what have been called identity politics.

I have dwelt on the scholarship on Nazism to indicate that even in an area of concern addressed by the politically correct of recent years—

"race"—those who did the most to raise the issue of race and anti-Semitism in the study of German history were made to seem politically incorrect. But in German history another area—the Cold War and Communism— became the subject of taboos as well. It became unacceptable in large parts of the academy to criticize Communism and/or any protest movements of the left anywhere without equivocation; to take seriously the possibility that the Soviet Union might actually have posed a threat to Western Europe; and, perhaps worst of all, to offer arguments and evidence that would lend plausibility to the claims of the Western and American foreign and defense policy during the Cold War in Europe. These taboos were not the result of identity politics or postmodernism. They were the consequence of the academicization of the anti-anticommunism of the 1960s. To break with these taboos, as I did in *War By Other Means,* a 1991 study of the interaction of political culture and power politics in West Germany before and during the disputes over nuclear weapons of the early 1980s, could unleash the kind of righteous indignation which gave scholars responsible for intolerance and job denials a clear conscience. Even the collapse of Communism in Europe and the Soviet Union has not fostered a soul-searching about past positions, nor some delayed generosity and respect to those of us who argued that Western policy had something to do with the collapse of Communist dictatorships. How much our knowledge of the history of the Cold War will be slowed by these taboos remains to be seen.

Thomas Nipperdey put it well. Every moment in the past was something more than the prehistory of that which followed it. It had multiple possibilities, and the lost causes were not, for that reason, the bad ones. It was not so very long ago that today's victors in the American cultural wars were consoling themselves with folk songs about the nobility of their own lost causes. As I have pointed out in regard to the tradition of German liberal historiography, it is not the case that the losers of recent years are the racists, sexists, and advocates of inequality they are often made out to be.

The attack on the liberal traditions of the university of the past twenty years has greatly enhanced the ease with which scholars can be labeled to be politically incorrect. The postmodernists continue the attack on liberalism that the New Left renewed in the 1960s. The first targets of the purge were white males with conservative views in the humanities and social sciences. Then it was the turn of the white males who thought they were liberals but were redefined as conservatives. Now, some white men who remain loyal to their New Left views are feeling the heat.

Yet the focus on the racial, gender, and class background of the offending scholar obscures the deeper and more frightening aspect of the

unfolding purge mentality. For the attack on shared standards and norms of scholarship is an attack on the idea of the university, an idea which contains within itself the much discussed value of *difference*. This attack gains its appeal from its hatred of those who have been distinguished from others, that is, who have indicated their difference from others with their scholarly, intellectual, and creative talents. The hatred of these others builds on resentment of their talent, the ease with which they write and speak, their capacity to spend long hours in archives and libraries, the pleasure they take in their scholarship, and the recognition they receive because of it. Few things arouse rage and resentment so much as the much-deserved success of those with greater talent and ability. In this climate, the worst label of all to wear is that of conservative. Yet the erosion of shared norms of excellence in the disciplines makes all excellent scholars suspect. They are suspect because, not in spite of their excellence. Their creative abilities, their scholarly diligence and boldness, their fame and recognition arouse resentment and jealousy among those who have come to despise the traditions of the university. Anyone with a fine and independent mind must arouse suspicion from those who wish to enforce conformity, because such a mind is, by its nature, unpredictable.

Parts of the academic left participated in the first years of this purge. They are not all-powerful, and have not won every battle, but neither have they been without influence, especially at the universities at the top of the prestige hierarchy. They have often been strong enough to prevent the employment of ideological deviants, if they chose to do so. Yet the left has its own traditions of tolerance that reflect its own enlightenment and liberal legacies, as well as memories of intolerance during the McCarthy era. Are there scholars who are now anxiously wondering who's next? As positions change with bewildering rapidity, fewer and fewer can be sure that last year's politically correct position is still valid this year. It becomes less certain who will move from the damned to the saved. In this climate, producing excellent scholarship becomes a drawback, so energy is poured into establishing and maintaining the status of a well-certified victim, and into banishing dangerous thoughts.

It is not hard to imagine how the previously politically correct move from being among the saved to the damned. Leftist male scholars become representative of repressive Western rationality; feminist historians who write and speak well are guilty of succumbing to patriarchal norms; black scholars who deviate from the proper topics of research or who take incorrect positions on others have fallen prey to the bourgeois, white values of the hegemonic, racist academy; homosexual scholars who now share the postmodernist critique may themselves be accused of using heterosexist norms. The history of this and previous centuries indicates that erosion

of shared standards of merit, achievement, and excellence does not unleash an era of splendidly anarchic creativity. Rather—as de Tocqueville, but also Nietzsche pointed out—it unleashes a hatred of otherness, of free spirits, of those who dare to differentiate themselves from others. The rhetoric of diversity and respect for the other masks the reality of hatred and resentment against scholars whose strength of mind and character makes possible otherness and diversity. In short, the same rage directed against the "reactionaries" of recent years can easily be turned against the politically correct of today. As scholars run for cover to avoid otherness, the growth of knowledge slows to a crawl.

Preservation of academic freedom, it is important to note, especially in the context of a book interrogating the relations between economics and ideology, will cost money. Those of us who have committed ideological crimes and methodological deviations are people who publish; to hire us means hiring at more senior levels at higher salaries than new Ph.D.s receive. The fiscal pressures in universities in recent years are such that it is very difficult to do that, and most positions are at the entry level. Administrators should be told that, if they are serious about wanting to protect academic freedom, it will be necessary to find the money to hire people either courageous or foolish enough to publish dissenting views in a particular discipline. A period of financial cutbacks is thus bad for us as well, because it reduces the job openings that could facilitate enhancing diversity of viewpoints. The academic establishment has acted with intolerance in too many instances. More diversity requires more funds to hire scholars who have challenged existing orthodoxies.

With Nipperdey, I want to defend modernity, growing complexity, and enlightenment. I want to defend and support the contributions of my colleagues doing social history, new cultural history, and women's history. But I will not dismiss political, intellectual, military, diplomatic, and economic history as relics of an unreflective, reactionary past. Without common standards, scholarship loses legitimacy, and is no more than reflections of the momentary balance of power. Threats to academic freedom in the universities are real. Scholars can and ought to stand up against these threats. They can do so without lurching backwards into a new traditionalism, or rejecting the complexity which is the burden and pleasure of living in a modern world.

WORKS CITED

Arendt, Hannah. 1951. *The Origins of Totalitarianism.* Cleveland and New York: Meridian Books.

Aschheim, Stephen. 1992. *The Nietzsche Legacy in Germany, 1890–1990.* Berkeley and Los Angeles: University of California Press.

Bok, Gisela. 1988. "Geschichte Frauengeschichte, Geschlechtergeschichte," *Geschichte und Gesellschaft*, 14, pp. 364–391.

Bracher, Karl Dietrich. 1970. *The German Dictatorship*. New York: Praeger.

———. 1976. *Zeitgeschichtliche Kontroversen um Faschismus, Totalitarismus, Demokratie*. Munich: Piper Verlag.

Caplan, Jane. 1989. "Postmodernism, Poststructuralism, and Deconstruction: Notes for Historians," *Central European History*, vol. 22, Nos. 3/4, September/December, p. 274. The entire issue is devoted to controversies concerning postmodernism and German history.

Dawidowicz, Lucy. 1981. *The Holocaust and the Historians*. Cambridge, MA: Harvard University Press.

Friedlander, Saul, ed. 1992. *Probing the Limits of Representation: Nazism and the Final Solution*. Cambridge, MA: Harvard University Press.

———. 1989. "The 'Final Solution': On the Unease in Historical Interpretation," *History and Memory*, vol. 1, No. 2, Fall/Winter, pp. 61–73.

———. 1987. "Überlegungen zur Historisierung des Nationalsozialismus," in Dan Diner, ed., *Ist der Nationalsozialismus Geschichte: Zu Historisierung und Historikerstreit*. Frankfurt/Main: Fischer, pp. 34–50.

Furet, François. 1981. *Interpreting the French Revolution*. New York: Cambridge University Press.

Gossman, Lionel. 1990. *Between History and Literature*. Cambridge, MA: Harvard University Press.

Greenfeld, Liah. 1992. *Nationalism: Five Roads to Modernity*. Cambridge, MA: Harvard University Press.

Hayes, Peter. 1991. "Introduction," *Lessons and Legacies: The Meaning of the Holocaust in a Changing World*. Evanston, IL: Northwestern University Press, pp. 1–10.

Herf, Jeffrey. 1984. *Reactionary Modernism: Technology, Culture and Politics in Weimar and the Third Reich*. New York: Cambridge University Press.

———. 1986. "The 'Holocaust' Reception in West Germany: Left, Right and Center," in Anson Rabinbach and Jack Zipes, *Germans and Jews Since the Holocaust: The Changing Situation in West Germany*. New York: Holmes and Meier, pp. 208–233.

———. 1991. *War By Other Means: Soviet Power, West German Resistance, and the Battle of the Euromissiles*. New York: The Free Press.

Himmelfarb, Gertrude. 1992. "Post-Modernist History and the Flight from Fact," *Times Literary Supplement*, October 16, pp. 12–15.

Kaplan, Marion A. 1991. *The Making of the Jewish Middle Class: Women, Family and Identity in Imperial Germany*. New York: Oxford University Press.

LaCapra, Dominick. 1983. *Rethinking Intellectual History: Texts, Contexts, Languages*. Ithaca: Cornell University Press.

Luhmann, Niklas. 1982. *The Differentiation of Society*. New York: Columbia University Press.

Maier, Charles. 1988. *The Unmasterable Past: History, Holocaust and National Identity*. Cambridge, MA: Harvard University Press.

Mason, Timothy. 1969. "The Primacy of Politics: Politics and Economics in National Socialist Germany," in S. J. Woolf, ed., *The Nature of Fascism*. New York: Vintage Books.

Merker, Paul. 1972. *Deutschland: Sein oder Nicht Sein*, 2 vols. Frankfurt/Main: Materialismus Verlag.

Meuschel, Sigrid. 1992. *Legitimation und Parteiherrschaft in der DDR*. Frankfurt/Main: Suhrkamp Verlag.

Mosse, George. 1964. *The Crisis of German Ideology*. New York. Grosset & Dunlap.

Muller, Jerry Z. 1987. *The Other God That Failed: Hans Freyer and the Deradicalization of German Conservatism*. Princeton: Princeton University Press.

Neumann, Franz. 1944. *Behemoth: The Structure and Practice of National Socialism, 1933–1944*. New York: Oxford University Press.

Nipperdey, Thomas. 1986. *Nachdenken über die deutsche Geschichte*. Munich: Beck.

———. 1980. "Geschichte als Aufklärung," in Michael Zöller, ed., *Aufklärung Heute*. Zurich: Edition Interfrom, pp. 50–62.

Novick, Peter. 1988. *That Noble Dream: The "Objectivity Question" and the American Historical Profession*. New York: Cambridge University Press.

Rusen, Jorn. 1990. *Zeit und Sinn: Strategien historischen Denken*. Frankfurt/Main: Fischer Taschenbuch.

Shils, Edward. 1981. *Tradition*. Chicago: University of Chicago Press.

———. 1983. *The Academic Ethic*. Chicago: University of Chicago Press.

Stern, Fritz. 1965. *The Politics of Cultural Despair*. New York: Anchor Books.

Volkov, Shulamit. 1990. *Jüdisches Leben und Antisemitismus im 19. und 20. Jahrhundert*. Munich: Beck Verlag.

White, Hayden. 1978. *Tropics of Discourse: Essays in Cultural Criticism*. Baltimore: Johns Hopkins University Press.

Zimmerman, Michael. 1990. *Heidegger's Confrontation with Modernity: Technology, Politics, Art*. Bloomington, IN: Indiana University Press.

Money, Merit, and Democracy at the University:
An Exchange

This discussion took place after the conference presentations by Paul Lauter, Michael Apple, Barry Gross, Jeffrey Herf, and the editors, and focuses on the issues brought up in their papers and in the debate that followed. As far as we know, it is the only published record of a substantial dialogue between conservative and progressive academics about the future of higher education. It is, of course, easy enough to find polemical essays across the spectrum of such positions, but until now there was no example of academics of the right and the left actually talking with one another, a process that happily blurs the familiar political dichotomies. The participants, notably, include both members and national leaders of several academic organizations recently formed to take these issues to the public— the National Association of Scholars, the Union of Democratic Intellectuals, and Teachers for a Democratic Culture.

JOAN SCOTT: My question is for Paul. You said that our primary problem is to organize as much as to analyze, yet I wonder if there aren't a few critical pieces left to analyze in the problem (which doesn't preclude organizing). PC is one piece of the effort to delegitimize or cut higher education budgets, but another piece is more insidious and less analyzed. It's the argument advanced very clearly in California by Pete Wilson, among others, that addresses the question of who's entitled to education, or of what the public democratic entitlement of education is. He said we have to raise student fees because students have been getting a bargain for years. In other words, education is something to which people haven't been entitled; they've just been ripping off the state. All of these kids going to school when they either didn't have a right to, or didn't deserve it! The attack on the notion that education is something people are entitled to is prevalent everywhere, and not analyzed enough, and I think it's tied

to the notion of organizing. Because if what you say is true, if students are bearing the brunt of it, it's students who should be making the biggest fuss about not getting something they deserve or something to which they are entitled, and it seems to me these arguments undercut that possibility. If, as part of the privatization of the whole society, the notion of public community social entitlement is talked away, then the grounds on which to organize to protect that right are also being talked away.

PAUL LAUTER: I think you've opened a wonderful and fundamental issue. It can be framed in the terms in which you put it: as a society which sees everything in individualistic, privatized terms, against a society which has a polity that sees community in such a way that it begins to be manifest in the educational world. Is higher education simply a process by which students accumulate the credentials and the learning they need to move forward, economically and in terms of status, or is higher education a community value, is education in general a community value, which we believe it's important for the community to pay for? That is part of the struggle that has gone on in this country since the beginning, and there have been very different views of it, as was illustrated by the arguments over whether the state should pay for education in the South after the Civil War—and, indeed, before. That's really what's being argued. It's very hard to make the case in the public right now for community values, because "community" means Communism; it's everything that sits over there on the left, that people try to discredit. The reigning ideology set in place during the 1980s was precisely this view of individualistic education as the credentialing process by which people became increasingly wealthy. Now, if you buy into that, of course it follows that students ought to pay for it themselves, just the way you pay for a course so you can get a job; that's the beginning and the end of it. However, if you see what goes on at a university as valuable to the entire community, and indeed, if you see education's potential for democratizing and unifying the sort of very divided community we have now—which was certainly one of the reigning ideologies at the turn of the century in this country— if you see it that way, then Pete Wilson's entire approach can be effectively countered. The reason I try to give organizing pride of place over analyzing isn't that I don't think a lot of analysis of the sort you were just making doesn't have to be done; I think it does. But I think what we analyze changes, and the way in which we express it in the public changes as that organizing process goes on. One sees that in those few instances when students have in fact been active. At Old Westbury, for instance, it was wonderful to see the students actually resisting the kind of cutbacks I was referring to in the African-American music program, getting out there

and challenging the fundamental question, which was state allocation of funds overall. We learned from that process and were encouraged. CUNY students have been doing similar kinds of things at a somewhat lower level of visibility. I think there's a lot more activism, in fact, going on around the country among students.

MICHAEL BÉRUBÉ: Can I just add one thing to Paul's comment? Talking about higher education in terms of entitlement brings up one of the most difficult issues we have to face. If you go back to the reign of Vice President Agnew, I think one of his most memorable comments, for the present context, is his claim that he never believed that it is the right of every American to go to college. And that's a very hard thing to debate. Speaking of higher education in terms of individual investment, as Paul points out, pretty near occludes the possibility of talking about higher education in terms of the national interest, or the community interest. And what I think Paul's driving at is that, if we go on the track we have gone on, we're going to end up with an educational system that looks a lot like the health care system: terrific services for the people who can afford them, and whatever you can cobble together for everybody else. So we're going to have to make the same kind of case for higher education that is now, only belatedly, being made for health care: that it is in fact a national investment, that it is in fact in our interest, economically and ideologically, to promote this broadened access for as many people as possible.

CARY NELSON: One other thing is that, whatever status the ideal of public commitment to universal access to education still has in the country, the reality of education practices belies it continually. The huge disparity in funding between suburban schools and inner-city schools pretty much demonstrates to people by material practices that access to education is not equal. So the material practices tend to undermine any ideology of equal commitment. There needs to be a public debate in which we can air the notion that determining people's access to education by their family income is wholly inimical to any notion of a democratic culture.

GREG JAY: I want to ask Michael Apple a question, and it has to do with Paul's essay and Michael's, and the different ways they address the question of what the purpose of higher education and education in general is. On the one hand, we get a critique that says that what's wrong today is that more and more students are not being given access to higher education, and that this is a class-based and race-based exclusion, which will keep them in poverty and prevent them from attaining the economic mobility and the economic development they have a right to. On the other hand,

you provide a critique of vocationalism that argues against seeing the university as a place primarily devoted to training workers. How we negotiate between the very popular discourse in which the goal of education is to train workers—and most of my students, and I teach at a working-class university, take that goal very seriously—and the discourse in which education ought to be, finally, a training in citizenship, or even something more philosophical than that, but that it ought not to be tied to the program of an economic enterprise. If we're going to negotiate in public with the powers that be, with state legislators, with parents, and with students, we certainly can't do it on the basis of a position—and I'm not ascribing this position to you, necessarily—that seems to reject out of hand the relationship between education, work, and economic advancement. So how do we negotiate between these two positions of training for citizenship and training for work, without selling ourselves out in one way or another?

MICHAEL APPLE: It's an easy question. No, actually it isn't. But there are a couple of things that I want to say about this. My argument was something like this: to the extent that we limit our discussion about higher education to the question of simply distributing knowledge equally to people, we're mystifying at least one half of what the university does. Universities are part of the form of commodity markets, in which there are complicated relations of exchange. I don't think saying that is anything radical; I think it's just something we have to understand. It may be radical in its implications, but it is not only about mobility patterns among people who have none now, and who never had any. It's about something else; the institution does something else. Since the institution is part of the state apparatus in some ways, it's caught in a very contradictory form, and you can't have an institution that has two competing goals at the same time and expect to do both of them equally well. And one of the goals that is forced upon universities—as well as aggressively grabbed by certain sections of the university—is the production of a particular kind of knowledge that can be sold.

That's a very complicated issue, and I'm literally only pointing to it. But you can't interrogate the production of saleable and "useless" knowledge at the same time as you would strengthen the popular—though I think partly unfounded—belief in the discourse of mobility. Paul said something earlier about student bodies which I think is strikingly apposite, and I'd like to give you a similar example. I teach in a school of education as well as in sociology, and we now have a situation where the tuition rises are so extreme that we have no students whatsoever within the entering class intending to become teachers at these beloved schools that we

love to criticize. There is no one who is from the working class, by whatever measure you use, not one. There is one person of color; she is the daughter of a Korean doctor. I don't mean to dismiss what it might mean to be Korean, but my point here is that we have a situation in which the institution is caught in a serious structural dilemma. And you can't do both at the same time, hold out the fiction of mobility towards work and foster a training in citizenship regardless of the economic enterprise. Besides, to hold out the fiction of mobility towards work is to naturalize particular kinds of discourses that worry me.

One effect of this is that it naturalizes what we count as "work." I want to find out what we mean by that; right now, with the emphasis at community colleges on what is called tech prep, it means simply the production of human capital for jobs that don't exist. Remember, three-quarters of the jobs in the United States were created in the service sector over the last decade. Three-quarters of those jobs paid one-third less than the current average annual wage. It doesn't require a hell of a lot of skill to push the button on a McDonald's machine that says Big Mac. On the other hand, and this is the dilemma, while I think we want to denaturalize what we mean by work, what about the unpaid labor of women, what about the reconstructions that have gone on over the Reagan-Bush years about what counts as full-time work and what counts as paid work and unpaid work? While we want to deconstruct that sense of "work," we also want to talk about the reality of the present, material connection between education and that standardized definition of paid work. That is different from saying that vocation is an essential, that vocational training is essential. I think education should be about something very different from a connection between paid or unpaid work. Remember, women in this society are being prepared for two labor markets. Even after numerous, partly successful, feminist struggles, women are still prepared for paid labor and unpaid labor; that's the way schools function. And we need to begin to think through, very carefully, what it means to have an education that isn't just a preparation for these fictitious jobs that are being transformed. Education is about critical literacy, it is about a struggle to name the world; that goes on even if there is no connection between schooling and paid work. That is what cultural struggle is about.

TODD GITLIN: In the spirit of Joan's remark, I'd like to append one. I'm in sympathy with much that Paul says, but I think there's a disconcerting tendency here that I would caricature as "left leg good, right leg bad." That pins the responsibility for the crisis in higher education strictly on fabrications. I want to mention a few things that won't fit into this model. One of them is that the primary rationale for public higher education in

America for forty-plus years was the Cold War, and the collapse of the Cold War as a rationale is part of what enables Pete Wilson and his ilk to stand up now and redefine higher education as strictly a private good. The loss of the public rationale is a problem for us on the Left that hasn't been faced seriously as an object of organizing. The proof of it is what has happened while tremendous energy has been spent by campus identity politicians organizing their own niches and protecting their own turfs; while those battles were being fought we lost the war. The emphasis has been on what constructs segregated identities rather than on the collective interest of education and indeed the society as a whole. Thus there's a problem for those who want to say that the upsurge of identity politics is an unadulterated blessing, or even as Paul had it, a somewhat adulterated blessing. I think this is far more troubling than has been generally recognized.

The second factor I want to mention has to do with yet another structural force that has undermined the funding of higher education, and that is the so-called taxpayer revolt, for which 1992's liberal—or I should say left-liberal—darling, Jerry Brown, deserves heavy responsibility—as do the media, which have been far more interested in the excrescences of political correctness than in the general institutional problem of higher education. And again, while what calls itself the left has been so preoccupied with its purification rituals, it has squandered any interest in, let alone a serious attempt at, talking seriously about tax inequities. Now perhaps this is an event lost in the arcana of California history, but let me mention that the reason why Proposition 13 passed in California in 1978 was first of all that Jerry Brown, in order to protect his political reputation, thought it important to keep a state surplus going; Jarvis and Gann and other right-wing ideologues used the existence of the surplus to argue that the state needed to be defunded. Secondly, the fact that Jerry Brown would not support a progressive property tax reform left the cause of property tax reform in the hands of the bad guys. Here again, left-wing defensiveness is not a help.

LAUTER: Yeah, I agree with you, Todd, except on one thing. I've been very critical of identity politics, but, you know there's an old political saying that you can't beat something with nothing. And when you think about what's offered out there, particularly in, let's say, South Central Los Angeles, what has been offered aside from forms of identity politics that, one way or another, young people there can buy into? That's a serious problem, one we generally don't address. I think identity politics on university campuses, by and large, has had, as you say, to do with the protection of turf, often if not always. On the other hand, it's also the case

that programs animated by identity politics extend beyond the university in ways you don't see elsewhere on the campus. Now, I think that's also a criticism of the left, because there has not been the development of both the intellectual base and the organizing process of alternatives.

GITLIN: I just would like to add—just to give a sinister example of how monstrous this can become—that I'm reliably informed that the black student union at San Diego State supported the president in making his cuts, because he set out to eliminate humanities, German, Sociology, Aerospace Engineering, and I forget which other programs, but explicitly protected the African-American Studies program.

LAUTER: I've been told the same thing.

JERRY WATTS: While that's fascinating about the black students at San Diego State, we don't want to get caught implying at any level that the campus president was actually *listening* to them. But, more important, I just want to throw something back to you all. Implicit in this dialogue is a discussion about the potential for making the university more democratic. And I just want to say that it's much more problematic than you all have suggested, partly because academic intellectuals, probably including many in this room, have had a vested interest in maintaining an antidemocratic higher education system. Many of us live off of the largesse of capitalist exploitation, whether it's at private schools, elite universities, or whatever, because it provides the space to do our research, have our facilities, and so forth. We get up here and act as if, in fact, we're authentically interested in a democratic higher education system, but what in the hell are we actually willing to give up ourselves? We often talk honestly about wanting access for more Americans to higher education and the public arena and so forth, but it's another thing to act like that's synonymous with the democratization of American higher education. Many of us are at flagship state schools or at private schools with distinct privileges. Indeed, I've always been struck by the fact that scholars on the left, as much as anybody, have fallen over themselves to get to the most elite environment they can possibly get to. They're also driven by the crass impulse to status acquisition. And all the while we're claiming to be counterhegemonic. We talk about greater access for people, but there's a certain hierarchy that we buy into nevertheless, because it privileges our voice, allows us the space to speak, gives us authority as intellectuals and so forth, and we can't deny that. We can't deny the materiality of our own ambitions, which are not necessarily synonymous with a democratic society.

LAUTER: I think that's absolutely right, Jerry. I know it from my own personal experience. I spent seventeen years at Old Westbury, which was a very different kind of institution from Trinity, and which ended up, I think, for many of us, being an institution that made for just enormous frustration: much more direct interaction with communities of students who had been excluded, much more struggle—the students went through three student strikes, and many of us were involved in those, one way or another. But the fact of the matter was that, after ten or twelve years, many people, including myself, began to think about going somewhere else. And it's precisely that we had those options, and that those options were possible to pursue and to live with, that gives a lot of weight to what you're saying. So I think that's true. It's also, however, true that there's a kind of dialectic involved. Old Westbury—a school which was fifty percent, sixty percent minority, and, what's more, made up of students from economically very poor environments—was starved by the state. Part of the problem was that elsewhere in the state university system, and in the state of New York, there was no political will, political organizing or analysis, that provided support for a different kind of state funding for such a college. You went to meetings, you beat your head against the wall, went to the unions, organized in them, organized in the State Senate, I mean you did all of those kinds of things, but the fact of the matter was that the majority of people who came from the same backgrounds as the students, and the majority of people who had an interest in change, were located at Old Westbury and they were ghettoized.

BÉRUBÉ: One of the things Jerry's comment brings up is the question— and this always hamstrings the academic left—of how sincerely you can argue for democratization from these relatively privileged locations. I should stress the "relatively," of course. And it's perfectly possible and right to point out that a lot of people doing it, ourselves included, are fairly insulated from the things we criticize. One of the ironies of the conference, which we shouldn't overlook, is that Barry Gross sees many more underprivileged minority students than anyone at this table. I also think it's right to say that we tend to elide the question of access with the question of democracy.

However, I do know what the alternative is. I do know what it means when Albert Shanker shows up, as he did in the summer of 1992 at a conference on education—alongside Chris Whittle—and says, well, the problem is that the high schools have no incentive to encourage excellence because the colleges take everybody, and what we need to do is basically choke off the colleges and then you'll see high school standards go up. I know that kind of market meritocracy will *not* work in the service

of social democratization, and I know that broadened access at least has the chance. So let's keep an eye on where the important antagonists are.

JEFFREY HERF: I'd like to make a couple comments about democratization and elites, and the most effective way of making the case for public support or private support for higher education. But first I want to comment on Paul Lauter's lack of civility. Fortunately, this is not a conference of the left alone, it's a conference that brings together people who can disagree. People can disagree and still be intelligent and decent people. I lost track of all the adjectives of abuse you filled your talk with, but just a few were "flacks," "reprobates," "mockingbirds," and "charlatans." This is not the kind of thing that encourages a rational discussion among adults, and it's not the kind of thing that encourages a rational discussion in universities. One of the reasons for preserving universities is that they are supposed to be one of the few places in this society where people can get together and talk rationally to one another. You didn't set a good example.

Speaking in terms of social science, you connected two phenomena: cutbacks in higher education, and conservative criticism of intellectual trends within the universities. As any social scientist would tell you, correlation is not causation. And Todd Gitlin suggested a few other reasons. The country is in difficult economic times. One of the reasons, perhaps, that there have been cutbacks is that public higher education benefits primarily the middle and upper-middle classes. And perhaps hard-pressed governors and mayors feel that there are a lot of poor people who need the money first. I don't know.

My main point, though, is this one. Universities and colleges are and ought to be elitist institutions. They are institutions devoted to an elite of intelligence and cultivation and this will always be an unpopular idea in a populist democracy such as this one. This will always be an idea surrounded with resentment, distrust, and lack of respect. It has been that way for the entire history of this country, as de Tocqueville understood, and nothing has changed. The institution of tenure originates in feudal Europe. It is a profoundly antidemocratic and elitist institution, and Joan Scott and Todd Gitlin and any number of prominent and distinguished left-wing professors would be out of a job if community standards and democracy determined the content of our curriculum and the nature of our faculties. Tenure is an absolutely crucial institution to defend difference, to defend dissenters, whether they are on the left or on the right, in the middle, what have you.

And in making the case for public support for education, I do not think you will be successful if you tell the lie that public higher education will give you all a job. Because it won't. You must be honest, you must

say that universities have limited purposes, one of which is to pursue important truths, truths about important matters. These may be good for nothing in economic terms, but we think they are intrinsically valuable. And if you are a civilized country, and you want to support that kind of endeavor, then you have to understand that you have an elitist institution in your midst which will only admit students who are able to deal with the demands it places on them, students who treat it as a privilege, not as an entitlement, to attend such institutions. Otherwise, in making the case for democratization that you've made, you will subject universities to outside pressures which will be far more dangerous to left-wing faculty than anything we've seen up to now. So in your own self-interest—not to mention, in my view, the interests of the university as an institution that is centuries old—it is crucial to defend its elitist character, not in the sense of an elite of race, or sex, or money, but an elite of the mind, where people from all kinds of different backgrounds meet on that common terrain.

BÉRUBÉ: Thanks, Jeffrey. I appreciate the critique. But first of all, I think you misconstrued part of the argument. I'm sure Paul will speak to this too, but even though it's undeniable that there are other, more benign interests behind the defunding of the universities, Paul's case was meant in part to demonstrate that recent cuts have hit the poorest students hardest. And although university education is widely perceived as a middle-class and upper-middle-class affair, state cuts hit the lowest economic strata hardest because of the phenomenon of bumping. The second thing, about the elitism of universities: again, this goes back to the critique that we're making disingenuous claims for the diminishment of our own privileges. One of the reasons it's a good thing to have this discussion at the University of Illinois is because it's a state-supported research university dealing with exactly that contradiction: on the one hand, the expectation and the ideal of public service, and on the other hand, the procedures of research, tenure, and peer review that are undemocratic and that partake of the ideology of professionalism, which always has this tension between client service and professional self-interest. So we have an elite of the mind, but we also have to answer to the state legislature. That imperative is already there, it's not something we're importing into the discourse. And in response to the argument that democratization is dangerous, you could look at Benjamin Barber's argument in *An Aristocracy of Everyone*, where he says the point of democratization in education is not the levelling down to some lowest common denominator, but education for excellence, so as to raise people to some higher common denominator, at which that elitism of the mind is, at least in principle, available.

Finally, I'd like to take issue with your remarks about the institution of tenure—which remind me about what gives the title of Roger Kimball's book its purchase, since *Tenured Radicals* names a supposedly self-evident contradiction. One of the recent books on the crisis of higher education, *Up the University* by Robert and Jon Solomon, does advocate the abolition of tenure, and you could give it a look. But in defense of people like Joan Scott and Todd Gitlin, you know they'd be the people who'd do *best* if we abolished tenure and had something like a ten-year rotating contract instead, because these people are among the most productive and interesting around. And you'd have a very high generational turnover very quickly, which would take some fields further to the cultural left than they've gone already.

NELSON: Can public universities ever overcome the tension between elite and democratizing impulses? In this culture, they're always going to be burdened with that tension; I don't see any easy or appealing way of resolving it by opting for one of those forces or the other. Both impulses in fact have productive programmatic consequences.

LAUTER: I think there's a way of unpacking that, though, that gets to what Jeffrey is talking about. Universities serve many purposes, and one of the problems that I have when people talk about the university is that it lumps all of these very different institutions—and universities and colleges in particular—into one pot, as if they're similar, and they're not. The differences among institutions of higher education in this country are enormous, they just have nothing to do with each other. I visit a lot with people in community colleges, for example, in New Mexico or in places in California, and they have nothing to do with the flagship universities; in fact the students have nothing to do with them either. The transfer rate is—well, publicly, people will talk about fourteen percent, but it's probably lower than that. There's an enormous difference among institutions, and what different universities do is very different, they serve many different functions.

As for the tension over the question of tenure: there's always a problem and a tension in democratic polity over representation itself. You can have the most democratically elected representatives in the world, and yet they will, in the course of time, and probably fairly early on, begin to act, in part, out of their own self-interest. They will perceive everybody's interest as their own interest. There is a real tension in any form of representation, including that form of representation which goes on in a university and in a college, so I think the question of tenure and the elitism of universities is part of larger contradictions inescapable in democracy

itself. It's not peculiar to the university. I wish it were the case that we could have a real debate, with, say, Pete Wilson, over whether money should go to health care and welfare in South Central LA, or whether it should go to the university, but believe me, I don't for a minute believe that that's what the debate is. He will do what he can to serve those people who elect him, and that isn't the people in South Central or in East LA, hardly.

I want to make two other comments, one about civility. I take those criticisms with seriousness, Jeffrey, but I also meant what I said. That is to say, that there have been charlatans, lowlifes, and reprobates—those were my terms—in universities and among intellectuals. I can think of nothing else to describe those people who set up that Aryanized version of the classics. Think of the question of where the Holocaust begins. I think it begins in that kind of characterization of Semites, that kind of talk about the depleting role of Semites on the beauty of Greek culture. That gets structured as a vision of history. Martin Bernal's book, *Black Athena,* may be inaccurate and inadequate in its analysis of ancient history, but his analysis of the development of classics as a discipline in the eighteenth and nineteenth century—and the deployment of that discipline as an intellectual rationale for Nazism and for the Holocaust and for slavocracy in this country—is a devastatingly accurate portrait, and an analysis that had not been previously made of the development of that critical part of the academic enterprise. To call that the work of charlatans, lowlifes, and reprobates is saying it mildly; it really is, Jeffrey. I don't apply that to anybody now, but that's not the point. I think some of the history of academe is a horror show. That's why I think the whole PC thing has been inflated, and that's why it is that I'm so angry that somebody like D'Souza gets taken seriously. And as far as D'Souza and Lynne Cheney and Woodward are concerned, they are peddling falsehoods. There is *no* standard of scholarship to which they are adequate—and by God, I was trained in that eighteenth-century tradition at Yale in the fifties by Fred Pottle, and we did learn what standards of evidence were. And the standards of evidence that are now cited out there by people like Cheney and D'Souza and Woodward are disgusting; they really trivialize the quest for scholarship. I would like to see real standards of evidence.

Finally, when we talk about democratization, I don't mean to construe "access" simply in terms of numbers in admissions, curriculum, or staff. By "democratic" universities I mean those that take seriously their responsibility to the communities that environ them—not just the farms of Illinois but the barrio of Hartford, where Trinity is located and has done damn little in terms of community relationship. Or the old story: where's Columbia located and what does it do? I mean, *that* seems to me

to be what we're talking about when we're talking about university access and democracy.

HERF: Well, so far the discussion here has seemed to revolve around what we could call the Nelson-Lauter Thesis, which is that there is a causal relationship between the neoconservative, right-wing, reactionary attack upon the universities and funding difficulties—cutbacks and the general fiscal crisis of the universities. Barry, I wonder if you could discuss what you think the causes of the fiscal problems in the universities in the last ten or fifteen years are, and respond to that thesis.

BARRY GROSS: I'll try. I thought Todd Gitlin answered it very well earlier. I think that the right-wingers, the neoconservatives, whatever you want to call them, would be very happy if they could take credit for the attack on universities resulting in budget cuts, but I don't think they can. I think they created a climate—notice I don't say *we*, I say *they*—I think they created a climate in which politicians could criticize higher education in a way that seemed more principled than just, "we got to get the money from somewhere, buddy, so we're going to take it from you." Nevertheless, the politicians would have taken it, as Professor Lauter pointed out, disproportionately from us; they realize that there's a lot of pork in universities. It's astonishing, you go to a university like this or Minnesota and you see these are huge places. And I walk around and I see what students are doing. They're not doing anything as far as I can see—they're in the cafeteria, they're playing billiards, they're walking around the campus. Why would you fund it? At the City University, it's become very clear— and it's part of Herman Badillo's attempt to become mayor to say this— that the City University does not turn out a graduate who is literate, even among the few graduates we *do* turn out. And that's increasingly true across the country with public higher education. Why does private higher education do better? I don't know. It may be that the kids come from slightly better high schools, although even the suburban high schools are pretty bad, on the whole. I think universities overexpanded wildly in the sixties when money looked like it was growing on trees, when there was money for everything and nobody looked down the road. Museums are in the same difficulty. The Metropolitan expanded well beyond its capacity to put guards in all its new floor space—they've doubled their exposition space in the last fifteen years—and now they disingenuously put on the television monitor, "due to lack of government funding, today the Lehman collection won't be open, the Riceman collection won't be open," but, in fact, if they hadn't built all that stuff, they could do it with the budget they had years ago. And I think that's what happened to universities.

There is a case for central planning, much as I hate to say it. And one of the things that ought to be centrally planned is universities and education, and they ought to be dovetailed together with public education, secondary education, and primary education.

HERF: That's interesting. In European countries, there are quotas on the number of students who are permitted to study particular disciplines, or enter professional graduate schools in any given year on a national basis, which is something that we would frown on here. If you're talking about central planning that's one of the things it would mean.

GROSS: Well, actually you bring up another point. When I was an undergraduate, twenty-five or thirty years ago, we had twenty-five hundred postsecondary institutions. Now we've got thirty-six hundred. There's about a hundred of these schools that turn down more people than they accept. For the rest, well, for instance, take City University: every branch of City University is enrollment-driven. If we don't get enough students, our budgets are cut, so we'll take anybody as long as they hang in there for five weeks. Because that's when the state does its accounting, then they don't cut your budget. Around the country, there isn't a student with alternative skills, with no skills, with a degree, with a high school diploma, with no diploma, who can't get into some institution, if only he or she would look hard enough. There are too many institutions, and that's part of the case for central planning. They ought, a lot of them, to cut down. Myself, I would cut down all the two-year schools and roll them into the four-year schools.

QUESTIONER: My question is for Professor Gross. First, let me say that I'm intrigued by your idea that the university ought to be more consumer-responsive. You're taking on the role of the muckraker, exposing these different costs and what goes on at the university in the interests of the consumer. I support that, and I also tend to agree with you that what you call preferential treatment programs and what I call affirmative action programs ought to be explained to the public in terms of what's going on and how much they're costing. But why didn't you talk about applying that same criterion to preferential treatment of privileged white males. You talked about the Bakke case, but you didn't mention that at UC Davis Medical School, they also had a special admissions program for people whose parents had given money to the university and who had been prominent in the state of California. Of course, most of those people tended to be privileged white men. And I hope you're not saying that these criteria of openness and consumer awareness ought only to apply to programs that

benefit women and minorities, whereas those programs that apply to privileged white males still ought to be kept in the dark.

Yet I wonder if we ought also to talk about the cost of *not* having those affirmative action programs, particularly when we look at a population generally, and a student population in particular, that is becoming more female and more nonwhite. In fact, in California the public school population is already majority nonwhite. So I wonder what the social consequences to the nation might be of not having programs that train people who are coming into the majority? What would be the cost to a university of failing to attract those individuals?

GROSS: I gave a talk a couple of years ago at Yale on preferential admissions, a subject I mention again in my paper. I was asked by some of the students what I thought of preferential admissions for children of alumni, for professors' sons, daughters, for athletes, for prominent politicians, rich donors, and I gave this answer: I said that it should never have been done in the first place; it should be cut out; it undermines the intellectual integrity of the university. So we're at one on that. Though it doesn't incur a monetary cost, I think it's wrong. I don't want to go into the comparative costs of affirmative action now, partly because my information is very sketchy, but I don't think that in terms of government compliance and regulations that need to be adhered to and central offices that need to be set up, "legacy" admissions incur those same kinds of costs. But you're right to take me up on it. I do agree that there should be one standard for all, frankly, and I think it's a racist and sexist argument to say that women and minorities would not get in under the one standard for all. About the cost of having affirmative action or preferential treatment versus the cost of not doing so: that's part of the public debate, and it's always been part of the public debate, but very few people have taken it seriously. People have either assumed dogmatically that it should be done, or that it shouldn't be done. I wrote a book on that topic, *Reverse Discrimination,* published in 1978, and I took both sides of the argument into account. Today, the ledger might look different than it looked then, but it certainly should be part of the public debate.

Incidentally, I proposed a plan, a way of making the high schools better. It was published in *Education Week,* and it was hooked to scores on the SAT, but essentially the plan was that, for students who get what I consider a modest score, a score anyone of normal intelligence with a decent high school education can get, the government should pay the entire cost of a four-year college education at any school that student is accepted at, provided that the student actually goes four years straight, absent family problems or documentable illness, and doesn't do any work

that's not associated with some scholarly project. I'm in favor of a system which is much more like the French system than what we have here, so I guess we're at one on that one as well.

LAUTER: I want to pick up something Barry just said and start a little dialogue about it, because it seems to me one of the places in which issues pinch, and that's the issue of admissions. I take it from what you said—and correct me if I'm mistaken—that you would say that those people who are most qualified should be admitted to elite institutions and that the terms of qualification are primarily objective standards—grade point averages, GPAs, board scores.

GROSS: With an emendation. I think the SATs are probably a pretty good test, but I don't think they're fine-grained enough in order to test for the large number of students. We have a really large number of students who score really highly on those exams, and they can't all be admitted to the best institutions, even if we put "best" in quotes. I would either have more best institutions—when I say I like the French model, including the *grande école* model, I'm serious—or I would like to have more rigorous and more fine-grained tests, and I would think that admission should be determined primarily on that basis, yes.

LAUTER: On the basis of tests?

GROSS: Yup.

LAUTER: But since we don't have a French model, and since the people at ETS and the College Boards and so on have been trying for a long time to develop more fine-grained tests, it seems to me that we're in something of a dilemma. There are far more people, as you just indicated, who are qualified for admission to Berkeley than Berkeley has any room for. What do you do under those circumstances? Is it not rational to begin to apply a set of social standards that might entail a form of affirmative action? To have, as one of your objectives, a heterogeneous class entering an institution?

GROSS: Why would that be rational, and why wouldn't you get a heterogeneous class anyway? The only answer that has been proposed for that dilemma, for medical and law schools—I believe they have it in Holland for medical school—is a lottery for those above the cutoff point. The problems with social engineering are, first, the problem of unintended effects, and, second, the problem that the social engineering goes the way

the people who are in control want it to go. I don't trust them. I'm with you in that sense, I don't trust authority, whether it's authority on what you call the right or the left. They will skew it in one way or another, so I would take a cutoff point and go for a lottery, and allow people to apply again next year.

LAUTER: But there again, see, I think you're into social engineering anyway. Because the cutoff point implies the validity of the existing tests. And if a lottery were applied at Berkeley, right now, to those students who have A averages in their high schools and extraordinarily high SATs, one would turn up with a class that—at least as far as I understand the studies people have done there—would primarily be Asian American. Now maybe that's a good idea, but the unintended effect there would be to produce the same kind of social tension we have now. Thus it's very hard to escape these issues by saying that we would like to remove them from the arena of politics. And I wonder whether what you're trying to do, in effect, in this particular area, which is such a conflicted one, is to remove from politics what is irredeemably political, rather than trying to develop an inclusive politics with which a lot of people can live.

GROSS: First of all, that's another topic. I didn't come prepared to talk about preferential treatment. And I haven't thought through the question of admissions, though I've thought around it a lot. You denigrated the exams. The SATs and exams like that have a very high correlation with your graduation place in class, about point seven, as I understand it. But you don't have to have all As, a 4.0 or a 3.95, and score fourteen hundred. Twelve hundred, eleven-fifty will do. And better than a B-plus average will do. You could make the cutoff point include more than just the Asian cohort, but if it did just include the Asian cohort, hey, that's an incentive for everybody else to work a little harder.

HERF: And if it was an all Asian cohort, so be it. The universities are based, and should be based, on a merit principle, and for minority groups in this country to reject a merit principle would be very dangerous. Because any other principle could be used to deny people access, and in the past obviously was.

GROSS: I agree with that.

MICHAEL DYSON: I want to respond to Jeffrey Herf about that notion of merit. Merit is not a politically neutral category. So I think that when we have discussions about what criteria and standards are used to determine

who gets in and who is kept out, we can't disassociate that from the ways in which merit is a socially constructed category—what things count as acceptable and desirable and what things are ruled out. Particularly when admissions decisions are not made simply on GPAs and GREs or SAT scores, but also on more nebulous, more amorphous reasons for accepting someone.

GROSS: Yeah, but I hate all that.

DYSON: Right, but even if we talk about hard, scientific numbers, 3.95, as you say, or whatever the cutoff point will be, even that has to be linked to a larger discussion about how that merit was achieved and upon whose backs it was achieved. We can't speak about merit in this philosophically isolated or depoliticized sense without trying to come to grips with how we construct merit, who gets to talk about the discussions of making merit a relevant factor, and what people are deemed to be meritworthy.

GROSS: It strikes me that it's only in education that we worry about how to tell what merit is.

BÉRUBÉ: Well, if we knew what intelligence or scholastic aptitude *was,* we wouldn't be testing for it all the time. It would just make itself known in practice. We don't have tests for runners, we just have races.

GROSS: Those *are* the tests.

BÉRUBÉ: Right, and they're not the same thing as SATs. SATs are tests that "predict" achievement in college, and races are not tests that "predict" achievement in running.

GROSS: Fine, but would anyone go to watch the Redskins if I were the quarterback?

DYSON: I'd be there tomorrow, Barry.

GROSS: It'd be crazy. Why? What do we do? We let people run with the ball—basketball, football, baseball, whatever it is—we let them up on a stage and they bang around on a guitar, and we have some standard, but in sports it's easier to measure, I think, than in entertainment, or maybe in classical music it's easier than in popular music, and we tell who's better and who's worse. Now, the standard is a fairly natural one, and I think it's shared pretty much by everyone, though I don't think it's transcendent.

I'm very Humean on this, as I said before. Let's take something clear, like medical school. Who is going to be a better doctor, who's going to make a better contribution? You can correlate that fairly highly with the kinds of credentials people bring. Now how the people wound up having those credentials is another question altogether. It may be that some people don't start on a level playing field. But once you get to the credentials, if the credentials are tied to performance, then OK. Let's take a ridiculous example. Say to get into the Columbia School of Physicians and Surgeons, you had to be an excellent polo player, and they took no other criterion into account. That would clearly be very dumb, because there's no correlation between your ability to hit a polo ball with a mallet and your ability to go through medical school. But if the criteria they do select are very highly correlated to what they're looking for in graduates, then it makes sense to keep the criteria. Now, the contrary argument is that there will be late bloomers, and that's absolutely true. But you can't know who they're going to be until late, by definition, so you can't say, oh, he looks like a late bloomer, she looks like a late bloomer, so they have MCAT scores that are about 400, they're in the 30th percentile, but we'll let them in anyway.

HERF: I'm glad Todd Gitlin is here because this is a matter of fact. It's my understanding that the University of California system, the Berkeley campus in particular, in its admissions policy, actively discriminates against Asian-American applicants, and that if it admitted all of those Asian-American applicants who were qualified, then there would in fact be a freshman class with a disproportionate share of Asian-American students, larger than their percentage in the population. Now, the discussion of multiculturalism has come up here, and the issue of white males defending their privileges has come up. I think it's important for us not to be provincial in the way we think about race. There is racism all over the world, directed at many different kinds of people, not just by whites against nonwhites. But in Berkeley, in California, if my facts are correct, and I think they are, there's this institutional racism against Asian-Americans. What is held against them? Their hard work, their intelligence, their diligence, their creativity—that is held against them. This is a terrible precedent; when you institutionalize a principle like that, there is no reason why it should stop with discrimination against Asian-Americans. What is good for Asian-Americans today can be good for African-Americans ten years from now, or who knows who else. Of course all the issues about the objectivity or lack of objectivity of tests are important issues, but once you go down the path Berkeley's taken, there are a whole lot of not very

"unforeseen," "unintended" consequences, quite ugly consequences, that could very well develop.

GITLIN: I have to respond to what Jeffrey's said about the admissions situation at Berkeley. It's false, actually, and it's Mr. D'Souza, once again, who deserves most of the blame for the canard about Berkeley admissions. In fact, before the Berkeley freshman admissions program was revised, the percentage of the incoming student body chosen strictly on merit, strictly on the combination of GPAs and SAT scores, was forty percent, in the good old days. Under the new scheme, which is now just been in effect for a year or two, it's fifty percent. So in fact there is a *higher* percentage now of strictly test-based admissions than before. And the percentage of Asians coming in under that rubric is far higher than their percentage in the population. In fact, there are now more Asians in the incoming class than there are whites.

DYSON: Jeffrey, you mentioned unforeseen consequences. But it's not the unforeseen ones that I'm worried about, it's the ones that we already know about but refuse to pay attention to. This argument is predicated upon a contingent analysis of the future, so that something that is going to appear in the future at some given time, quantity unknown x, will prevent certain factors from being taken into consideration in the quantity known now, which is B. My argument is that there are other quantities that we already know about. We know about their political content, in terms of racial discrimination, we know about the ways in which people acquire certain skills to allow them to participate in the academy, in higher education, or in the employment sector, in whatever we're speaking about. We know this even in Barry's argument about sports, where the rules are pretty explicit. But that's not the question. The question is not whether the rules are explicit or whether merit is proper to talk about. If we historicize that debate we can understand that. Are you telling me that before Jackie Robinson, for instance, there were no qualified black second basemen who could play for Brooklyn? Of course not. There were political measures that imposed upon a notion of merit. Now, I'm saying, if it operated then, let's say forty, fifty years ago, all I'm asking for now is an accounting for the continued presence of certain historical legacies that we can't wish away, that we have to take account for. I'm not arguing any specific measures, though I think some are better than others, but I'll say again that merit is not a politically neutral category. And unless we pay attention to the ways it's been historically constructed, and philosophically shaped, then we do a great disservice to the people we want to help most.

BRUCE WILSHIRE: Barry, I'm not very impressed with your figures about the correlation between SAT scores and accomplishment in universities; whether it's a reliability or validity quotient, I really don't know, but you said point seven. I'm not impressed because I think what you've got there is a self-reflecting, self-congratulating, and self-confirming little universe. The very people who make up those tests are the prime products of the university type, the university that we're talking about.

GROSS: Do I get to answer Bruce and Michael at the same time? Let me take Bruce first. Yes, right, the test is correlated. That's what correlation means. It means it tests for what we do in school now. You want to change the schools? If you change the schools the way you want them to, maybe those tests won't correlate. But, as they are now, they do correlate very highly. To go back to Michael's argument. I support Jeffrey here, and in fact I wrote that when I wrote *Reverse Discrimination.* We don't have to look at the future, we can look at the past to see how discrimination worked. Michael gave us an example in sports, we have examples in schools. Blacks were excluded completely, Jews were under a very heavy quota in the elite institutions, and if you make those quotas and instantiate them and give them the coloration of law, you will license it in the future. What was ironic about the Civil Rights Movement, from about the middle of the 1950s until the early seventies, was that it was designed to cut out all of that. New York state passed a law that said you could not, on a college application, ask for an applicant's picture or religion or any affiliation of that kind. Now we've come full circle to asking about it again. The criteria of merit are neutral. What you say is that they weren't applied before, and so there is a legacy such that a certain group can't reach that standard. That they weren't applied before is, I think, not contested territory. That there is such a legacy that these groups can't meet the criteria, I don't think is borne out. I think it's very clear, and it will become clearer as time goes on and social conditions change, that eventually we're going to end up pretty much with the admission on a nonpreferential basis of pretty much any group at all, because each group will be able to put up enough candidates. But I don't even like to talk that way because I don't like the group-think.

WILSHIRE: Well, Barry, you value the correlation, and I see reason not to value it. I think it's valuable for social engineering, but not for educational purposes.

WATTS: Yeah, I just have a comment to follow up on Dyson and Paul. It seems to me that politics inevitably comes into this discussion. For instance,

there's one thing about the discussion of SATs that's always perplexing to me. I mean, if I could show that there was a fairly good range of SAT scores that allowed for a competent mastery of whatever the educational offerings were at an elite college, then we wouldn't be arguing that only the top people scoring this number have to be let in under meritocratic rules. We would then begin to problematize what it is that the test is predicting and measuring. The second issue is that Michael Dyson isn't talking about previous generations. He's talking about the sociology of what you might want to call the meritocratic pool. If you're going to call for strict meritocratic notions, which I think are problematic anyway, then if *we* can claim in return that these scores have something to do with class hierarchy, class distinctions—and all kinds of other invidious American cultural parochialisms—then it follows that you can't begin to call for "merit" decisions on that basis alone. So you're caught within that circularity, unless you're going to call for some kind of broader egalitarian access to the preconditions for realizing these scores.

LAUTER: And we have to assume that training in medical school and contemporary practices in medicine are not only correlated but desirable as they presently exist.

GROSS: Well, those are very large questions. Let me try to cut them down into smaller ones. What has happened is that we now have a scarce resource. When I was an undergraduate, you could walk into any law school in the country, if you had a warm body and a positive bank balance . . .

WATTS: . . . and weren't black . . .

GROSS: . . . right. And get in.

WATTS: Or a woman.

GROSS: I don't even know, by the way, if that was true.

WATTS: That was true, brother.

GROSS: I don't doubt you, but I'd like a little empirical evidence. Anyway, the point I wanted to make is that there's nothing inherently difficult about getting through law school. The reason you need such high scores now is because you have a small number of seats compared to the number of people who want to go. What's thought to be a rational way of partitioning them is in a competition which is meritocratic in the sense that

the scores can be correlated fairly well with the way you will graduate. Now, if you don't like that, you can accept my lottery method. But what *you* want to do is to restructure society. I don't want to restructure it, I just want to make it better a little bit at a time. I don't think anyone knows how to restructure it, even if you want to, so I think those experiments turn out to be fairly dangerous, certainly utopian, and too long-range to help anybody. The fact is that Harvard isn't very hard to get through. If Edward Kennedy got through it, there's no reason why almost anyone can't get through it. That's one of the problems with the schools. The schools ought to be harder to get through, but then more people would get through them, I think, because they would rise to the standard. The fact that people who don't score fourteen or fifteen hundred on the SAT still do well at Harvard is fine. The problem is that the number of places at Harvard is what, a thousand, fifteen hundred, two thousand, and there are ten, twenty, thirty thousand applicants. So the SAT is one way to sort it out. I don't say it's ideal, but I do say that it's dangerous to start sorting it out by other kinds of social programs because what you end up doing is taking the Civil Rights Movement and going full circle, from a point where we said we were going to be completely race-neutral and race-blind, even if we didn't achieve it, to the point at which we now have become extremely race-conscious. That's a very dangerous precedent. If you want to know where the origins of the Holocaust lie, they may very well lie there.

MYRNA ADAMS: I want to say a couple things to Barry. I wish you would not do what ETS and the publishers plead with the public not to do, which is to misconstrue the purpose and the validity of their tests. The publishers of the SAT constantly insist that the test must be validated against the local norms of every institution that administers them. Moreover, they do not claim that they predict beyond the first year of study, so your assertion that they predict success and graduation rates is absolutely wrong, unless you can show me some data from ETS that says that.

GROSS: I don't think it's ETS's data, but there is that correlation.

ADAMS: But ETS publishes the test and they do the data. College Board and Educational Testing Service have never made those claims, and it's a disservice both to the testing industry, and to what they are useful for, to make them. What's more, it fuzzes up all the issues that you were trying to make clear. Secondly, with respect to the issue of merit, we have never used meritocratic standards except when we wanted to close people out because the numbers we were prepared to accommodate exceeded our

capacity. In other words, we have too many applicants, as you say, and therefore in law and in medicine and engineering, and in every other field, we've developed quick and dirty measures—not to measure applicants' capability so much as simply to make it easier for us to cut people off. That's not what I want to advocate for the future. That's not what this society needs to do. Is that what you're proposing here?

GROSS: Well, you've put me in a difficult position . . .

ADAMS: I intended to.

GROSS: . . . by phrasing your question in that rhetorical way. But the answer is, as I already said, that there are two reasons for the test. One of them is that we don't have enough spaces for all the people who are qualified. The second reason is—and the original reason for the test was—local variation in the quality of high schools. We are a large country. Most people don't know the principals and the teachers of the schools from which students apply to their universities, unlike Oxford and Cambridge, where applicants' schools are much more clear and much more well known. So the tests were given to even out the question of whether such and such a school gave easier or more difficult courses. They did that fairly well. I don't want to advocate simple cutoffs. What I said was, I would like either to open up the supply more, or to use lotteries to allocate the places.

ADAMS: Let me say, then, that I have supported the use of lotteries for some time. It's the privileged group that complains the loudest against the lottery system.

GROSS: I agree.

ADAMS: And that is why we've been unsuccessful in developing an egalitarian measure such as that to govern the supply and demand issue. The notion of merit having ever been the major determinant of admissions or success is pure hogwash, and you know that.

GROSS: I don't want to be stuck with positions I didn't take. I made it very clear in my paper that anti-intellectualism was the prime mover in American universities and in American life to begin with. Merit has never been an issue here, as it has been in France.

ADAMS: OK. The final point, then, has to do with what you said about attrition rates. In terms of high selectivity on the basis of merit, doctoral programs could not be more selective on that ground. Yet the attrition rate in doctoral programs is almost as high as the rate you cited for the City University of New York, so attrition obviously has very little to do with intellect.

GROSS: I never said it did.

ADAMS: You implied it.

GROSS: No, I didn't imply it.

ADAMS: Barry, your line of argument has linked open admissions, declining standards, and the completion of degrees.

GROSS: Open admissions have made standards decline, there's no question of that at City University. But in large measure it's because open admissions have taken students who were very poorly prepared and socially and economically very fragile, and put them into universities, and their lives are coming apart and that's one of the reasons they don't complete. I could suggest a very different reason why people don't complete their Ph.D.s; you can see it in the job situation.

JAY: Let me change direction and pose a question for Jeffrey. What I want to suggest has to do with the position that Arendt and others were in when they began to advance this thesis that National Socialism was, in fact, not a cultural nor an economic expression, but was fundamentally an expression of anti-Semitism and racism. I'd like to suggest an analogy. I'd like to suggest an analysis that would compare that to the current debate about Afrocentrism and its assertion that the construction, over time, of the ideology of the so-called Western tradition has been essentially racist, and has been specifically racist in relationship to Africa and the African diaspora. Liberal intellectuals like Arthur Schlesinger have been prominent in the vilification, often through gross distortion, of a completely marginalized and peripheral movement in the academy today, which is the movement of Afrocentricity. It would not bear any empirical scrutiny to suggest that the arguments of Afrocentricity have some large or dominant influence in the academy today, yet Schlesinger himself, in *The Disuniting of America*, singles out Afrocentrics for what I think is his most rabid and inaccurate criticism. I find this analogy particularly striking because it seems to me that the parallels are very strong, since both cases involve the

construction of a myth about Greece, about a slavocracy, about an imperialism, that claims for itself a priority in the knowledge of philosophy. It's my prophecy that—however outrageous may seem the critique that Afrocentricity provides today of the ideological construction of the West and of Western rationality—that in twenty or thirty or fifty years that critique will be as strongly established, as pervasive, and as intellectually solid as the critique of National Socialism as having been grounded in and been the agency of anti-Semitism.

HERF: That's very provocative. I don't know the literature on Afrocentricity other than through Arthur Schlesinger's supposedly biased and inadequate account, or my reading about it in the press and in journals of opinion. So if it turns out that there is a historical foundation for Afrocentric arguments, well, they'll have to prove themselves as all arguments among historians do, and that is by demonstration, by coming up with the evidence and making the arguments. That would be my point about that. But I would also make another argument about the way we think about the rest of the world. I hope that one result of multiculturalism is the end of the use of the term "Third World." I think the use of the term "Third World" is a legacy of imperialism and colonialism which was taken over in the fifties by the postcolonial regimes in Bandung in 1955, and then, for some reason, became a scholarly term. But it's insulting. There are over a hundred distinct nations, as distinct from one another as the countries of Europe are distinct from one another, in Africa, in Asia, in Latin America. Why should we assume we understand all of them by placing them in something called the Third World? So if Afrocentrism, which I don't know a lot about, contributes to a more complex understanding of Africa, and of the distinctions among Africans, I think that's wonderful. That is needed. That is crucial.

NELSON: Jeffrey, I wonder if you could give us an example of how political bias in the American academy has limited our ability to analyze American culture and history? Also, could you be more explicit about the ways in which your own work has been considered politically incorrect?

HERF: Well, there's another talk in which I discuss Daniel Patrick Moynihan and the Moynihan report of 1965, along with a very important speech on race in the American city that Bill Bradley gave in the senate in March of 1992. Moynihan, as you know, raised the issue of single-parent households in the black community, and was denounced as a racist as a result. When the Moynihan report was published, the rate of single-parent households in the black community was twenty-two to twenty-

three percent; now it's in the 60s [percentile points]. The question I raised—and the question Bradley raised—was how many lives have been lost, how many children have grown up in poverty, how much unnecessary suffering has taken place from the 1960s to the present that could have been avoided *if* there had been a fuller debate within the academy and within the liberal community in the country generally? What might we as a scholarly and an intellectual community have done to prevent a situation that was bad then from becoming disastrous afterwards? When knowledge is repressed or stifled and its advocates ostracized, it is not only those persons who suffer. Moynihan obviously went on to a career in Washington and now serves as a senator, so he didn't suffer. It was the black community that suffered. Now, I'm not an expert on these matters, and of course there are many, many causes for why these things got so much worse, but it strains credulity to think that nothing in the Moynihan report was true, that it was all wrong and that it should not have been discussed at all in universities. Those discussions took place instead in Washington, where they were easy for liberal opinion to dismiss, because they were taking place in the Nixon administration.

As for my own work, as I said, one of the taboos during the Cold War in some academic disciplines was anticommunism. I broke it with my second book, *War By Other Means*. Everything was politically incorrect about the book. I studied elites instead of the people; paid attention to the balance of power between states; made harsh judgments about Soviet policy and the West European peace movements of the 1980s; made an argument for the plausibility of Western strategy; presented evidence to demonstrate that West German intellectual opponents of Western military policy had, after what the Germans called a decade of the long march through the institutions, secured positions of power and influence from which to make a political difference; drew attention to the impact of interpretations of politics offered by leading politicians, intellectuals, and journalists on the outcome of events; argued that an important issue for historians of the Soviet Union in its last years should be the impact of the defeat of its political offensive directed against Western Europe in the early 1980s; and pointed out that the virtues of open debate in liberal democracy need not, as some neoconservatives had feared, be strategic vices when confronted with dictatorship. This has proven to be a formidable list of transgressions, especially for a scholar who would like to change from the exciting life of high-anxiety fellowships to the more predictable pace of a steady academic position.

SCOTT: Jeffrey, you were arguing that we need to have a set of common standards of judgment, some kind of commitment to the notions of ob-

jectivity and truth, as if those things in the past have guaranteed the flourishing of debate and difference, as if those things were indeed transparent, objective criteria, that in the past didn't protect disciplines or departments or universities from exactly the kind of critical approach you're talking about. All you have to do is read the chapters in Peter Novak's book about Beard and Becker to see the ways in which the charge of relativism—they, themselves, never called themselves relativists—was wielded by so-called objective historians to make sure the kind of critique they represented was, if not disallowed from the profession, certainly not allowed seriously into the mainstream. Becker's books were reviewed as tragic attempts to make believe he's a historian—after all, he's never been to the archives, he's too wordy, he's too philosophical, philosophy isn't history, and so on. So it seems to me, the notion of common standards of judgment gathered around objectivity and truth, gathered around transparent notions of quality as if those existed free of political or power influences, is very problematic. As is the notion that there are singular meanings for any of these terms that we could agree on.

And my second point is related to this. Germany I will leave to you as the expert. But the Moynihan report, and the way you talk about it, seems to me an example of this kind of problematic question. First of all, I don't think the Moynihan report and its presumptions were banned from the academy in any way at all. On the contrary, Moynihan's views live in the work of William Julius Wilson, and of other sociologists and historians of the black family, of urban poverty, of welfare, and so on. So there was no banishment of those views from the academy under the terrible term of racism. But more than that, your suggestion that suffering could have been avoided if there had been fuller debate in the academy on Moynihan's positions seems to assume that Moynihan was simply right about the state of the black family and that the loss of his voice on that issue *was* responsible for the way welfare policy has proceeded. I would argue exactly the opposite, that Moynihan represented a point of view about the presumed normality of the heterosexual nuclear family that continues to inform welfare policy. It's *exactly* the view he was expressing at the time that continues to inform welfare policy and that is responsible for the enormous increase in poverty among female-headed households. It seems to me there weren't at the time, and there have never been, suggestions outside the framework of the normalcy of this standard for social organization. They could have said, "Well, we have these female-headed households, white and black, poverty is enormous there. Let's devise a policy that underwrites women's wages, so that they're not earning substandard wages, but that the federal government throws in, or insists on a minimum wage, which is really a subsistence wage, which will enable

not only black families to live however they want to, but all sorts of families to live however they want to, with or without fathers." The premise that the organization of the nuclear heterosexual family is the key to social stability is itself a political position that is associated with certain traditional premises of social organization, whatever we want to call it, and it's exactly that that Moynihan was articulating. Linking it to slavery is what led to the outcry by Herb Gutman and other people, and by all sorts of black scholars, about the racism of this position. But it wasn't banished from the academy, it wasn't banished as a premise of welfare policy, and so only if you believe the things Moynihan was saying were objectively true or somehow the right solution, could you make the kind of argument that you're making.

The sticking point for me in all this is that this question of objectivity, this question of how we decide what's right and true and good and meets a certain high standard, whether of scholarship or of social policy, is one that you avoid in the kind of critique and analysis that you've made, and so it's where I have to part company with those of your positions or comments or statements I otherwise would agree with.

HERF: I guess, maybe I do think Moynihan put his finger on something. I've been having this argument at home for many years, too, and I've heard those arguments made often. I guess I have a commonsense view of the situation. I think that what has happened in the last twenty years is awful, and I don't see it as a result of four hundred years of racism. I see it as a result of something that happened in the late sixties, or mid-sixties, and early seventies, and, therefore, I instinctively feel that there was something that we could have done that might have prevented it. That is, I thought that Moynihan opened up a debate which was important to continue, and it isn't only with the academy that I was concerned, because I think the kind of discussion that I'm saying should have taken place should have gone on in the Democratic Party, as well, and in the left-liberal community. But when those issues were raised only on the political right, they could easily be discredited because sometimes they were raised by truly ill-intentioned people. I'll think about the second point you made. As for the question of objectivity, my own epistemological position is neo-Kantian, which is very old-fashioned. That is, it's influenced primarily by Max Weber. Reality is infinitely complex, and we only choose to look at certain parts of it, and those parts we do choose to look at depend very much upon our own moral convictions. So I am not out to defend a simpleminded conception of objectivity. As the world grows more complex in the present, our understanding of the past should become more complex. You're quite right, the norms of objectivity and truth in

the past did not guarantee that our picture was adequate. But what concerns me about not placing importance upon some conception of objectivity is that the new history, or new insights in the field of history, could easily be discredited, or more easily be discredited, if they are seen as merely political statements—that is, if they are not also tethered to some stronger claim about verifiable knowledge. You're a very fine historian, and other historians recognize that fact according to shared standards. They can say, "Well, we disagree with what Joan Scott is arguing, but she's an excellent historian." And if you weren't a fine historian and you just made a theoretical argument, then historians wouldn't be interested in your theoretical argument. They would say, instead, "anyone can write about Foucault," or "anybody can talk about poststructuralism." But it's because of those shared standards and shared norms of evidence that the kind of contributions you've made, or that Claudia Koonz or Gisela Bok has made, will endure. If those standards weren't there, those contributions could be more easily undermined.

ADAMS: I'm not an academic and I'm not a scholar. I'm an affirmative action officer. I listen to these discussions with a pragmatic interest in deciding what this means in terms of what we do about the university and about the nature of the problems it faces. Joan has said much of what I was about to say, in much more scholarly terms. So let me put the challenges, as I see them, in a practical light: In the process of selecting what courses and programs will be offered and, consequently, who we need to employ within departments, we are always confronted with virulent departmental disputes about the appropriateness of certain kinds of content and perspectives and contributions to the field. What's going to be left out? What's going to be included? How can we build various combinations of people into working units that have some degree of harmony and mutual respect? I don't see a lot of tolerance within the academy for difference, even among people who are presumably more alike in their ideological perspective. I think Gerry Graff's book points out, very clearly, that we have very little in the way of preparation for how to resolve conflict within the academy, within the department, within the discipline. And it clearly is a deficiency that we need to remedy and find alternative ways to resolve, because what I see of the food-fights that go on within disciplines, within departments in the institution in which I work, are the most absurd yet intense and devastating attempts to expel from the center and marginalize people whose perspectives are different. I don't know where and when this intolerance began, but I don't think it began only in the sixties. I do, however, think the economic and cultural climate of the university has an impact, and not just the climate in the humanities

and social sciences themselves. I think the emphasis currently being placed on obtaining research funding in the sciences—in which the desire to get grants and to bring in outside resources has dominated our conception of what it is we ought to offer, who it is we need to hire, and what groups of people will be most efficient and productive—has had a broad and destructive impact on university culture as a whole. In any case, I see this intolerance operating in a whole range of disciplines. I certainly don't think an analysis of the historical struggle between liberalism and conservatism can account for it.

HERF: Well, I cannot imagine some process or form of conflict resolution that would address the issue. I think it wouldn't be a bad idea for people to reread Edward Shils's book, *The Academic Ethic;* it's about seventy pages, and he restates some of the fundamental reasons why there are universities. That is, the reason we have universities is to pursue truths about important matters. That's it, that's the most important reason why we have universities. Everything else is secondary. The applied research could be farmed out to think tanks or private foundations or companies; it's not our main reason for being here. Now, I think one explanation of why we have trouble is that we have academics who may understand this but don't articulate it. And if there could be some moral consensus that this is the central purpose of the institution, maybe that would help. I think one of the purposes and the responsibilities of leaders of educational institutions is to articulate their moral purposes. The faculty may not like it, or may criticize it, but somebody ought to do it.

ADAMS: It also seems to me very important that we underscore the importance of vehicles of common experience as part of the realization or reaffirmation of what Benjamin Barber calls "constitutional faith." What that means for me is that we ought never to abandon the concept of the public school and its importance in this society, and that we ought also to consider, quite seriously, calls for national service which cut across class lines and ethnic lines and give common experience to diverse peoples, out of which they can then recall and have a memory which differs from their ethnic and neighborhood memory. To the extent that we create more of those vehicles and institute something like national service, or broaden the opportunities for people to come together around important interests, we will, I think, begin to supplant some of the fear and intolerance with a better sense of what's really out there.

LAUTER: I want to pick up on what Myrna just said because it relates very much to the question Jeffrey was raising about why there is a certain

animus—rightly, I think—against some traditionally liberal historians, of whom Arthur Schlesinger is a good example. It has to do with the question of public space and what constitutes a constitutional public faith. Barber emphasizes the importance of common experience, as Myrna was saying, and common institutions like the public schools. It's interesting to me, therefore, to look at the kinds of critiques people like Schlesinger have mounted, and see where those critiques are aimed. Schlesinger's is aimed at Afrocentrists, multiculturalists. The multiculturalists and the Afrocentrists, very much in the tradition of the Civil Rights Movement in this particular respect, are making the argument: let us in. Let us into the lunch counter, let us into the ballot box, let us into the school, let us into the curriculum. Let us in. Don't dismantle those institutions, but let us into them and let us have space within them and in real relationship to them. Those are the people Schlesinger, C. Vann Woodward, and so forth, choose to attack rather than those people on the right—and they are on the political right—whose objective is, on the contrary, to destroy that common space, to make private what is now public in the public schools, for example, or in public universities. One does not hear a whisper from Schlesinger or from Woodward analyzing or attacking those kinds of initiatives, which characterized the Bush Administration, in particular, and the Reagan Administration before, and continue to characterize the work of people like Stuart Butler—but he's just one among many—who are committed to a set of policies like vouchers, that would effectively undercut and undermine what has been an absolutely critical public space in American history, the public schools. It's a peculiar blindness not to see that what multiculturalists are doing and arguing for is the continuation of that public space on an inclusive and expanded political basis. Not to see that, on the one hand, and not to see either that the real danger to constitutional public faith is not coming from multiculturalism, but is coming, in fact, from those who are engaged in a concrete, concerted, and very well-financed attack on public institutions is extraordinary. Institutions like the public schools have undergirded the very constitutional faith that Schlesinger talks about but is actually engaged in undermining. That helps explain my animus against historians like Schlesinger and Woodward. The practical effect of the sort of polemic Schlesinger wrote is to bring about precisely what he says he's afraid of—the kind of ethnic rivalries that truly will disunite the nation.

BÉRUBÉ: I think that's entirely right, and this speaks to my own critique of Schlesinger as well. Jonathan Kozol's work is extremely pertinent here: if you really want to disunite the country, Kozol says, just implement the Whittle program across the nation. Create Whittle's shadow school sys-

tem, issue vouchers, and leave all public schools contingent on the ability of local communities to finance them. That will disunite this country faster than any Afrocentrist, Leonard Jeffries, or Al Sharpton, or Martin Bernal, or whoever. The deal with Schlesinger is that he either doesn't distinguish between "common culture" and "common society," or he thinks you need the former to have the latter, which just isn't so. We don't have a common culture, we Americans, but we have common social grounds, like public schools. That gives us the public space in which to negotiate uncommon cultures, or cultures not in common, or cultures being-in-common, and all you need to do, to let these uncommon cultures fragment into ethnic tribalisms and factions, is to destroy the common social foundations, like public schools, that allow for their articulation and negotiation.

GERALD GRAFF: Jeffrey, you talked about objectivity, but in talking about that you more or less elided a defense of objectivity with a defense of common standards. Are these things really the same?

HERF: Again, I am an orthodox Weberian in this regard. There are a variety of things about inquiry that are interesting and important, whether past, present, literature, what have you. If by objectivity you mean there is one true and important thing to study about *Moby-Dick* or about the Civil War, and if you don't study that then you're politicizing the discipline— that I think is ridiculous and anti-intellectual. Once you then decide to study, say, Captain Ahab's body and the whale and sex and all that, or how *Moby-Dick* is a parable of American imperialism, once you then decide to do that, which is a moral decision, then you have to operate pretty much along the same lines as somebody who wants to study *Moby-Dick* as the novel that indicates how everything in the United States was absolutely perfect in the nineteenth century. Though nobody would do that. But there are commonly held standards of excellence and evidence that historians with different moral and interpretive perspectives can agree on, and that's what I mean by objectivity.

GRAFF: There may well be, but my reason for raising the question is that it seems to me that this whole set of debates is very confused and confusing. And part of the reason is that in academic life we're simply not organized in such a way that we can even have these debates very frequently; they tend to be the exception rather than the rule, they break out in angry moments and so forth, or they happen at conferences, but they're not a steady feature of academic life, so that consequently, when they do erupt they're extremely confused. But it seems to me in the current debate,

particularly, and I take your talk to be something of a reflection of this, we're simply operating with representations of each other that we don't recognize. In other words, just now in your comment, your account of how contemporary theoretically oriented critics would interpret *Moby-Dick* would not be recognizable to any of those critics. Similarly, I suspect that you have a hard time recognizing yourself in the representations of liberals and conservatives that are made by the so-called academic left.

I raise this question with respect to objectivity, the glide from objectivity to common standards, because some of the principal critics of objectivity, like Richard Rorty, or people like Stanley Fish or others coming out of the pragmatist tradition, *counterpose* objectivity *to* common standards. They argue that beliefs in objectivity rest on shaky ground because what people call "objectivity" is really a set of common standards—that is, the consensus or the agreement of the community—and that's what they think they mean by objectivity, and that's wrong. Consensus, or agreement about standards and procedures, doesn't give you objectivity; it just gives you agreement about standards and procedures. But by mushing together those terms, you seem to be making a move which adds to the confusion of the debate, and I think we're not going to be able to disentangle these issues unless we begin, first of all, listening to each other more carefully, resisting the temptation to construct each other's positions in easy ways that we can then demolish. And it seems to me we're doing this now, and recycling an unproductive kind of refusal to listen to one another. I know that's a moralistic remark, but I don't think it's going to be changed just by deploring this. I think it's going to be changed by changing the structural conditions in which we work and in which we teach, and by that I mean changing the patterns of classroom discussion and curriculum design, so that we are more frequently debating these issues and can, in some way, work toward better, more recognizable representations of each other.

NELSON: Jeffrey, I wanted to connect some of your concern with truth and objectivity and excellence in your paper with some comments you made when we were talking about admissions policies for universities and the ability to draw distinctions on those bases. And I want to pose a hypothetical. One of our tendencies is to talk about what higher education in general should do, even though, as Paul pointed out, educational institutions are incredibly diverse. Just to give you one surreal example from the real world. There's a small college in the mountains of Nevada that urges its students to sleep out in the desert at night so that they get a sense of isolation and self-reflection. It's not a religious school, but the founder thinks of a lot of the Biblical stories of Moses and Jesus spending

time in the desert learning something about themselves. Well, that wouldn't be too practical a suggestion for the City University of New York's student body to adopt, so it's a fairly peculiar instance of a college that sets itself a goal that is going to be pretty decisively local. Let me give you another, a hypothetical instance of a local goal that a college might articulate. Let's say that a college in Los Angeles decides that, whatever the University of Iowa *thinks* hypothetically about living in a multicultural society, we in Los Angeles *live* in a multicultural city, in a very dramatic and real and material way. Thus we think one of our purposes as an institution should be to encourage our students and our faculty to seek certain truths about multicultural relations, to seek possible ways of negotiating them and articulating them. In order to do that, we need a diverse student body and we need a reasonably diverse faculty; because of that need, although we're going to seek the best students that we can, we will sometimes compromise on SAT scores or whatever "objective" measures there are so as to produce some reasonable degree of racial, ethnic, gender, etcetera, diversity in our student body, *because* we think these questions are crucial questions to the culture, and because we think negotiating those questions is absolutely central to our mission. We needn't make a statement that everyone in higher education has to do this; there might be another institution that simply looks at SAT scores, or other objective measures, and makes its admissions purely on that basis. Would it, from your perspective, be a great moral wrong or a great intellectual and cultural danger for a particular institution, given its local circumstances, to say we're going to make this kind of diversity a priority, and we're going to compromise on some other issues in order to achieve it?

HERF: No. Again, if you were going to make the argument, though, you should say—and again, here I take off from Shils—that the most important purpose in the university is to pursue truths about important matters, and there is no one single truth that is important. And that if a particular institution decides that it feels that other institutions have neglected this way of advancing knowledge, well, OK. But I would not want to see that generalized throughout higher education, because if that was generalized throughout higher education, then the growth of knowledge in the range of other areas would slow down; I think that that's really unavoidable.

GROSS: I wanted to follow up on a remark of Gerry's. The business about how we deal with caricatures of each other struck me, and in one respect I agree very much with Paul and Myrna. I have always opposed the voucher movement, for two reasons, one of which they articulated. I think the public schools are the best public space in American life and they ought

to be preserved. And secondly, I think the voucher movement won't work. It'll just be another form of hype. What'll happen is that the schools will say, as the City University now says, you know, John Jay is supposed to be the school for the firemen and the policemen, but that's just B.S. It's just a *raison d'être* so they can get a little more money, and parents will get sucked in by that kind of hype, and I just don't agree with it at all. But I don't think that all people pushing privatization necessarily have nefarious motives. They may well be closet or overt racists or classists, but I'm not. And I think there are other people who are not, and they're pushing it because the public schools have simply collapsed and are not doing their job. But I think vouchers are the wrong route. I think the thing one should do is to redevelop the public schools, but that's a monstrous task. And then I wanted to say one more thing about the Afrocentrists and the multiculturalists. I think the analogy between the Civil Rights Movement and them is wrong. In this country, everyone has a constitutional right to sit at whatever lunch counter he wants, and he has a right to vote, and when that right is abrogated, you have to force open the doors by any means possible. But you don't have a constitutional right to get your program in the university; the way to do that is the way Jeffrey was arguing for before, by making the arguments.

BÉRUBÉ: OK, well, on procedural grounds I agree with the point Greg Jay made earlier, that the stuff that does survive twenty, thirty, fifty years from now will be the stuff that makes its case by the standards of evidence that are generally accepted academic procedures. And a lot of the vilification of Afrocentrism and of black activism depends on the assertion that this multiculturalism, this Afrocentricity, this black activism is running outside normal channels and just doing demonstrations and shouting down and so forth. But then again, some Afro-American studies departments would never have been founded, not at Cornell, not at Columbia, not at Yale, without that kind of activism, and originally their founding—the accession by some university administrations to their founding—was simply this temporizing means of saying, "We'll have these little programs until you troublesome people graduate." And they really didn't take hold as important centers for the production of research and the transformation of knowledge until long after those first four or five years were over with. And so the stuff that has survived over the past twenty-five years from that legacy has indeed been the stuff that made its case, its research case, in the traditional terms of evidence and scholarship that were in play in 1968 and in 1993.

II

Pedagogy and Populations

A Critique of Critical Pedagogy

GREGORY JAY AND GERALD GRAFF

For the last few years, we have joined many of our colleagues in defending the academy against charges of "political correctness." We still believe that the anti-PC assault was and is orchestrated by politically motivated operatives outside higher education who want to turn back the clock to the days of ivy-covered, white male prep schools catering to the American power elite. This threat seemed serious enough to us to warrant minimizing the grain of truth in the PC charges, which were always exaggerations rather than pure fabrications.

At some point, however, those of us who think of ourselves as advocates of reform and progressive agendas in higher education are going to have to return to the original meaning of "political correctness"—as a name for the extravagances and follies that our own side commits. The hijacking of the term "political correctness" by the right should not obscure the fact that it began on the left, with the left's own sense that recurrent self-criticism of our excesses ought to be a regular feature of our reflections. But once everyone on the left, or even near the middle, was declared PC, we were put on the defensive. The traditional task of criticizing our flaws now appeared either superfluous—since the right was doing it so vociferously—or a betrayal.

Ironically, the dogmatism of the right made it less, not more, possible to isolate and criticize dogmatism on the left, for the entire left and much of the middle had been heaped together under the PC rubric. But the time has come when some serious efforts at left self-criticism have to be ventured, even if they give some aid and comfort to the enemy. The risk is necessary, for it is only such self-criticism that can save the movement for the democratic transformation of the academy from being undermined by its own advocates. In the long run, this movement will benefit from

such self-criticism, which will sharpen our thinking and enable us to answer our critics more persuasively.

Let us leave no doubt about our own allegiance. We regard the new studies in gender, race, ethnicity, and sexuality as the most revitalizing developments to have taken place in education in our lifetime. We believe these studies, along with the affirmative action initiatives that have accompanied them, have opened up questions about politics, power, and representation that educational institutions had too long suppressed. We also believe, however, that when these questions are translated into pedagogical practices and programs it is crucial that they be kept open, not treated as if they had been settled. Terms like "cultural diversity" and student "empowerment" should denote a set of problems to be explored and debated, not a new truth which teachers and students must uncritically accept.

It remains important to maintain, then, that criticism can be supportive, and indeed that without criticism no social movement can get very far in improving its program and chances. We do not see enough of such self-criticism in the various movements toward critical and oppositional pedagogy that have become so prominent on the current scene. As our contribution, we would like in this paper to point out a troublesome double bind that has plagued these movements since the 1960s.

How Not to Politicize the Classroom

What worries us is the way that efforts by teachers to empower students often end up reinforcing the inequalities of the classroom. This is clearest when teachers directly promote progressive political doctrines in their courses, merely inverting the traditional practice of *handing* knowledge *down* to passive students who dutifully copy it into their notebooks.

This problem appears in the work of such radical educational theorists as Paulo Freire. In his influential book *The Pedagogy of the Oppressed,* Freire does attack the Leninist model of education in which revolutionary leaders impose their teleological blueprint on students, merely inverting rather than breaking with the "banking" model of education in which knowledge is seen as a kind of deposit that the student receives from an authoritative teacher. Instead of imposing their own "thematics" on the people, from the top down, Freirean educators must "re-present to the people their own thematics in systematized and amplified form. The thematics which have come from the people return to them—not as contents to be deposited but as problems to be solved."[1] Freire says that libertarian education "starts with the conviction that it cannot present its own program but must search for this program dialogically with the people" (118).

It is an attractive program in principle, but can Freire remain faithful to it? How real can the Freirean dialogue be, when Freire clearly presumes he knows in advance what the authentic "will of the people" is or should be? However much Freire may insist on teaching "problem-posing" rather than top-down solutions, the goal of teaching for Freire is to move the student toward "a critical perception of the world," and this critical perception "implies a correct method of approaching reality" (103). It is, as he puts it, "a comprehension of *total* reality" (99).

Thus though Freirean pedagogy claims to give the oppressed the autonomy to decide for themselves what their transformation will look like, it is clear that for Freire the oppressed are free to decide only within limits. Suppose a student ends up deciding that he or she is *not* oppressed, or is not oppressed in the way or for the reasons Freire supposes? What if, after a Freirean dialogue, the student embraces capitalism, or decides that, for him or her, authentic liberation means joining a corporation and making a lot of money?

Freire can only count such decisions as the result of the student's having been brainwashed by the dominant culture. Freire says that the "oppressed feel an irresistible attraction towards the oppressor and his way of life." "The oppressed want at any cost to resemble the oppressor, to imitate him, to follow him" (49). This may often be the case, but to assume it as a pedagogical premise is to condescend to students from the start. It means that students who are not persuaded by radical politics cannot, by definition, be expressing an authentic desire. It cannot be their true selves speaking, but only the internalized voice of the oppressor.

This assumption spares Freire from ever having to consider an unpleasant possibility: that what "the people" authentically prefer might conflict with the pedagogy of the oppressed. The assumption is that, deep down, in our most authentic selves, we are all Christian or existential Marxists. According to Freire's model, the resistance of students to the pedagogy of the oppressed would be taken seriously only as a symptom of their woefully mystified consciousness. The teacher would treat their ideas as the suspect products of their political unconscious, not as arguments that might have their own rationality, persuasiveness, and basis in experience. Needless to say, the possibility never arises that the radical teacher might have his or her mind seriously challenged by the conservative student.

In any case, the proper outcome of critical pedagogy is already predetermined. Freire assumes that we know from the outset the identity of the "oppressed" and their "oppressors." Who the oppressors and the oppressed are is conceived not as an open question that teachers and students might disagree about, but as a *given* of Freirean pedagogy. As Kathleen

Weiler argues, "while Freire's work is based on a deep respect for students and teachers as readers of the world, the conscientization he describes takes place in a relatively unproblematic relationship between a liberatory teacher and the equally abstractly oppressed."[2]

To be sure, Freire's assumption of a student body that will readily accept a description of themselves as the oppressed is understandable in the original context of Freire's work with Latin American peasants. But Freire's model encounters serious problems when it is transplanted to a North American campus, where not all students are obviously members of an oppressed class, and where even many of those who might plausibly fit that designation refuse to accept it.

If Freire assumes a predetermined outcome for the student, he is equally sure what the politics of the teacher must be. In picturing the classroom, Freire and other proponents of critical pedagogy seemingly envisage a teacher who is already committed to social transformation, and simply lacks the lesson-plan for translating the commitment into practice. The question never arises of what role will be played in a radical curriculum by teachers who do not go along with the lesson-plan.

The premise seems to be that radical pedagogy is for those teachers who have already been radicalized—or have decided they wish to be. Presumably, those who decline to join the movement will mind their own business, recognizing, like good academics, that "it's not my field." The recent uproar over political correctness suggests that, on the contrary, these teachers will strenuously object, and often with good reason. The failure to take seriously the objections of the unpersuaded seems to us a serious limitation of critical pedagogy both on ethical and strategic grounds. It means that critical pedagogy is usually a business of preaching to the converted, leaving the unpersuaded overlooked, alienated, and receptive to the counterpropaganda of conservatives.

Oppositional Pedagogy

Of course, radical pedagogy has no problem construing such resistance as further evidence of complicity in the dominant culture, a response that further exempts the radical teacher from having to criticize his or her own position. This self-congratulatory tactic—if you criticize me you must obviously be a reactionary—is conspicuous among exponents of so-called "oppositional pedagogy" such as Donald Morton and Mas'ud Zavarzadeh. Like Freirean pedagogy of the oppressed, oppositional pedagogy offers itself as training in critique rather than as indoctrination, with "critique" defined as "an investigation of the enabling conditions of discursive practices. It subjects the grounds of the seemingly self-evident discourse to

inspection, and reveals that what appears to be natural and universal is actually a situated discourse."[3] This version of "critique" is a poststructuralist updating of the notion of ideology articulated by Marx.

Morton and Zavarzadeh justify the teacher's "assuming a position in the classroom" on political issues by arguing that this "makes it possible for the student to become aware of his position, of his own relations to knowledge/power formations" (11). Again, there is the assumption that the teacher is possessed in advance of the true map of knowledge/power formations and the student's relation to them. Again, there is the claim of an open process of possibility and becoming that actually entails the students' subordination to the predetermined politics of the teacher.

Oppositional pedagogy claims to go beyond the pedagogy of the oppressed, however, by positioning the teacher in a frankly "adversarial role in relation to the student," challenging students' presumed complacency about their position in the dominant culture. The teacher is not only authoritatively right about the issues, but is also justified in assuming the inauthenticity of the student's opinions. The teacher "helps reveal the student to himself by showing him how his ideas and positions are the effects of larger discourses (of class, race, and gender, for example), rather than simple, natural manifestations of his consciousness or mind" (11–12).

Here the helpful oppositional pedagogue is not content to exercise the already considerable powers of persuasion and intimidation that accompany the traditional structure of teaching, and apparently is also not content to offer his or her own position as just one among a number of possible conclusions. More frankly than the Freirean teacher, though ultimately repeating the same gesture, he or she treats each student viewpoint as merely another case of false consciousness to be demystified.

This mixture of self-righteousness and disrespect, however, turns out to be just what the doctor ordered: "The outcome of such an adversarial relation to the student," according to Morton and Zavarzadeh, "is to develop in him a critical oppositional position in relation to the dominant order" (13). Again, however, it is not clear what the alternatives are for the student who disagrees with the "critical oppositional position" that has been defined as the guiding purpose and most important outcome of the course. If a student continues to disagree with the teacher's description of the "dominant order," is it unreasonable if that student should censor her class comments or fear a lower grade? And how many students will respond to the "adversarial position" of the instructor by truly challenging his or her premises instead of simply following the path to the prescribed revolutionary finale—or final exam? Does the oppositional pedagogue also take pains to demystify his *own* authority, to contextualize his or her own

discourse? Does he assign texts that powerfully challenge his own posi-
tions—Leo Strauss and Milton Friedman, say, alongside Karl Marx and
Michel Foucault?

In fairness, oppositional teachers may be telling the truth when they
deny that they are indoctrinating students. In another article, Donald
Morton rejects a student's charge that Morton's grading policies were
politically biased, and that his classroom environment was one of "intim-
idation" and "indoctrination."[4] Morton offers a great deal of persuasive
evidence that, in this particular case, the student is wrong: other con-
servative students got high grades, some radicals got low grades, and the
complaining student failed on a number of occasions to understand or
fulfill the stipulated course goals and assignments. Morton also demon-
strates the complicity between the student's charges and the larger media
campaign against so-called "political correctness," a campaign waged at
the departmental level, says Morton, by hostile colleagues who encouraged
and advised the complaining student.

In mounting his defense, however, Morton falls back into a version
of the double bind that we discussed at the outset of this paper. If, as
Morton maintains, his course *did not* aggressively seek to effect a change
in the political opinions of its students, then in what way can his practice
be called "oppositional pedagogy"? Can there be an oppositional pedagogy
worth its name that does not attempt the direct political transformation
of its students? Faced with the student protest that such an attempt pro-
vokes, however, Morton is forced to backpedal, emptying his claim to
oppositional pedagogy of its concrete force. It seems the only way op-
positional pedagogy can avoid being authoritarian is by ceasing to be
oppositional.

The route taken by this backpedalling retreat is often the claim that
one is only teaching "critical thinking." In denying that he has graded
the student on the basis of his beliefs, Morton writes: "The grade he
received, like all other grades I gave, is not based on the content of his
ideas . . . but on the mode of his inquiry (the rigor of his conceptualization,
the tightness of his argument, the degree of meticulousness in attention
to textual details, the complexity, subtlety, and nuancedness of his read-
ings)" (81). This abrupt shift, however, to a rhetoric of politically neutral
rigor, which is repeated frequently in this essay, is anomalous in a pedagogy
that claims a specifically political oppositional stance. Suddenly, qualities
like "rigor," "tightness," "meticulousness," and "complexity" are invoked
as if they were merely formal and technical, as if they stood above insti-
tutional politics or ideological dispute, and as if determining the existence
of such qualities did not itself involve questions of politics and culture. As
Morton imagines it, the unleashing of critique in the classroom ultimately

leads to the unmasking of the structure of domination and disenfran-
chisement. The dominant groups, stripped of arbitrary or coercive power,
will fail to justify their position when thrown back solely on intellectual
weaponry; the disenfranchised, liberated from material and institutional
oppression, will gain the technical skills they need to understand their
condition and engage in revolutionary contestation with the powers that
be. Thus, in a manner reminiscent of Hegelian and Marxist dialectic,
critique turns out to be at once inherently formal and yet historically
progressive. This double nature of critique is what allows Morton both
to defend his course as unbiased *and* to suggest that it has an oppositional
political power.

This double play only works, however, if one assumes in advance
that no really effective arguments for injustice can be mounted that will
survive critique. Even the most skillful tracts in behalf of homophobia,
racism, sexism, flat-earthism, and UFOs will inevitably face deconstruction
as their own internal failures are exposed, and as they are subject to rigorous
external argumentative assault. History, however, teaches us the folly of
this assumption. Good, wise, talented, and brilliant people have regularly
made what appeared to be rock-solid arguments in behalf of all sorts of
injustice and untruth. There is no reason to assume that such arguments
will not also occur in Morton's classroom; indeed, they did occur, as he
implies when telling us that one conservative student got a very high
grade. Critical pedagogy, then, cannot guarantee that students will arrive
at a predetermined political stance, and students will rightly experience
this expectation as dogmatic.

In our view, the definition of categories such as the disenfranchised
and the dominant, oppressed and oppressor, should be a *product* of the
pedagogical process, not its unquestioned *premise.* So must the way these
categories are described, theorized, and historicized. One suspects that
Morton's complaining student was reacting to such an unquestioned prem-
ise when he accused Morton of dogmatism. The premise that the class-
room, like society, is constituted by a readily identifiable hierarchy of the
disenfranchised and the dominant is not unreasonable or indefensible, but
it *is* a premise and one that should be as open to criticism as any traditional
axiom.

Persuasion and Community

The premise that teachers should unmask the ideologies of their students—
or that they should teach them how to unmask the ideologies of everyone
else—has disturbing ethical and political consequences. One consequence
is to efface or trivialize the status of personal agency. According to Morton,

"persons" must be "distinguished from their 'discourses'" (82) so that those discourses can be effectively critiqued. This distinction removes the critique of discourses from the realm of the ethical, where relationships between persons require attitudes such as tolerance, respect, responsibility, sympathy, justice, and humility.

Most students will not readily perceive a distinction between the professor's contempt for their discourse and contempt for their persons, as many women and people of color can testify. By treating persons as discourses, critical pedagogy applies poststructuralist theory in a reductive manner that is shallow theoretically and harmful strategically. By depersonalizing critique and pedagogy, oppositional theorists underestimate the emotional and psychological ties that individuals have to knowledge and power. The connection of persons to discourses is an ethical one that cannot be reduced to ideology. The person takes responsibility for negotiating the relationship between discourses and institutions of knowledge and power, on the one hand, and the experience of the individual on the other. An ethic, like a discourse, is precisely a set of principles that is not coincident with the person, but rather something he or she embodies only imperfectly and individually.

Keeping the connection of persons to discourses is vital to an effective theory of agency and a coherent view of injustice and responsibility. The kind of alienation effect produced by oppositional pedagogy overstates the determination of persons by discourses, and so opens the way both to irresponsibility and social fragmentation. A relentless critique of every student's and every teacher's bad faith leads to contempt for the idea of community. Real political opposition and change cannot be accomplished by isolated individuals or random acts of critique. Unlike critique, politics is a social enterprise. It requires that persons form communities based on some degree of trust and faith and mutual respect—even for those with whom one is ideologically at odds.

It is just such notions of respect, trust, and faith that critical and oppositional pedagogies reject, usually out of a fear of being "co-opted" by the dominant social institutions. A political community depends upon a mutual recognition of common interests, which must be understood in part by testing discourses against persons and ideas against experiences. It is difficult to imagine how the students in an oppositional classroom are to form a bond with each other, much less with those who *oppose* their point of view. Critique can succeed only by resorting to *persuasion,* and persuasion has no chance unless it is willing to respect the resistances of those who are not yet converted. At some point, critique has to turn into a positive program that those not yet persuaded will find intellectually satisfying, emotionally desirable, and ethically acceptable. In the end, then,

an ethical pedagogy, which poses questions about the relationship between individual good and social good, and between personal character and political action, will be more helpful in orienting a way through and beyond opposition.

Persuasion is political because it aims to address a community about problems and interests that are vital to how people conduct themselves towards each other. Persuasion recognizes the social nature of human life and the necessity of attending to the improvement of the organization of society. Persuasion accepts the plurality of goods, that is, the existence of many different notions of the good life among its audience. Politics is not the implementation of a single truth, but the process of structuring the negotiation between differing truths in a manner that respects their claims as much as possible. We grant that critical pedagogy has its place at the level of individual teaching practices, at least when it is willing to respect the resistance of students. But as long as education is an institution in an overlapping system of democratic processes, the school cannot and should not enforce a program that commits everyone to a predetermined worldview, however just we may believe it is. Theorizing the practice of entire institutions of higher education means thinking from the viewpoint of conservatives, liberals, and others with whom we work, not just from the viewpoint of radicals. This calls for a model of education in which we engage with those who hold the "wrong" politics and will not take our assumptions for granted, that is, a model in which ideological opponents not only coexist but cooperate.

This in turn means thinking of models beyond that of the single classroom with the single instructor, the model that still dominates critical pedagogy, in spite of its unorthodoxy in other respects. If educational institutions hope to be true communities of intellectual inquiry, reforming them will require models that respect the ethical and political dimensions of community life. This means respecting those with the "wrong" politics, and even accepting the risk that they may change *us*.

Democratizing the Dialogue: Some Proposals

What is to be done? Are critical and oppositional pedagogies as they are currently imagined the only possible ways to conceive a political pedagogy? Consider another kind of political pedagogy—"teaching the conflicts"—that starts from a different vision of how to organize teaching. Instead of attempting to transform the consciousness of students directly, the strategy of conflict pedagogy is to present students with political conflicts while giving them space to choose their own positions. Such a tactic should not be mistaken for a wishy-washy debating society, however, that aims only

to "keep the conversation going." In fact, its point is to create conditions in which instructors can be *more* assertive about their political and other views with less risk of coercing their students.

Though teaching the conflicts is a viable tactic for individual instructors—many of whom will not be in a position to reconfigure the whole curriculum—it ultimately involves going beyond the limitations of "the classroom" as an autonomous space cut off from other classrooms. However "radical" in content critical pedagogy may be, this pedagogy is perfectly conventional in its assumption that it is normal and proper for education to take place in separate courses taught by a solo instructor.

To be sure, there is a useful place for the "collaborative learning" strategy of decentering authority by breaking the class into small groups. To decenter authority in a fully useful way, however, and transcend the double bind of radical pedagogy, our classrooms need not just to diffuse authority but to introduce *counter*authorities. And this for us means moving beyond the limitations of the isolated course, a model that unwittingly echoes the myth of the unified subject. How can this be done? Let us look at a recent experiment at the University of Chicago, one that, in fact, ended up both teaching the conflicts and putting the idea of teaching the conflicts into question.[5] The experiment involved a freshman general education Humanities course that enrolls some two hundred students in ten sections. One-quarter of the course has traditionally been designed to illustrate specifically *philosophical* aspects of the humanities, typically dealing with topics such as "Freedom and Constraint" or "The Nature of Virtue" in a variety of texts and genres. In recent years, many instructors have become dissatisfied with the rarefied nature of these topics, and this dissatisfaction last year led the staff to change the topic of the course to gender.

This change was unpopular, however, with a portion of the student body and faculty. They argued that though gender might be a legitimate enough topic for study, it was not a properly philosophical problem, and therefore was out of place in the course. Some traditionally minded instructors decided to resign from teaching the course. Thus a familiar conflict divided the humanities core staff between traditionalist and revisionist views of what can legitimately count as a philosophical mode of reading. Several of the instructors who continued in the course decided to try to bring the conflict into the course by organizing a two-hour symposium that all sections would be asked to attend. In preparation for the event, all students and instructors read an excerpt from Graff's book, *Beyond the Culture Wars,* in which Graff describes his youthful fear of reading, growing up in a tough Chicago neighborhood where bookish or studious boys were stigmatized as "sissies" and regularly beaten up. Graff recounts how

he overcame this distaste for books on being exposed to interpretive and theoretical debates in college courses. His chapter thus makes the case for "theory," and attacks Allan Bloom's idea (and by extension the rationale of the Chicago Humanities core course as many understand it) that the humanities are best taught by "just reading" the books themselves.

In the symposium, two faculty responses challenged Graff's position from different directions. A defense of the Bloom position in answer to Graff's criticisms was presented by one of the instructors who had dropped out of the course when the theme was changed to gender. A second instructor then criticized Graff from the point of view of gender studies. This instructor charged Graff with acquiescing in the *macho* street code that stigmatized reading and bookishness as effeminate. It seems, this instructor suggested, that "teaching the conflicts" had recommended itself to Graff only because it allowed "him to read books without running the risk of being called a sissy or a fag." If you can only "turn the reading of books and the writing of literary criticism into fisticuffs," he wrote, "then there's no risk of being mocked as a sissy. Let's duke it out over *Huckleberry Finn;* nobody can call us sissies then."

Graff retorted to this criticism that while the underlying motivation of the idea of teaching the conflicts might indeed have had a good deal to do with the *macho* street code, this did not discredit the idea. This led to a discussion of the extent to which an argument can be compromised by its motivations, or in this case by the complex of power-relations into which it enters. Graff also wondered whether it was really legitimate to associate conflict and debate with maleness. In these ways—which proved to be quite unexpected to the planners of the event—the question surfaced that had been at the center of the course and the faculty disputes about it: What relationship exists between philosophical analysis and gender-critique? Could gender indeed be legitimately treated as a philosophical rather than a political problem?

It turned out not to be difficult to relate the discussion of these issues to the texts read in the course so far—Plato's *Symposium,* Descartes's *Discourse on Method,* and *Huckleberry Finn.* Thus the debate connected intimately with the close reading and writing assignments that students had been doing, a fact that helped students feel that the symposium discussion was relevant to their work in the course. Several instructors followed up by assigning a paper on the symposium, and Graff and the instructor who had presented the gender-critique continued the debate in the latter's section.

Note that the symposium made several things happen that tend not to happen when there is no cross-course conversation. Political issues were moved to a central place in classroom discussion, and the commitments

of instructors were aggressively expressed, yet the format prevented students from feeling forced to accede to one instructor's position. Like critical pedagogy, teaching the conflicts can make students aware of the history, terms, and institutional context of intellectual or ideological disagreements, like this one over gender. But there is no predetermination, as there is in critical pedagogy, that critique will inevitably expose the folly of one side. When one teacher advocates a particular position within the debate, the claim to authority of that position is checked by the counterauthority of other teachers' positions, protecting students from arbitrary impositions of power.

Note, too, that the discussion in this case worked to undo the rigidification of "positions" and "sides" that so readily sets in in solo teaching. Graff initially occupied the "progressive" position in relation to the Allan Bloom defender, only to be repositioned on the conservative side by his colleague's gender-critique. The students thus experienced the relational, negotiated aspect of cultural discussion that the isolated classroom tends to screen from view.

In effect, such an event imports the principle of the academic symposium into courses, creating dialogical links between classrooms. It assumes that if attendance at professional conferences is becoming an indispensable aspect of the education of graduate students, as it increasingly is, then, suitably adapted, such conferences can be an equally effective means of socializing undergraduates into the ways of the academic intellectual world. In 1993–94 there will be a year-long series of such conferences in the Chicago core Humanities course, culminating, it is hoped, in conferences organized and run entirely by undergraduate students.

Though teaching the conflicts is not an oppositional pedagogy, it is not and does not claim to be apolitical. It redefines the politicization of education as something other than simple advocacy or opposition. It recognizes the need to debate not just the traditional view, according to which politics, say, has nothing to do with philosophy, but the recent challenge to that view, which says that "everything is political." Oppositional critiques therefore have a major voice in the dialogue, but they too are open to critique and challenge in the public sphere of discussion. Of course, this means that oppositional teachers must take the risk that their pet assumptions and positions will be publicly refuted, but we believe this is a fair expectation, for finally there is no risk-free position. In the long run, in fact, subjecting themselves to the challenge of the liberal and conservative "other" figures only to help oppositional critics to clarify their positions and explode standard misconceptions about their work.

Bringing antagonists together in public would in turn help students better understand what is at stake in debates, say, about the propriety of

taking gender, race, or class as a category of literary and philosophical analysis. And since critiques of these critical and oppositional approaches would be fairly represented in the discussion, those many students who now harbor suspicions about them would be less likely to feel intimidated by political correctness, and more receptive to an open consideration of the new approaches.

The "politicized" university we describe, then, would not propagandize for a particular politics, but it would not claim to be simply neutral and above politics. It would seek to dramatize and bring into open discussion the actual political conflicts between agents of intellectual and institutional power. It would seek to bring to public light the arguments, values, prejudices, and ideals of these agents, and thereby serve the purposes of democratic education. It would look to turn the campus into a *polis,* a community where empowered citizens argue together about the future of their society, and in so doing help students become active participants in that argument rather than passive spectators. Political conflict is essential in this pedagogy, but in a way that does not prescribe the proper outcome of the conflict in advance, but makes the question of what politics is, what politics does, and where politics is going part of the process of education rather than its predetermined premise.

NOTES

1. Paulo Freire, *The Pedagogy of the Oppressed* (New York: Continuum, 1970), p. 116; subsequent page references given in the text.

2. Kathleen Weiler, "Teaching, Feminism, and Social Change," in C. Mark Hurlbert and Samuel Totten, eds., *Social Issues in the English Classroom* (Urbana, IL: NCTE, 1992), p. 329; we are indebted to Kathleen McCormick for calling our attention to Weiler's article.

3. Donald Morton and Mas'ud Zavarzadeh, "Theory Pedagogy Politics: The Crisis of 'The Subject' in the Humanities," in Morton and Zavarzadeh, eds., *Theory/Pedagogy/Politics: Texts for Change* (Urbana: University of Illinois Press, 1991), p. 7; subsequent page references given in the text.

4. Donald Morton, "On 'Hostile Pedagogy,' 'Supportive Pedagogy,' and 'Political Correctness': Letter to a Student Complaining of His Grade," *Journal of Urban and Cultural Studies,* 2:2 (1992), p. 79; subsequent page references given in the text.

5. See Gerald Graff and Christopher Looby, "Gender and the Politics of Conflict-Pedagogy: A Dialogue," forthcoming in *American Literary History.*

Writing Permitted in Designated Areas Only

Linda Brodkey

The international sign that bans smoking in public places can also be read as a sign of cultural hegemony, a frequent and forcible reminder that in democratic societies such civic regulations commonly inscribe the will of the dominant culture. That there are two versions of the sign suggests that the dominant culture is of at least two minds when it comes to smoking in public places. One version of the sign prohibits smoking altogether, and the other regulates smoking by appending a text that may be more familiar to smokers than nonsmokers: "Smoking Permitted in Designated Areas Only." This second sign, signaling the temporary segregation of smokers from nonsmokers, is nonetheless part of the same expansionist public policy as the first, whose chances for eventual success can probably be measured by the rapidly diminishing number and size of public spaces where smokers are still allowed to smoke. In the meantime, however—so long as they remove themselves to those designated public areas—smokers constitute a literal and figurative body of evidence that a desire to smoke remains strong enough in some people to withstand the ever increasing pressure of social hostility and medical injunctions. That smokers commonly honor the signs, either by not smoking or only smoking in designated areas, provides smokers and nonsmokers alike with continual public enactments of civil power, namely, of the professional/managerial middle class to enforce the public suppression of a desire it has recently identified and articulated via science as endangering its well-being—as a class.[1]

The sign has radically and no doubt permanently altered the public behavior of smokers and nonsmokers in many regions of the country. At issue, however, is whether these or possibly other even more punitive legal

214

and economic sanctions will ultimately not only regulate smoking but also extinguish the desire to smoke. While I doubt that I would care all that much if people lost the desire to smoke (and as a smoker I could probably live with the loss of that desire), I care a good deal that more than a century of publicly regulating the desire to write in North American schools seems to have eradicated it in many people. I am couching my case for the "deregulation" of writing and writing pedagogy in terms of the recent and the seemingly more reasonable campaign to ban smoking in public areas because, just as smokers are arguably surrogate targets for the tobacco industry, I consider composition to hold students hostage to a peculiarly American version of meritocracy.

There is no doubt in my mind that this society prohibits and regulates smoking in public areas because the tobacco industry has thwarted efforts to outlaw the sale of cigarettes by submitting itself instead to ever more stringent government regulation. The industry's success has, of course, shifted the burden of responsibility onto consumers, smokers whose desire to smoke could, until the recent public concern about secondary smoke, be defended as a constitutionally protected individual right. In the current cultural climate, however, any defense of smokers' civil liberties can and sooner rather than later probably will be met with a rarely voiced but easily inferred *subtext* from scientific studies of secondary smoke: "Cigarettes don't kill. Smokers do." Unlike "Guns don't kill. People do," the *text* produced and circulated by the National Rifle Association in defense of what it claims to be an absolute constitutional right to bear arms, a subtext on the order of "Cigarettes don't kill. Smokers do" is not in the public domain, and not then readily available to public scrutiny. A subtext which asserts *not* smoking to be an act of moral as well as civic virtue is a nonetheless influential and powerful text precisely because as a subterranean text it insinuates rather than argues its claims. In much the same way that white supremacists code racism by claiming they are not racists, just proud of being white, the subtext permits the antismoking campaign to continue publicly condemning smoking while silently indicting smokers. It goes without saying, or should, that the tobacco industry is hardly likely to point out that smokers are the designated culprits in a subtext that protects its economic interests, for such a subtext would effectively insure companies that sell cigarettes against liability in suits brought against them by smokers. Nor does it seem all that likely to me that tomorrow, or even the next day, the signs that now target a smoking cigarette will be replaced by ones that target a cigarette smoker.

At least as long as the sale and use of tobacco remain legal, the signs are likely to continue issuing civil directives to, rather than moral indictments of, smokers. Increasingly, however, there is evidence that a

subtext indicting smokers is emerging as a *text* in the public service announcements aired by local television stations, and evidence, too, that the spots which identify the culprits and assess their culpability trot out the usual suspects, working-class women of all colors and working-class men of color. During the fall of 1992, the commercial stations in San Diego, where I live, regularly aired two such public service announcements. The first depicts a woman in the delivery room whose joy in giving birth is dramatically and abruptly reversed when a white male doctor orders the newborn to intensive care. An explanation of sorts is provided by a flashback of the woman smoking and drinking at a party. The spot indicting her, that blames her and her *irresponsible* social behavior for the infant's peril, locates any hope for its survival in the doctor and his *responsible* professional behavior. The other public service announcement focuses on a young Latino seated on a sofa beside a Latina child. As they sit staring at a television in a poorly lit and furnished room, he is oblivious to the girl, who coughs every time he takes a drag on the cigarette. Like the pregnant woman, the Latino is indicted, and his irresponsible social behavior identified as imperiling the child. The adults in both spots are held morally responsible. Once having identified the culprits, however, the spots also assess culpability, wherein the indictments of smokers are furiously confounded by some familiar middle-class anxieties about women and men of color.

Set in the public space of a hospital, the delivery room trauma at the very least suggests that a medical intervention is both possible and justified when a woman (she is marked for pregnancy, not race or ethnicity) behaves in ways believed to jeopardize a fetus. The medical intervention, warranted in this instance by the flashback, is represented as a beneficent act on the part of the doctor and the hospital. This is not the only example of medical charity toward fetuses known to us, however, and feminist analyses of reproductive technology do a great deal more than suggest that women may themselves be in need of protection from medical-legal traditions and practices in which their interests are represented as conflicting with and subordinate to those of fetuses (see, for instance, Hartouni; Martin). Any interpretation of the spot depends on deciding in whose flashback the woman is smoking and drinking. It could be the woman who is remembering the party, or the doctor or even one of the nurses who is imagining the scene. Since the camera focuses on the woman's horrified expression immediately before the flashback, however, it is most likely her memory, which at the very least suggests that the woman has assumed, or is at least capable of assuming, moral responsibility for her past behavior (including responsibility for getting preg-

nant), and may also suggest that she plans not to behave similarly in the future.

In my reading, the birth trauma teaches the woman to see herself as the doctor does, or, more precisely, to look on her pregnant body as he does, as a uterus. His medical gaze is in this case a middle-class gaze, which views not smoking as not only reducing the risks to which fetuses are prone, but as also enacting a public commitment to the middle class, which advertises smoking as endangering its well-being as a class, and not smoking as one of its many virtues as a class. Hence medical agonism between the female and the fetus is projected onto working-class rather than middle-class women, and attributed to "differences" in class behavior. Such an advertisement invites working-class women of all colors to resolve the narrative conflict between fetuses and themselves and, in the course of esthetically resolving that narrative, close the material gap between middle-class women and themselves, by not acting on their desire—to smoke? to drink? to have sex?

The synoptic recoding of material conditions—including access to and the availability of prenatal care—as matters of individual choice and merit is a familiar middle-class belief, amplified by a rhetorical appeal to ethos, which in this instance focuses exclusively on the *character* of smokers rather than, say, the cost and quality of health care or the political influence of the tobacco industry. The campaign to privatize schooling by way of vouchers created a similar illusion that each and every *good* parent would be able to choose the schools their children attend, when in fact such a tax credit would have enabled only a fraction of middle-class taxpayers to exercise their "right" to choose. Representing smoking (and drinking) as vices of working-class women circumscribes middle-class civic responsibility, for, in singling out these women, the narrative valorizes their behaviors at the expense of systemic practices that impinge on the health of poor women and children. I am not arguing that smoking is moot. Rather I am arguing that the narrative told by the public service announcement does considerably more than warn pregnant women against smoking, and I am suggesting that advertising the suppression of desire as a virtue of middle-class women exonerates the entire class from its responsibility for inequitable health care, even as it holds poor working-class women entirely responsible for their own health *and* that of their children.

The spot featuring the Latino narrates no such belief that he holds or ever will hold himself accountable to either the child or the middle class. The Latino is outside law, at home, the private space where the state, despite a fair amount of evidence to the contrary, represents itself as helpless to intervene without due cause. My sense that he is an outlaw has to do with portraying him as oblivious to the child's peril. Since Latinos

are commonly depicted in the media as familial, I cannot but wonder whether this man is even a blood relative. And if he is just a "friend," perhaps that would explain why he is being caricatured as unlikely to ever assume even a measure of responsibility for the well-being of a child not his own. For unlike the woman, whose possible guilty knowledge at least makes her a candidate for remediation, the Latino is projected as incorrigible, the smoker whose absolute difference from middle-class nonsmokers is irremediable. That the culprit who is not just ignorant but stupid is a Latino, and that he had only to notice the child and put out the cigarette to transform what I see as a gratuitously reactive message into a proactive one, is reason enough to suspect that the ostensible purpose is not the only and perhaps not even the primary purpose of this particular public service announcement.

Rather than contributing to the campaign against smoking, this spot seems to target not Latinos who smoke, so much as those in the middle class who have been taught that immigrants generally and Latino immigrants in particular threaten what the English Language Political Action Committee, in a letter to California voters in the last Presidential election, calls "the language of unity and opportunity," in the absence of which "we'll [English speaking voters] be faced with *years of unrelenting pressure* for a costly multilingual, multicultural society" (ELPAC, original emphasis). No one speaks in this spot. But that this particular man and child do not speak implies that if neither can speak English, neither has a right to speak for themselves. The English Only Movement commonly represents not speaking English as evidence of immigrant indifference or hostility to American values (see, for instance, Baron; Crawford). Presumably, then, a Latino smoker who does not speak English, may not be family, and may not even be a U.S. citizen represents a threat not just to the Latino family, not just to the middle class, but to the nation. This nonetoo-subtle identity of language, class, and nation as one and the same is disturbing for any number of reasons, not least among them that language education is invariably the site at which many of the vested political interests of the middle class and the state are reincoded as identical subtexts in putatively apolitical curricula. As the dismissal of Joseph Fernandez, the Chancellor of the New York City public schools, in February of 1993 so dramatically illustrates, efforts to raise these political subtexts to the level of texts (the Rainbow Curriculum) and make them available to public scrutiny are likely not only to raise the ire but also to provoke the enmity of those who believe their political interests are better served in subtexts than texts (see also Kohl).

Let me reiterate that I am not arguing for or against smoking. What I find disturbing in the public service announcements is the strategic tar-

geting of female ignorance and male stupidity as endemic in specific classes and/or groups of people. Such a spin is uncannily reminiscent of policies that have historically singled out the individuals the most likely to benefit from literacy education as those who accept not only the middle class's version of itself as an inherently virtuous and hence meritorious class, but also its caricatures of the working class, the working poor, and the just plain poor as criminally illiterate, promiscuous, violent, seditious. Public policies that represent only to write off these constituencies constitute and also regulate the middle class by depicting conduct becoming to its members. Nowhere is this more evident than in policies regulating public education. Conservative and liberal policies alike produce curricula that justify disciplining all the children, regardless of class, according to some widely received middle-class definition of learning and teaching (cognitive development, cultural literacy, critical thinking), and every policy implicitly or explicitly also justifies punishing students, parents, teachers, and/or administrators who challenge its exclusive authority by threatening them and/or the children with expulsion from the middle class (tracking, ranking, flunking, detention, suspension, expulsion). My point is that the curriculum, like the constitution, commonly represents society itself as classless, and hence class membership as entirely within the control of individuals and/or families.

Composition classrooms are the designated areas of American colleges and universities. Composition courses are populated by students who for one reason or another do not produce fluent, thesis-driven essays of around five hundred words in response to either prompts designed for standardized tests or assignments developed by classroom teachers. Since most prompts and assignments are so many variations on the notorious "Write an essay about what you did on your summer vacation," the form and content of successful student essays are likely to display knowledge of and fealty to middle-class values. If you are middle class, you must convince the teacher (reader) that someone you met or something you did on vacation made you appreciate your family and/or country. And if you are working class, you must convince the teacher (reader) that by working hard or reading the right books you acquired a taste for things middle-class and/or American. Middle-class and working-class children alike are expected to exemplify rather than question such venerable notions as the undisputed "educational" value of travel, literacy, and work in their essays, even though some working-class children may have to betray their families in the process, and some middle-class children collude in happy family fictions. The fiction that the family and the nation are united solely on behalf of children lends credence to the notion that literature, history,

physics, psychology, and so on are unified on behalf of the middle class. Like summer vacations, it seems, great books are coherent from a middle-class perspective, and students who fail to see or appreciate and represent a principle that unifies a work of literature and distinguishes it *as* literature in the form and content of their essays are sent off to composition to learn how to see the obvious and to write about it—in five hundred words or less.

It has always seemed to me gratuitous to regulate writing and writers via the content of prompts and assignments, since a policy of coherence is already being "objectively" executed by assessing student writing on the basis of form and format: the grammar, spelling, diction, and punctuation, along with the thesis sentence, body paragraphs, and conclusion. Perhaps both are necessary, however, because while form identifies class interlopers (working-class ethnic and black students), content singles out class malcontents. While it seems to take longer in some cases than in others, composition instruction appears to have succeeded best at establishing a life-long aversion to writing in most people, who have learned to associate a desire to write with a set of punishing exercises called writing in school: printing, penmanship, spelling, punctuation, and vocabulary in nearly all cases; grammar lessons, thesis sentences, paragraphs, themes, book reports, and library research papers in college preparatory or advanced placement courses. It is probably worth wondering whether the most successful students are not those who learn early on that writing assignments are occasions for students to display and teachers to correct errors, and not, as one might think, invitations for students to write about and teachers to respond to ideas.

Like smokers who enter public areas designated for smoking, students in required composition classes publicly enact the power of the middle class to enforce the suppression of writing and writers, a desire it has long identified as inimical to its best interests as a class in literacy campaigns calling not for a nation of writers but a nation of readers (Brodkey, "Tropics"). Writing is also a desire that has been historically albeit ambiguously articulated as dangerous to the nation, via curricula and pedagogy in which authors are depicted as martyrs to Literature, condemned to live in splendid isolation from the rest of us in garrets or penthouses (Brodkey, "Modernism"). Writing and writers may be represented as well beyond the reach of middle-class rules of conduct, but good student writing has repeatedly been defined, taught, and evaluated in American schools as good manners. That much seems apparent in any handbook or style manual. It is well known in the field of composition that this version of good writing and, by extension, good writing pedagogy, as a matter of training students to produce well-formed essays on demand, was firmly in place

at Harvard (where composition was invented as a college subject) by the late nineteenth century (see Douglass; Halloran). And it is also known by some in the field that not all that much has changed at Harvard, or elsewhere, in the last hundred-some years (see Crowley; Faigley; Miller).

It is fair to say that, despite what may appear to be radical shifts since the 1960s in how writing is taught—despite, that is, a twin focus on the so-called writing process and personal experience of students in a good many public and private schools, colleges, and universities—composition continues to do what it was established to do: guard the gates of the professions by offering what, in *Textual Carnivals,* Susan Miller calls "a consciously established menu to test students' knowledge of graphic conventions, to certify their propriety, and to socialize them into good academic manners" (66). In other words, the *text* explicitly used at Harvard and similar private and public institutions in the nineteenth century to justify the regulation of students and their writing is an implicit *subtext* in even seemingly liberal textbooks to this day (Faigley, 132–162). Students may now be invited to write personal essays, and students may even be encouraged to revise them, on the advice of teachers and peers, but the persistent subtext guarantees that teachers will revert to verbal fluency in their comments and thus that teachers will continue to test, certify, and socialize students according to the dictates of an unacknowledged middle-class constituency. While what counts as fluency varies over time and place and population, that is, may be more or less generous in one era than another, or may mean subject-verb agreement for students with low placement scores and diction for advanced placement students, the policy of isolating and then reifying selected formal features of student texts as markers of verbal fluency does not.

It is this deflection that concerns me, not only because it fecklessly begs the issue of content, which is undoubtedly crucial to writers and writing, not to mention readers and reading, but because fluency surreptitiously calibrates all writing to middle-class notions of literacy, and then installs a middle-class version of fluency as the *exclusive* standard by which to measure the value of any and all written texts. For by that standard not only most student texts, but most academic texts, and many of the canonical as well as noncanonical texts academics study, would probably fare poorly, since they usually are narratively and rhetorically and even syntactically more complex than the forms vaunted by style manuals. That the rules of scholarly writing are not synchronized to the taste of the middle class is most evident when a pundit accuses scientists or social scientists of using jargon to disguise the fact that a study "proves" the obvious or when a pundit lambastes professors of literature, *not* for using jargon or for studying the obvious, but for raising topics like masturbation or homosexuality

or canonicity or colonization or any other notion these media-sponsored, self-appointed guardians of the people (also known as *the public*) see as challenging their authority to dictate what and how professors and students *should* be reading and writing.

Measured primarily by its fealty to rules prescribed by handbooks and style manuals, a fluent but invalid theory of physics would be a better text than a less fluent but valid one. Since creationism theories often are more fluent than most Darwinian theories, in some composition programs (as in some quarters of society) the fluency of the one, which makes it the better *text,* would effectively also make it the better theory. Invoked as a single or even supra criterion, fluency is dangerous because it assumes there to be a necessary and positive correlation between *clear* writing and *clear* thinking, which any honest student can tell you is patently not the case. The fluency trick, and it is seen as a trick by many students, is to write a thesis statement simple enough that it can *appear* to be adequately elaborated and naturally resolved in the requisite number of words. My son, who once explained this to me in some detail, went so far in high school as to make it a policy never to read literature about which he would be asked to write, on the grounds that reading would unnecessarily complicate his understanding of the assignment and increase the difficulty of producing the kind of essay his teachers wanted. In other words, this white, middle-class boy (and no doubt countless other middle-class children) possessed of verbal fluency had learned that a good composition ignores rather than addresses the complexity of topics, and treats the reader instead to a display of verbal fluency.

The will of the middle class to regulate whatever it sees as threatening to its interests as a class cannot be overestimated. One need only call to mind Richard Bernstein's sly condemnation of the new *Webster's College Dictionary* in the *New York Times* a few years back to see how furious some middle-class pundits can become when linguistic descriptions refuse to confirm linguistic prescriptions that are used to justify the middle-class hegemony over good English. After asserting that some will no doubt welcome the attempt to eliminate sexist language and to identify potentially disparaging usages, Bernstein produces the agonism for which journalists are justifiably notorious: "But Random House lexicographers *acknowledge* that the dictionary is likely to arouse opposition, particularly from those who feel it has bent to political fashions, dropping its role as an arbiter of *correct usage* in favor of a kind of anything-goes descriptivism" ("Nonsexist Dictionary," emphasis added). Prescriptive linguistics is a discredited theory to the extent that the rules it imposes ignore language structure and usage, and the explanations it provides are incorrect or suspiciously incomplete. Strictly speaking, prescriptivism is not a candid the-

ory. It is precisely this lack of candor in prescriptivism, and in many other commonsense theories about language, society, culture, history, literature, economics, biology, physics, and so on, that frustrates academics, whose work is grounded in candid theories, but whose "public" credibility the media increasingly measures against the standards of commonsense theories. Surely middle-class common sense contributes to, if it has not actually created, the chilling effects at the National Science Foundation, which of late seems unusually intent on funding (or at least appearing to fund) only science of practical value, that is, of immediate, marketable value.

What we are more likely to see than linguistic analysis in prescriptive accounts of language, and in arguments based on them, is an unfettered will to control social and political reality by stemming the inexorable tides of linguistic variation and change and, barring that, an utterly self-righteous and self-serving devaluation of new usages. Since English handbooks prescribe usage (albeit in the guise of description), their continued, nearly universal use in composition courses and programs as the *exclusive* arbiters of fluency, and the invocation of fluency as the *exclusive* measure of writing ability, bespeaks a commonsense influence in the field out of all proportion with its influence in any of the other academic fields and disciplines. In other words, while the middle class grudgingly concedes the necessity for counterintuitive theories in the sciences, and to a lesser extent even in the social sciences, however infuriatingly daunting and inaccessible they may find them, many pundits and even some professors assume that the language theory on which writing pedagogy is (or should be) based must be the same one they believe should prescribe usage for not only the middle class but all Americans. Hence any pundit can claim with relative impunity that the purpose of composition is to police the grammar, spelling, punctuation, usage, and so on of students, and be seen by many people as only making common sense. I should add that these same commonsense pundits and professors can and do, with equal impunity, assign literature professors to the same beat, for the language they seek to protect is thought to *live* in the literary canon. Middle-class literacy is a form of cultural capital that once seemed to rest on the gold standard of prescribed books and language, but turns out to be a volatile form of cultural currency whose seemingly stable value is alarmingly easy to destabilize in practice. A neologism here, a split infinitive there; a novel by Toni Morrison, Sandra Cisneros, Leslie Silko, or Amy Tan here, a work by Americo Paredes, Ishmael Reed, or Rigoberta Menchú there. Adding any or all would apparently wreak havoc on the exchange value of English as a world language and on Western literature as the exclusive depository of universal and timeless truths.

It is this widely held and largely unexamined middle-class belief in its absolute right to prescribe virtually everything, from what fork to use to what music to record and words to publish, that vexes me as a theorist, researcher, teacher, and program administrator. It is as a program administrator, rather than theorist, researcher, or teacher, however, that I finally realized the devastating and pernicious consequences of rampant prescriptivism for the field of composition. For the pundits and professors who—without ever so much as looking at the syllabus—rallied and railed against the decision to reform the required, one-semester, first-year, undergraduate writing course at the University of Texas at Austin seemed able to stoke anxiety over "Writing about Difference" in large part because prescriptivism is after all *just* common sense.[2]

After a hundred-some years, any fool apparently can see, because it is after all only common sense, that students can't write because they can't spell, punctuate a sentence, tell an adjective from an adverb, a phrase from a clause, a restrictive from a nonrestrictive clause, and so on. That many students do not attend to these matters in their writing does not mean they do not know the rules. To conclude that lack of knowledge of the rules is the problem is very like presuming that middle-class adolescents whose rooms are a mess do not know *how* to clean them. No matter how many times I explained that common sense is not always good sense in writing pedagogy, that attending to form while writing inhibits some writers to the point of distraction, that matters of form are commonly dealt with not as rules, independent of the texts produced, but when writers have a stake in what they are saying—the critics knew better. Prescriptivists always know better, because like the commonsense theory that supports them, they confuse symptoms for causes, and so do not ask, as people in my field have, why after years of learning rules, students still act as if they have never heard of them. Composition teachers are not doctors, and do not prescribe for what *ails* students and offends the sensibilities of those who would prescribe even more of the same medicine that many of us have good reason to believe may account for the widespread amnesia among students (see Shaughnessy; Bartholomae; Hartwell). It's not that students do not know rules. If anything, they know too many of them: "never use *I*," "never start a sentence with *and*," "always state the thesis in the first paragraph," "always conclude by paraphrasing the thesis." They know the rules of composition. They just don't know what composition has to do with anything, save the fluency trick.

If you want students to learn to write, students who for years have been learning *not* to write, it is probably a good idea to recreate the circumstances under which others have turned to writing. While it is not the only reason, a good many literate people write when speech fails, that

is, when something they have decided is worth reflecting on and asking others to contemplate is sufficiently complex that writing about it seems more promising than just talking it over with someone. This is at least a reason that a good many students would understand, for they live in the same troubling world as their teachers, a world where speech is just as likely to have sometimes failed them as it has us, and thus a world where writing is just as likely to hold the same promise for them as us, unless teachers use it as bait for yet another fluency test. Everyone who worked on "Writing about Difference" saw the syllabus as inviting students to use writing to develop informed opinions on complex issues raised in the aftermath of civil rights law. While nearly everyone has an opinion on discrimination, I have learned, it seems that hardly anyone offers what could be called an informed opinion, one based on an understanding of law, its application by the courts in particular cases, and the implications of legal decisions for those classes which are named in antidiscrimination legislation, and for those which are not. Such ignorance and confusion seemed to me then, and seems to me still, made for writing, since the arguments that are at once the hardest and the most worthwhile to make in writing are those which readily acknowledge that the complexity of a situation allows not for one, not for two, but for an indefinite number of *arguable* positions.

As the Director of Lower Division English at Texas, in the spring of 1990 I recommended that the Lower Division English Policy Committee require all the graduate student instructors of English 306: Rhetoric and Composition (known as English 101 or Freshman Composition in most places) to teach from a common syllabus, to be known as "Writing about Difference," for one year, rather than to continue the practice of providing new teachers with textbooks the week before classes, and requiring them, as well as experienced graduate student teachers, to design their own courses. In large measure, my decision to use a common syllabus was an effort to offset what I believed to be the worst consequences of a long and bitter history of conflict between composition and literary studies in the English department at Texas. When the university fired most of the lecturers in English at the request of the department in the mid-1980s, several years before I agreed to come and direct the program, the department lost nearly all the instructors whose practical knowledge of composition justified pedagogical autonomy. By the time I assumed the directorship of lower-division English courses in 1989, only a handful of graduate students were enrolled in the Ph.D. program in rhetoric and composition, and a good many graduate students in literature resented being asked to design writing courses which, as one student put it, were

conceived in ignorance (since, having tested out of it, he had never taken such a course himself), and were therefore destined to fail. He and many others, in other words, saw the practice that some faculty later construed as protecting the academic freedom of the graduate student instructors as protecting faculty who, because they are not required to teach composition at Texas, preferred to dismiss the problems of writing pedagogy in convenient rationalizations.

The English department dealt with the newly created shortage of staff to teach lower-division courses by voting, nearly unanimously, to reduce the two-semester sequence of composition courses for incoming students to one, in return for which the department agreed to forego teaching writing about literature, and to teach writing from expository prose in the remaining course. That decision created problems for the graduate student instructors and the program director alike, since graduate students in literary studies typically know a good deal less about expository prose than literature. Little wonder, then, that student evaluations of the courses and the teachers often reflected these facts, and that often the same teachers who fared poorly as teachers of composition received considerably better course evaluations when they taught sophomore literature surveys (see Brodkey and Fowler).

Writing program directors are commonly held responsible not only for their own course evaluations, but also for those of courses taught by graduate students they direct/supervise. And in addition to being held responsible for all the lower-division courses in both literature and composition taught by graduate students, at Texas, as at most places, the director approves transfer credits and adjudicates grade complaints, appears on behalf of graduate student teachers at formal grievances, and stands in as the defendant for any graduate student instructor named in a suit against the university. These mundane duties not only define the usual institutional arrangements under which I and a good many others direct composition or lower-division programs, they radically distinguish us from most of the professoriate, inasmuch as we are held legally as well as ethically accountable for courses taught by graduate students in our departments. The department at Texas offers in excess of fifty sections of English 306 to approximately fifteen hundred students every semester, nearly all staffed by graduate students. Given the odds, my concern that most graduate students in literature are probably not particularly good teachers of writing convinced me that sooner or later I would be asked to explain to a court why I had not better prepared them to teach a course required of all entering students who do not pass a proficiency exam or take an equivalent course elsewhere. And even though many graduate students are more eager to learn about writing pedagogy than they once were, their ignorance of

writing as a field of study only heightened my concern that many students could rightfully claim that they had not done much writing in English 306, let alone learned much of anything they had not already learned all too well in high school.

The decision to teach one semester of composition provided a rationale for an administrative reorganization of lower-division courses in which the same person would direct the programs in both composition and literature. While that may sound feasible, the institutional and intellectual history of the fields is such that literary studies largely depends on theories of reception and composition, on theories of production. Simply put, reading is not writing, nor is writing reading. A little less simply, a reception theory accounts only incidentally for the production of written texts. And, while some theories of reading seem more friendly to production than others, none suffices because none is meant to account for writing. For some years now, I have argued that poststructuralism is the friendliest of the language theories to writing and writing pedagogy, if only because it deals with the part language plays in constructions and representations of self and other, along with everything else we call reality (see Brodkey, "Articulating Poststructuralism" and "On the Subjects"). Anyone who teaches writing as more than a set of rules that students should learn and follow is likely to find such a theory attractive, at least initially, for collapsing the recent distinction between form and content also suggests that an adequate theory of writing would account for the contingencies of *what* is said as well as *how* it is said, and from that it follows that an adequate theory of writing pedagogy would teach students how to deal with the theoretical inseparability of form and content in practice. While the nearly two hundred graduate students at Texas do not all subscribe to a single theory, I suspect the current interest in writing and pedagogy among graduate students at Texas and elsewhere positively correlates with their widespread interest in and facility with critical theory, specifically with theories of language that at least suggest an account of the production as well as reception of written texts.

Although the committee of faculty and graduate students that wrote the syllabus for "Writing about Difference" made what might be called a courtesy gesture toward prescriptivism, by requiring a handbook written by two local opponents as part of the course, the syllabus cobbles together the two language theories, structuralism and poststructuralism, that have supported virtually all scholarship on composition and literature for the past forty-some years. At least, I am not aware of any *scholarship* that is explicitly warranted by the commonsense precepts of linguistic prescriptivism, although it is arguable that many of us implicitly acknowledge the power of prescriptions in our own writing, and literary preferences. As

the title suggests, "Writing about Difference" derives from poststructuralism, for the counterintuitive and theoretical notion of *difference* concerns the part language plays in fabricating realities that use received definitions of difference to explain inequitable social, political, and economic treatment of particular groups or classes of people as arising out of or justified by inherent differences among people. What is not apparent in the title, but made explicit in the syllabus, is that all the writing assignments focus on the *structure* of arguments, by far the most important of which are opinions in discrimination suits, some of which are from the Civil Rights Act of 1964, the Educational Amendments of 1972, and the Bill of Rights, and others of which are commentaries on legal opinions and issues raised by legal theory.

In asking students to identify and summarize and evaluate the claims and grounds in the arguments they read and wrote, in light of warrants, we risked teaching them (or at least convincing them that we believe) that texts can be adequately analyzed and evaluated in relative isolation from other texts, and also that good reasons *alone* explain which laws are passed and legal opinions handed down. I suppose some students might have reached these or perhaps similar conclusions, but to have done so would have meant missing the point of the course, namely, that argument means precisely that, that every assertion is arguable (including those made by laws and by the courts, and those published in scholarly journals and handbooks, not to mention those expressed by their teachers and classmates). Thus, a chapter from legal scholar Martha Minow's decidedly poststructuralist *Making All the Difference: Inclusion, Exclusion, and American Law,* with which notions of difference were introduced, in turn became the material to be summarized, analyzed, and evaluated.

In my own defense, and on behalf of the others who worked on the syllabus, I would like to say that we took the position (which, along with claims and grounds, we borrowed from ordinary language philosopher Stephen Toulmin) that warrants bear visible traces of discourses—not in the sense that linguists are apt to mean discourse (as stretches of text above the level of the sentence), but as discourses are defined by poststructuralists, as the ideologies or vantage points from which everyone views reality. By way of example, in a case we planned to use in the course, *Chambers v. Omaha Girls Club, Inc.,* Crystal Chambers, a single black woman, argued that the club violated her civil rights by firing her when she became pregnant. The majority opinion in favor of the defendant turns on the club's requirement that all employees sign an agreement to be role models, but the minority opinion argues that since the club offered no empirical evidence that such a thing as a role model exists, the plaintiff cannot be fired on the grounds that she was not a *good* role model. The club argued

(and the court agreed) that violating Chambers's civil rights was a jus-
tifiable "business necessity," since a single, pregnant employee is a poor
role model in an organization dedicated to preventing pregnancy among
its largely adolescent, black, female population. The majority opinion in
Chambers is arguably based on common wisdom, the minority opinion, on
science. If you accept that distinction, then it is also arguable that received
opinion and science are warranted by two distinct discourses, and that in
this court and in *this* case a precept warranted by common sense prevailed
over science. Without either invoking the recent history of privileging
the testimony of expert (scientific) witnesses over the accounts of ordinary
people, or resorting to what is called students' personal experience (what
they have heard at home, school, and in churches or synagogues), relatively
inexperienced undergraduate writers could identify, analyze, and evaluate
even these seemingly unassailable legal arguments by focusing on claims,
grounds, and warrants. In other words, it is possible to argue that a single
black mother would be the best role model, the worst one, that black
women have a greater responsibility to be role models than white women,
that it is unjust to require poor black women to be good role models when
rich white women are not also expected to perform this function, that an
anecdote is superior or inferior to experimental research as testimony, for
these claims and more are implicitly or explicitly either raised in or implied
by *Chambers,* not to mention the other cases selected for the course. The
point is not to agree or disagree with an opinion, but to locate an un-
questioned assumption and explore (argue) its possible ramifications.

Learning argument alone is a demanding task, though we admittedly
made it more daunting still by asking students to construct arguments in
the context of antidiscrimination law and legal opinions. That was a de-
liberate decision on my part, not to introduce multiculturalism (the courts
are rarely accused of harboring multiculturalists), but to offer students
what I consider the quintessential academic experience, the often exhil-
arating and at times even liberating experience of making a sustained
analysis and critique of unexamined assumptions, an intellectual privilege
tantamount to an academic right, founded on the willingness to lay out
a *candid* argument in support of a position. While most students are will-
ing, even eager, to acknowledge that "everyone has a right to their own
opinion," few are willing to acknowledge that invoking this seemingly
democratic principle in lieu of an argument is likely to be seen as an
admission that an opinion is based either on no reasons at all or on reasons
that will not withstand scrutiny. The syllabus takes their inexperience
with and anxiety about public disagreement into account, and yet invites
all students to argue with texts of unmistakable importance, to plaintiffs
and defendants in the first instance, but ultimately to the citizenry.[3]

I make no apologies for asking students to read law or cases or essays, and to base their writing on what they have read. Nor do I see any reason to apologize for asking them to read and write about difference, simply because the topic makes people uneasy. Eighteen-year-olds are not very large children. They are young adults. They can legally vote, marry, drive, and enter into contracts; the men among them can be drafted into the military, any among them can enlist, and all among them are subject to the full penalty of law if convicted of a crime. They may be young, but they are not children in anyone but their parents' eyes and, when it suits them, their own. And even though they may not know much about antidiscrimination law, surveys of entering classes suggest that college students increasingly believe discrimination to be a problem: about 20 percent of the class of 1991 agreed that "Racial discrimination is no longer a major problem in America" (*Almanac,* 13), compared to 15 percent of the class of 1992 (Collison, A31). While student attitudes are not in themselves sufficient grounds for a course, they suggest topics of interest and, in their turn, topics amenable to writing.

We professors do students and ourselves a disservice when we collude with institutions that insist on representing the first two years of college as the 13th and 14th grades, in order, I presume, to justify herding students into large lecture halls and keeping them on ice until the survivors amass enough credits to reemerge as juniors. In composition, the infantilization of students is most evident in courses that prescribe rules for what ails them, but probably most pernicious in those that condemn them to writing from personal experience. Students may be young, but they are not stupid. Many probably resist writing from personal experience because even in this area, where they are supposedly undisputed authorities, teachers invariably invoke form, and assess their lives along with their grammar, spelling, and so on. Probably the safest and smartest way to handle such assignments is to lie. And telling lies then makes it all the easier for students to resist the exhortations of process pedagogy, since drafting and revising an essay in which you have little or no stake is foolish.

The pedagogies of process and personal experience are valiant efforts to circumvent the institutional power and authority of teachers over students. These seemingly progressive approaches fail to the extent that both deny that composition teachers *are* the designated institutional representatives of the power and authority of language. Would that the power and the authority of language were confined to classrooms or even to forms, that discourses were as easily shucked as handbooks and Richard Bernstein seem to believe. But then, trade presses and pundits that have an economic stake in dispensing prescriptions, and in denying that they are themselves empowered not by their prescriptions but emboldened by a middle-class

will to prescribe, are not in business to teach writing. But schools are, or should be, and if they are not, and we who work in them are not, then they and we are the unwitting accomplices to the most recent common-sense attack on all the uncommon, counterintuitive theories that generate scholarship, and without which there would be far fewer discourses in which to challenge common sense. What distinguishes the most recent attack on the professoriate is that the professors who have joined forces with the pundits also invoke common sense when excoriating colleagues with whom they disagree. They do not, however, make commonsense arguments only in faculty meetings and before the faculty senate, or even in open letters to their colleagues—in places where common sense can be checked against the kinds of intellectual contingencies that have tradi-tionally exposed some of the limitations of received wisdom. Instead, they make common sense in newspapers and on talk shows, where familiar theories comfort and unfamiliar ones discomfort the middle class. At the University of Texas, the unchecked forces of common sense were per-mitted to silence those of good sense when the administration capitulated to the din of negative publicity, and rescinded the authorized departmental committee's right to make and institute policy to meet the curricular goals of its course offerings (see Brodkey and Fowler; also Brodkey, "Making a Federal Case").

Public criticism of the committee's decision came from several quart-ers in the university: two professors of composition, two in literary studies, and a handful in other departments and schools. The collective position is probably best represented by an advertisement that appeared in the student newspaper under the title, "A Statement of Academic Concern." It was later learned that the advertisement, signed by fifty-six professors (there are more than 2200 on the Austin campus), was paid for by a check drawn on the account of the Texas Association of Scholars, an affiliate of the National Association of Scholars (Henson and Philpott). While many people might argue that members of the NAS are conservative or even reactionary, NAS recruitment advertisements and essays published in its journal, *Academic Questions,* suggest an academic group bonded by a un-characteristic devotion to common sense, or at least to using commonsense arguments against colleagues with whom they disagree. In addition to taking the egregious liberty of renaming the course—calling it "Differ-ence—Racism and Sexism" rather than "Writing about Difference"—the advertisement states as its primary concern "that the new curriculum for Freshman English distorts the fundamental purpose of a composition class—to enhance a student's ability to write—by subordinating instruction in writing to the discussion of social issues and, potentially, to the ad-vancement of specific political positions" ("Statement," 2). It apparently

just takes a bit of common sense to know that form cannot be taught in tandem with content, or that all graduate student instructors are of one mind about what positions students must take on "social issues."

The collective position taken in the advertisement is a considerably more restrained commonsense criticism of colleagues, however, than the one written some weeks earlier by the most persistent and vocal of its signers, Alan Gribben, then a professor of American literature at Texas. In a letter to the editor of the local newspaper, Gribben claimed that students in the course "will begin having their social attitudes as well as their essays graded by English Department instructors in what has to be the most massive effort at thought control ever attempted on the campus," and then used his assertion to justify this rather startling recommendation:

> I hope that alumni and taxpaying Texas citizens will remind Standish Meacham, liberal arts dean, Joseph Kruppa, English Department chairman, and Linda Brodkey, director of lower-division English, that if so fundamental a course as English 306 can be blatantly politicized, then the state Legislature and the UT faculty, administration and board of regents have a right to consider abolishing required English courses. (Gribben)

This, too, is apparently just common sense, for while I never heard from any of these quarters directly (I have no way of knowing if unnamed callers who in the days following this letter threatened to cut off or otherwise mutilate selected parts of my body represented any of the constituencies identified), the university effectively canceled the plan when it postponed implementation of the syllabus, without providing the policy committee or the department any formal procedure for reversing the postponement. No terms were given in the first instance, nor later, because the president of the university refused even to meet and discuss the syllabus with the committee.

Common sense prevailed at Texas. Alan Gribben was later reported in the *Chronicle of Higher Education* as declaring simply: " 'If you really care about women and minorities making it in society, it doesn't make sense to divert their attention to oppression when they should be learning basic writing skills' " (Mangan, A15). This strikes me as being of a piece with the opponents of sex education, who seem to think that adolescents would not even know about sex if their teachers would only refrain from mentioning it. Another professor of American literature circulated his own countersyllabus, based on principles of copyediting, and bearing some unfortunate reminders that even full professors of English can and do make errors in punctuation and spelling (Duban). A professor who writes handbooks, a coauthor of the one required for "Writing about Difference,"

published an editorial in the student newspaper identifying rhetoric as "the subject matter to be taught and learned," and defining an introduction to rhetoric as focusing "on the logic and validity of arguments, the development and enrichment of ideas, the appropriate arrangement of subject matter, and the power and correctness of language" (Ruszkiewicz). Rhetoric as techniques devoid of content is just common sense. The other coauthor of the handbook made the argument in the popular press and a professional journal that since student texts should be the focus of instruction, teachers should assign no readings, so students can write about their own ideas (Hairston, "Required Writing Courses," B1; "Diversity, Ideology, and Teaching Writing," 186). There is just no arguing with common sense.

The common sense that characterizes the arguments of professors who took exception to the course is amply reiterated by pundits. Richard Bernstein, who would later take lexicographers to task for not sharing his devotion to grammatical correctness, introduced a feature article on "political correctness" with the mistaken but fluent claims that the course was being taught, and that it had replaced the "literary classics" with what he described, without asking to see the syllabus, as materials some people said gave the course "more relevance" but others said made it "a stifling example of academic orthodoxy" (Bernstein, "The Rising Hegemony," 1). Such ill-informed hyperbole seems to me a classic example of journalism's commonsense precept that news is only newsworthy if there are two (and only two) diametrically opposed sides to a story. Never mind that his sources are reacting to the idea of the course, not responding to the syllabus. Never mind that, in claims ostensibly about writing, the reporter and his sources are concerned only about what students will read. George F. Will used his syndicated column to lambaste the course, about which he knew so little that he described one at another university, and then took the occasion of his outrage to remind his readers that teachers are supposed to teach grammatical correctness, not political correctness. Judging by what I have read, the most wonderful thing about possessing common sense must be the satisfaction of saying in so many words that it goes without saying that you are right, that there would be nothing to talk about if people would just see "reason"—end of conversation.

The end of conversation is also the end of language. My most abiding fear is that, just as the signs regulating smoking do not satisfy the desire to ban smoking, even the most stringent regulation of writing by prescription would not satisfy professors and pundits whose faith in the doctrine of meritocracy is so fragile as to justify silencing any challenge to the triple identification of language/class/nation as one and the same.

Women, Latinos, and illiterates are paraded before us as fetishes in a spectacle of patriotism, and caricatured in narratives on national defense, because a vocal and persistent minority of the middle class projects its fears onto their bodies. The results of what amounts to a cultural Rorschach are passed off as common sense, and common sense is in turn used to warrant state regulation. Thus the nation's fetuses must be protected from feminists and their dupes; its citizens must be defended from the south by fences; its language must be policed. In this scenario, medicine, the Immigration and Naturalization Service, and the schools are the sites where doctors, border patrols, and teachers are installed as the gatekeepers of the nation, and any reluctance on their part—to prevent abortions, turn back undocumented workers, identify illiterates—becomes a reason for regulating them as well their charges. If I must be a gatekeeper, and all teachers are by definition, I at least insist on my right to imagine a more inclusive America than the America projected by the most recent purveyors of common sense.

To my mind, the charges of political correctness mask my even more heterodox offenses against the orthodoxy that grammatical correctness is the *sine qua non* of both writing pedagogy and middle-class privilege. Yet had professors and pundits who reacted to the very *idea* of difference bothered to look at the syllabus for "Writing about Difference," they might have noticed that antidiscrimination law reproduces the nearly canonical middle-class presumption that America is (or at least is meant to be) a classless society. For only when a society guarantees the civil rights of all its citizens can it even hope to convince any but the already privileged that the privileges of, say, professors and pundits are entirely owing to individual merit. While you or I might like to believe that *our* privileges are wholly or even mostly merited, all campaigns to persuade the citizenry that individual merit rests on the writing of fluent English, or on any other ability we might name, are and will remain suspect in the face of discrimination.

If composition can be said to abet middle-class illusions of meritocracy, then the deregulation of writing is about replacing that empty promise with pedagogy that honors the First Amendment by teaching students that such a freedom is only meaningful if the citizenry is literate. Not just functionally literate. Literate. Not just fluent. Literate. Literacy is not just skills, nor is it abilities. Literacy is attitude, entitlement, the entitlement that middle-class privilege masks in prescriptions but that writing lays bare in the sheer force of the desire to see and to get readers to see what can be seen from where the writer stands. Virtually everything depends on the desire for a hearing, for it is that desire that makes the learning of rules or anything else that might also clarify a position welcome

to the writer. Writers take stands. In standing for writing pedagogy, I have also taken a stand against what I see as gratuitous and cynical representations of composition students as unruly children who lack discipline. In part that means standing with others in the field who have also expressed reservations about the institutional arrangements under which writing is taught as composition. I see those conditions as justifying everyone from poison pens to professors to pundits to prescribe—without benefit of theory, research, or practice—what students and their teachers should be doing in composition courses—in the name of common sense. In standing for writing, I have taken a stand against others in the field, in the academy, and in the media who refuse to consider even the possibility that prescriptions that seem to regulate only the "correct" use of language threaten to extinguish the desire to write altogether—in middle-class and working-class students alike. Unless regulating that desire *is* the point, I suggest we begin again and try to teach writing—for a change.

NOTES

I would like to acknowledge the following people for their generous intellectual contributions to the argument I lay out in this essay: Lester Faigley, Michelle Fine, George Mariscal, Robert McDonell, Susan Miller, Roddey Reid, and Barbara Tomlinson.

1. I am using "middle class" as it is defined by Barbara Ehrenreich in *Fear of Falling*. "This class can be defined," she writes, "somewhat abstractly, as all those people whose economic and social status is based on education, rather than on the ownership of capital or property" (12). The middle class, which includes professionals and managers but excludes entrepreneurs, accounts for only about 20 percent of the population, but "plays an overweening role in defining 'America': its moods, political directions, and moral tone" (6). As the middle class has become conscious of itself over the last 30 years as a distinct and privileged class based not on capital but on cultural capital, she argues, its class anxieties have been expressed increasingly in cultural and political conservatism. Although the middle class and its anxieties are the subjects of Ehrenreich's book, I think it's fair to conclude that the ubiquity of middle-class values as American relies in large measure on middle-class definitions of the working class as inimical to the middle class and to America.

2. The names of the 11 members of what came to be known as the Ad Hoc Syllabus-Writing Group are: Linda Brodkey, Margaret Downs-Gamble, David Ericson, Shelli Fowler, Dana Harrington, Susan Sage Heinzelman, Sara Kimball, Stuart Molthroup, Allison Mosshardt, Richard Penticoff, and John Slatin. The syllabus, "Writing about Difference," is copyrighted in my name.

3. See Penticoff and Brodkey for a full description of the intellectual considerations raised by the approach to argumentation used in the syllabus for "Writing about Difference."

Works Cited

Almanac. 1992. "Attitudes and Characteristics of Freshmen, Fall 1991." *Chronicle of Higher Education.* 26 August, p. 13.

Baron, Dennis. 1991. *The English Only Question: An Official Language for Americans?* New Haven: Yale University Press.

Bartholomae, David. 1980. "The Study of Error," in *College Composition and Communication,* 31, pp. 253–269.

Bernstein, Richard. 1991. "Nonsexist Dictionary Spells out Rudeness." *New York Times.* 11 July, pp. C13, C18.

———. 1990. "The Rising Hegemony of the Politically Correct." *New York Times.* 28 October, Sec. 4, pp. 1, 4.

Brodkey, Linda. "Making a Federal Case out of Difference," in *Writing Theory and Critical Theory,* eds. John Clifford and John Shilb. New York: MLA, 1994.

———. 1992. "Articulating Poststructural Theory in Research on Literacy," in *Multidisciplinary Perspectives on Literacy Research,* eds. Richard Beach, Judith L. Green, Michael L. Kamil, and Timothy Shanahan. Urbana: National Conference on Research in English, pp. 293–318.

———. 1989. "On the Subjects of Class and Gender in *The Literacy Letters,*" in *College English,* 51, February, pp. 125–141.

———. 1987. "Modernism and the Scene(s) of Writing," in *College English* 49, April, pp. 396–418.

———. 1986. "Tropics of Literacy," in *Journal of Education,* 168, pp. 47–54.

———, and Shelli Fowler. 1991. "Political Suspects," *Village Voice,* 23 April, p. 11.

Chambers v. Omaha Girls Club, Inc. 834 F. 2nd (8th Cir. 1987): 697–709.

Collison, Michele N-K. 1993. "Survey Finds Many Freshmen Hope to Further Racial Understanding," *Chronicle of Higher Education,* 13 January, pp. A29–A32.

Crawford, James, ed. 1992. *Language Loyalties: A Source Book on the Official Language Controversy.* Chicago: University of Chicago Press.

Crowley, Sharon. 1990. *The Methodical Memory: Invention in Current-Traditional Rhetoric.* Carbondale: Southern Illinois University Press.

Douglass, Wallace. 1976. "Rhetoric for the Meritocracy: The Creation of Composition at Harvard," in Richard Ohmann, *English in America: A Radical View of the Profession.* New York: Oxford University Press, pp. 97–132.

Duban, James. 1990. "Letter to Joseph Kruppa, Chair, Department of English at Texas, accompanied by his syllabus for E 306." 31 August, 14 pp.

ELPAC: English Language Political Action Committee. Undated letter (received in late October or early November 1992), addressed "Dear California Voter" and signed Steve Workings, Executive Director.

Ehrenreich, Barbara. 1989. *Fear of Falling: The Inner Life of the Middle Class.* New York: HarperCollins.

Faigley, Lester. 1992. *Fragments of Rationality: Postmodernity and the Subject of Composition.* Pittsburgh: University of Pittsburgh Press.

Gribben, Alan. 1990. "Politicizing English 306," *Austin-American Statesman*, 23 June, p. 5.

Hairston, Maxine. 1992. "Diversity, Ideology, and Teaching Writing," *College Composition and Communication* 43, May, pp. 179–193.

———. 1991. "Required Writing Courses Should not Focus on Politically Charged Social Issues," *Chronicle of Higher Education*, 23 January, pp. B1, B3.

Halloran, Michael S. 1990. "From Rhetoric to Composition: The Teaching of Writing in America to 1900," in *A Short History of Writing Instruction: From Ancient Greece to Twentieth-Century America*, ed. James J. Murphy. Davis, CA: Hermagoras Press, pp. 151–182.

Hartouni, Valerie. 1991. "Containing Women: Reproductive Discourse in the 1980s," in *Technoculture*, eds. Constance Penley and Andrew Ross. Minneapolis: University of Minnesota Press, pp. 27–56.

Hartwell, Patrick. 1985. "Grammar, Grammars, and the Teaching of Grammar," in *College English* 47, February, pp. 105–127.

Henson, Scott and Tom Philpott. 1990. "E 306: Chronicle of a Smear Campaign: How the New Right Attacks Diversity," in *Polemicist* 2, September, pp. 4–5, 7, 18.

———. 1990. "English 306: Reading, Writing and Politics," *Austin Chronicle*, 10 August, p. 8.

Kohl, Herbert. 1993. "Over the Rainbow," *Nation*, 10 May, pp. 631–636.

Mangan, Katherine S. 1990. "Battle Rages over Plan to Focus on Race and Gender in U of Texas Course," *Chronicle of Higher Education*, 15 November, p. A15.

Martin, Emily. 1987. *The Woman in the Body: A Cultural Analysis of Reproduction*. Boston: Beacon Press.

Miller, Susan. 1991. *Textual Carnivals: The Politics of Composition*. Carbondale: Southern Illinois University Press.

Minow, Martha. 1990. *Making All the Difference: Inclusion, Exclusion, and American Law*. Ithaca: Cornell University Press.

Penticoff, Richard and Linda Brodkey. 1992. "*Writing about Difference*: Hard Cases for Cultural Studies," in *Cultural Studies in the English Classroom*, eds. James A. Berlin and Michael J. Vivon. Portsmouth, NH: Boynton/Cook-Heinemann, pp. 123–144.

Ruszkiewicz, John. 1990. "Altered E 306 Format Compromised by Ideological Freight," *Daily Texan*, 24 July, p. 4.

Shaughnessy, Mina P. 1977. *Errors and Expectations: A Guide for the Teacher of Basic Writing*. New York: Oxford University Press.

"A Statement of Academic Concern." 1990. Advertisement. *The Daily Texan*, 18 July, p. 2.

Toulmin, Stephen. 1958. *The Uses of Argument*. Cambridge: Cambridge University Press.

Will, George F. 1990. "Radical English," *Washington Post*, 16 September, p. B7.

Beyond the Ivory Tower:
Public Intellectuals and the Crisis of Higher Education

HENRY A. GIROUX

Higher education is under assault. This is most evident in the barrage of attacks initiated in the popular press and by right-wing cultural critics against multiculturalism, political correctness, and a variety of other forces that are allegedly undermining what George Will has called "the common culture that is the nation's social cement" (quoted in Menand, 56). But even more is at stake than the question of national identity or the role of the university as a cultural gatekeeper for dominant values. The university is suffering from a crisis regarding the relationship between authority and knowledge, and the responsibility of intellectuals in producing social relations that deepen democratic life by extending the range of critical public cultures across diverse economic, cultural, and social spheres. This suggests more than a crisis of representation in the university; it is also a profound political threat to the cultural consensus that has shaped academic life during the first half of the twentieth century.[1]

Paradoxically, while the university is being attacked for allowing tenured radicals to take over the humanities and undermine the authority of the traditional canon, there is the simultaneous implication that the university should not assume the role of a critical, public sphere actively engaged in addressing either the social problems of the larger society or the broader global landscape. On one level, the undermining of the university as a public space can be seen in both the fiscal cuts that have plagued universities across the country, and in the increasingly widespread belief that issues that are central to public life need not be addressed within the hallowed halls of higher education. Of course, for the neoconservative

hard-liners writing in the *National Review,* the *New Criterion,* and similar publications, this position translates into the unproblematic assumption that social criticism has no place in the university, and that those who engage in it are as, Paul Hollander (1992) has suggested, radical intellectuals who are anti-American.[2] Other critics, such as Louis Menand (1991), take a more cautious line, and argue that universities should simply impart knowledge that is outside of the political and cultural whirlwinds of the time. Menand represents the classic liberal retreat into a politics of refusal, one that depoliticizes the university while calling for the professionalization of its resident intellectuals. In this perspective, culture serves as trope to decouple knowledge from power, and to reduce the university's role to the Arnoldian imperative to teach the "best that has been thought and known in the world" (Arnold, 113).

The crisis of the university as a crucial public sphere is also evident in the rhetoric of a currently popular group of diverse, right-wing, public intellectuals who are located and supported financially in the worlds of business, private foundations, and the popular press. CEOs such as Ross Perot are now touted as exemplary intellectuals who will apply a no-nonsense, marketplace approach to running the commanding institutions of civic life. In addition, public intellectuals who speak regularly on prime-time television, network cable news, and radio shows are drawn primarily from the Heritage, Olin, Bradley, Scaife, and other neoconservative foundations that offer huge salaries and the opportunity for full-time research activities. Such intellectuals increasingly play a significant role in shaping political, cultural, and social policy in the United States. In addition, journalists, many of whom seem resentful that academics are addressing vital public issues, have invoked the populist issue of clarity and "plain speech" to reaffirm themselves as the "real" voice of the people. One rather grotesque example of such public intellectuals can be seen in the popularity of a reactionary figure such as Rush Limbaugh. What these various conservatives share—beyond their common battle against the perils of deconstruction, postmodernism, cultural studies, black studies, gender studies, poststructuralism, and other theoretical insurgencies—is the deep-rooted belief that university academics have no role to play as critical, public intellectuals.[3]

What is so alarming about this attack on the university is that it cuts across ideological lines. This is not a position limited to Roger Kimball, John Silber, Lynne Cheney, Dinesh D'Souza, Charles Sykes, and other battering rams for the ideological right. For instance, David Reiff, writing from a liberal perspective in *Harper's Magazine,* argues that most academics battle over ideas that are as hollow as they are irrelevant. For Reiff, "Reality is elsewhere. For better or worse, ours is a culture of

consumerism and spectacle, of things and not ideas" (63). Ironically, once Reiff sets up this reductive binarism, he quickly reverses it by claiming that the real radicals in American society are those intellectuals who recognize that global capitalism, far from being at odds with a multicultural world, is actually quite attentive to its ideological and material configurations. In this apologetic scenario, ideological legitimation becomes useful in order to defend the expansion of capital as a progressive force that is attuned to the new global conditions of multiculturalism. Reiff conveniently forgets that corporations might appropriate multiculturalism simply to commodify it in the interest of capital accumulation and in doing so remove multiculturalism from relations of domination and power and the discourse of social justice. Obviously, Reiff has not pondered the glaring example of Benetton's advertising approach to multiculturalism.[4]

According to Reiff, the most important intellectual analyses of multiculturalism and other emerging postmodern conditions are not to be found in the pages of journals like *Cultural Studies* but in the *Harvard Business Review*. Ethics, power, and inequality evaporate in this argument, in a discourse that is as intellectually vapid as the unprincipled and unexamined arrogance that fuels it.

While the theoretical particulars are different, a similar critique of critical intellectuals in the university has emerged among a number of left theoreticians. It is evident in Russell Jacoby's (1987) nostalgic lament in *The Last Intellectuals* about the decline of public culture in the United States, and the rise of academic intellectuals who allegedly write in arcane discourses and largely forsake any viable political intervention into public life. It is also evident in the works of Jan Zita Grover (1992) and Teresa Ebert (1992–1993), who disparage university intellectuals for working with representations and ideas rather than addressing material concerns such as AIDS or homelessness. In this view, critical thought, nurtured in the halls of higher education through the study of texts and representations, offers very little in the way of understanding or promoting concrete struggle over pressing social problems. As self-serving, binaristic, and anti-intellectual as this argument is, it has gained substantial currency in the last decade, and is indicative of one dimension of the crisis that higher education is facing. Michael Denning (1992) provides a commentary on some of the more specific charges being brought by leftists against radical academics who work in the university:

> For these writers—and they range from David Bromwich writing in *Dissent* to Barbara Epstein writing in *Socialist Review*—the controversy over "political correctness" is a symptom of serious political and intellectual shortcomings of the academic left. For them, the academic left is made up of an unholy and unlikely marriage between "identity

politics" and poststructuralist theory. Irving Howe called it "a strange mixture of American populist sentiment and French critical theorizing"; Barbara Epstein argued that "identity politics and the postmodern/poststructural sensibility do come together in the field of cultural studies, and, more broadly, in constituting the academic and intellectual arena that defines itself as radical." The result is a "left" that is only apparently radical. (22)

I want to enter this debate regarding the purpose and meaning of higher education by arguing that the university is a major public sphere that influences large numbers of people, not only in terms of what is taught and how one might locate oneself in the context and content of specific forms of knowledge, but also in terms of the large numbers of students who impact significantly on a variety of institutions in public life.[5] For example, if cultural critics were more attentive to what is taught in professions such as nursing, social work, and education, it might become more apparent what the impact of such teaching has on the thousands of teachers, health workers, and community people who battle in the health care system, social services, or the public schools. Surely, institutions such as the public schools, for instance, can be considered a major public sphere; yet there is hardly a word uttered by radical and conservative critics about the critical relationship between higher education and the public schools. Perhaps the more important question here is what silences have to endure in the debate on higher education in order for academic intellectuals to be dismissed as irrelevant—even though much of the work that goes on in institutions of higher education directly affects thousands of students, whose work is significantly related to critical public issues and the renewal of civil society.

I want to elaborate further on this debate, not by reviewing the endless interventions made over political correctness, multiculturalism, or other such concerns, but by analyzing how certain features of cultural studies over time have attempted to address some of the same issues that conservatives and liberals have taken up with respect to higher education. In addition, I want to argue that the absence of any serious discussion of pedagogy, both in cultural studies and in the debates about higher education, has significantly narrowed the possibilities for redefining the role of educators as critical cultural workers and public intellectuals.[6] Hence, I want to stress the importance of pedagogy both in the further development of cultural studies and in the broader attempt to reform higher education.

In focusing on cultural studies, I want to highlight some issues that also speak to important problems that have not been taken up as part of the debate on higher education. Cultural studies, in this sense, provides a

referent not only for engaging left cultural practice in the university, but also as a signifier for broader educational reforms. More specifically, I want to reformulate "literacy" as a politics of representation and pedagogical practice that is essential for analyzing how knowledge and power operate to secure particular forms of authority in specific contexts, and for understanding how academics might locate themselves within regimes of representation that redefine their roles as public intellectuals within higher education.

Cultural Studies and the Absence of Pedagogy

As Cary Nelson ("Always Already Cultural Studies") has pointed out, it has become commonplace to acknowledge that cultural studies needs to be approached historically as a mix of founding moments, transformative challenges, and self-critical interrogations. And it is precisely this spirit of rupture in cultural studies—which informs elements of its postdisciplinary practice, social activism, and historical awareness—that prompts my concern for the current lacunae in cultural studies regarding the theoretical and political importance of pedagogy as a founding moment in its legacy. At the same time, it is important to stress that the general indifference of many theorists to the importance of pedagogy as a form of cultural practice does an injustice to the politically charged legacy of cultural studies, one which points to the necessity for combining self-criticism with a commitment to transforming existing social and political problems.

It is generally argued that cultural studies is largely defined through its critical analyses of culture and power. This is particularly evident in two areas. First, cultural studies has strongly influenced a shift in the terrain of "culture toward the popular" (Hall, "What is This 'Black' in Popular Culture," 22). Second, it has expanded the traditional reading of texts to include a vast array of cultural forms outside the technology and culture of print and the book. Not only has this resulted in a critical reading of the production, reception, and diverse use of popular texts; more basically, such analyses have also expanded the conventional meaning of "text." Texts in this case constitute a wide range of aural, visual, and printed signifiers; moreover, such texts are often taken up as part of a broader attempt to analyze how individual capacities, social identities, and social forms are mobilized, engaged, and transformed within circuits of power informed by issues of race, gender, class, ethnicity, and other social formations.

More specifically, the expansion of culture into the popular realm and the expansion of the meaning of what constitutes cultural texts have resulted in a new attentiveness to the ways in which dominant intellectual

and institutional forces police, contain, and engage meaning as a site of social struggle. The importance of this critique for challenging the disciplinary borders of the humanities has been rightly recognized by conservatives as one of the more radical aspects of cultural studies.

Another emergent theoretical feature of cultural studies involves work that refutes the notion that the struggle over meaning is primarily about the struggle over language and textuality.[7] On the contrary, a number of cultural studies theorists have named terror and oppression in concrete terms, and have addressed how domination is manifested in a variety of sites, on a number of different levels, and how it can be understood in historical and relational terms through a variety of articulations and categories.[8] In fact, cultural studies increasingly draws its theoretical and political inspiration from feminism, postmodernism, postcolonialism, and a host of other areas. Lawrence Grossberg claims that cultural studies as a strategic practice performs two functions: first, it keeps alive the importance of political work in an "age of diminishing possibilities" (*We Gotta Get Outta This Place,* 18). That is, it radicalizes the notion of hope by politicizing rather than romanticizing it. Second, it refuses to collapse a commitment to political work into the frozen theoretical winter of orthodoxy. In this case, it responds to the specificity of history and, in doing so, leaves open the political cartography that informs how it names both its own strategies and the world of political struggle. The notion that cultural studies is unstable, open, and always contested becomes the basis for its rewriting as both the condition for ideological self-criticism and the construction of social agents within rather than outside historical struggles. Moreover, such a position is of enormous theoretical service in redefining public intellectuals outside the vanguardist sentiments that have plagued modernist radical intellectuals.[9]

In spite of these major theoretical contributions, I want to argue that cultural studies is still too rigidly tied to the modernist, academic, disciplinary structures that it often criticizes. This is not to suggest that it does not adequately challenge the ideological structure and organizing power of the academic disciplines. In fact, this is one of its most salient characteristics.[10] What it fails to do is to critically address a major prop of disciplinarity, which is the notion of pedagogy as a transparent vehicle for transmitting truth and knowledge. Lost here is the attempt to understand pedagogy as a mode of cultural criticism for questioning the very conditions under which claims to authority are secured, and knowledge and identities are produced. Of course, theorists such as Larry Grossberg, Cary Nelson, Stanley Aronowitz, and others do engage the relationship between cultural studies and pedagogy, on the one hand, and the relationship between public schools and higher education on the other, but

they constitute a small minority.[11] Neither critical educators nor cultural studies theorists can ignore the relationship of pedagogy to cultural studies in the current historical juncture. Indeed, such indifference warrants our deep suspicion of the viability of the political project that informs such a decontextualized view of cultural studies. The haunting question here is this: What is it about pedagogy that allows cultural studies theorists to ignore it?

One answer may lie in the refusal of cultural studies theorists either to take schooling seriously as a site of struggle, or to probe how traditional pedagogy produces particular forms of subjectification, how it constructs students through a range of social forms. By contrast, within radical educational theory, there is a long history of developing critical discourses of the subject around pedagogical issues.[12]

Another reason cultural studies theorists have devoted little concern to pedagogy may be due to the disciplinary terrorism that leaves the marks of its legacy on all areas of the humanities and liberal arts. Pedagogy is often deemed unworthy of being taken up as a serious project; in fact, even popular culture has more credibility than pedagogy. This can be seen not only in the general absence of any discussion of pedagogy in cultural studies texts, but also in those studies in the humanities that have begun to engage pedagogical issues. Even in these works there is a willful refusal to acknowledge some of the important theoretical gains in pedagogy that have gone on in the last twenty years.[13] Within this silence lurk the seductive rewards of disciplinary policing, a refusal to cross academic borders, and a shoring up of academic careerism, competitiveness, and elitism. Of course, composition studies, one of the few fields in the humanities that does take pedagogy seriously, occupies a position as devalued as the field of education.[14] It appears that the legacy of academic elitism and professionalism still exercises a strong influence on the field of cultural studies, in spite of its alleged democratization of social knowledge.

Reclaiming Pedagogy

While the discourse of pedagogy is central to any notion of educational reform worthy of the name, it is a concept that must be used with respectful caution. Not only are there different versions of what constitutes critical pedagogy, but there is no generic definition that can be applied to the term. At the same time, there are important theoretical insights and practices that weave through various approaches to critical pedagogy. These insights involve, but are not limited to, the relationships between knowledge and power, language and experience, ethics and authority,

student agency and transformative politics, and teacher location and student formations.

This is precisely how Raymond Williams (1989) addressed the issue of pedagogy in his discussion of the emergence of cultural studies in Britain. According to Williams, pedagogy offered the opportunity to link cultural practice with the development of radical cultural theories. Not only did pedagogy connect questions of form and content, it also introduced a sense of how teaching, learning, textual studies, and knowledge could be addressed as a political issue which foregrounded considerations of power and social agency. For Williams, it is precisely this attempt to broaden the notion of the political by making it more pedagogical that reminds us of the importance of pedagogy as a cultural practice. In this context, pedagogy deepens and extends the study of culture and power by addressing not only how culture is shaped, produced, circulated, and transformed but also how it is actually taken up by human beings within specific settings and circumstances. In this instance, pedagogy becomes an act of cultural production, a form of "writing" in which the process whereby power is inscribed on the body and implicated in the production of desire, knowledge, and values begins not with a particular claim to postdisciplinary knowledge, but with real people articulating and rewriting their lived experiences within rather than outside history.

The importance of pedagogy to the content and context of cultural studies lies in the relevance it has for illuminating how knowledge and social identities are produced in a variety of sites—including schools. Pedagogy, in this sense, offers an articulatory concept for understanding how power and knowledge configure in the production, reception, and transformation of subject positions, forms of ethical address, and "desired versions of a future human community" (Simon, 15). By refuting the objectivity of knowledge and asserting the partiality of all forms of pedagogical authority, critical pedagogy initiates an inquiry into the relationships among cultural work, authority, and the securing of particular cultural practices. As a mode of cultural politics, pedagogy takes as an object of study the relationship between the possibilities for social agency expressed in a range of human capacities and the social forms that often constrain or enable them. What is at stake here is not only the political insistence to recognize that pedagogy is a cultural practice, but also what Larry Grossberg has called "the pedagogy of cultural practices" (cited in Giroux and McLaren, 15).

Literacy and the Politics of Representation

In what follows, I want to be more specific about the importance of pedagogy for cultural studies and other emerging forms of interdiscipli-

nary work within higher education. I want to do so by focusing on the association between literacy and pedagogy on the one hand, and their relationship to the wider debate on the politics of higher education and the role of university intellectuals on the other.

I believe that those of us teaching in higher education who are concerned about language and experience need to rethink the politics of literacy as part of a broader attempt to understand the importance of cultural work in challenging how diverse semiotic systems in an information-based society are used to "produce hegemonic and counterhegemonic representations in texts and other discursive systems" (Bove, 35). At stake here are not only a defense of the politics of cultural work and the need to argue that the "question of power has important cultural and ideological aspects" (Bailey and Hall, 19), but the development of pedagogical practices that can enable students to engage in forms of cultural production that expand the purpose and meaning of literacy in the interest of greater freedom and human emancipation. Central to such a consideration is a theory of literacy that is attentive to how knowledge and authority in their numerous forms are produced historically, semiotically, and institutionally at various levels of society. Literacy rewrites the discursive and institutional face of culture as part of a critical attempt to analyze "how and where knowledge needs to surface and emerge in order to be consequential" (Bennett, 30). This suggests that the role of the public intellectual is deeply pedagogical, in that he or she must attempt to provide the conditions necessary for students to critically engage the relationship between knowledge and authority, in order to define what issues are worth struggling over and how such struggles might be taken up collectively both within and outside of the university. Literacy, in the broader pedagogical sense, emphasizes the importance of linking the struggle over signs to the struggle for students and others to become agents rather than objects of representation (Mercer 1992).

Literacy as a politics of representation and a pedagogical practice is concerned with how social agents write and are written by culture, but also with how they struggle to change it. In this case, literacy is not only about learning simply how to read, write, or develop deconstructive skills, it also serves to focus attention on the important insight that meaning is not fixed, and that to be literate is to undertake a dialogue with the multiple languages, discourses, and texts of others who speak from different histories, locations, and experiences. But it is important to note that literacy is about more than negotiating and translating the terrain of cultural and semiotic differences. It is also central for linking issues of agency with the possibility for social struggle. As a rupturing, power-sensitive practice, literacy offers teachers and students alike the possibility to engage questions

regarding who narrates, for what audience, in what institutional setting, and with what purpose in mind. Put another way, it raises the haunting postcolonial question regarding who speaks, for whom, and under what conditions. In this case, literacy helps to make visible how oppressive and dominating practices mediate between the margins and centers of power. Refashioned more critically as a notion of border literacy, it points to pedagogical relations which comprehend the cartography of difference under conditions of inequality, while simultaneously recognizing the possibility for agency in the service of human freedom.

Border literacy, redefined as a critical cultural practice, points, at the very least, to three important pedagogical considerations. First, it can be used by educators to draw attention to the historically and socially constructed strengths and limitations of those places and borders we inherit and which frame our discourses and social relations. It raises questions at the very edges of our historical and disciplinary existence. Furthermore, it offers the possibility for engaging canonicity as the effects of institutions while simultaneously challenging the authority such canons attempt to secure. Literacy in this sense is not about mastering the canon, but dethroning the canonical method (Spivak 1990). Second, literacy can be used as a form of ethical address to highlight how teachers and students construct relationships between themselves and others. Hence, it can provide a referent for analyzing how power is inscribed differently on the body, culture, history, space, land, and psyche. It can also be used pedagogically to make problematic the conditions of travel among teachers and students between different theoretical discourses and cultural worlds (Giroux 1993). Furthermore, it offers a critique of those approaches to literacy, defined in monolithic terms, that erase power, multiplicity, and diversity, while at the same time sustaining borders of privilege and domination. Third, border literacy calls into question those spaces and locations that intellectuals inhabit as they seek to secure authority through specific ways of reading or misreading their relationship with the world and others.

Pedagogy as a critical, cultural practice appears dangerous to neoconservatives and others who believe that social criticism and struggle are inimical to the meaning of higher education, the role of university intellectuals, and the lived experience of students. This is precisely why cultural studies theorists and critical educators cannot let pedagogy and politics of literacy be subordinated to cleansing and comforting self-righteous appeals made in the name of transmission pedagogies, an appeal to a common culture, or the promises of a pluralism devoid of the trappings of struggle, empowerment, and possibility. Students deserve neither an education constrained by the smothering dictates of a monolithic and totalizing view of culture, nor an invitation to become learned through an

empty appeal to "conflict resolution" teaching trends. They deserve an education that acknowledges its role in the preparation of critical political subjects, one that prepares them to become agents capable of locating themselves in history while simultaneously being able to shape it.

Pedagogically this suggests that intellectuals who want to develop such possibilities within cultural studies need to construct forms of literacy that enable students to speak differently, so that their narratives can be affirmed and analyzed along with the consistencies and contradictions that characterize such experiences. This not only suggests hearing the voices of those students who have been traditionally marginalized, it means taking seriously what all students say by engaging the implications of their discourse in broader historical and ideological terms.[15] But equally important is the need to provide safe spaces for students to engage critically with their teachers and their peers, as well as with the limits of their own positions as border crossers, without having to put their identities on trial each time they address social and political issues that they do not experience directly. The task here is to hold students accountable for what they say without performing pedagogical terrorism. Students must be given the opportunity to cross ideological and political borders as a way of clarifying their own moral vision, as a way of enabling counterdiscourses, and—as Roger Simon points out—as a way of getting students "beyond the world they already know in order to challenge and provoke their existing views of the way things are and should be" (47).

I believe that within the framework of cultural studies, the call for litera*cies* rather than literacy extends rather than cuts off the possibilities of acknowledging a world forged in differences that matter, and serves to address the memories, traces, and voices of those who think and act in the struggle for an extension of human dignity. This suggests the need for pedagogical practices infused with an understanding of the dynamics of culture and power in which "differences are recognized, exchanged and mixed in identities that break down but are not lost, that connect but remain diverse" (Chambers, 114). It is a pedagogy that both affirms and disrupts in the name of hope, committed to the radical responsibility of a politics and ethics that acknowledge the need for teachers, students and other cultural workers to reconstruct human imagination in the interest of human freedom—and to presuppose a notion of democratic public life that is worth struggling for.

To borrow a phrase from Homi Bhabha, it is also a pedagogy and politics of literacy that offers a "third space" in which teachers and students can rethink the politics of their own location, in order to create borderlands of learning where dialogue and debate emerge as conditions for linking individual freedom, justice, and social agency. Central to any critical no-

tion of cultural studies is the need to create the pedagogical conditions, whether in schools or other public spheres, for students and others to become cultural producers who can rewrite their own experiences and perceptions through an engagement with various texts, ideological positions, and theories. This means constructing pedagogical relations in which students learn how to theorize rather than to simply appropriate theoretical discourses, and, in doing so, learn how to decenter the authoritarian power of the classroom. They must also be given the opportunity to challenge disciplinary borders, create pluralized spaces where new hybridized identities might emerge, take up critically the relationship between language and experience, and appropriate knowledge as part of a broader effort at self-definition and ethical responsibility. What I am suggesting here is the need for critical intellectuals to move away from the rigid, ideological parameters defining the debate about the canon. What is needed is a new language for talking about literacy and the possibility for giving students power over what is taught and how it is taught under specific circumstances. This is not merely about who speaks and under what conditions; it is about seeing the university as an important site of struggle over regimes of representations and over ownership of the very conditions of knowledge production.

Michael Denning (1992) has argued rightly that cultural studies can insert itself into the debate about higher education not only by offering a critique of the content and configuration of the disciplines, but also by engaging in a fundamental reform of general education. He writes:

> I am suggesting that we resist thinking of cultural studies as another field, another program, and consider it as the place to think through an alternative to the "humanities." It should be a global mapping of cultures, a way to explore not only the "great books" but the many arts that make up a culture, the relations between culture and society, the cultures of various classes, genders, and peoples. (43)

I agree with Denning, but what is missing from his analysis is an account of the pedagogical implications of his concerns. I want to extend his argument by focusing briefly on some of these concerns and how they might be connected to developing an academic agenda for public intellectuals in higher education.

Public Intellectuals and the Politics of Representation

University intellectuals can play an important pedagogical role by redefining for their students the myriad political linkages that mutually inform the relationship between the university and the larger society. In this sense, the institutions of higher education must be seen as deeply moral and

political spaces in which intellectuals assert themselves not merely as
professional academics, but as citizens whose knowledge and actions pre-
suppose specific visions of public life, community, and moral accounta-
bility. Higher education must be defended through intellectual work that
self-consciously recalls the tension between the democratic imperatives or
possibilities of public institutions and their actual formation in everyday
practice. On one level this suggests that academics assume the role of
specific intellectuals working within local contexts and institutional sites
in order to expand the spheres of freedom, justice, and human agency. In
this context, the public nature of intellectual work can be developed
through teaching, research, and collaboration aimed at challenging the
diverse forms of domination that link the university to the wider society.
The decisive notion here is that intellectuals must link theory and ped-
agogy with a commitment to expanding democratic social forms both
within and outside the university. This is not to suggest that academics
define themselves exclusively as specific intellectuals. This is important
but too limited a role for them to play in a world where the boundaries
between the public nature of the university and the spheres of public
power are difficult to separate.

As public intellectuals, academics must develop their research pro-
grams, pedagogy, and conceptual frameworks in connection to opposi-
tional work undertaken in many arenas, whether they be the media, labor
organizations, or insurgent social movements. Such relationships should
not be uncritical, but they do represent the necessity for public intellectuals
to speak critically to issues from a number of public arenas to a diverse
range of audiences. At the same time, such connections and alliances should
not suggest that higher education define its public function simply through
its association with other public spheres. First and foremost, it must be
defended as a vital public sphere in its own right, one that has deeply
moral and educative dimensions that impact directly on civic life. Such a
defense is a necessary condition for academics to redefine their role as
public intellectuals who can move between academic institutions and other
public spheres that are actively engaged in the production of knowledge,
values, and social identities.

Public intellectuals need to expand the meaning and purpose of the
university as an active site for the production of oppositional thinking,
collective work, and social struggle. That is, they need to define higher
education as a public resource vital to the moral life of the nation and
open to working people and communities that are often viewed as marginal
to such institutions and their diverse resources of knowledge and skills.
At stake here is restructuring the knowledge, skills, research, and social
relations constructed in the university as part of a broader reconstruction

of a critical tradition that links critical thought to collective action, knowledge and power to a profound impatience with the status quo, and human agency to an ethic of social responsibility.

In part, this suggests, as Michael Geyer has argued, that workers in higher education take sides. That is, he urges them to take up the comprehensive project of reformulating the meaning and goal of general education by providing knowledge that students need to comprehend and "map the overflow of information about the world . . . knowledge to apprehend the critically fractured realities of the world before us in order to produce the knowledges that allow us to transcend these fragments without destroying them individually while challenging the inequality and the violence of their interconnection" (527). On one level, Geyer recognizes that teachers must provide students with knowledge shaped by normative considerations and oriented towards forms of political engagement that insert them in the process of historical change. What Geyer implies is that the basis for such knowledge cannot be reduced either to the traditional domains of academic knowledge or to the limited project of Enlightenment rationality. In this instance, what university intellectuals must recognize is that the students who are inhabiting institutions of higher education are border youth. That is, they are youth positioned between cyberspace informational systems and a world that is increasingly more global and hybridized. Under such postmodern conditions, the technology and culture of print must accede its exclusive claims to literacy, and redefine the subject and object of knowledge in accord with the new visual, audio, and computer cultures that are redefining the relationship between space and time. Literacy as a marker of place and identity that is fixed has given way to an understanding of knowledge, place, space, and identity based on flows (Gilroy, 304). Nowhere does this expanded notion of literacy seem more obvious than in the sphere of popular culture.

The shift in the political toward popular practices has made clear that the hybridized space of popular culture is where the conflicts over the related issues of memory, identity, and representation are being most intensely fought over, as part of a broader attempt on the part of dominant groups to secure cultural hegemony. If cultural studies is to translate its theoretical insights into a viable strategy for academics it will be necessary for university intellectuals to understand more critically how the dynamics of culture and politics have changed, given the emergence of the electronic media and their global capacity to create "new images of centrality." As Edward Said (1993) points out, it would be irresponsible politically for cultural workers to underestimate the profound effects the new media are having on the shaping of everyday life and global agendas. Unlike tra-

ditional cultural social forms, the new media constitute a unique moment
in the expansion of cultural imperialism into the sphere of everyday life:

> [t]he difference here is that the epic scale of the United States' global
> power and the corresponding power of the national domestic consen-
> sus created by the electronic media have no precedents. Never has
> there been a consensus so difficult to oppose nor so easy and logical
> to capitulate to unconsciously. (Said, 323)

The new shift towards culture as a terrain of struggle not only ac-
centuates the emerging role of the media in securing cultural authority,
it also signifies the need for university intellectuals to become more at-
tentive to the various pedagogical sites in which the politics of remem-
bering and forgetting produce different narratives of a national past, pre-
sent, and future. One crucial intervention that can be made in this regard
is to develop a notion of literacy through analyses of popular culture. As
Stuart Hall has noted, there is no escape from the politics of representation;
moreover, issues of textuality, meaning, and identity cannot be limited to
the academy or subordinated to the allegedly more "serious" single issues
related to low pay, poverty, child care, and other material concerns.[16] At
the very least, this suggests that any viable notion of political activism
must reject the traditional binarism and strategies of reversal that abstract
cultural considerations from so called concrete material issues. The chal-
lenge for university intellectuals is to create the institutional sites and
pedagogical conditions for students to be able to critically study, use, and
transform the new electronic media and popular cultural forms as part of
a larger attempt to engage and transform the public cultures of the uni-
versity, wider society, and the larger global sphere.

This suggests that academics can in part exercise their role as public
intellectuals by giving students the opportunity to understand how power
is organized through the enormous number of "popular" cultural spheres
that range from libraries, movie theaters, and schools to high-tech media
conglomerates that circulate signs and meanings through newspapers,
magazines, advertisements, electronic programming, machines, films, and
television programs. In this instance, university intellectuals must draw a
lesson from cultural studies in extending the historical and relational def-
inition of cultural texts, while simultaneously redefining how "knowledge,
however mundane and utilitarian, plays about in linguistic images and
forms cultural practices" (Morrison, 49–50). It is precisely in highlighting
the political connections between higher education and other public
spheres that university intellectuals can illuminate how pedagogy works
in a variety of sites to produce social identities, secure and contest forms
of cultural hegemony, and "shed light on the prospects for emancipatory

change" (Fraser 1992, 51–52). Cultural studies offers valuable lessons in this regard, but if it is to be useful in transforming higher education and redefining the role of teachers as public intellectuals, it must insert the pedagogical back into the political, and in doing so erase the long silence over the importance of pedagogy that has served to undermine the most progressive aspects of its cultural politics.

Making the pedagogical more political also suggests that public intellectuals take a stand without "standing still." That is, such intellectuals need to challenge epistemological and social relations that promote reactionary forms of material and symbolic knowledge, but they must also be deeply critical of how their own authority can be made problematic in the service of a radical cultural politics. Pedagogically, this suggests that the authority they legitimate in the classroom become both an object of autocritique and critical referent for expressing a more "fundamental dispute with authority itself" (Radhakrishnan, 122). In addition, public intellectuals must move beyond recognizing the partiality of their own narratives, so as to address more concretely the ethical and political consequences of the social relations and cultural practices generated by the forms of authority used in the classroom. In this way, educators as public intellectuals can "take a stand" while simultaneously refusing either cynical relativism or doctrinaire politics. It is precisely within the interrelated dynamics of a discourse of commitment, self-critique, and indeterminancy that pedagogy can offer educators, students, and others the possibility for embracing higher education as a crucial public sphere while simultaneously guarding against the paralyzing orthodoxies that close down rather than expand democratic public life.

Notes

1. Stanley Aronowitz (1993) provides a detailed analysis of the breakup of this cultural consensus. Some of the elements he analyzes include:

> the assimilationist melting pot, modernity and modernism, long-term economic expansion and its concomitant of consumerism, imperialism, and a virtual one-party state that, nevertheless, maintained two or more competing organizations differing chiefly on strategic and tactical questions. (5)

2. For a representative example of neoconservative attacks on the university, see selected articles in Berman. See also Bolton for an example of similar neoconservative critiques used in the arts.

3. For a glimpse of the elitism and left-bashing that informs the National Association of Scholars, see Diamond. For instance, NAS members Professors Jeffrey Hart and Barry Gross view higher education not as a democratic public sphere but as a channelling colony for middle-class, white students. Diamond writes that

"Gross summed up the prevailing sentiment (at the fourth national NAS Conference) that vocational schools are the proper destination for working-class high school graduates" (32). According to Gross and Hart, expansion of higher education to include working-class and other minority students has not only "led to a corruption of the curriculum" (32), it has opened the university to a left "cultural elite."

4. I take up the issue of Benetton's approach to cultural differences in Giroux (1994).

5. Analyses of the university as a critical public sphere can be found in Aronowitz and Giroux (1994), and Giroux (1983, 1988). For a theoretical elaboration of the relationship between the public sphere and democracy, see Habermas (1989); Felski (1989); Fraser (1990); Calhoun (1991).

6. Recent examples of theoretical work that attempts to insert the issue of pedagogy back into cultural studies include representative writings in Grossberg, Nelson, and Treichler; and Giroux and McLaren.

7. Some forceful expressions of this position can be found in Grossberg, et al. (1992); Hall ("Cultural Studies and its Theoretical Legacies," 1992); Grossberg (1989).

8. See for instance, a variety of writers in Grossberg, Nelson, and Treichler (1992).

9. For a discussion of the relationship between modernity and intellectuals, see Aronowitz; Boggs.

10. A representative example of this type of critique can be found in: Hall, et al. ("Cultural Studies and the Center: Some Problematics and Problems," 1980); Johnson (1987); Morris (1988).

11. See Stanley Aronowitz (1993); See also a few articles in *Cultural Studies* edited by Grossberg, et al. Also, see various issues of *College Literature* under the editorship of Kostas Mrysiades. It is quite revealing to look into some of the latest books on cultural studies and see no serious engagement of pedagogy as a site of theoretical and practical struggle. For example, see: Brantlinger (1990); Turner (1990); Clarke (1991); Franklin, Lury, and Stacy (1991). In Punter (1986), there is one chapter on identifying racism in textbooks.

12. While there are too many sources to cite here, see Connell, Ashenden, Kessler, and Dowsett (1982); Henriques, Hollway, Urwin, Venn, and Walkerdine (1984); Sears (1991); Fine (1991); Simon (1992); Giroux (1992).

13. For instance, while theorists such as Jane Tompkins, Gerald Graff, Gregory Ulmer, and others address pedagogical issues, they do it solely within the referenced terrain of literary studies. Moreover, even those theorists in literary studies who insist on the political nature of pedagogy generally ignore, with few exceptions, the work that has gone on in the field for twenty years. See, for example, Felman and Lamb (1992); Henricksen and Morgan (1990); Donahue and Quahndahl (1989); Ulmer (1985); and Johnson (1983).

14. One interesting example of this occurred when Gary Olson, the editor of the *Journal of Advanced Composition*, interviewed Jacques Derrida. He asked Derrida, in the context of a discussion about pedagogy and teaching, if he knew of the work of Paulo Freire. Derrida responded with "This is the first time I've

heard his name" (cited in Olson, 133). It is hard to imagine that a figure of Freire's international stature would not be known to someone in literary studies who is one of the major proponents of deconstruction. So much for crossing boundaries. Clearly, Derrida does not read the radical literature in composition studies, because if he did he could not miss the numerous references to the work of Paulo Freire and other critical educators. See, for instance, Atkins and Johnson (1985); Brodkey (1987); Hurlbert and Blitz (1991).

15. For excellent analyses of the issue of student voice and critical pedagogy, see Mohanty; hooks.

16. For a critique of theoretical positions that argue that the "real" issues in left politics are undermined by discourses around identity, representations, agency, and culture, see Butler (1991).

Works Cited

Arnold, Matthew. 1960–1977. "Sweetness and Light," in *The Complete Prose Works of Matthew Arnold.* Vol. 5, ed. R. H. Super. Ann Arbor: University of Michigan Press.

Aronowitz, Stanley. 1993. *Roll Over Beethoven: Return of Cultural Strife.* Hanover: University Press of New England.

———, and Henry A. Giroux. 1993. *Education Still Under Siege.* New York: Bergin and Garvey.

Atkins, C. Douglas, and Michael L. Johnson. 1985. *Writing and Reading Differently.* Lawrence: University of Kansas Press.

Bailey, David and Stuart Hall. 1992. "The Vertigo of Displacement," in *Ten. 8.* 2:3, pp. 15–23.

Bennett, Tony. 1992. "Putting Policy into Cultural Studies," in *Cultural Studies,* eds. Lawrence Grossberg et al. New York: Routledge, pp. 23–34.

Berman, Paul, ed. 1992. *Debating P.C.: The Controversy over Political Correctness on College Campuses.* New York: Dell.

Interview with Homi Bhabha. 1990. "The Third Space," in *Identity, Community, Culture, Difference,* ed. Jonathan Rutherford. London: Lawrence and Wishart, pp. 207–221.

Boggs, Carl. 1993. *Intellectuals and the Crisis of Modernity.* Albany: State University of New York Press.

Bolton, Richard. 1992. *Culture Wars: Documents from the Recent Controversies in the Arts.* New York: New Press.

Bove, Paul. 1987. "The Function of the Literary Critic in the Postmodern World," in *Criticism Without Boundaries,* ed. Joseph A. Buttigieg. South Bend, Indiana: University of Notre Dame Press, pp. 23–50.

Brantlinger, Patrick. 1990. *Crusoe's Footprints: Cultural Studies in Britain and America.* New York: Routledge.

Brodkey, Linda. 1987. *Academic Writing as a Social Practice.* Philadelphia: Temple University Press.

Butler, Judith. 1992. "Contingent Foundations: Feminism and the Question of 'Postmodernism'," in *Feminists Theorize the Political,* eds. Judith Butler and Joan W. Scott. New York: Routledge, pp. 3–40.

Calhoun, Craig, ed. 1991. *Habermas and the Public Sphere.* Cambridge, MA: M.I.T. Press.

Chambers, Iain. 1990. *Border Dialogues.* New York: Routledge.

Clarke, John. 1991. *New Times and Old Enemies.* London: HarperCollins.

Connell, R.W., D.J. Ashenden, S. Kessler, G.W. Dowsett. 1982. *Making the Difference.* Boston: Allen and Unwin.

Denning, Michael. 1992. "The Academic Left and the Rise of Cultural Studies," *Radical History Review.* No. 54, pp. 21–47.

Diamond, Sara. 1993. "Notes on Political Correctness," *Z Magazine,* July/August, pp. 30–33.

Donahue, Patricia and Ellen Quahndahl, eds. 1989. *Reclaiming Pedagogy: The Rhetoric of the Classroom.* Carbondale: Southern Illinois University Press.

Donald, James. 1992. *Sentimental Education.* London: Verso.

Ebert, Teresa. 1991. "The 'Difference' of Postmodern Feminism," *College English.* 53:8, pp. 886–904.

———. 1992–93. "Ludic Feminism, the Body, Performance, and Labor: Bringing Materialism Back into Feminist Cultural Studies," *Cultural Critique* 23, Winter, pp. 5–50.

Felman, Shoshana and Dori Lamb. 1992. *Testimony: Crisis of Witnessing in Literature, Psychoanalysis, and History.* New York: Routledge.

Felski, Rita. 1989. *Beyond Feminist Aesthetics.* Cambridge, MA: Harvard University Press.

Fine, Michelle. 1991. *Framing Dropouts.* Albany: State University of New York Press.

Fraser, Nancy. 1990. "Rethinking the Public Sphere: A Contribution to the Critique of Actually Existing Democracy," *Social Text* 25/26, pp. 56–80.

———. 1992. "The Uses and Abuses of French Discourse Theories for Feminist Politics," *Theory, Culture, and Society* 9, pp. 51–71.

Franklin, Sarah, Celia Lury, and Jackie Stacy, eds. 1991. *Off-Centre: Feminism and Cultural Studies.* London: HarperCollins.

Geyer, Michael. 1993. "Multiculturalism and the Politics of General Education," *Critical Inquiry* 19, Spring, pp. 449–533.

Gilroy, Paul. 1992. "It's a Family Affair," in *Black Popular Culture,* ed. Gina Dent. Seattle: Bay Press, pp. 303–316.

Giroux, Henry, A. 1983. *Theory and Resistance in Education.* New York: Bergin and Garvey.

———. 1988. *Schooling and the Struggle for Public Life.* Minneapolis: University of Minnesota Press.

———. 1992. *Border Crossings: Cultural Workers and the Politics of Education.* New York: Routledge.

———. 1994. *Disturbing Pleasures: Learning Popular Culture.* New York: Routledge.

———, and Peter McLaren, eds. 1994. *Between Borders: Pedagogy and Politics in Cultural Studies.* New York: Routledge.

Grossberg, Lawrence. 1989. "The Formation of Cultural Studies: An American in Birmingham," *Strategies*. 2, pp. 114–149.

———. 1994. "Bringin' It All Back Home: Pedagogy and Cultural Studies," in *Between Borders*, eds. Henry Giroux, et al. New York: Routledge, pp. 1–25.

———, Cary Nelson, and Paula Treichler, eds. 1992. *Cultural Studies*. New York: Routledge.

———. 1992. *We Gotta Get Out of This Place: Popular Conservatism and Postmodern Culture*. New York: Routledge.

Grover, Jan Zita. 1992. "AIDS, Keywords, and Cultural Work," in *Cultural Studies*, eds. Lawrence Grossberg, et al. New York: Routledge, pp. 227–239.

Habermas, Jürgen. 1989. *The Structural Transformation of the Public Sphere: An Inquiry into a Category of Bourgeois Society*, tr. Thomas Burger with Frederick Lawrence. Cambridge, MA: M.I.T. Press.

Hall, Stuart. 1980. "Cultural Studies: Two Paradigms," in *Culture, Media, Language: Working Papers in Cultural Studies*, eds. Stuart Hall, et al. London: Hutchinson, pp. 57–72.

———. 1992. "Cultural Studies and its Theoretical Legacies," in *Cultural Studies*, eds. Lawrence Grossberg, et al. New York: Routledge, pp. 277–294.

———. 1980. "Cultural Studies and the Center: Some Problematics and Problems," in *Culture, Media, Language: Working Papers in Cultural Studies*, eds. Stuart Hall, et al. London: Hutchinson, pp. 117–21.

———. 1992. "What is This 'Black' in Popular Culture?," in *Black Popular Culture*, ed. Gina Dent. Seattle: Bay Press, pp. 21–33.

Henricksen, Bruce and Thais E. Morgan, eds. 1990. *Reorientations: Critical Theories and Pedagogies*. Urbana: University of Illinois Press.

Henriques, Julian, Wendy Hollway, Cathy Urwin, Couze Venn, and Valerie Walkerdine. 1984. *Changing the Subject*. London: Methuen.

hooks, bell. 1989. *Talking Back*. Boston: South End Press.

Hollander, Paul. 1992. *Anti-Americanism: Critiques at Home and Abroad, 1965–1990*. New York: Oxford University Press.

Hurlbert, C. Mark and Michael Blitz, eds. 1991. *Composition and Resistance*. Portsmouth: Heinemann.

Jacoby, Russell. 1987. *The Last Intellectuals: American Culture in the Age of Academe*. New York: Basic Books.

Johnson, Barbara, ed. 1983. *The Pedagogical Imperative: Teaching as a Literary Genre*. New Haven: Yale University Press.

Johnson, Richard. 1986–87. "What is Cultural Studies Anyway?," *Social Text* 16, Winter, pp. 38–80.

Menand, Louis. 1991. "What are Universities For?," *Harper's*, December, pp. 47–56.

Mercer, Kobena. 1992. "Back to my Routes: A Postscript on the 80s," *Ten. 8*, 2:3, pp. 32–39.

Mohanty, Chandra Talpade. 1989–1990. "On Race and Voice: Challenges for Liberal Education in the 1990s," *Cultural Critique*, 14, pp. 179–208.

Morris, Meaghan. 1988. "Banality in Cultural Studies," *Discourse*, 10:2, pp. 3–29.

Morrison, Toni. 1992. *Playing in the Dark: Whiteness and the Literary Imagination.* Cambridge: Harvard University Press.

Nelson, Cary. 1991. "Always Already Cultural Studies: Two Conferences and a Manifesto," *Journal of Midwest Modern Language Association,* 24:1, Spring, pp. 24–38.

Olson, Gary. 1991. "Jacques Derrida on Rhetoric and Composition: a Conversation," in *(Inter)views: Cross-Disciplinary Perspectives on Rhetoric and Literacy,* eds. Gary Olson and Irene Gale. Carbondale: Southern Illinois University Press, pp. 121–141.

Punter, David, ed. 1986. *Introduction to Contemporary Cultural Studies.* New York: Longman.

Radhakrishnan, R. 1991. "Canonicity and Theory: Toward a Poststructuralist Pedagogy," in *Theory/Pedagogy/Politics,* eds. Donald Morton and Mas'ud Zavarzadeh. Urbana: University of Illinois Press, pp. 112–135.

Reiff, David. 1993. "Multiculturalism's Silent Partner," *Harper's,* August, pp. 62–72.

Rutherford, Jonathan, ed. 1990. *Identity, Community, Culture, Difference.* London: Lawrence and Wishart.

Said, Edward. 1993. *Culture and Imperialism.* New York: Alfred A. Knopf.

Sears, James T. 1991. *Growing Up Gay in the South.* New York: Harrington Park Press.

Simon, Roger I. 1992. *Teaching Against the Grain.* New York: Bergin and Garvey Press.

Spivak, Gayatri C. 1990. "The Making of Americans, the Teaching of English, and the Future of Cultural Studies," *New Literary History,* 21.1, pp. 781–798.

———. 1990. *The Post-Colonial Critic: Interviews, Strategies, and Dialogues,* ed. Sarah Harasym. New York: Routledge.

Turner, Graeme. 1990. *British Cultural Studies.* London: HarperCollins.

Ulmer, Gregory. 1985. *Applied Grammatology.* Baltimore: Johns Hopkins University Press.

Williams, Raymond. 1989. *What I Came to Say.* London: Hutchinson-Radus.

"To Sir With Love":
National Pedagogy
in the Clinton Era

JUDITH FRANK

It may sometimes resemble a college dormitory full of zany over-
achievers, but it is the White House. Berke, A24

It has become habitual for the public discourse about Clinton to
evoke college. Before the election, his status as a Rhodes scholar and his
pleasure in ideas made the rhetoric shift between two fantasies of the
student: the geek ("policy wonk"), and—George Bush's fantasy—the un-
dercover agent, or the student with illegitimate knowledges and powers.
As Clinton grew closer to gaining the presidency, though, and since he
has taken office, the public discourse has increasingly placed him in the
role of teacher. For example, the morning after the inauguration, the *New
York Times* ran an article by Walter Goodman about Clinton's responses
to the various balls and celebrations, with the headline "In the Inaugural
of Inclusion, All the Arts are In." Calling him "the diversity President,"
Goodman wrote, "few viewers could have worked up the undiscriminating
enthusiasm that the Clintons and Gores showed for every act that took
the stage on Tuesday night." At the end of the article, in an anxious slide
from culture to politics, he warned that the administration would even-
tually have to put its foot down, saying "what it is for and what it is
against" (Goodman, C20). In his description of the slack and dissolute
heterogeneity of the president's taste, Goodman was drawing upon a figure
that had become familiar in the popular press: the contemporary human-
ities professor.

Indeed, during both the election campaign and the transition period, Clinton himself showed a penchant for pedagogical scenarios. A month before the election, he and Gore appeared on Donahue, and Clinton spent the first part of the show fielding questions about his trip to Moscow, his movements and intentions as a student. Then, in the question-and-answer period, a middle-aged white man helped him switch roles when he asked: Where do jobs come from? The question startled me into laughter at the time, suggesting, as it did, the archetypal Scene of Pedagogy, where the child asks: Where do babies come from? Clinton buckled down to answer with true egghead pleasure.[1] To me, the Little Rock economic conference that convened shortly after his victory was more remarkable for its *form*— the seminar—than for its content. Could any teacher not feel a little shiver of recognition to see Clinton sitting back in his chair, looking around the room and asking, "Does anyone else have anything to say about the strong dollar/weak dollar argument?" Or, for that matter, to hear him say, "That chart you had was very moving"?[2]

I want to discuss here a trope in the national discourse around which a knot of national psychic energy tightened in those last months of 1992 and the first month of 1993,[3] a trope I call the Figure of Learning. I say *learning* rather than *knowledge* or *pedagogy* because I want to emphasize the process by which we take things in and they change us. The Figure of Learning was at the center of the national meditation about citizenship and the future; as Clinton increasingly became a teacher, citizens became, in this discourse, students—students whose specific lesson was the economic decline of the American middle class. The evocation of pedagogy weaves unsteadily between embracing and evading the moment of learning: between the sense that we cannot exercise citizenship without learning, and the dread that what we have to learn might be unbearably painful. That dread echoes, I will argue, the debates of the past few years about the humanities, which have been, in part, debates about the experience of learning: particularly, about how much learning is supposed to hurt. If those debates were stimulated by several decades of expanded access to the university, the recent economic threat to those whose access to it has traditionally been least problematic—the white middle class—has given them a new resonance.

The Figure of Learning reverberated with particular force on Inauguration Day, when youth culture met up with national politics at the MTV Inaugural Ball, a rock concert performed at the Washington Convention Center, and produced by MTV to celebrate its Choose or Lose campaign. I take the MTV ball as my primary text in this essay because MTV was a major political force in the 1992 election, especially in the mobilization of that elusive eighteen-to-twenty-four-year-old demo-

graphic—many of them college students—that had turned out in such small numbers in 1988. Rock the Vote, the nonpartisan and nonprofit music industry group formed in 1990 (in the wake of the obscenity arrest of 2 Live Crew) to combat censorship and encourage voting, set up voter registration booths at concerts and college campuses nationwide, and lobbied in Congress for the "motor-voter" bill (Simpson, 66; Light, 17); its exuberant public service announcements were created by and aired on MTV. And MTV ran its own voting campaign, Choose or Lose, in which it assigned twenty-four-year-old Tabitha Soren to cover the election, and ran regular reports on issues relevant to young people. The press had plenty of both condescending and grudgingly respectful things to say about the foray into politics of MTV, which has traditionally been thought of as the no-attention-span channel. It is worth saying in this context that Soren's reports averaged a whopping four minutes in length—"luxurious," as *Time* pointed out, "by network-news standards" (Simpson, 67), and that Clinton's appearance on MTV in June 1992 before two hundred college-age students was widely credited for reenergizing his campaign.

The Inaugural Ball was visited by the new president and his family (they dropped Chelsea off there) and peppered by witty and aggressive antiracism spots produced by MTV. Six or seven bands performed, as rock stars and movie stars celebrated the fact that, as host Dennis Miller put it, "finally, one of our guys is driving the car." The ball opened with a pedagogical scenario, Tabitha Soren announcing:

> Tonight, MTV celebrates the young voters of America. You turned out in force last year, registering, learning the issues, studying the candidates, and voting. As a reward for all your hard work, you get a nation headed in a promised new direction, and a big fat star-studded, full-throttle MTV rock 'n' roll jam.

Figuring citizenship as learning, and learning as "hard work," Soren described the election and its aftermath in that primal code of student life: study, then party.

Anyone for whom rock 'n' roll gives their affective life its beat and its melody had to be overwhelmed, I think, by the interface between rock genre and lyric, sumptuous televisual production, and ebullient leftist celebration at this event. En Vogue, that complex mixture of slick rock-industry marketing and African-American female vocal power, opened the evening by singing a doo-wop version of the "Star Spangled Banner" that shot it through with color. Then they threw off their capes to reveal psychedelic clothes—not the only moment in this concert to evoke the sixties—and roared to a driving synthesized beat their antiracism and sexism anthem, "Free Your Mind," whose charge "Before you read me you

got to learn how to see me" resonated as a fierce gloss on "Oh say can you see." In this context, even rock music that was not in the least about the nation—music whose composers and performers could not have imagined that their songs would ever have contact with a moment like this— was transformed into resonant reflections upon nation-ness and futurity. R.E.M.'s Michael Stipe, for example, sang the Irish band U2's soaring, bitter, complicated ballad "One," a song that as it unfolded seemed more and more brilliantly apt for this nation, alternating as it does between:

> We're one
> but we're not the same
> we get to carry each other
> carry each other,

and:

> We're one
> but we're not the same
> well we hurt each other and we do it again.

It was a musical and televisual event worthy of a full and richly descriptive analysis.[4] Here, though, I will limit myself to a sequence performed by 10,000 Maniacs and Michael Stipe, a sequence which seems to have been a rock event of some moment: in a cover story on 10,000 Maniacs's lead singer, Natalie Merchant, *Rolling Stone* referred to it as "a highlight of the evening" (France, 36), and the performance boosted the band's latest album, *Our Time in Eden,* to No. 28 on the *Billboard* charts after initially tepid sales (Isaak, 14). I will also limit myself primarily to song lyrics and performance. I am aware of the claim of critics of rock 'n' roll that the meanings of any given rock event cannot be apprehended by interpreting the internal logic of individual songs, both because rock is a cultural form that involves such additional and complicating aspects as performance, cover art, and video (Shumway, 223), and because rock 'n' roll fans "relate to and use the music at levels other than the signifying or representational" (Grossberg, 180–1).[5] Nevertheless, I am going to treat the songs as individual representational units addressing the occasion of the inauguration, because I believe that, as such, they signified in volatile and interesting ways. The 10,000 Maniacs sequence interested and moved me because of the ways it used rock to meditate upon citizenship, futurity, and loss—a meditation suffused with tropes of learning.

Natalie Merchant opened with a song from *Our Time in Eden* called "These Are Days." The song begins, "These are days you'll remember. Never before and never since, I promise, will the whole world be warm as this." Merchant, whose stage persona is often brooding and introverted,

elatedly evoked Utopia—at this moment, clearly, the promise of warmth and blessedness emanated by the Clinton inauguration. She sang, "And as you see it, you'll know it's true, that you are blessed and lucky," and taking her bow at the end of the song, she said, beaming, "Congratulations!" Thus, the audience constituted by "These Are Days" on this occasion was an audience different from the one the song is likely to conjure in regular concerts: this was an audience of citizens celebrating "the days" of the transfer of presidential power.

But the voice that makes these promises and has these knowledges also constitutes the audience as students. Knowing what its audience will remember at a future time, and invested with the authority to "promise" that this will be the warmest moment ever, this is, to some degree, the voice of official, authoritative knowledge, of the parent who tells the child that these are the best days of her life. Specifically, the authoritative voice sounds like the ideology of the school at its most seductive—a hunch borne out by the fact that "These Are Days" became, in the wake of the MTV ball, even better known for being played in the promotional spots for Fox's sentimental and short-lived series about college life, *Class of '96,* spots that portrayed beautiful young people living the best days of their lives upon the steps of gothic buildings.

The climactic moment of "These Are Days," evokes a surplus of pleasure:

> These are the days you might fill with laughter until you
> break.
> These days you might feel a shaft of light make its way
> across your face.

And the image of light takes the song in the direction of portraying Utopia as a moment of, an effect of, *knowledge:*

> And when you do, you'll know how it was meant to be, see
> the signs
> and know their meaning. It's true, you'll know how it was
> meant to be,
> see the signs and know they're speaking to you.

In the moment of joy, we are assured that we will need only "see" signs to know all we need to know, that signs and referents will come magically together. That plenitude is enacted in the words "you'll know how it was meant to be," which assume that we know what the referent to *it* is; and we in fact feel as though we do. For this song, Utopia is, I think, spontaneous knowledge, knowledge that comes like a shaft of light. Utopian knowledge is, in other words, knowledge that makes the process of learn-

ing unnecessary—although for me, the exciting and sinister "You might fill with laughter until you break" intimates something of the possible shattering effects of learning. Overall, though, the joy that permeates knowledge in "These Are Days" comes from the possibility of evading learning.

If "These Are Days" requires a certain degree of interpretive pressure to yield a pedagogical meaning, what followed did not: with Michael Stipe of R.E.M. arriving mid-song as a surprise guest, Merchant sang, of all things, "To Sir With Love." Alluding to the 1967 hit by the singer Lulu, from the English movie in which Sidney Poitier plays an unemployed engineer who becomes the teacher of working-class high school toughs, Merchant and Stipe set off a hugely overdetermined network of cultural meanings surrounding race, class and gender; the sixties; and the act of pedagogy—not to mention the eroticization of the president, here figured as a black teacher.[6] I will return to the film at the end of this essay; here I want to talk briefly about the song, which has had, interestingly, somewhat of a revival in the wake of Merchant and Stipe's performance of it at the MTV ball. Soul Asylum has performed it on *MTV Unplugged* with Lulu, who is herself having a career revival. In a May 1993 profile in *Entertainment Weekly*, Lulu said of the song that made her famous, "Its popularity is very strange, isn't it? . . . I worked with Gloria Estefan two weeks ago, and one of her musicians said, 'That song is part of American history' " (McKelvey, 49). The strange popularity of "To Sir With Love" twenty-six years after its debut on the charts was, I think, produced at least partly by the way the song tapped into middle-class longings at this volatile moment in American history.

Merchant and Stipe are intellectual rock stars, adroit in the use of irony—Stipe's persona in particular is virtually synonymous with irony—so what struck me most about this performance was its sincerity and its pathos. They sang it straight, as a love song to the new president: Merchant sang the first verse with a shy, even coy, girlishness, and when Stipe walked onto the stage for the second verse, wearing a plain brown suit and a bowler hat, he bowed gallantly to her, giving the performance the aura of a courtship ritual. During the instrumental bridge, in which the saxophonists played a melancholy, minor-key version of the opening few bars of the song, Stipe and Merchant slow-danced; Stipe sang the refrains with his eyes closed and his hands outstretched, palms up. While a viewer who had never seen these singers perform before might have rolled his or her eyes at the sentimentality of this performance, a more expert viewer, one familiar with the brittle and knowing personae Stipe and Merchant often bring with them on stage, would, I think, have been arrested by the tension

between those personae and the singers' full-throttle emotion on this occasion.

In "To Sir With Love," Merchant and Stipe are now in the position of the student, with the president as Sir. The song calls the teacher "my best friend," and describes the pedagogical situation as follows:

A friend who taught me right from wrong
And weak from strong
That's a lot to learn.
What can I give you in return?

That last question is answered in two hypothetical and magnificent offers:

If you wanted the sky
I would write across the sky in letters
That would soar a thousand feet high
To Sir with love

and:

If you wanted the moon
I would try to make a start but I
Would rather give my heart
To Sir with love.

In one possible reading, when it calls the teacher "my best friend," the song asserts a loving equality between teacher and student. Indeed, the students are saying that learning has made them feel so powerful that not only do they want to perform extravagant feats of gratitude, but they believe they can. But I also hear in this song a certain skittishness about the possible *inequality* of teachers and students. It seems possible to read "To Sir With Love" as an anxious fantasy that the teacher would want so much back (the sky, the moon) that his demand would far exceed the student's resources ("But I would rather give my heart"). That is, rather than referring to the feeling generated by learning, the enormity expressed in that celestial graffiti could refer to the demand exacted by the teacher. The repeated claims that "It isn't easy but I'll try," and "I would try to make a start" reinforce this sense of exertion. In other words, even though the students claim they have learned the difference between weak and strong—one of the concrete lessons actually evoked by the song—I think that the question of what to give in return inspires a feeling in which strength and weakness are uncomfortably indistinguishable. I am arguing that the song's affect is mobilized in the tension between the assertion that learning makes you strong and the worry that it may reveal a fundamental inequality in the contract between student and teacher, in the

face of which the student can only make sputtering and grandiose claims. Like that of "These Are Days," "To Sir With Love" 's relation to learning is a powerful and stirring ambivalence.[7]

Why should learning generate such an ambivalence? I think that at the historical moment embodied so vividly by the MTV ball, learning had become painful because it was associated with the decline of the middle class. The Figure of Learning came into the national discourse as a response to the faltering economy, as though our eroded standard of living and degraded economic stature in the world have precipitated a national intellectual crisis whose specific uncertainty is how capitalism works. Kevin Phillips has documented in excruciating detail the economic ravages sustained by the middle class in the Reagan-Bush years, and the increasing tenuousness of those features of middle-class life it has often taken for granted: home values, insurance coverage, pension coverage, and the ability to pay college tuition. He refers to "the special discomfort and trauma that overtakes a fading great economic power, less and less able to sustain the unique affluence once bestowed on its ordinary middle-rank citizenry" (Phillips, xxiii)[8]; and indeed, I want to stress that for the middle class (including those professionals who shape the national discourse) this was as importantly an intellectual trauma as an economic one, not only because the slow fade of its economic power came to the middle class as a traumatic thing-to-be-learned (for the poor and the working poor this presumably did *not* come as a surprise), but also because the uncertainty generated by such events as bank and insurance company collapses have demanded on the part of the middle-class citizen an unprecedented degree of self-protective expertise. In this context Ross Perot was appealing because he is a billionaire, and thus might be said to sufficiently understand how the economy works; he responded to and stimulated the national craving to learn when he appeared on television with his pointers and his charts.

The national debt, which Perot attempted to bring out of its haze of mystification, was a central and resonant figure in the public discourse of the election, often coming to stand for the economy as a whole. It did so, I think, precisely because it is such a ripe epistemological problem. How can we know what the national debt is? How can we account for the way Bush's budget office painted a much worse economic forecast in early January 1993 than they had all the previous year? (Rosenbaum, 1, 4). Should we think of it as a deliberate plot? Or as an index of the debt's slipperiness in our cognitive grasp? How should we read Clinton's much-touted post-election surprise about the magnitude of the debt? One afternoon during the period when I was writing this essay, National Public Radio's *Fresh Air* devoted a segment to the national debt, in which CBS News economics correspondent Robert Krulwich explained to Terry Gross

what the national debt is (and the difference between the national debt and the deficit). A large portion of the segment involved an exemplification of the concept of a *trillion,* where he had Gross guess how old she was a million, a billion, and a trillion seconds ago: a million seconds ago, he then explained, was two weeks ago; a billion seconds ago, 1963; a trillion seconds ago, the Stone Age (*Fresh Air,* 19 March, 1993). While the *Fresh Air* segment rendered piquant the difficulty of wrapping one's mind around the debt, the national debt more characteristically brought together a rhetoric of learning and a rhetoric of pain. With each unsettling revelation of its increasing enormity, announced on the front page of the *New York Times* all through January of 1993, it functioned as a figure for how hard it is to learn—hard both because learning is difficult and because what we learn may hurt.

Of course, the social realm in which the uncomfortable relations between learning, history and pain have been a vivid problem is the university, particularly in the study of the humanities. It is possible, in fact, to think of the university of the past few decades as a kind of theater of pain: the debates about the canon, new methodologies, and free speech have perhaps been about nothing so much as what learning is supposed to feel like to students—particularly, how much it is supposed to hurt. Although this has often remained implicit, one of the right's primary objections to the theoretical developments in the humanities has been that by stressing such issues as power and oppression, teachers have caused some students pain. Speaking out against the so-called politicization of the humanities, Lynne Cheney's latest jeremiad, last September's National Endowment for the Humanities report to Congress on the state of the humanities called *Telling the Truth,* argued that new methods of inquiry make students feel bad:

> If students hear repeatedly that all human endeavor is, at bottom, nothing more than a struggle for power, who can blame them for falling into cynicism? . . . A professor at Vanderbilt University observes: "Cynicism prevails. More and more students have become cynical about the possibilities of democracy itself. It finally comes down to power and how to grab one's share of it." (NEH, 17)

It is certainly true that the various forms of revisionist history—social, intellectual, economic, and literary—have insisted upon analyzing the various forms of power exercised by Western cultures—upon, in fact, viewing Western cultures as constituted by the exercise of an often oppressive power. But the Vanderbilt professor's idea that university professors are teaching students "how to grab one's share of [power]," which neatly illustrates how intellectually pathetic the right-wing conception of

"power" is, misses precisely the point of what most hurts to those studying it: the complex systemic nature of power, and its imperviousness to the individual human grasp. In using the overarching term "students," the professor also fails to recognize that not everyone is cynical in the same way or for the same reason. Reading Marxist theory or Foucault may indeed be depressing to those students who have managed to come into the classroom still untouched by cynicism, students in whose interests it has been *not to know* how their privilege is created and perpetuated. It is also painful, although in a very different way, to those students who come from social groups that have been dissociated from political power.

Indeed, the left too has worried about pain caused to students, although it finds that pain in different places. Critical pedagogy, for example, takes as a fundamental premise the alienation of marginalized students from the forms of social and cultural life represented and perpetuated by the school, and its perhaps most characteristic and urgent call is for strategies of *empowerment.* Professors in the humanities have often sought to construct courses, syllabi, and institutional spaces in which social wrongs and pains might be addressed, perhaps even partially *re*dressed. Marginal groups have figured the study of their histories as a recovery of voice, while the right has often complained that such groups are more interested in making themselves feel good than in intellectual rigor and academic standards. Indeed, claims of oppression on the part of minority groups have been read by the right as suspicious attempts to parlay pain into pleasure.

As my examples suggest, this debate about learning and pain came into being because expanded access to the university by heretofore marginalized groups (by this I mean primarily nonwhites, but also women, and gays and lesbians, whose presence was legitimized by new disciplines) forced into our consciousness the fact that different kinds of students are situated differently *vis-à-vis* the university. And I think a central problem in the debate has been that each side complains self-servingly about the pain inflicted upon a different kind of student, but neither side admits that. Not wanting straight white men to be hurt, the right has tended to treat minority constituencies with contempt and hypocrisy. In a chapter called "Politics on the Campus," for example, *Telling the Truth* praises the "undergraduates of independent mind" who resist their professors by refusing "to move beyond what common sense and their own experience tell them" (NEH, 16); but tellingly, it places its discussion about the common sense and experience of traditionally oppressed groups in a chapter called "The Attack on Standards," arguing that when we assume that such groups might have "distinct normative insights" or "special perceptions" we are both eroding standards and being racist (NEH, 25–6). Such

a contemptible double standard cannot get us anywhere. The left, meanwhile, has agitated on behalf of women, gays and lesbians, and students of color, those students we see as most historically vulnerable to the kinds of pain inflicted by this culture and its educational institutions. And we have tended to treat dismissively the anxieties of straight white male students. No matter how we might feel about their entitledness, or about the difficult forms in which their resistance often comes, or about the ways in which the demographic composition of the university is weighted to constantly mirror back to them their identities and their concerns, anyone serious about education and social justice knows that these students, too, need our full pedagogical energies.

Each side of this issue will at some point argue for the necessity of pain in any serious pedagogical exchange. Many teachers on both sides of the ideological divide *value* discomfort in their students, understanding it as a sign of authentic learning and possible transformation. The idea of "critical distance" so cherished by many teachers on both the left and the right suggests a process of loss, a severing of students from the things they hold close. The classicist Martha Nussbaum has argued that the Socratic way of learning demands a relinquishing of the mastery our culture associates with manliness; it "requires a form of vulnerability and even passivity. It means dropping the pose that one is always adequate to any occasion, always on top, always hard" (27). The debates about pedagogy need, I think, to take into account the pain intrinsic to *all* learning. It is psychoanalytic theory that assists us here. Freud's *Beyond the Pleasure Principle* claims, for example, that the primary urge of the human organism, like other organisms, is to *ward off* stimuli; and in a reading of Freud's and Lacan's writings about teaching, Shoshana Felman has argued that "teaching, like analysis, has to deal not so much with *lack* of knowledge as with *resistances* to knowledge. . . . Ignorance, in other words, is nothing other than a *desire* to ignore . . . not a simple lack of information but the incapacity—or the refusal—to acknowledge *one's own implication* in the information" (Felman, 30). The process of learning, then, has resistance—the warding off of pain—at its core. But to say that learning *always* hurts is not to justify the hurts perpetrated by oppressive pedagogy. Indeed, psychoanalytic theory is insufficient to a nuanced account of learning, because it does not take into account the fact that different learning subjects are positioned quite differently *vis-à-vis* teachers and lessons. I think a powerful and politically useful theory of the learning process would account for both the fact that learning is always painful, and the fact that that pain takes different social forms and has different social purposes.[9] Such a theory would, in other words, explore the dynamic between re-

sistance in the psychoanalytic sense and resistance in the sociopolitical sense.[10]

I have argued that, both in the social sphere of the university and in the larger public sphere, middle-class Americans have experienced pain and dismay generated by learning: that the culture we like to think of as the greatest in the world was built upon oppression and brutality, and that the United States is in economic decline. How might we articulate the relations between those spheres? When the middle class turns to the pedagogy trope to express its relation to the man they elected to get it out of this mess, is that because there is something immemorial in the structure of pedagogy—or a certain fantasy of it—that speaks to its need? Or is it more specific? Is the evocation of pedagogy an evocation of the university? It is tempting to read the developments in the humanities as having provided a precedent and impetus for rethinking American history, as having developed a predisposition in the larger public to thinking of the country as off-track. When the NEH book quotes the Vanderbilt professor as saying, "More and more students have become cynical about the possibilities of democracy itself," for example, we cannot help but think of the collective bummer over the democratic process that overtook the American electorate in November 1992, and wonder, with a wild surmise, whether we might attribute it to humanities professors. But it is more likely that, despite the right's tendency to blame professors and students who bad-mouth America for middle-class decline, and despite our own desire to see our work as having an impact beyond our small academic circles, the painful revelations in the academic sphere were actually a partial *effect* of white middle-class anxiety over its own power and future: anxiety that came first from the pressure of the upstart groups knocking at its door and, more recently, from its own economic vulnerability. It is inevitable, after all, that anxiety over the decline of the middle class should reverberate through its primary instrument of reproduction, an institution whose very viability, in the wake of the recession and enormous budget cuts, has been put at risk.

Indeed, I would argue that when pedagogy is evoked in the rhetoric of the national debt, that is because the middle class is thinking anxiously about actual students and their loss of educational opportunity. Those students learning their painful lessons in university departments such as African-American or queer studies always pose the possibility of a traumatic repetition of a student movement. But the rhetoric around the national debt suggests that the more serious generational threat may come from those middle-class young people who believe they may not be able to *be* students. The national debt has frequently been described as the mortgaging of the birthright of the young; a *Nightline* episode on ABC TV this February featured representatives from Lead or Leave, a grassroots

movement mobilizing around deficit reduction, who argued acrimoniously with senior citizens about the role of Social Security in reducing the national debt.[11] ABC News's Chris Bury described this struggle as "a battleground in what some young activists described as a looming generational war," while Rob Nelson, from Lead or Leave, called the debt "our generation's Vietnam." Jon Cowan, also from Lead or Leave, stated, ". . . None of us want [sic] to go to war with our parents or our grandparents, at least over the national debt, but that's what's going to happen" (ABC News, 1). Cowan's witty, sinister and perhaps unintentional suggestion that they would be perfectly happy to "go to war" with their parents and grandparents for some *other* reason hints at a possible free-floating and excessive menace in this young generation.

Barbara Ehrenreich has argued that generational conflict is, in fact, constitutive of middle-class life because, unlike other classes, the middle class does not automatically reproduce itself:

> We may be born into the middle class, but we are expected to spend almost thirty years of our lives establishing ourselves as members of that class in good standing. . . . The middle class is the only class that routinely cannibalizes its young—denies them an adult-level income till near middle age, exploits their labor, and ignores or appropriates their creative contributions. (Ehrenreich, 76)

In the eyes of their parents, Ehrenreich claims, the student activists of the sixties were committing a kind of class treason because they rejected the arduous training and apprenticeship required for such a reproduction; refusing to join their own class, they were figured as undisciplined children spoiled by permissive parenting (74). In contrast, the generation represented by Lead or Leave feels itself betrayed by its parents, whose errors and excesses have, it believes, thwarted its desire, and its traditional prerogative, to join its own class. Increasingly unable to afford college, or the kinds of elite colleges they were raised to believe they would attend, and increasingly uncertain whether a college education will get them anywhere in this economy,[12] the young people of the MTV generation loom in middle-class consciousness as both victims and threat.

It is in the context of this threat that I want to return to "To Sir With Love." I had a lot of trouble figuring out what Merchant and Stipe could possibly have had in mind when they evoked the film *To Sir With Love,* especially since it's so conservative. (It wasn't that shocking that they might be expressing conservative ideas, but what untenured radical likes to think she could be *moved* by such ideas?) James Clavell's film partakes of the antiracist program of the sixties in that an authoritative black man is the erotic and affective center of the film; but what this outsider teaches

the mostly white savages is to internalize the values of the ruling class, and the discipline he imposes is so traditional and hierarchical that William Bennett would adore it. The teachers spend the early part of the film lamenting that corporal punishment has been outlawed, and wondering how they will discipline their students if they cannot beat them. Sir responds to this challenge by imposing rituals of class and gender hierarchy: the students are to call him "Sir," and, in his most contested and cathected rule, the boys are to be called by their surnames, while the girls are to be given the title "Miss." They will, in other words, imitate—and ideally, internalize—the social codes of middle- and upper-class English public schools, as well as maintaining the decorums of sexual difference. (It is this deliberate performance of gender difference that is evoked in the song when the female singer equates the acquisition of cultural literacy with being "taken . . . from crayons to perfume.") After Sir instates these rules the leader of the girls, Pamela Dare, develops a crush on him, a crush that culminates in their dancing together at the graduation party. What she and her cohort learn to do is to eroticize discipline, a process that comes to substitute for and do the work of corporal punishment. It is this eroticization of discipline that is enacted in the film's title.

I have argued that an ambivalence about learning pervades the song "To Sir With Love," an ambivalence that concerns what a powerful figure might ask for in return for learning. Alongside that ambivalence comes another tension, specific to this particular performance of the song, and that is its temporality. In effect, Merchant and Stipe's performance of the song says "hello" to Clinton by saying "goodbye"; while the nation might expect Utopia to be in the future, or even perhaps in the present (as "These Are Days" suggests), "To Sir With Love" places it in an idealized past from which we must now part with "long last looks." What I wonder is whether the paradoxical simultaneity of glad welcome for the Clinton regime and nostalgia for a happier past comes from the prospect of the discipline that regime may impose upon its middle-class student-citizens. What if the indebtedness expressed by the students in their offer of the sky and the moon is in fact a literal debt, and an astronomical one?—if what the teacher demands as learning's price is austerity, even deprivation? I think the performance of "To Sir With Love" may have been so moving because it was about learning to eroticize Clinton's knowledge and ours, and then paying the price of that knowledge. It is in this context that we might read Stipe's natty thrift-store suit and the simplicity of Merchant's dress, and the fact that what Stipe and the band members wore as adornment was the red ribbon, the symbol of their generation's frailty. The students of *this* student movement, Stipe and Merchant seemed to be say-

ing, will learn to love the discipline required of them, slow-dancing—in the mode of older people—into an uncertain future.

NOTES

Thanks to Michael Moon and friends for "To Sir With Love" lore and supplies; to Joe Thoron for enterprising research assistance; and to Michèle Barale and Sasha Torres for kicking the novel out from under me.

1. "Jobs come from investment. That's where jobs come from. Jobs are lost when this company [the Marlene Corporation in Nashville] disinvested in Tennessee and invested in Central America with a subsidy from the taxpayers" (Donahue, 9).

2. Following the Little Rock seminar, the *New Yorker* ran a full-sized color cartoon called "More Charts With Heart" (69). In one of the charts, the incidence of "Found love" had risen while "Lost love" had fallen, over a certain number of years.

3. I began this essay shortly after the inauguration, and wrote the last revisions in the days following the narrow passage of Clinton's deficit reduction package in the House of Representatives, and his subsequent appointment of David Gergen as communications director. The traces in this essay of uncertainty about the character of his presidency—and particularly the confusing dissipation of pedagogical energy in the first "100 days"—may be discerned in the way the tenses wobble between past, past perfect, and present tense.

4. The evening was rife with contradictions and disjunctions: the audience cheering for the Gore family, when Tipper is to rock audiences the embodiment of censorship, an enemy to rock music; the alternation between the vivid antiracism spots and commercials, in particular a grotesque ad for Nintendo's Super Mario games in which a parody of an African "headshrinker," leaping about animalistically with a bone through his nose, shrinks a white, male, adolescent, Super Mario consumer's head; and, of course, the juxtaposition of what the *New Yorker*'s witty "Talk of the Town" article on the ball called the "talented, successful, cool performers" and Roger Clinton (32).

5. Grossberg's claim that fans do not listen to the lyrics requires some revision in the light of the advent of rap.

6. "To Sir With Love" was made by Columbia Pictures (British) in 1967—written, produced, and directed by James Clavell, and based on the novel by E. R. Braithwaite.

7. In "The Theory of Infantile Citizenship," Lauren Berlant argues that pilgrimage-to-Washington narratives (*Mr. Smith,* Lisa Simpson) are about "the activity of national pedagogy, the production of national culture, and the constitution of competent citizens"; and she argues too that the acquisition of knowledge by the (infantile) citizen is experienced as a crisis, a crisis "relieved not by modes of sustained criticism, but by amnesia and unconsciousness."

8. I find persuasive Barbara Ehrenreich's claim that the middle class *always* feels itself to be in decline—that that feeling is constitutive of middle-class ex-

perience (15). It is also true, though, as Phillips' book suggests, that the middle class of the early 1990s has suffered a serious economic decline. We are trying to cope with this historically specific decline by reaching for many of the time-honored middle-class tropes Ehrenreich describes, especially the tropes of softness and discipline.

9. One example of the latter work is Jan Dizard's excellent essay on teaching social stratification to Amherst College students, in which he argues that the stressful workload and environment at colleges like Amherst have the function of producing the illusion of meritocracy for elites whose status and power are pretty much determined in advance.

10. The closest thing I can find to such a theory is Gregory Jay's work on pedagogy in *America the Scrivener,* which attempts to bring Lacanian insights about learning and the unconscious into relation to the politics of location (chap. 9).

11. My thanks to Lauren Berlant for drawing my attention to this program.

12. The same issue of *Rolling Stone* that put Natalie Merchant on its cover ran an article called "Greatly Reduced Expectations," which argued that "the value of the [college] diploma—once a general-admission ticket to the economy—is dropping with each quarter and each crop of grads, leaving a lot of people standing at the door, unable to get in" (Sullivan, 29).

WORKS CITED

ABC News *Nightline* No. 3059. 1993. "Social Security: Budget Deficit Scapegoat?" *Journal Graphics,* February 11.

Berke, Richard L. 1993. "Inside White House: Long Days, Late Nights," *New York Times,* March 21, pp. A1, A24.

Berlant, Lauren. "The Theory of Infantile Citizenship." *Public Culture,* 5:3 (Spring 1993), pp. 395–410.

Dizard, Jan. 1991. "Achieving Place: Teaching Social Stratification to Tomorrow's Elite," in *Teaching What We Do: Essays by Amherst College Faculty.* Amherst, MA: Amherst College Press, pp. 145–62.

Donahue, Phil. 1992. *Live from Nashville, Presidential Front-Runners Clinton and Gore. Journal Graphics,* October 6.

Ehrenreich, Barbara. 1990. *Fear of Falling: The Inner Life of the Middle Class.* New York: Harper Perennial.

Felman, Shoshana. 1981. "Psychoanalysis and Education: Teaching Terminable and Interminable," *Yale French Studies* 63, pp. 21–44.

France, Kim. 1993. "10,000 Maniacs Grapple With the Pleasures and Perils of Success in the Real World," *Rolling Stone,* 652, March 18, pp. 36–49.

Goodman, Walter. 1993. "In the Inaugural of Inclusion, All the Arts Are In," *New York Times,* January 21, p. C20.

Grossberg, Lawrence. 1986. "Teaching the Popular," in *Theory in the Classroom,* ed. Cary Nelson. Urbana and Chicago: University of Illinois Press, pp. 177–200.

Isaak, Sharon. 1993. "Flashes," *Entertainment Weekly,* 158, February 19, p. 14.

Jay, Gregory S. 1990. *America the Scrivener: Deconstruction and the Subject of Literary History*. Ithaca and London: Cornell University Press.

Kobel, Peter. 1993. "A Soulful Asylum," *Entertainment Weekly*, 172, May 28, p. 63.

Light, Alan. 1992. "Rock the Vote's New Campaign," *Rolling Stone*, March 19, pp. 17, 24.

McKelvey, Tara. 1993. "Lulu: The Grunge Years," *Entertainment Weekly* 171, May 21, p. 49.

National Endowment for the Humanities. 1992. *Telling the Truth: A Report on the State of the Humanities in Higher Education*. Lynne V. Cheney, Chairman. September.

Nussbaum, Martha. 1992. "The Softness of Reason: A Classical Case for Gay Studies," *New Republic*, July 13 and 20, pp. 26–35.

Phillips, Kevin. 1993. *Boiling Point: Democrats, Republicans, and the Decline of Middle-Class Prosperity*. New York: Random House.

Rosenbaum, David E. 1993. "Clinton's Bright Ideas Get to Meet the Ugly Facts," *New York Times*, January 10, Section 4, pp. 1, 5.

Shumway, David R. 1989. "Reading Rock 'n' Roll in the Classroom: A Critical Pedagogy," in *Critical Pedagogy, the State, and Cultural Struggle*, eds. Henry A. Giroux and Peter McLaren. Albany: State University of New York Press, pp. 222–235.

Simpson, Janice C. 1992. "Rock Vote," *Time*, June 15, pp. 66–7.

Sullivan, Robert E., Jr. 1993. "Greatly Reduced Expectations," *Rolling Stone*, 652, March 18, pp. 29–32.

"Talk of the Town." 1993. *New Yorker*. February 1, pp. 31–2.

They're Taking Over!
and Other Myths about
Race on Campus

Troy Duster

The University of California at Berkeley has been my permanent academic home since 1969, when I was appointed to the tenured faculty in the Department of Sociology. At the time, I was one of only six blacks on a faculty of 1,350, and the most junior. In those early years, it was not uncommon for students, white and black, to come to my office, look dead at me, and ask: "Is Professor Duster here?"

The question, which turned me into a living Invisible Man, reflected the depth of racial problems in U.S. higher education, even at its most progressive university. Years of fury and tumult followed. And for over two decades now, I have been thinking about race and higher education— both as my area of professional study, and because of the realities that have shaped my personal life here. A few months ago, I went to the retirement party of one of my original black colleagues, who caught me off guard by saying that I was now the senior African-American on the faculty. From this vantage point, I have a story to tell about the remarkable transformation of Berkeley's undergraduate student population. Because Berkeley, once again, is at the center of a raging national controversy—this time over the issue of "multiculturalism" and what its enemies call "political correctness"—a term that I believe to be, at bottom, about the shifting sands of racial privilege. It is also about the future of American education: what happens in Berkeley, one of the nation's largest public universities and the bellwether of social change and innovation in academe, will affect all of us.

In January 1989, Berkeley's chancellor commissioned me and the Institute for the Study of Social Change to prepare a report on multiculturalism on campus. Our research team intensively interviewed hundreds of students over an eighteen-month period—first in single-ethnic groups with an interviewer of the same background, then in mixed groups. We asked them what kind of environment they had hoped to find upon arriving on campus, and what they actually encountered. Who were their friends, where and how powerfully were racial tensions felt, what did they think of other ethnic groups, of affirmative action? We asked them about their frustrations and their positive experiences around racial and ethnic issues, and what they would do to change things. We developed a rich and complicated portrait of campus culture at Berkeley, drawn directly from the students who make it up. It isn't an easy picture to draw, nor to compress into a headline. And it certainly isn't the side of the story that ideologues like Dinesh D'Souza and his imitators have focused on. What the study, and my own experience, tell me is that multiculturalism's critics are selling students short by propagating five key myths.

Myth 1. Terrible "Tribalism"

Multiculturalism is tearing the campus apart.

Self-segregation. Balkanization. School days claustrophobically lived out in ethnic enclaves. That's how Berkeley and other campuses are often portrayed these days, as intellectual and cultural disaster zones wracked by racial conflict.

Very rarely is there any mention of the forces that push students into familiar groups. Long before there were African-American theme houses, even before the Second World War, on-campus Catholic and Jewish societies helped those "minority" students survive; the Hillel and Newman Foundations supported students navigating through hostile WASP territory. Today, I almost never read that this phenomenon might also benefit African-American or Latino students. As many students told us, those who otherwise would feel alienated on a supercompetitive campus are getting together and finding support, creating a common comfort zone, making it easier to succeed.

In 1968, the Berkeley campus was primarily white. The student body was 2.8 percent black, 1.3 percent Chicano/Latino, and the massive Asian immigration of the 1970s had yet to occur. Only twenty-three years later, half the Berkeley student body is made up of people of color. Inevitably, with such a dramatic social transformation, there is tension and sometimes even open conflict over resources, turf, and "ownership" of the place.

Back in the 1950s, students turned the campus radio station either on or off. In the late 1980s, different ethnic groups fought over what kind of music it should play during prime time: salsa, rap, country, or heavy metal? (This same issue surfaced during the Gulf War, when Latino troops demanded more salsa on Armed Forces Radio.)

Conflict is expected, perhaps even healthy, in a social situation where people have different interests and compete for scarce resources. Few of California's "feeder" high schools are racially integrated, so it is not surprising that students experience shock and tension when they arrive at their first experience of multiculturalism. But it may be a more realistic preparation for life's later turns.

Berkeley, of course, is no more a racial Utopia than any other place in this divided and racially wounded country. Nonetheless, what strikes this sociologist as remarkable is how well and relatively peaceably it works.

Myth 2. Diversity Means Dumber

Multiculturalism is diluting our standards.

Nowadays we hear that the academy is in deep trouble because multicultural admissions policies let in students who are less capable. Actually, by measures the critics themselves tend to use, SAT scores and grade point averages, the typical Berkeley student is now far more competent, far more eligible, far more prepared than when this was an all-white university in 1950. Of the more than 21,300 students who applied in 1989, 5,800 had straight-A averages—and all were competing for only 3,500 spots in the freshman class.

As recently as 1980, only 8,000 students in *total* applied to Berkeley. In 1988, about 7,500 Asians alone applied. Such demographic facts cannot help but heighten racial awareness on campus. Many more thousands of students wanting the relatively scarce Berkeley diploma create increasingly ferocious competition at the same-sized admissions gate.

Back in the 1960s, when the campus was mainly white, almost every eligible student who applied to Berkeley was admitted. So, in a framework of plenty, people could afford to be gracious, and say that civil rights, even affirmative action, were good ideas. When the United States changed its immigration laws in the 1970s, well-qualified candidates with families from China, Hong Kong, and Korea swelled the pool of applicants. Suddenly, not everyone who was eligible could get in. Today, Berkeley is thirty percent Asian, and that means that white students who are not getting in are feeling the crunch from the "top" (students with higher GPAs and SATs) and from the "bottom" (students admitted through music, athletic ability, affirmative action, and other eligibility allowances). The

media, so far, have chosen to emphasize the beleaguered white student who has to adjust to affirmative action. Isn't it a shame, stories imply, that these students are feeling uncomfortable in an environment that used to be *their* university?

It isn't theirs anymore. Since the demographics of this state are changing at a rapidly accelerating rate—by the year 2000, whites will account for only fifty-two percent of California's population—shouldn't the university population and curriculum reflect more of this new reality? Meanwhile, the quality of student at Berkeley is only getting better.

Myth 3. Affirmative is Negative

Getting rid of affirmative action and other special admissions programs would improve the university.

In the 1960s, there was so little diversity on campus that white students experienced other cultures voluntarily, on their own terms, like choosing ethnic cuisine on the night you're in the mood for it. Now there is no way to avoid it, and that leads to the big question on campus: *Why are you here?* Some white students have told us in their interviews how unfair they think a policy is that permits students with lower GPAs and SATs to be here.

Black and Chicano students know the rap. What they never hear, even from university officials, is strong morally, historically, and politically informed language that justifies affirmative action. Most of the black and Chicano students we interviewed were themselves unclear on why affirmative action exists.

It exists because, over the past two hundred years, blacks and Latinos have had a difficult time entering higher education, and the legacy has not gone away. The median family income of white Berkeley students is approximately 70,000 dollars a year, and for blacks it is 38,000 dollars a year. The gap is not closing; the economic barriers that restrict minority access to college are not disappearing.

But Americans' cultural memory lasts about five years, so the idea that affirmative action exists to redress past grievances doesn't resonate with today's students—of all colors. The notion that black people have a past of slavery and discrimination, that this is a fact of American history, is buried so deep in the consciousness of most students that it doesn't surface. The right wing says that if you bring that fact to the fore and teach it, that's called Oppression Studies, or "political correctness," and by telling people of color they should feel good about themselves, you're making white people feel bad about themselves.

There is a different way to argue for affirmative action, which hits home even with historical amnesiacs. That is to remind students that the future will reward those who master the art of coming together across ethnic, cultural, and racial lines. Suddenly, affirmative-action admissions are not a debt payment that lets in students who "don't deserve to be here," but rather a way of enriching the student culture—and career hopes. Just ask Xerox or other corporations that promote executives who have proved their ability to "manage diversity."

A lot of white students are already intuitively on board. When we asked graduating students what they regretted about their time on campus, many told us, in effect, "I wish I had spent more time availing myself of the potential of Berkeley's diversity." The smartest among them also see that, in a globalized economy, Berkeley's multiculturalism can make them better leaders.

Myth 4. Good Old "Meritocracy"

GPT + SAT = MIT

I've already said that using critics' own yardsticks, GPAs and SATs, Berkeley's student body is more qualified than ever. To those who, in the interest of "preserving meritocracy," would admit every student solely on GPA and SAT, I say: get real. There are over twelve hundred high schools in California. To assume a 3.7 means the same in each is nonsensical. Even within the same school, one 3.7 student may have taken advanced elective physics and chemistry, while another 3.7 was piled up via Mickey Mouse courses. And yet by laying such emphasis on GPA, we've encouraged students to convert a bureaucratic convenience into a moral right.

What we know about SAT scores is that they correlate almost perfectly with zip code and economic status. It is no secret that expensive cram courses can boost your score hundreds of points. Obviously there should be other routes into the university. And in allowing them, Berkeley reflects the historical norm, not some new "politically correct" departure.

Before 1955, GPA and SAT were not used as the sole basis for admissions. Elite universities like Yale and Princeton have regularly tinkered with their entrance criteria in order to bring in students from different parts of the country. And such institutions have a different kind of affirmative action for one group: children of alumni who, in 1988, entered Harvard in greater numbers than did those admitted via affirmative action.

Yet the only time we scream "Unfair!" as a nation is when the beneficiaries are people of color. We never screamed when it came to privilege for people of privilege. Arguments for "meritocracy" are usually made on behalf of privilege, one more time.

Myth 5. Fire-Breathing Faculty

Radical professors are setting the campus political agenda.

Late in the 1950s, U.S. universities exploded in size, and new faculty arrived in droves. Thirty years later, they are in their sixties and still around. They have not changed, but their students sure have. And that inevitably creates another source of tension on campus.

Today at multicultural Berkeley, 88.6 percent of the professors are white, and 83.9 percent are men. Given its 1960s reputation, the faculty should be a hotbed of radicalism, but by any criterion, finding a leftist on the Berkeley faculty is like searching for a needle in a haystack. In a sociology department of thirty members, there is only one self-described Marxist. The Political Science department is profoundly conservative. Berkeley reflects the findings of a recent poll of 35,478 professors at 392 institutions nationwide, conducted by the Higher Education Research Institute at UCLA: only 4.9 percent of all college instructors rate themselves "far left," while the vast majority, 94.8 percent, call themselves "liberal" (36.8 percent), "moderate" (40.2 percent), or "conservative" (7.8 percent).

Some of my colleagues, left and right, have a knee-jerk ideological position on the topics discussed here, and a few are heavy-handed in their "political correctness." Also, there have always been many eighteen-to-twenty-year-olds who are strident and angrily simplistic in their rhetoric. But it insults those who are agitating for change on campus simply to say they have been programmed with PC ideas by a cadre of leftist academics.

Beyond the Myths—A Reality Check

Berkeley students have a chance that students at the far more white University of California at Santa Barbara don't have—they're rubbing up against difference all the time. Many of them told us they came here specifically for that reason, though some graduated with stereotypes intact or with disappointment that they weren't leaving with a better sense of other cultures. How can we make diversity a constructive experience? We asked Berkeley's students, and they told us.

First they gave us the "don'ts." Don't, they said, try to fix things by putting us through three-hour sensitivity sessions designed to raise our consciousness about gender, or racial issues, or homophobia. Those are too contrived and short-lived to make much of a difference.

And don't force matters by asking different cultures to party together. Black students told us whites are too busy drinking to want to dance up a storm. White students said Chicanos and blacks would rather be raucous than sociable. The perfectly integrated, all-university "We Are the World"

dance party is a bad idea, all sides told us, mainly because we don't all like the same music.

What, then, did Berkeley's diversity seekers remember as their most positive experiences when they reflected on their four years here? Again and again, they would describe the time when an instructor had the class break into groups and work on joint projects. Engaged in a collective enterprise, they learned about other students' ways of thinking and problem-solving, and sometimes they found friendships forming across the ethnic divide.

A more cooperative approach to learning, then, would breathe some fresh air into the sometimes tense ethnic atmosphere on Berkeley's campus. And a clear explanation and endorsement of the merits of affirmative action by the school administration, something on paper that every student would receive, read, and perhaps debate, would counteract the tension that grows in the present silence. These are two concrete recommendations our report makes.

But Berkeley is not a sealed laboratory, and students don't arrive here as *tabulae rasae.* They bring their own experiences and expectations; some are angry about injustices they've felt firsthand, while some are blithely unaware of what social injustice means for their own lives and for the culture as a whole.

What our hundreds of interviews showed is that there is a sharp difference between the ways black and white students feel about racial politics; Asians and Chicanos fall somewhere in between. White students tend to arrive with an almost naive goodwill, as if they are saying, "I think I'll just go and have some diversity," while music from *Peter and the Wolf* plays in the background. They expect to experience the "other" without conflict, without tension, without anything resembling bitterness or hostility. Meanwhile, many blacks arrive after being told in high school that Berkeley is a tough place, an alien environment, and that in order to survive, they should stick with other black people.

Imagine, then, what happens in the first few weeks of the first semester. White students looking for diversity run into black students already sure that race is political, so pick your friends carefully. White students seeking easy access to a black group can quickly find their hands slapped. They might say something offensive without knowing it, and get called "racist," a word they use to mean prejudging a person because he or she is black. *Why do you call me racist? Hey, I'm willing to talk to you like an ordinary person!*

But when black students use the term, they tend to aim it at a person they see participating in a larger institution that works against black people. *If you're not in favor of affirmative action, that means you're racist.*

The white student retorts: *I'm willing to have dinner with you, talk with you about ideas, I'm not prejudiced.* But the two are talking past each other, the white student describing a style of interaction and friendship, the black student talking about the set of views the white student appears to hold.

It is misunderstandings such as these, arising in an atmosphere of fierce competition, in a setting of remarkable ethnic and racial diversity, that lead some critics to jump gleefully to the conclusion that diversity is not working. But there is another, more hopeful interpretation. Berkeley's students are grappling with one of the most difficult situations in the world: ethnic and racial turf. They are doing this, however modestly, over relatively safe issues such as what kind of music gets played or who sits where in the lunchroom. Perhaps they will learn how to handle conflict, how to divvy up scarce resources, how to adjust, fight, retreat, compromise, and ultimately get along in a future that will no longer be dominated by a single group spouting its own values as the ideal homogenized reality for everyone else. If our students learn even a small bit of this, they will be far better prepared than students tucked safely away in anachronistic single-culture enclaves. And what they learn may make a difference not just for their personal future, but for a world struggling with issues of nationalism, race, and ethnicity.

No Special Rights

Michael Warner

This semester, in a course called "Introduction to Lesbian and Gay Studies," I assigned some Shakespeare sonnets. Most of the students in the class are English majors, and had in fact studied the same sonnets both in high school and in other English classes. Yet they did not know the most elementary fact about the sonnets I assigned: that they are addressed to a man. I don't say that the students hadn't been taught much about the theory or history of sexuality and eroticism. They hadn't, but that wasn't surprising. What surprised even me was that they had actively studied Shakespeare's sonnets and had been kept ignorant about the simplest description of their literal meaning. These students have had Shakespeare mandated by the curriculum, but they had never been allowed to recognize—let alone reflect upon—the speaker's relation to the addressee. In the past years we have heard many expressions of shock over students' ignorance; why do the examples never look like this?

Here's another example. Harold Bloom, in *The American Religion,* writes that "Our father Walt Whitman, despite his self-advertisements and the dogmatic insistences of our contemporary gays, seems to have embraced only himself." Since "our contemporary gays" have written many books providing evidence and arguments about Whitman and sexuality, and since Bloom provides neither evidence nor arguments for saying that Whitman "seems to have embraced only himself," how exactly is his claim superior to their "dogmatic insistences"?

Nothing is easier than to compile such examples, in which ignorance—even about the literal meaning of some of the most canonical texts and histories in the Western tradition—has been treated not as deplorable, but as desirable by many of the same people who claim to be the guardians of that tradition. For this reason, many of the terms in the debate about our alleged crisis are misleading. I notice in the NAS statement of purpose,

284

for example, that a threat has been perceived against "Western values and institutions." Many people before me have pointed out that Western values and institutions are conflicted, not monolithic, and that the forces of evil (in the NAS scenario) in fact speak a language of value that derives from the Enlightenment. But for gay men, and perhaps even more for lesbians, one of the greatest political obstacles in this culture is a general will to ignorance. In the academy that means a will to ignorance about what are very often canonical matters—ignorance enforced by the very people who claim to be defending knowledge and Western values.

What, for example, is passing for military history these days at West Point? The best and brightest at the Pentagon seem never to have heard of Alexander the Great, let alone the sacred band of Thebes. And the journalists and pundits who have mediated the gays-in-the-military issue seem never to have read the *Symposium*. I tell you, the Western tradition is going to hell in a handbag.

Lesbian and gay politics in general is a special challenge to education, because homophobia may be more directly constituted by enforced ignorance than any other sociopolitical problem. Because being queer necessarily involves and is defined by a drama of acknowledgment, a theater of knowledge and publicization, the institutions that transmit and certify knowledge take on special importance. No other issue is comparable; conservatives disapprove of adultery, for example, but they don't argue for a policy that simply encourages adulterers to dissemble. One consequence of this fundamental difference between queer politics and other social issues is that education and knowledge become danger zones. Women have been teachers since Catharine Beecher's time; teaching has even been a kind of ghetto for them; African-American male leaders from Douglass to Washington to Du Bois were involved in teaching. But few things make people more fearful than the simple thought of a gay teacher. Many studies have shown that even people who support gay rights do not want out gay teachers.

Ignorance of military history at West Point does not just mean that the national elite is badly educated. Even most of our homophobic legislators have now been forced to admit that gays and lesbians are in the military, that there is no way to keep them out, that the hundreds of millions of dollars spent purging them are a waste. The issue is not whether lesbians and gays should be in the military; they are there. The issue, explicitly recognized in the 1993 Senate hearings, is simply the enforceability of the closet. When the generals complain on *Nightline* about having to shower with gay men, they continue to pretend that they have not been showering with gay men all their lives. (Barney Frank put this well: "We don't have ourselves dry cleaned," he said. "We've been taking show-

ers for a long time.") What they seem to fear is simply the acknowledged presence of gays and lesbians. One female witness told the panel, "If I had to room with a lesbian who was openly lesbian, I wouldn't have any place to unwind." The remark is typical of the testimony. It all but frankly avows phobic reaction: I can't unwind. And it traces that reaction to nothing more than knowledge; she worries not just about a lesbian, but a lesbian who is openly lesbian. We are witnessing, now, the high comedy of generals and senators debating, in the phobic agora of C-SPAN, the difference between saying you're gay because you were asked and saying you're gay on your own initiative. It has been seriously, expertly proposed that national policy should make it OK for soldiers to say they're gay if they're asked, but grounds for discharge if they volunteer it.

That discussion at such high levels can be so ridiculous tells us something about the nature of the closet and the unimaginably great collusion necessary to keep it in place. The military and the Senate are now showing that they will defend their own ignorance above all. The activity of closeting is what they care about most. Really, the closet is in many ways an unfortunate spatial metaphor. It suggests that queer persons have gone into a segregated zone of secrecy, that everything else is living space and outdoors. But of course no one goes into a closet. You might have to come out of one, but its construction was the act of those who live out in the den and the yard. Your stigma does not result from your poor self-esteem. It is a heritage of knowledge and shame, supported by virtually every institution of cultural transmission. It is more house than closet.

I stress this broad cultural commitment to ignorance partly because it shows why higher education should concern itself with issues of gay and lesbian identity, and partly because the cultural nature of the closet has surfaced in newly explicit ways in a number of recent political contests: in the military issue; in battles over antigay ballot initiatives in Oregon and Colorado; in the controversies over school curricula in California and New York; and in flaps about St. Patrick's Day parades in several cities, and a flap about a New York parade honoring Israel. All of these controversies have in common a core issue of acknowledgment. In both the Irish and the Israeli parades, homophobic leaders proposed, not that lesbians and gays be kept out of the march, but that they not be allowed their own banners. In the fight over the Children of the Rainbow curriculum in New York, even H. Carl McCall, the school board's president and probably its most progressive member, was quoted as saying, "I personally am disturbed by the section of the curriculum that calls for teachers to introduce proactively the topic of homosexuality." The emphasis is on "proactively,"

since the educational system, like so much else in the culture, has been devoted to preserving ignorance.

In Colorado and Oregon, ballot initiatives were launched last year to invalidate any local gay rights laws. The Colorado initiative succeeded, and is now being used as a model for upcoming elections in several other states, including Illinois. The Oregon measure would have precluded the teaching of any material portraying homosexuality in a positive light. Presumably that would have to include the writings of Plato, Shakespeare, Whitman, Stein, Proust, and Rich. In both states, the slogan of the far right has been "No special rights." Like the other political disputes I've mentioned, this one revolves largely around the fear of specifying gays and lesbians. The leaders of the ballot initiatives seem not to have noticed that the phrase "special rights" is oxymoronic, and that special rights therefore could not possibly be really at issue. But the slogan plays well with voters, and goes unchallenged in the media, despite the illogic. Lon Mabon, Phyllis Schlafly, and other pioneers of this rhetoric have only feebly attempted to say what's special about rights to housing, employment, and privacy. They will say rather that the issue is, say, a right to sodomy, which supposedly only queers want. They have launched a naming game in which the conflict reduces to a contest between universal and specific ways of describing the same freedoms, and in which any activity that might be protected as a general right is treated as the defining trait of a special population, and therefore a special right.

"No special rights" is also a sucker ploy. If gay activists respond by pointing out that special rights are not really at issue, they get trapped in a mainstreaming rhetoric. We're not really all that different from you. We just want what you want. Please let us be like you. If, on the other hand, they reject the fiction of mainstream value, and insist on their own legitimacy, they are called special interests, a lobby, advocates of parochialism, or worse.

HRCF (the Human Rights Campaign Fund, the largest lesbian and gay PAC) recently completed the first half of a focus-group study designed to figure out how to pursue a program of rights in the face of antigay organizing by the right. It is apparently an expensive study, though the HRCF will not say just how expensive. And it turns up some interesting information. Besides telling us, for example, that lesbian spokespersons are much more acceptable in the public eye than gay male spokespersons, the study reports that many people who respond negatively to what is called "lesbian and gay rights" nevertheless respond positively when asked about "civil rights for lesbians and gays." Gay rights, for these focus groups, means special rights—rights affecting only gays. According to the study, the focus groups did not think that lesbians and gays lack the

enjoyment of any rights at all. But when asked about any civil rights—protection from violence, access to housing and employment, benefits for partners, and so on—they reacted with much more sympathy and support.

(I might add that the study also shows a problem with the idea of gay marriage. Many of the same people who support domestic partnership legislation—particularly straight women—balk when the same legislation is called "gay marriage." "Apparently," says the study, "the word marriage has a special meaning for them.")

The upshot of the focus-group study is that the HRCF is committing itself to a mainstreaming rhetoric. I think it is a mistake. Mainstreaming rhetoric turns out to resemble the closet, especially for those gays and lesbians who don't fit the mold of proper, "normal," monogamous coupling. It allows most people not to think about queers. It allows them not to think critically about themselves. And it allows them to remain ignorant of what the conservatives so fondly call the Western tradition.

I have to say, however, that the usual alternative of multiculturalism is not much better. The multiculturalist affirmation of specialness or difference does oppose mainstreaming rhetoric and the closet. But it carries no moral force by itself. The strong version of this argument has been imagined by Charles Taylor, who writes in *The Ethics of Authenticity* that "a rhetoric of 'difference,' of 'diversity' (even 'multiculturalism'), is central to the contemporary culture"; and that "this discourse slides towards an affirmation of choice itself":

> But this implicitly denies the existence of a pre-existing horizon of significance, whereby some things are worthwhile and others less so, and still others not at all, quite anterior to choice. But then the choice of sexual orientation loses any special significance. It is on a level with any other preferences, like that for taller or shorter sexual partners, or blonds or brunettes.... Once sexual orientation comes to be assimilated to these, which is what happens when one makes choice the crucial justifying reason, the original goal, which was to assert the equal value of this orientation, is subtly frustrated. Difference so asserted becomes insignificant.[1]

Taylor's main point here is that the rhetoric of difference and diversity weakens its own motivating ideals by concealing them. Choice itself is empty; not evil, of course, just insignificant. So also, one might add, is the unchosenness of sexuality, when affirmed without what Taylor calls "a horizon of significance."

Now, although I think Taylor makes a mistake when he says that the goal is to assert the "equal value of this orientation"—a notion that allows heterosexuality to be a standard, an unchallenged ideal, and a po-

sition freed from any comparable burden of demonstration—I think he is right to point out that difference is not desirable for its own sake. This weakness in most multiculturalist rhetoric is subtly exploited in the no-special-rights campaigns. Those campaigns convince people that the only question is: special, or not special? And there's no winning that one.

Thus I think the phobic rhetoric of the Oregon/Colorado religious right shares key assumptions with what I would call corporate multiculturalism—a pluralist affirmation of cultures, where cultures are conceived on a racial or ethnic model.[2] The tendency to imagine the challenge to education as simply a task of pluralizing cultures has not only falsified the nature of queer culture, it has also weakened our moral and political language for what we are doing. The most frequently heard rationales for multiculturalist curricula take as their terms of value such empty formalisms as subversion, inclusion, empowerment, self-representation, and difference. I have nothing against any of these things necessarily, but each is now widely taken to be valuable in itself—as though we want subversion regardless of what is subverted by what; as though inclusion and democracy are the same, and no bounded group has a right to exist; as though empowerment is to be encouraged regardless of who is empowered to do what; as though self-representation is an end and no one ever represents him- or herself in damaging ways that could legitimately be criticized by others; as though the difference between oppression and freedom could ever be reduced to the difference between speaking for others and speaking for oneself.

Of course most critics who are called multiculturalists also speak stronger moral languages; my point is that the false opposition between liberal Western tradition and postmodern multiculturalism encourages a rhetoric that cannot acknowledge its own motivating ideals. I do not think that these problems cripple or invalidate identity politics or more critical versions of multiculturalism. I mean only to point out that they share some premises with "no special rights."

Taylor is right to argue, in "The Politics of Recognition," that affirmations of difference can have moral force when connected to assertions of dignity that require not just individual self-esteem but cultural conditions of identity and its recognition. Thus I think queer activists should avoid equally the mainstreaming rhetoric now promoted by HRCF—pushing for rights that are in no way special—and the empty affirmation of difference that pretends to be its alternative. Instead we should develop a moral language in which the queerest elements of our lives and communities can be grasped as sites of value, culture, and right not yet approximated by official heterosexual culture and its condescending "tolerance."

In many ways the dilemmas I'm describing are common to other social movements, even intertwined with them. In Oregon, for example, "no special rights" seems to have expressed widespread resentment about eroding economic and political power, just as much as it expressed homophobia. It resonated with distrust of environmental activism and of affirmative action. Like the backlash against affirmative action, "no special rights" refuses to recognize that liberal proceduralism fails to solve systemic social inequality. The antigay ballot initiatives and the backlash against affirmative action have therefore become occasions for voicing both allegiance to and resentment against the failed utopian project of the welfare state. Allegiance, because it renews the promise of liberal rights; why else would you denounce special rights? Resentment, because special rights reminds people of the special interests, needs, and lobbies that distract the state from plain folk, as they see themselves.

At the same time, however, "no special rights" has a source of appeal beyond the backlash against affirmative action. For although both movements refuse to recognize that equality and dignity for individuals require certain cultural preconditions, in the case of queers that refusal resonates with the social structure of the closet: do not be special.

An educational project that tried to eliminate rather than institutionalize the cultural conditions called the closet would look very different from the current system of higher education. But it would not be corporate multiculturalism, either. Cornel West and others have noted that the opposition of traditional and multicultural texts is historically false, anyway. But a language of "multiculturalism" (which I gather is coming into use in South Africa to mean apartheid) is especially inappropriate for queer knowledge. It imagines a plurality of culturalisms, and typically predicates a racial or ethnic model. Lesbians and gays have a different relation to the bounding and reproduction of what is called lesbian and gay culture.

Corporate multiculturalist rhetoric succeeds in part for institutional reasons: it is especially well suited to the environment of the university, in which irreconcilable demands are dealt with by giving every constituency its own course or, if necessary, program. At Rutgers, "Introduction to Lesbian and Gay Studies" satisfies a requirement for multicultural courses. (The course in which my students learned the closet version of Shakespeare's sonnets did not.) Of course, the nature of the closet is such that the very people most in need of closet-free culture are those who will necessarily not be enrolled in "Introduction to Lesbian and Gay Studies."

An even more pernicious logic prevents antihomophobic education at the primary level. For there the only interests recognized as legitimate are those of parents. In the fight against the Rainbow Curriculum in New York, antigay activists used all the new techniques of the religious right:

church organizations, stealth candidates, coordinated call-ins to talk shows, slickly scandalous videotapes. But they were treated by officials and media alike only as concerned parents. As Donna Minkowitz pointed out, proponents of the curriculum were called "activists." Never mind that some lesbians and gays are parents. Never mind that those who are not parents have an equal if not greater stake in educational policy, as they are the ones likely to be harmed by the ignorance produced by any institution in which they do not participate. Should we not worry that the rhetoric of crisis in higher education, combined with the current tuition spiral, will have the effect of endowing parents with a privileged interest in higher education as well? A welfare-state crisis leads schools to treat students as clients. But several developments, notably Bush's proposal for privatizing federal school funding through a voucher system, show that one of the most direct results of the weakened public hold on education is the elimination of groups deemed unacceptable when parents are thought to be the only people interested in education. Even the AAUP public service announcement against the Oregon measure, an announcement played at the conference on which this book is based and discussed in Linda Pratt's paper, opposes the antigay family values movement by appealing to parents. Do nonparents have any less stake in education?

At the end of Richard Meeker's 1933 novel, *Better Angel,* one of the first explicitly gay novels published in the U.S., the main character becomes a teacher. Just where the marriage plot would normally kick in for a conventional novel, the climax of this one turns out to be an elemental scene of generational transmission; the hero is talking to his best student in his rooms as night falls, when he suddenly imagines the inadequacy of any available pedagogy:

> In a strong dark flood the sense of the destiny of this boy swept over him, the destiny of all such boys everywhere—their heritage of desire and shame, of uncertainty, of deception, of hypocrisy and of tumultuous joy and burning regret, of friends without friendship, of concealing the truth and revealing the lie, and ultimately—what? Would such a one be better off never to know, never to recognize his inversion for what it was—but to live lonely and apart in an incomprehensible and unfriendly world? No. No. Whatever happened ultimately, whatever advancing years might bring, knowledge was necessary.[3]

But what knowledge? And how many people would have to have it? I take these to be real questions. The narrator imagines that the boy will need knowledge of others like himself, self-knowledge and, what comes to the same thing, cultural knowledge; these are minimum requirements for dignity. The boy recognizes all three needs in the same scene when

he gives his teacher a gift: a replica of Donatello's "David." But the same passage also implies that the boy will need these knowledges because he receives "a heritage of desire and shame." His dignity depends not just on his knowledge, or even on the mutual knowledge of others like him, but on a different heritage, a different environment of acknowledgment, different conditions of publicness. Donna Minkowitz has made a similar point about the Rainbow Curriculum; citing the Department of Health and Human Services study, according to which thirty percent of teenage suicides are gay or lesbian, Minkowitz writes: "The status quo—teaching kids nothing about homosexual literature, history, and families—is what kills them."[4]

NOTES

1. *The Ethics of Authenticity* (Cambridge: Harvard University Press, 1993), pp. 37–38.

2. The phrase is explained in an essay I coauthored with other members of the Chicago Cultural Studies Group, published as "Critical Multiculturalism," *Critical Inquiry* 18.3 (Spring 1992), pp. 530–55.

3. Richard Meeker, *Better Angel* (Boston: Alyson Publications, 1990), p. 274.

4. "Rainbowphobia!" *Village Voice,* December 29, 1992, p. 16.

The Rhetoric of Crisis in Higher Education

Joan W. Scott

> The rhetoric of crisis states its own truth in the mode of error. It is itself radically blind to the light it emits.
> **Paul de Man, *Blindness and Insight* (1983)**

The rhetoric of "crisis in higher education" has figured its meaning in terms of warring oppositions. We have learned to understand the current malaise in terms of "culture wars" and "canon wars" that feature campus radicals versus conservative publicists, proponents of multiculturalism versus defenders of tradition, scholars who insist on the political construction of all knowledge versus those who would preserve the purity and beauty of a necessarily nonpolitical, because objective, truth. Or the crisis is described as a fierce clash of basic values between those who define campuses as communities based on shared consensus and those who define campuses as places where individuals exercise their inviolate rights to speech, however hateful; or between those who conceive of classrooms as sacred sites for the purveying of truth and those who treat classrooms as places where so-called "politically correct" attitudes are instilled. The crisis is also portrayed as the destruction of a citadel—once a haven in a heartless world—by the war between the sexes. Date rape and sexual harassment were cited recently in a *New York Times Magazine* article (March 7, 1993) as the major components of a new campus crime wave, eclipsing the class-based thefts and muggings that have long been the bane of all but the most insulated campuses. Finally, there is the reign of terror attributed to the financial crisis, the agents of which are administrators and government officials exacting ever deeper cuts from already lean operations with no end in

sight—even, or perhaps even more, now that there is a new President in the White House.

These images of war and ravishment carry with them a diagnosis and an implied cure. If we could defeat the enemy—whoever we take that to be—the crisis would be over, and peace or health would be restored; if the enemy triumphs, on the other hand, the university, as it was or should be, will be destroyed.

I think this is too easy a way to understand the crisis in higher education, for it misses a chance to read the rhetoric of crisis itself. It takes literally what needs to be read symptomatically, substituting advocacy for analysis at a moment when analysis is needed, not in order to avoid political engagement, but to undertake it more effectively.

In order to pursue this analysis, I think it is most useful to treat the crisis in higher education not in terms of warring opposites, but as a series of paradoxes that have produced further paradoxes: seemingly contradictory developments have elicited similar responses from apparently opposing sides. There are four such paradoxes I want to examine, concretely and in some detail. First I will list them, and then go on to discuss each in turn.

1. The more the university community has diversified, the more relentless have been the attempts to enforce community.
2. The more individualism is used by those opposed to the institutionalization of diversity, the more advocates of diversity invoke individualism.
3. The greater the need for open-ended research, reflection, and criticism in the production of new knowledge, the more instrumental the justifications for taking new directions have become.
4. The greater the need for theorizing—for the practice of questioning unquestioned assumptions and beliefs—the faster has been the turn to moralism and the therapeutics of the personal.

1. The more the university community has diversified, the more relentless have been the attempts to enforce community.

Demographic data document major changes in the gender, racial, and ethnic profiles of people teaching at and attending universities. Although the recent statistics presented in the *Chronicle of Higher Education* (March 3, 1993, pp. A31–9) show how small improvements have been for African-Americans, still there is evidence that formerly all-white, largely

male preserves have been breached not only by white women, but also by men and women of color. In addition, heightened concern about identity and the political articulation of it have given minorities visibility and clout beyond their numbers. The expectation that these new groups would quietly assimilate to existing institutional practices has been quickly dispelled by demands both for specialized courses (and a critique of what passes for the "mainstream" curriculum), and for decent treatment. As a result, multiculturalism has been inscribed on the agenda, not merely as an academic or curricular question, but as a matter of social relationships inside and outside the classroom. (Here I want to note that I include feminism in my references to multiculturalism.) None of this has happened without generating enormous conflict; indeed, multiculturalism and diversity are to the 1990s what affirmative action was to the 1970s: highly contested policies that are far less revolutionary than their critics avow.

If the demographic data and the arguments about curricular and campus life are any indication, diversity has strained to its limit the model of community based on consensus. Yet, paradoxically, the politics of life in academic communities shows, if anything, increased determination to produce community by imposing consensus. There are university administrators drawing up uniform codes of conduct and rules about hate speech based on the notion that membership in an academic community carries with it the moral obligation to subscribe to shared beliefs. There are members of the National Association of Scholars decrying social critics and reformers seeking change as "barbarians" at the gates—all those who disagree with their assessment of the university are, by definition, dangerous outsiders or, worse, subversives within. There are those, on the right and left, determined to impose totalizing regimes of truth about the necessary and unitary meanings of class, race, sex, and gender. And there are the self-appointed mediators—of every rank and status—who offer "diversity workshops" with pious lessons about our underlying human sameness in an effort to heal the wounds of difference. (These workshops, ironically, homogenize the very differences they claim to be recognizing.)

Whatever their political stripe, these groups substitute the idea of community for an analysis of social relationships. Moreover, they take community to be an essence, an organization or institution that subsumes its members to some larger project, overcoming the differences that are secondary to the shared existence which binds us together. Communities based on the presumption of the underlying human sameness of their members—whether that sameness is political, moral, cultural, religious, racial, or sexual—must resort to coercion to achieve their existence; coercion that eliminates the real expression of differences among members. The means of coercion are the same on the right and left: totalizing

moralisms, the policing of the words and actions of community members, the shaming and/or ostracism of dissenters, and the attempt to use personal guilt as a way of producing understanding of one's errors—an understanding that I would say can only come from an analysis of the relations of power that structure discriminating differentiations. The insistence that community is a solution to the problem of difference represses but does not resolve the problem. And it is this contradiction (and not the fights between right and left about whose truth will prevail) that constitutes a crisis in higher education.

This crisis is not occasioned by the loss of the organization that enshrined the communion of like-minded, similarly motivated persons, nor is it the loss of that communion itself; rather it is the inefficacy of the notion of community as communion to address and deal with the differences that at once bind and divide us. What is wanted is not communities that insist on dissolving difference, but instead some notion of community that acknowledges difference as the very condition of individual being, and thus as the only possibility for what Jean-Luc Nancy calls "being in common" (Nancy 1991). As long as that vision of community eludes us, the "crisis" will persist.

2. The more individualism is used by those opposed to the institutionalization of diversity, the more advocates of diversity invoke individualism.

During the Reagan-Bush years, the privatization of education and the attack on affirmative action took place in the name of the individual whose absolute rights transcended what Lynne Cheney called the "accidents" of class, race, and gender (Cheney 1988). This individual, abstract and disembodied, was actually initially summoned to defend white men's loss of privilege in the face of unprecedented competition for things to which they considered themselves entitled. The individual was counterposed to the group, whose members gained unfair advantage, it was claimed, by appeals to history and to "compensatory" principles like justice and equality which substituted for merit and excellence. Eventually this argument was espoused by some minority spokesmen who considered their achievement compromised by the perception that they had not earned it as individuals, but had been given it because they were members of a disadvantaged group. In a curious inversion, those who were meant to be the beneficiaries of affirmative action portrayed themselves as its victims.

But the notion of victimization was not confined to these groups or individuals complaining about affirmative action. Those who appreciated its intentions and took advantage of its opportunities also resorted increasingly to the image of the victim. Partly, this was the result of the conservative direction taken by legal discourse in the 1980s, which em-

phasized not the claims of socially marked groups, but only the rights of individuals to equal protection by the law. Under this doctrine a person had to demonstrate that he or she had suffered a specific injury in order to make a rights claim. Partly, too, it was the result of strategies improvised in the face of increasing conflict about the legitimacy of affirmative action. These strategies appealed not to historic inequity, but to personal insults experienced by individuals in order to legitimize demands for protection from the law or university officials. Personal injury became the sign of an oppressed identity and identity was then articulated as the experience of injury. The language of experience and personal suffering (intersecting with the therapeutic discourse of victimization) replaced the language of rights and history as victims demanded their due. Criticism of another intellectual or political viewpoint was taken as a personal affront or worse, an attempt to censor the free expression of another. All distinctions among injuries collapsed as those accused of insults themselves claimed to have been insulted by the accusations, and the victims proliferated dramatically. Deciding among competing claims of injury meant abandoning structural, historical, and ideological analyses—all of which attended to power—and substituting instead questions about who had suffered the greater hurt or who had the more "authentic" experience. This often boiled down to a matter of who had the louder and more threatening voice, or who could immediately provoke the greater guilt.

The stance of the victim constructs a set of relationships which depend for their dynamic and their explanatory force on personal psychology, on attitudes held by individuals. Victims know they are such because of the feelings they experience; their oppressors are defined as lacking in empathy, "ignorant," or intolerant, feelings and attitudes susceptible to modification by some form of "consciousness-raising." What follows from this is the multiplication of support groups, tolerance workshops, speak-outs, and the like, where the exposure of personal pain is both the means of identification with and of transformation of others—procedures as far from politics as I can imagine, but which are indeed the form politics increasingly takes. The agency of victims, or others' empathy with them, will hardly lead to social or structural reform, but it has produced a "crisis" for higher education, as the conflict of individual sensibilities and injured identities replaces rigorous conceptual argument in the classroom, and as well-meaning attempts to implement diversity result in the appearance of ever more victims.

This crisis is symptomatic of the exhaustion of the notion of the individual that constitutes these victims of every color on the political spectrum. That notion conceives of the individual as finally abstracted from every context, whole unto itself, with experiences and the feelings

they inspire fully transparent. Stripped of history, structural positions, and the relationships that constitute subjects, this is an individual for whom difference is an alien or victimizing concept; indeed being a victim means being treated as different from some presumed norm. The argument that differences are superficial compared to the underlying humanness of every individual, whether made by opponents of affirmative action or leaders of diversity workshops, is meant to accommodate difference to this notion of abstract individualism, but it only heightens the contradiction and compounds the sense of crisis. For the differences that multiculturalists must recognize are constitutive differences; that is, they position subjects as fundamentally and sometimes irreconcilably different. (These positions are not fixed, indeed they fluctuate according to context; they are not totalizing, though certain political practices have made them seem so; they are not enduring, but they do have a history.)

The concept of individualism that produces victims cannot accommodate our need to think of people, societies, ourselves in terms of historically specific, constitutive differences. We need a notion that neither pluralizes an abstract type-of-one, reducing us all to variations of the same, nor essentializes collective identities. It might work better (following Jean-Luc Nancy) to think of individuals as singular beings, necessarily different from one another, beings whose singularity is, in fact, constructed by their perception of unlikeness—difference from others—but for whom the relation of difference is the necessary ground of being (without it there would be no sense of the limits of the self). If the relation of difference is the ground of individual being, the articulation of differences (and here it is Foucault I turn to) is nonetheless contingent. Social differentiation, historically variable, constitutes relations of power and their accompanying interests. These relations of power appeal to, indeed claim to be, the founding difference of individual being, but they are not. To avoid the conflation of individual and collective being, and yet to hold on to difference as an analytic concept, requires making a distinction between difference as a condition of individual being and differences as constitutive of social identity. That kind of distinction might enable us to get beyond the "crisis" of which the victim is so telling a symptom.

3. The greater the need for open-ended research, reflection, and criticism in the production of new knowledge, the more instrumental justifications for taking new directions have become.

American higher education has from its inception known the tensions between research and teaching, between research with and without direct application, and between the pursuit of knowledge for its own sake or for its immediate utility. In the course of the nineteenth and twentieth cen-

turies, the marriage of business and academe—the corporate penetration of the university—has made instrumentalism the reigning ethos, albeit with gestures about the positive contributions of the (less directly useful) arts and humanities. In times of scarcity, this pragmatism becomes even more pronounced as administrators try to hold onto shares of diminishing resources. The opportunism of City University of New York Chancellor W. Ann Reynolds is thus not surprising in this connection. The *Chronicle of Higher Education* (January 6, 1993, p. A29) reported that she and other officials wanted to remind state governments about the importance of higher education for economic development ("not to mention"—the *Chronicle* adds, and I think we should take that literally—"not to mention intellectual and cultural well-being"). Reynolds, the *Chronicle* reported, "thinks much of her institution's growth will be in new and expanded programs that train people for New York's growing service and high-technology economies. That belief undergirds part of CUNY's budget request." It also undergirds the plan Reynolds has floated to consolidate the multicollege system into a single one, eliminating duplicate programs and courses (one can be sure, especially in the fine arts and humanities, including cultural, women's, and ethnic studies) in the name of greater efficiency.

Those of us in the humanities and peripheral "studies" programs have not adjusted to the fear such reasoning strikes in our hearts. And we have, over the years, developed arguments about the usefulness of "useless" (that is, critical or aesthetic or esoteric) knowledge for improving the creativity and spirit, if not the income, of our students. At their best, these arguments stress the critical function of such knowledge and the possibility for learning something new and unforeseen, for seeing differently; they warn, as well, against the dangers of a reductive instrumentalism that tailors knowledge to a narrowly specified outcome.

It might have been expected that all the defenders of diversity, all those demanding multiculturalism and new ways of learning, would be staunch allies for humanists seeking to protect the value of learning as critical inquiry. But that has not been the case. Instead, many multiculturalists, through a certain instrumentalism of their own, have often become the unwitting allies of those administrators and scientists who have little use for such "belletristic" areas of the humanities as philosophy, classics, literature, and the arts. Paradoxically, though perhaps understandably (given political processes in the academy), the appeals of many of those who justify diversity in the curriculum are as instrumental as Ann Reynolds' budget, although the language used is dramatically different. This language conceives of new knowledge in terms of "empowerment"; it is meant to affirm students by giving them knowledge that is a reflection

of themselves (usually as they already know themselves to be). "We who are not white males," writes a young, white, feminist woman, "must find the stories that represent *us,* and share them with each other." With women's history, she continues, we need no longer ask "where is *my* history?" (Lasoff 1993). "My history" contains surprise only in its wealth of anecdotal detail, otherwise it is a narrative whose appeal (comfort, empowerment) rests on its familiarity. In this kind of argument, educational motivation is seen to come only from positive and direct personal identification with what is being taught (it is even better, sometimes absolutely necessary, when the teacher is the vehicle for this identification). There is no interruption conceivable between who one is and what or how one learns; identity is the only foundation for learning. Ruled out as possible stimuli for the desire to learn are the challenge of the new and fundamentally unfamiliar, or a sense of frustration, or an inability to identify, or a purely cognitive interaction, or the sheer pleasure of acquiring mastery. Indeed these are taken to be "disempowering," because they disrupt rather than confirm the reproduction of what is, in some sense, already known.

I understand that the source of some of this argument lies in a serious and radical challenge to the idea of objectivity by standpoint epistemologists. These theorists (with whom I am in sympathy, though not total agreement) insist that all knowledge is partial, and that claims to "know it all" or to tell the whole story are ruses of the dominant, who thereby advance their story as true while suppressing the stories of others (stories which would call into question the "truth" they want to promote). The point of letting the others tell their stories is to speak another truth, to grant voice to the silenced and to disrupt the power of the "official story." But surely the point of telling those stories is also to provoke a search for insight that neither the tellers nor the hearers already have, to open different possibilities for reading and explanation, not to narrow or close them down.

"Empowerment" as an educational goal depends on transmitting received knowledge to a specified clientele. It contradicts the promise of proponents of diversity that new knowledge will benefit everyone, and it precludes the difficult search for the means of implementing that promise. Instead, the idea of empowerment implies the defense of a certain orthodoxy (not the prevailing canonical orthodoxy, to be sure, but an orthodoxy nonetheless) and gives teaching (defined as the transmission of received and self-evident truth) priority over research (defined in the humanities as speculative exploration with no immediate practical end in sight). The crisis is expressed as a fight between whose orthodoxy will get the funding it needs, but it is actually a symptom of something else: the inability of

academics to provide a rationale for, or perhaps any longer to believe in, the value of critical intellectual work—work typically associated with the humanistic disciplines. The necessary transformation of those disciplines that has accompanied the reevaluation of humanism as a philosophical ground has deprived us of arguments for research, at the very moment when we need them most. I am not urging an uncritical embrace of the old justifications; analyses of the politics of disciplines, the power of ideology, and the bankruptcy of the notion of "innocent" readings have made that impossible. I am simply pointing out that we need to rethink our justifications for research by employing the kind of critical inquiry that offers neither a presumed outcome nor a final solution.

4. The greater the need for theorizing—for the practice of questioning unquestioned assumptions and beliefs—the faster has been the turn to moralism and the therapeutics of the personal.

In the great culture wars, the right and significant factions of the left have converged on the diagnosis that "theory" is both symptom and cause of the decline of higher education. Sometimes called "French theory" (with all the distaste of Victorian references to venereal diseases as "the French pox"), sometimes labelled "deconstruction" (conflated misleadingly but deliberately with "destruction"), "theory" (with its modifiers explicit or only implied) has borne the brunt of attack. On the right, there are denunciations of the nihilism of theory, which, it is said, will leave us orphans without cultural patrimony. On the left, theory is indicted for its impracticality: it does not connect to "real life" or "lived experience" and so cannot lead directly to politics, to revolution, or at least to social reform. In the attack on "theory," right and left clear the field of all possible critiques of their foundational premises; with those intact, they can fight safely and familiarly among themselves.

On this familiar terrain is enacted the "crisis," which seems to have to do with differences between right and left about what and how things are taught. On the one hand, there is the traditional classroom, in which the great teacher imparts to his acolytes the wisdom of the Greeks; on the other hand, there is the confessional classroom, in which students construct identity by recounting their experiences. In the one, the search for truth and the extirpation of error is imposed from above, in the other, it emanates from below, but in both cases students are encouraged to discover reflections of themselves in the work they do. The instability of their quests is apparent, even acknowledged (how can the personal experience of one female student, for example, stand for the overarching experience of all women?); yet the illusion of stability is achieved by arbitrary assertion and by persistent attacks on error. "Political correctness"

is the epithet hurled in both directions in these debates, while those caught
in the middle despair of deciding among the warring factions. So much
noise must mean a crisis.

Yet it is not the cacaphony of the clash of truths that constitutes the
crisis, but its contradictory relationship to the concerted refusal of "the-
ory." Like the attempt to enforce consensus on diversity in the name of
community, this repudiation of theory—in the name of both practice and
truth—conceals and reveals intense ideological strain. I use the term "ideo-
logical" to refer to the taken-for-granted knowledge which organizes
societies and constructs subjects. The crisis has been provoked by what
seems to be the irreducible nature of difference, and it thus challenges
some of our most deeply held beliefs, beliefs expressed as truths about
who we are and how we relate to others. In this context, it is precisely
those who would ask, not what is true, but how is truth produced—those
who would question the very concepts (of community or the individual,
for example) that organize and legitimize knowledge—it is those "theo-
rists" who are considered most dangerous.

And yet, of course, it is also those "theorists" who offer a way to
read a crisis not within its own terms, nor outside them either, but critically
and against the grain. By this I mean not accepting at face value (as natural
or true) the categories that organize and explain our existence, but figuring
out how they work to produce their effects. This figuring out is done by
readings that map relations of power and the operations of knowledge and
difference that sustain them. These readings call into question the closed
terms of any debate, by asking how oppositional positions get stabilized
in relation to one another and then preclude our imagining anything
beyond them. Such reading requires rigor and training. It is disciplined
in the best sense; it is the practice of theory. This practice often leads to
that cognitive transformation associated with deep insight and new un-
derstanding—the change of vision, the clarity, that the Romantics thought
signalled a change of heart, and that many of us have idealized as the
finest product of a liberal education. Such reading is not itself a politics,
nor does it claim to be one, but it does open the imaginative possibilities
for new kinds of political thinking. Without such reading, we remain
stuck in the paradoxes I have been describing today, paradoxes whose
appearance suggests that the crisis of higher education is also a crisis of
democratic politics.

This last observation leads to what may seem yet another paradox;
but perhaps it is only an anticipation of challenges that will be made to
the arguments of this paper. Historically, American education at all levels
has been justified in terms of a vision of democratic politics based on the

very notions I have described as "exhausted": community as communion, individualism as a homogenization of difference, knowledge as instrumental, and practice, not theory, as the guide for thought and action. If the exhaustion of these concepts has produced a crisis in higher education, does abandoning (rather than salvaging) them imperil democracy itself? That, surely, is what some of my critics will say, have already said. We have all heard the lines: "this is not the moment for elitist intellectualizing or philosophizing, this is the moment to mobilize popular action," or "our political survival depends on not questioning the terms of an identity we've just discovered."

The oppositions that structure those arguments are not only self-defeating, they rob higher education in democratic society of its best political justification. For if action requires suspending thought, and politics requires turning away from theory, if political survival is imperilled by critical reflection, where will radical critiques come from, and how are we to value them? If there is no fundamental criticism and no place where it is practiced, taught, and perfected, what will be the sources of renewal and change? Without critical thinking, and the conflicts and contests it articulates, will there be democracy at all? These are questions deflected by the current rhetoric of crisis, but enabled by a critical reading of that rhetoric. They are worth pondering both in themselves and because they point the way to a reformulation of the relationship between higher education and democracy. The reformulation is this: higher education is to democracy as theory is to politics. This analogy restates the obvious only if we think we know what all the terms mean. In any case, it may open the way for imaginings that take us beyond the current crises; it may also, of course, provoke new ones.

Notes

For their advice and suggestions I wish to thank Wendy Brown, Judith Butler, Christina Crosby, Donald M. Scott, and Elizabeth Weed. Conversations with Lizzie Scott were particularly helpful for clarifying many of the arguments in these pages.

Works Cited

Bumiller, Kristin. 1988. *The Civil Rights Society: The Social Construction of Victims.* Baltimore: Johns Hopkins University Press.

Cheney, Lynne. 1988. " 'Report to the President, the Congress, and the American People' on the Humanities in America," *Chronicle of Higher Education,* September 21, pp. A17–23.

Connolly, William E. 1991. *Identity/Difference: Democratic Negotiations of Political Paradox.* Ithaca, NY: Cornell University Press.

Crosby, Christina. 1992. "Dealing with Differences," in Judith Butler and Joan W. Scott, eds., *Feminists Theorize the Political*. New York: Routledge.

de Man, Paul. 1983. *Blindness and Insight: Essays in the Rhetoric of Contemporary Criticism*. Minneapolis: University of Minnesota Press.

Lasoff, Melanie. "Engendering Historical Change," The Diamondback (Student newspaper of the University of Maryland, College Park). March 8, 1993: 4.

Miami Theory Collective, eds. Community at Loose Ends. Minneapolis: University of Minnesota Press, 1991.

Nancy, Jean-Luc. 1991. *The Inoperative Community*. Minneapolis: University of Minnesota Press.

Rooney, Ellen. 1989. *Seductive Reasoning: Pluralism as the Problematic of Contemporary Literary Theory*. Ithaca: Cornell University Press.

Spivak, Gayatri Chakravorty. 1982. "The Politics of Interpretations," in W.J.T. Mitchell, ed., *The Politics of Interpretation*. Chicago: University of Chicago Press.

———. 1987. "Subaltern Studies: Deconstructing Historiography," in *In Other Worlds: Essays in Cultural Politics*. New York: Routledge.

Identity Politics and
Campus Communities:
An Exchange

Few campus controversies are so dynamic and ill-understood as those over "identity politics." That's not only because issues surrounding race and gender are as volatile on campus as they are in national politics; it's also because "identity politics" names a complex intersection of political and intellectual conflicts, where debates over affirmative action, date rape, gay and lesbian studies, and poststructuralist social theory (among many other things) meet. Because the politics of identity are not a class politics— no students demand "Lower-Middle-Income Cultural Centers"—they confound traditional political analysts, who tend to regard identity politics simply as "divisive" strategies deployed around gender and ethnicity, or, more simply still, as narrow-minded, mean-spirited attacks on straight white men.

Crucially, identity politics are more tangled on campus than elsewhere in the culture, precisely because of their coexistence alongside theoretical developments in poststructuralist thought. The campus has seen both the energetic deployment of identity politics and its most substantive critiques. Yet the friction between identity politics and poststructuralist thought is widely misunderstood by most critics of American universities. In his introduction to *Debating P.C.,* for instance, Paul Berman mistakenly describes poststructuralism and identity politics as two sides of the same coin, missing the often explosive tension between antiessentialism in poststructuralism (which holds that there can be no fixed, stable identities based on gender, race, or anything else) and various kinds of essentialist thought in identity politics (which hold that, either biologically or culturally, people are predisposed to view the world in one way or another). Those of us who participate in these debates know that there is no unified front of poststructuralists and identity politicians; on the contrary, con-

frontations between these groups can be quite tense, one side claiming that race and gender are historically and socially "constructed" and variable and, thus, that neither outsiders nor members of a group can confidently "speak for" the group, the other side insisting on a long shared history of race or gender oppression and on the exclusive right of members of a group to "represent" the group's experience and interests. Complicating matters further, the multiple injunctions against "speaking for others" have also licensed a kind of manic self-questioning on the academic left, whereby progressive intellectuals query each other and themselves about whether they are indeed perpetuating what Foucault called the "indignity" of speaking for others. Often it is of little use, in this climate, to point out that we cannot do otherwise than to speak for others, and that intellectuals inside and outside the university should rather charge themselves with speaking as responsibly as possible.

The controversies around and about "identity politics," then, constitute one critical aspect of the leading edge of intellectual practices in the contemporary American university, and the ramifications of these controversies, in a world riven by ethnic hatreds and brutal inequalities, could not be more consequential or immediate. "Identity politics," therefore, designates an important nexus of political struggles among myriad campus groups and constituencies, but its implications are by no means confined to the classroom, the quad, or the cultural center.

The following exchange, compiled from conference recordings and including both several brief position papers and sections of open debate, offers a strikingly comprehensive discussion of identity politics inside and outside the university. It also offers a number of approaches to the subject that are not often aired—or not aired often *enough*—either in academe or elsewhere. Todd Gitlin opens by throwing down the gauntlet: the rise of identity politics, he claims, has fragmented the left and ceded the rhetoric of universalism to the right by default. These days, says Gitlin, it is the right wing that speaks of universalism and commonality, whereas the left, caught in its own rhetoric of "difference," can advance nothing but particularist projects. The exchange that follows is partly a record of response to Gitlin from a series of articulate black, gay, and feminist critics, all of whom protest that the rubric of "identity politics" leaves them unable to speak except *as* black, gay, or feminist—and thus as representatives of so-called "special interests"—even when they aspire to make more general, universalist claims about power, knowledge, privilege, identity, or history. In his paper, for example, Jerry Watts chooses to illustrate his own "confinement" within African-American studies in a particularly provocative fashion, by telling a story about how he was asked by the Anti-Defamation

League to respond to anti-Semitic literature published by the Nation of Islam—but only so long as he did not bring up the matter of Jewish racism. Although this potentially explosive topic produced some sharp exchanges, it did not yield a standoff in which differing parties congealed into permanently opposed camps. On the contrary, a number of parties sought ways of reopening or reconfiguring the stalled conversation between the ADL and Watts.

While providing alternative accounts of recent history, and insisting on what has been gained by way of identity politics, many of the other participants add their own criticisms of identity politics. Cameron McCarthy opens his paper with a challenge of his own: although it is often assumed that only minority groups promote and profit from identity politics, white heterosexual Americans benefit substantially from identity politics as well. Identity politics, he notes, prevents us from seeing conflict *within* groups by focusing only on conflict *between* groups. Michael Dyson, while seeking to provide the historical context for the rise of black nationalism in the 1960s and thus for the roots of current investments in African-American group identity, does not simply nominate Black Power as a form of "strategic essentialism," as if social conditions were too pressing to allow activist African-Americans to do anything but pretend to believe in a mystical "blackness" until they got what they wanted. Instead, Dyson suggests, black nationalism answered a spiritual need left unfulfilled by the Civil Rights Movement's appeal to "the sacred trinity of social goods: justice, equality, and freedom." As an expression of black ambivalence about integration and long-suppressed resentment against having to seek the approval of white mediators, black nationalism, according to Dyson, reflected "a tension between the quest for inclusion and reconciliation, on one hand, and autonomy and recognition on the other."

This brief summary of some of the key arguments in what follows gives an indication of the substantive contribution they make. Marked as it is by the care, nuance, and respect with which these speakers address and criticize one another, this exchange provides some valuable questions— as well as some very good arguments—about the multiple relations between our identities as individuals and our identities as members of larger human communities.

The Rise of "Identity Politics":
An Examination and a Critique

Todd Gitlin

I believe the political correctness dispute in the academy is only the ruffled surface of a profound shift in ideas and feelings. Its background is the defeat of the left as a live political and intellectual force. I want to give an account of the rise of specialized identities as foundations for knowledge and politics in the universities. At one level the proliferation of specialized angles of vision can be understood as the consequence of two decades of the movement of new populations into the university. But it is also the latest phase in a longer-running process, the weakening, even the breakdown, of ideals that were traditionally the preserve of the left, specifically Marxism and the liberalism of individual rights. That is why it will not do simply to call for the restoration of the grand old academy. Conservatives and reformers of every description are going to have to navigate in far more turbulent waters. I want to reflect first, then, on the thickening of identity politics on campus and elsewhere.

The rise of "identity politics" forms a convergence of a cultural style, a mode of logic, a badge of belonging, and a claim to insurgency. What began as an assertion of dignity, a recovery from exclusion and denigration, and a demand for representation, has also developed a hardening of its boundaries. The long-overdue opening of political initiative to people of color, women, gays, and others traditionally voiceless has developed its own methods of silencing. Much of the energy once liberated has been recaptured.

At the extreme, in the academy but also outside, "genealogy" has become something of a universal solvent for universal ideas. Standards and traditions now are taken to be nothing more than the camouflage of interests. All claims to knowledge are presumed to be addressed from and

to "subject positions," which, like the claims themselves, have been "constructed" or "invented" collectively by self-designated groups. Sooner or later, all disputes issue in propositions of the following sort: the central subject for understanding is the difference between X (for example, women, people of color) and Y (for example, white males). P is the case because my people, X, see it that way; if you do not agree with P, it is (or more mildly, is probably) because you are a member of Y. And further: since X has been oppressed, or silenced, by Y—typically, white heterosexual males—justice requires that members of X, preferably (though not necessarily) adherents of P, be hired and promoted; and in the student body, in the curriculum, on the reading list, and at the conference, distinctly represented.

This is more than a way of thought. Identity politics is a form of self-understanding, an orientation toward the world, and a structure of feeling that is frequent in developed industrial societies. Identity politics presents itself as—and many students and young people experience it as—the most compelling remedy for anonymity in an impersonal world. This cluster of recognitions, this system of feelings seems to answer the questions: Who am I? Who is like me? Whom can I trust? Where do I belong?

But identity politics is more than a mind-set and a sensibility felt and lived by individuals. It is a pattern of belonging, a search for comfort, an approach to community. The sense of membership is both a defense and an offense. It seems to overcome exclusion and silencing. Moreover, in a world where other people seem to have chosen sides and worse, where they approach you—even disrespect you, even menace you—because you belong to a particular group, it seems a necessity to choose or find or invent one's strength among one's people. From popular culture to government policy, the world has evidently assigned you a membership. Identity politics turns necessity into virtue.

But there is a hook: for all the talk about "the social construction of knowledge," identity politics in practice slides toward the premise that social groups have essential identities. At the outer limit, those who set out to explode a shrunken definition of humanity end by shrinking their definitions of blacks or women. In separatist theory, they must be, and have always been, all the same. After a genuflection to historical specificity, anatomy once again becomes destiny. This identity politics is already a tradition in its second generation, transmitted and retransmitted, institutionalized in jargons, mentors, gurus, conferences, associations, journals, departments, publishing subfields, bookstore sections, jokes, and, not incidentally, in affirmative action and in the growing numbers of faculty and students identified and identifying themselves as "of color."

In this setting, identity politics promises a certain comfort. But what was, at first, an enclave where the silenced could find their voices ends up now hardening into a self-enclosed world. In the academy, the pioneering work in the early 1970s toward making women's studies legitimate, bolstering labor studies, rethinking the damage done by slavery and the slaughter of the Indians, opening up the canon to hitherto silenced traditions—all this work was done by scholars who had one foot in the civil rights and antiwar movements and who came to their specialties already bearing something of a universalist or cosmopolitan bent. But much of the succeeding work tended to harden and narrow. Identity politics in the strict sense became an organizing principle among the academic cohorts who had no political experience before the late 1970s—those now in their twenties and early thirties. After the late 1960s, as race and gender (and sometimes class) became the organizing categories by which critical temperaments addressed the world in the humanities and social sciences, faculty people working this territory came to display the confidence of an ascending class, speaking predictably of "disruption," "subversion," "rupture," "contestation," "struggle for meaning." The more their political life is confined to the library, the more aggressive their language. They radiate *savoir-faire* and an aura of solidarity, a heady mixture that graduate students in search of a cloistered style of intellectual companionship and collective identity can identify with.

But identity politics is not simply a product of the academic hothouse. It also thrives in the society at large—in the media of the mass and the margins alike, in schools, in television, and in street lore. Some students carry the rhetoric of their particular group to campus with them. Alert to slights, they cultivate a cultural marginality both defensive and aggressive. Fights over appropriate language, over symbolic representation (whether in the form of syllabus or curriculum or faculty or even cuisine), over affirmative action and musical styles and shares of the public space are, to them, the core of "politics." Just as these cohorts have their clothes and their music, they have "their politics"—the principal, even the only, form of "politics" they know.

The specialists in difference may do their best to deny the fact that, for a quarter of a century, they have been fighting over the English department while the right held the White House as its private fiefdom. But academic currents are not as insulated from the larger social worlds as parochial theory may presume. The legitimacy of racial animus on a national scale, the boldness of right-wing politicians, the profusion of straightforward race prejudice among students have all made the academic left edgier and more offensive. Affirmative action has been successful enough to create a critical mass of African-Americans who feel simulta-

neously heartened, challenged, and marooned. The symbolic burden they bear is enormous. In the absence of plausible prospects for fighting the impoverishment of the cities, unemployment, police brutality, crime, or any of the economic aspects of the current immiseration, it is more convenient—certainly less risky—to accuse a liberal professor of racism. Identity politics is intensified when antagonistic identities are fighting for their places amid shrinking or zero-sum resources, the subject of the Lauter and Benjamin papers in this book. For many reasons, then, the proliferation of identity politics leads to a turning inward, a grim and hermetic bravado celebrating victimization and stylized marginality.

The thickening of identity politics is relative. We have to ask, Thickening compared to what? Compared to "universalism," "common culture," "the human condition," "liberality," "the Enlightenment project"—the contrary position wears different labels. I shall group them all (at Robert Jay Lifton's suggestion) under the heading of commonality politics—a frame of understanding and action that understands "difference" against the background of what is not different, what is shared among groups. This distinction is one of shadings, not absolutes, for differences are always thought and felt against a background of that which does not differ, and commonalities are always thought and felt in relation to differences. Still, the shadings are deeply felt, whence the intellectual polarization that shows up in debates about the complex of problems including the curriculum, diversity, and so on.

The point I wish to assert is that the thickening of identity politics is inseparable from a fragmentation of commonality politics. In large measure, things fell apart because the center could not hold. For chronologically, the breakup of commonality politics predates the thickening of identity politics. The centrifugal surge, on campus and off, is the product of two intersecting histories. There is, obviously, the last quarter-century of America's social and demographic upheavals. But these, in turn, have taken place within the longer history that snakes forward throughout the West since the revolutions of 1776, 1789, and 1848. Throughout this period and beyond, believers in a common humanity clustered around the two great progressive ideals: the liberal ideal enshrined in the Declaration of Independence and, later, in the Declaration of the Rights of Man and Citizen; and the radical ideal that crystallized as Marxism.

Such legitimacy as the left enjoyed in the West rested on its claim to a place in the grand story of universal human emancipation. Two hundred years of revolutionary tradition, whether liberal or radical—from the American, through the Russian, the Chinese, the Cuban—were predicated on the ideal of a universal humanity. The left addressed itself not to particular men and women but to all, in the name of their common

standing. If the population at large was incapable, by itself, in theory, of seeing the world whole and acting in the general interest, some enlightened group took it upon itself to be the collective conscience, the Founding Fathers, the vanguard party. Even Marx, lyricist of the proletariat, ingeniously claimed that his favored class was destined to stand for, or become, all humanity. Even nationalist revolutions, liberal nationalist revolutions—from 1848 to the present—were to be understood as tributaries to a common torrent, the grand surges of self-determination justified by the equivalent worth of all national expressions. Whether liberals or socialists, reformers or revolutionaries, the men and women of the left aimed to persuade their listeners to see their common interest as citizens of the largest world imaginable. All men (and later women) were supposed to have been created equal, workingmen of all countries were supposed to unite. Historians of women are right to point out that the various founding fathers were not thinking of half the species; yet potentially inclusive language was in place. The power of the discourse of political rights was such that it could be generalized by extrapolation. Thus, within fifty years, women—grossly subordinated in the antislavery movement—were working up a politics based on their constituting half of a human race that had been decreed to share equal rights.

Marxism, in all its colorations, became the core of what may be called the idea of the left—the struggle to usher in, to speak the name of, and to represent common humanity. There exists, Marx asserts in his early writings, a universal identity: the human being as maker, realizing his "species being" in the course of transforming nature. With the audacity of a German idealist primed to think in first principles, Marx adapts from Hegel the idea that a "universal class" will give meaning to history—though not without help. To accomplish its glorious mission, this class to end all classes requires a universal midwife: the revolutionary, the Communist. To every particular circumstance and cause, the universal priesthood of Communists is charged with bringing the glad tidings that History is the unfolding of Reason. The Communist Party, like God, in principle has its center everywhere and nowhere. The proletariat is his nation. Like the emigré Marx, he is at home nowhere and everywhere, free to teach people of all nations that not a historical event or a struggle against oppression rises or falls which does not have its part to play in the great international transfiguration.

Such is the lyric of Marxism, the rhetoric that appealed to revolutionaries for a century after the death of the founding father. And therefore Marxism-Leninism, the universalist technology of revolution and rule later codified by Stalinists, is, if not the unshakable shadow of Enlightenment Marxism, at least its scion. Lenin's Bolshevik Party thrives on and requires

this lineage, even if Lenin and Marx are not identical. Under Lenin, the Party and the international, these directive forces that see all and know all and act in the ostensibly general interest, become the incarnation of the Enlightenment's faith in the knowability of the human situation. Farther down a road already surveyed by Marx, Lenin makes intellectuals essential to the revolution, thereby securing the dominion of universal ideals.

What Lenin develops in theory, the October revolution of 1917 accomplishes in action. But Marxism without a revolutionary proletariat was a theology without God. Failing to take its poetry from the future, as Marx recommended, residual Marxism went on dressing up in a wardrobe from the past. Leftover or, as I prefer to think of it, late Marxism borrowed authority from the fact that the Church, when all was said and done, for all its corruption and barbarism, existed. From 1935 to 1939 and again during the Second World War, the Popular Front could even conjure a new commonality—a cobbled-together anti-Fascist fusion. In the end, Marxists could always ask rhetorically, what was the alternative that promised a universal transformation, universal justice, and a single humanity? And so, partly by default, from one revision to the next, Marxism remained the pedigreed theoretical ensemble hovering over all left-wing thought. And yet, once the anti-Fascist alliance was broken, with the beginning of the Cold War, the universalist promise of Marxism proceeded to unravel.

From this point of view, the intellectual radicalism of the early sixties can be seen as a search for a substitute universalism. Having dismissed Marxism for what C. Wright Mills called its "labor metaphysic," the New Left tried to compose a surrogate universal. "The issues are interrelated" was the New Left's approach to a federation of single-issue groups—so that, for example, the peace, civil rights, and civil liberties movements needed to recognize that they had a common enemy, the Southern Democrats, "Dixiecrats," who choked off any liberal extension of the New Deal. More grandly, in a revival of Enlightenment universalism, Students for a Democratic Society's Port Huron Statement spoke self-consciously in the name of all humanity, or at least in the gender-bound form in which it was then generally spoken. Human brotherhood must be willed as the most appropriate form of social relations. The universal solvent for particular differences would be the principle that, to quote from the Port Huron Statement, "decision-making of basic social consequence be carried on by public groupings": that is, participatory democracy. In theory, participatory democracy was available to all. In practice, it was tailored to students, young people collected at "knowledge factories" as the industrial proletariat had been collected at mills and mines; young people who were

skilled in conversation, had time on their hands, and, uprooted from the diversities of their respective upbringings, were being encouraged to think of themselves as practitioners of reason. When the early New Left set out to find common ground with a like-minded constituency, it reached out to the impoverished—the Student Nonviolent Coordinating Committee in the South to sharecroppers, and SDS to the urban poor, who, by virtue of their marginality, might be imagined as forerunners of a universal democracy. If students and the poor were not saddled with "radical chains" (Marx's term) in the system of production, at least they could be imagined with radical needs for political participation.

But the student movement's attempts at universalism broke down—both practically and intellectually. In fact, the ideal of participatory democracy was really only secondary for the New Left. The passion that drove students—including Berkeley's Free Speech Movement—was the desire to support civil rights as part of a movement with a universalist design. The New Left was a movement-for-others searching for an ideology to transform it into a movement-for-itself, but participatory democracy was too ethereal and bounded an objective with which to bind an entire movement, let alone an entire society. Freedom as an endless meeting was alluring only to those who had the time and taste to go to meetings endlessly. The universalist impulse regressed. Enter, then, mid-sixties, the varieties of Marxism by which universalist students could imagine either that they were entitled to lead a hypothetical proletariat (Progressive Labor's Stalinism) or that they themselves already prefigured a "new working class."

But these attempts at recomposing a sense of a unified revolutionary bloc were weak in comparison with centrifugal pressures. Such unity as had been felt by the Civil Rights Movement began to dissolve as soon as legal segregation was defeated. Blacks began to insist on black leadership, even exclusively black membership. When feminist stirrings were greeted with scorn by unreconstructed men, the principle proliferated. If white supremacy was unacceptable, neither could male supremacy be abided. One group after another demanded the recognition of difference and the protection of separate spheres for distinct groupings. This was more than an *idea,* because it was more than strictly intellectual; it was more of a structure of feeling, a whole way of experiencing the world. Difference was now lived and felt more acutely than unity.

The crack-up of the universalist New Left was muted for a while by the exigencies of the Vietnam War and the commonalities of youth culture. If there seemed, in the late 1960s, to be one big movement, it was largely because there was one big war. But the divisions of race and then gender and sexual orientation proved far too deep to be overcome

by any rhetoric of unification. The initiative and energy went into pro-liferation—feminist, gay, ethnic, environmentalist. The very language of collectivity came to be perceived by the new movements as a colonialist smothering—an ideology to rationalize white male domination. Thus, by the early 1970s, the goals of the student movement and the various left-wing insurgencies were increasingly subsumed under the categories of identity politics. Separatism became automatic. Now one did not imagine oneself belonging to a common enterprise; one belonged to a caucus.

But note: the late New Left politics of dispersion and separateness, not the early New Left politics of universalist aspiration, were the seedbed of the young faculty who were to carry radical politics into the academy in the 1970s and 1980s. The founders of women's and black studies had a universalist base in either the Old or the New Left. But their recruits, born in the early or later 1950s, did not. By the time they arrived on campuses in the early seventies, identity politics was the norm. They had no direct memory of either a unified left or a successful left-of-center Democratic Party. In general, their experience of active politics was seg-mented, not unified. The general left was defeated, and that defeat was a huge background presence, so obvious it was taken for granted. For the post-1960s activists, universalist traditions seemed empty. Mass move-ments were nothing more than sectoral movements for themselves. But this condition was not resented, or experienced as a loss. Rather it was felt as a marker of generational solidarity and a motor of exhilarating opportunities.

This profusion of social agents took place throughout the society, but nowhere more vigorously than in the academy, where resistance to fragmentation was weakest. In fact, given the specialization of the su-permarket university, it was, in a certain sense, the norm. Here, in black and ethnic studies, women's studies, gay and lesbian groupings, and so on, each movement could feel the exhilaration of group-based identity. Each felt it had a distinct world to win—first, by establishing that its group had been suppressed and silenced; then by exhuming buried work and ex-ploring forms of resistance; and, finally, by trying to rethink society, literature, and history from the respective vantages of the silenced, asking what the group and, indeed, the entire world would look like if those hitherto excluded were now included. And since the demands of identity politics were far more winnable in the university than elsewhere in the society, the struggles of minorities on the campus multiplied. When ac-ademic conservatives resisted and even mocked these angles of vision, they only confirmed the convictions of the marginal—that their embattled or not-yet-developing perspectives needed to be separately institutionalized. In the developing logic of identity-based movements, the world was all

periphery and no center, or, if there was a center, it was their own. The mission of insurgents was to promote their own interests; for if they would not, who would?

From these endeavors flowed extraordinary achievements in the study of history and literature. Spurious wholes were decomposed, exposed as partisan or partial. Whole new areas of inquiry were opened up. Histories of the world and of America, of science and literature, are still reverberating from what can legitimately be called a revolution in knowledge. But as the hitherto-excluded territories were institutionalized, the lingering aspiration for the universal subject was ceded. A good deal of the cultural left felt its way, even if half-jokingly, toward a weak unity based not so much on a commonality or universalist premise or ideal, but rather on a common enemy—that notorious, Platonically ideal type of the White Male. Beneath this, they had become, willy-nilly, pluralists, although this fact was at first frequently disguised by the rhetoric of general revolution hanging over from the late sixties. The idea of a unitary left with an emphasis on what unifies the whole sounded to the insurgents pious and abstract.

Soon, difference was being practiced, not just thought, at a deeper level than commonality. It was more salient, more vital, more present— all the more so in the 1980s, as practical struggles for university facilities, requirements, and so forth culminated in fights over increasingly scarce resources. For the participants in these late-sixties and postsixties movements, the benefits of this pursuit were manifold—a sense of community, an experience of solidarity, a ready-made reservoir of recruits. Seen from outside as fragments in search of a whole, the zones of identity politics came to be experienced from within as worlds unto themselves. The political-intellectual experience of younger academics could be mapped onto other centrifugal dispositions in post-Vietnam America. Group self-definitions embedded in political experience merged with other historicist and centrifugal currents to form the core and the legitimacy of the multicultural surge, the fragments of the cultural left. The idea of a common America and the idea of a unitary left, these two great legacies of the Enlightenment, hollowed out together.

Thus a curious reversal of left and right. In the nineteenth century, the right was the property of aristocracies who stood unabashedly for the privileges of the few. Today, the aspiring aristocrats of the academic right tend to speak the language of universals—canon, merit, reason, individual rights, transpolitical virtue. For its part, seized by the logic of identity politics, committed to pleasing its disparate constituencies, the academic left either dares not own up to, or has lost interest in, the commonalities that undergird its obsession with difference.

Now, I would argue, if I had space, that there is plenty of inflammable history piled up like brush within burning distance of the current fires. The symbolic stakes of the fights that interest us are long in the making. And on the foreshortened scale of academic disputes, the territorial stakes are not inconsiderable either. The bitterness of the academic disputes is infused with the bitterness of federal funding fights in the arts and humanities, in turn infused by the acrimony of the long-running culture war within modernity.

Polarizers on every side have a stake in their polarization. To this extent, the outlook for a solution is not auspicious. Overpolarization is always in part a misrepresentation of motives. The right tends to see in the left nothing but *la trahison des clercs*. The left tends to see in the right nothing but the protective tropism of white males whose ill-gotten privileges are coming under long-overdue attack.

The right, if it wishes to be intellectually serious, needs to understand, for example, that hardly any of the left is Afrocentric, needs to acknowledge that affirmative action has arguments and didn't become a political issue as long as it was the children of alumni who were the beneficiaries of admission preferences. It needs to acknowledge that the PC orthodoxy in the economics department is neoclassical, as Robert Kuttner has pointed out, and scarcely neo-Marxist.

The left needs to face some of the ugly outcomes of centrifugal motion—race hatred, political impotence, the declining utility of the narcissism of small differences. Intolerance is no one's monopoly. And *tu quoque* is by itself a rhetorical device of limited truth value. Further, the left needs to understand that the universalism of the academic right—whether in the natural law theories of Leo Strauss's students or the rights-based pluralism of Arthur M. Schlesinger, Jr.—is no simply, strictly, cynical political ploy cooked up disingenuously for the consternation of Democrats or the greater glory of manifest destiny.

Like all moral panics, the anti-PC crusade did not concoct the conditions in which it has stirred. Rather, Mrs. Cheney and Messrs. Bennett, Bloom, and D'Souza have addressed a widely felt longing. They know that, along with our local, multiple, situated, decentered, historically specific selves, we harbor an unassuaged longing for a sense of human community.

Those who think the unity of the world is guaranteed by a single market should be challenged by those whose idea of a single planet requires a single standard of human rights in a single greenhouse. The left is right to ask, insinuatingly: Whose human community? Who is inside, who outside? But once the question is asked, that is not the end of the conversation. If there is to be a left in more than a sentimental sense, its

position has to be: the desire for human unity is indispensable. The ways, means, basis, and costs are a subject for disciplined conversation. If, among human differences in a broken world, no principle of unity is yet self-evident, then how might it be formed? Let's get on with it.

Perhaps, then, there might be a synthesis in the making. (This is the wishful peroration.) Neither camp, it seems to me, at this point holds the undisputed initiative. Many sensitive, sensible scholars have been seeking out and, often enough, finding a central ground where the distinctly multicultural reality of American life, indeed the multicultural nature of Western and other cultures themselves, can be taken seriously, though not all-importantly. There has been much virtue in an attunement to the historical and particularist limits of knowledge. Now, alongside the indisputable premise that knowledge of many kinds is specific to time, place, and interpretive community, thoughtful critics are placing the equally important premise that there are unities in the human condition and that, indeed, the existence of common understandings is the basis of all communication; that is, the making common, across boundaries of language, and history, and experience.

Today, some of the most exciting scholarship entails efforts to incorporate new and old knowledge together in unified narratives—master, mistress, or otherwise. Otherwise there is no escape from solipsism, whose political expression cannot be the base of liberalism or radicalism, or, for that matter, any serious cultural conservatism. From many quarters there is a growing distaste for group solipsism.

Historians and sociologists normally pegged as conservative, Nathan Glazer and Diane Ravitch, for example, have declared themselves multiculturalist. No less a canon-conserving academic of the cultural, not political, right, necessarily, than John Searle, has helped puncture the Bennett/D'Souza canards about Stanford's ideas and values program. Among others, Leo Marx has reminded us that the canon is always revisionist, and has also reminded us that his cohort of graduate students in the 1940s had to fight to include good, gray, gay Walt Whitman in the literary canon, at the cost of losing John Greenleaf Whittier and James Russell Lowell. Such literary canon openers as Edward Said and Henry Louis Gates, Jr., have argued forcefully against the wrongheaded, hamhanded, reductionist—and, if this were not enough, banal—premise that all propositions only mask the interests of the proposers. Reed Way Dasenbrock has exploded the terms of the dispute by arguing that the West is essentially multicultural.

The intellectual historian David Hollinger and others have been battering at the Berlin Wall erected between the camps, with the result that something of a third position is actively being sought, and is already

looming in outline. There is a widespread conviction that the terms of the debate need to be, and are being, transfigured. Indeed, now Gerald Graff has made a strong case for normalizing the canon dispute, incorporating it into the academy's foreground by teaching the conflict. So, just as all the sound has not been noise, perhaps not all the fury has been wasted.

Discussion

JOAN SCOTT: I'd like to take issue with the story we've heard from Todd, although I certainly don't disagree with his critique of identity politics. I do, however, think that the opposition identity/commonality, difference/ universality needs to be looked into more fully, because I think what you've offered us is basically a return to commonality, to the Enlightenment, to universality. Certainly feminist scholarship shows that the story of universality is much more complicated than you've indicated with these oppositions. And, in fact, the more recent story—about the emergence of identity politics from the weakening of the old universal left—has a lot to do, not simply with its weakening, but with its inability to take into account the issues of difference people were raising. So this is not a question of two poles balancing up and down, I would say, so much as an interrelated problem which many different identity groups within the academy have been pointing to: that the notion of universality itself, the notion of commonality itself, is based on a set of liberal political ideals that underestimate the importance of difference in the construction of those individuals who claim individual rights or the rights of man. The whole question of how a self is defined as a coherent individual has built into it the notion of difference; who that different other is for the self being defined is integral to the definition of any human individual. How, then, difference gets spelled out is a historical story, and the emergence of "others" is part of that story. The political problem, or the problem for political theory, is to take into account the ways in which—at least since the Enlightenment—the notion of the individual, of the self, requires a notion of difference, and then, to understand how that different "other" has been formulated socially. That being the case, it's very hard to argue for this deep human longing for human community. It's difficult to posit commonality, consensus, shared anything, as the ground of our getting together. I agree that we need some ground on which to stand, or to think about standing together, but it's not the ground of commonality or universality. I would argue, following Jean-Luc Nancy, that it's some notion of *being-in-common*. And *that* notion of being already includes in it the

notion of the formation of self through difference, and the formation of groups through processes of power, hierarchical differentiation.

We can't rule out difference. We can't assign identity politics to the sort of unfortunate, enclosed territory that universality will solve, because we're not going to address the problems of the late twentieth century if we do that. We're not going to return longingly and nostalgically to the politics of Marxism, the New Left, and the common. Universality, in the unexamined way in which you offered it, is not going to be the answer.

TODD GITLIN: OK, good. First, I said nothing to imply that any of those struggles was easy or concluded. To the contrary. I'm simply talking about the persistence of the ideal in the name of which people have sought the rights which were and then weren't offered to them. That Western double bind has been the ground on which all these struggles have taken place for two hundred years. Of course, I don't think difference should be overcome to the point of elimination. I agree that one element of the human situation is existence in difference—the fact of difference. One of the bases for any universalism worth its name is respect for difference. What I am trying to address is the relative balance within the field universality/difference. I am enough of a structuralist or a binarist to think that these two terms are inconceivable without each other, that they do form a unit. So I don't think one of them should simply be chucked. But were there not a serious commonality, we couldn't be having this conversation. You get up, you make an argument, I hear an argument, I make an argument back, you know, I consult my sense of the world, you consult your sense of the world. Is this not part of what's required?

SCOTT: But the very notion of "respect for difference" that you're talking about excludes the realization that differences are created in power relationships, that difference is not simply a sociological category. Difference has to do with something that's vital to the sense of self of an individual or a group, and it constitutes a power relationship with a set of interests and problems that are not easily resolved or given over by the notion of universalism.

GITLIN: Let me make just one other point, since we could be at this for several years. We have been, actually. I don't think the universalism I propose is nostalgic. I didn't intend to make it nostalgic. I could be more corrosive about the ideal of participatory democracy if you like, but I don't think there's anything in what I said that suggests it's actually a livable possibility. I'm nostalgic neither for that nor for the good old Marxism, which in any case I never shared enthusiasm for. Rather, it seems to me

that the project ought to be not simply the proliferation and clarification of difference, but also the construction of the common. The construction of the common is just as much your business as mine; it's not something that's inherited, it's not something to be passed on by going back, say, to Bill Bennett's canon, or anybody else's canon. It's rather something to be made. But if we understood that that was the objective of the enterprise, then I think that we would find ourselves acting more fruitfully in a number of ways. That's the commonality that interests me.

LISA DUGGAN: I'm really struck, Todd, at the re-creation from a left position of the sort of language of special interests and special rights that we usually hear from the right wing. The redefinition of movements for racial, or gender, or sexual justice as "special interest" groups, as people who are speaking only for a bounded group and for a certain special, isolated interest—I think this was recreated in your paper, so that when we wish to speak about gender, or race, or sexuality in the academy or in public discourse, and when we wish to speak about our common stake in redistributing cultural or material resources around those issues, we are interpreted and received as though we are speaking for women, for people of color, for queers, in an isolated way. Or when we try to speak of the general stake we all have in reorganizing race, gender, and sexual relations, what comes back is "Oh, you're only talking about women, you're only talking about people of color, you're only talking about queers. You're representing a special interest. You're representing a bounded group." Yet the critique of identity politics has come, to a large extent, from feminist scholars, from people of color, and from people in queer studies in the academy, who specifically want to resist being forced to speak always and only for and from the particular. I noted that when you were talking about the Port Huron Statement, and the New Left, you could speak of that as a universalist politics which had its limits and its flaws, and not as a particular, narrow kind of interest group representing predominately white, male, heterosexual students, a bounded group, a particularist group. Even though you identified those people in that way, you did talk about their speech, their language, as being universalist—in the same way, I think, that the conservatives, when *they* talk about the universal, see their own position as being in some way identified with the universal. But if I try to speak—not of the universal, which for the reasons Joan Scott pointed out I wouldn't try to do—but about our common interests in looking at the brutal conditions both of economics, race, gender, and of the way we organize sexuality, I'm going to be received as a narrow, particular, special interest group. And that now is not only received that way by the right, but received that way on the left as well.

GITLIN: I don't see how you could possibly think I was declaring unambiguously that there was something universal in performance, or universal in authorship, about such an idea as participatory democracy when, in the next breath, and I can't speak all breaths simultaneously, I talked about it as the expression of an interest, and therefore described its limitation, as a limitation of an interest. Now, that happens to be one of the ironies of history. Thus we don't quite know what to make of the fact that Thomas Jefferson owned slaves, but to pose the problem, and it's a very good problem to pose, isn't to answer it. Likewise, when I use the language of interest, I'm not condemning interests. You know, I'm not presenting my entire political encyclopedia here, but I do think that interests are legitimate, and I'm sure I support most of the interests you do; I say that again out of a general spirit which you may call overconfident, presumptuous, but I'll be that way. I have no difficulty with the expression of interests. My difficulty, my argument, is with the belief that once the interests have been stated, once the identities have been demarcated, our work is done. I say again that the politics of the last quarter-century, certainly in the academy, while the universities have been undermined and clobbered in all the ways we've been talking about, have been devoted to the perfection of boundaries, and what I say about boundaries in this respect I would also say about disciplinary boundaries. I'm not much of a respecter of boundaries.

JERRY WATTS: You said that we don't know what to do with the fact that Jefferson owned slaves. I know what to do with it. I mean, I don't see what's so problematic about it. He was a slaveowner, and he was very explicitly white-supremacist in his views.

GITLIN: You want to give up the First Amendment, therefore?

WATTS: No, no, but I'm trying to say that the fact that he owned slaves doesn't make it problematic; that's not a contradiction. He was explicit; Jefferson didn't hide that. Anyway, I want to confront you on a couple of points. First, you have a notion that black studies and women's studies and such and such studies developed and viewed themselves as the center of their world, and I think empirically that's ridiculous. Black Studies departments arose explicitly knowing that they were black in a white-dominated academy. The idea that any Black Studies department, whether at Yale, Harvard, whatever, arose with the idea that the world would function around it is ridiculous. And materially they couldn't exist like that, given that they were faced with questions of intellectual legitimacy and cultural authority in terms of what was constituted as valid knowledge,

as well as the stigmatization placed on all things black, not only bodies but subject matter and cultural products of people who were black. If you go back and look, Black Studies programs could have been insular, could have been parochial, but they did not think they were living in a world that centered around blacks and Black Studies. And when you make those claims, you should have some data. Because when we go around and talk about founders of Black Studies and what they went through, that's an empirical question.

Secondly, when a black person speaks, the way in which American culture works intellectually—and this happens in the left and all kinds of circles—what happens is that you come as the bearer of a parochial view. Your status as a speaker is determined *a priori* by your race position. I can speak about black Americans, but I'm seen as speaking about a parochial entity, when I might actually be making a generic point about American citizens, and who these people are. But the way I'm culturally understood as a *black* speaker makes me inherently parochial. It will look like I'm playing identity politics in many cases where I'm trying to make claims about *other* folk, and identity has nothing to do with it, it's just that it's *me* speaking that makes it look that way. And, of course, there are some times when I'm not allowed to speak, when I become an interloper. So I can't buy the idea that we're in this ideal speech moment where each group is in some sense just now perversely deciding to become parochial around this question of commonality. There's power out there; there are dominant languages that people have to respond to. And if it forces you to be assertive, that doesn't mean you're being parochial; it just means that the grand narrative that you presuppose, Todd, was never as tolerant as it claimed in the first place. Let me put it this way. Let me tell you a story. I'm sitting in a bar in Hartford, and this brother walks in and says to me, "Wow, the Japanese just bought Rockefeller Center," and he says, "damn, you know, it's terrible. Like we don't own anything anymore." I remember I said to him, "Man, you never owned Rockefeller Center. You own it as much now as you ever did." The mystification of community, the false notions of community that so many Americans adhere to, only mask the inequality in this society. I do believe we have to construct a democratic discourse, but it can't begin with nostalgia for a past that wrote us out.

MICHAEL DYSON: I think the points Lisa and Jerry and Joan have pressed you on are valuable, and I want to raise another question along those lines. I'm a severe critic of the politics of identity, but only when we give a historical narrative that tries to place them, and talk about the ways in which they were developed, and against what political factors they arose

in the first place. Lisa and Jerry have mentioned that whenever we speak
from "our" perspectives it's always assumed that we're speaking about
black folk, or gay folk, or lesbian folk. What book can you think about,
written by a person of color, say, that has been adopted not just as a great
book within the Western canon, but has been viewed by nonblack people
as a text to which they can refer, not only for getting information his-
torically, but also for insight into contemporary discourse? Not that the
texts haven't been written, not that the insights haven't been generated.
So when you invoke the language of unity, we begin to think there's a
nostalgic undertone running through your discourse. Perhaps you can
prove us wrong, so we can be chastened in our belief that you are appealing
to some golden moment of the past that was neither golden nor a moment,
because that nostalgic undertone extends itself in a powerful way into
present discourses, and has the force of silencing those who now finally
get the power to speak.

GITLIN: Well, this is part of a conversation that obviously should be preoc-
cupying all of us, about how it's possible to assemble the knowledge of
commonality. It can't simply be found in the past, as if it had once been
buried there for the rediscovery, but rather needs to be *created*. It strikes
me as very sad that, as soon as a word like "unity" comes up, it's assumed
that one is talking about something that was once believed, or that once
was true. Maybe I didn't make it explicit enough, but I'm not talking
about a hand-me-down unity, not any kind of nationalist identity of "our-
selves" as the entirety, but the *big* unity. The big unity—I don't know
what else to call it and it seems euphemistic to call it anything else—is
the unity, human unity. I don't see any way around that. You're absolutely
right about the enormous travesty of unity, the travesty of the narrative
that was passed down, for example, by American historians through
Schlesinger, on the very soggy grounds of which it was necessary for
people to go off and invent, crucially, black history, women's history, gay
and lesbian histories, and others. No question about the necessity of that;
if I were presenting a history of our time or a history of higher education,
that would loom very large. I was being provocative here, because I am
eager to get beyond the self-congratulations, including my own—I mean,
I could deliver my own story about how my friends and I shook up media
studies or something, and are still embattled and so on, because all that
is true. Yet I'm trying to look at this from the vantage of a common
political predicament, which needs to be addressed head on, and I don't
know any other way to do it than to do it in this somewhat bullheaded
way. Let me just make clear, though, in response to Jerry Watts, that
when I talk about identity politics, I don't mean to oppose distinct college

departments or programs. That's not what I was doing. I would attack distinct departments only in the sense that I would attack all departments. I have no beef with departments; I've supported the creation of such entities and still would. It's rather a certain mentality that I'm describing; if the mentality fits, those who will recognize it as theirs will claim it and other people, I think, may undermine their own political niche as well as their own philosophical prospects, if they pretend that what I and many others have described doesn't exist.

GREGORY JAY: Just one further comment on that. There's an excellent essay by the African-American writer, Paule Marshall, called "The Making of a Writer: From the Poets in the Kitchen." I was teaching it in my course on multiculturalism, and it begins with an anecdote about how, during a course that Marshall was teaching, she invited a prominent African-American male novelist to talk to her class about his work and his writing process; he told the students how lucky African-American women were to have spent so much time in the kitchen, because there they would have learned the language and the stories that they could then make all this great fiction out of. The interesting thing about the essay, as it unfolds, is that, while Marshall first expresses the outrage and the anger that she and the students felt at this, it turns out that there is a fundamental way in which the observation was true. The problem that gets raised here is the problem of the subject position of the enunciator, and the contingent relationship between statements and the positions of the people making those statements. We thematized that in the class; we're talking about it here. We discussed amongst ourselves the relationship between statements that we make and who we are, in terms of our bodies and in terms of our institutional situations. I tried to talk about difficulties I had had as a pedagogue, for example, enunciating positions in feminism, and what happens to men in feminism, and the relationship between an enunciation whose truth value you may believe in, and the contingent circumstances and rhetorical effects of its utterance, which may lead a particular statement to be taken in a sense opposite to its "literal" meaning. I think that those kind of contingencies, and those kinds of variable institutional locations, are what's being discussed here.

Contradictions of Existence:
Identity and Essentialism

CAMERON MCCARTHY

Identity politics are often discussed in ways that suggest only minority groups, particularly African-Americans, Hispanics, and so on, promote and profit from identity politics. They propagate these politics to their interests, and they are chiefly the ones affected by these politics in terms of notions of fragmentation of identity and so on. I think this is manifestly false, that, in fact, white heterosexual Americans benefit substantially from identity politics. One only needs to look at contemporary popular culture, including films like *Falling Down, Dances With Wolves,* and so forth, to see this recoding taking place—a displacement of certain victims and their replacement by a white middle-class subject. One only needs to look at the media coverage of the murder of Charles Stuart's wife or the Los Angeles trial of the police who brutalized Rodney King to see how the issues get displaced onto the inner city in a way that foregrounds that white subject. I'm going to talk about this, though, from an angle different from the one provided by the narrative of the white subject. I'm concerned primarily with questions of essentialist theories of race in education—which I find limited in terms of their explanatory adequacy, validity, and predictive capacity, and inadequate in terms of a basis for evaluating education reform with respect to race relations.

Michael Omi and Hart Winant put the problematic of waning white ethnicity in this post-Civil Rights Era in the following terms: most whites do not experience their ethnicity as a definitive aspect of their social identity. They perceive it dimly and irregularly, picking and choosing among its varied strands to exercise, as Mary Waters suggests, an ethnic option. The specifically ethnic components of white identity are fast receding with each generation's additional remove from the old country. Unable

to speak the language of their immigrant forebears, uncommitted to ethnic endogamy, unaware of their ancestors as, say, Poles or Scots, rather than a combination of four or five European and non-European groups, whites undergo a racializing panethnicity as Euro-Americans. Nowhere is this sense of the twilight of white ethnicity felt more deeply than on American college campuses. In these deeply racially Balkanized and polarized sites of the American educational system, we are entering the brave new world of the post-Civil Rights Era, a world in which the proliferation of ethnic diversity has led to a heightened state of race consciousness on the part of both minorities and whites.

The post-Civil Rights Era is the era of the displaced and decentered white subject, as it is for fragmented minority subjects. White students on college campuses find themselves positioned as the antagonists in an unpredictable racial drama in which middle-class subjects speak in the voice of the new oppressed, a progeny spawned in an era of resentment and reverse discrimination. For instance, white students interviewed in a recent study on racial diversity, conducted at Berkeley, emphasized a sense of racial encirclement, ethnic instability, and a new conflictual under-standing of identity. A few examples of comments made by white students and recorded in the report underscore these new dilemmas over the nature of racial and ethnic identity.

STUDENT COMMENT 1: Many whites don't feel like they have an ethnic identity at all. I pretty much feel that way too. It's not something that bothers me tremendously, but I think that maybe I could be missing something that other people have, that I am not experiencing.

STUDENT COMMENT 2: Being white means that you are less likely to get financial aid. It means that there are all sorts of tutoring groups and special programs that you can't get into because you are not a minority.

STUDENT COMMENT 3: If you want to go with the stereotypes, Asians are the smart people, blacks are the great athletes. What is white? We're just here. We're the oppressors of the nation.

These stories of racial/ethnic instability come at a critical juncture in debates over racial identity, and racial inequality, and curriculum reform in the educational field in the United States. They also point to the crisis in the theorization of race and racial logics in education. But it is also, paradoxically, a time in which there is a peculiar language of racial and ethnic certainty, of panethnic camps drawn tightly around specular origins. The world is a vast Lacanian mirror in which theorists of racial purity and racial essence see themselves standing in front of their ancestors. It is the perfect image, a snapshot of history, collected in the nuclear family photo album. It is the story of the singular origin, the singular essence, the one, true, primary cause. The old Marxist and neo-Marxist orthodoxies

of class and economic primacy in education debates are rapidly being replaced by the new panethnic cultural assertions of racial origins. The proponents of Western civilization and Eurocentrism and their critics, the proponents of Afrocentrism, now argue for the heart and soul of the educational enterprise.

This is not, of course, to suggest that there is an equivalence in the deployment of material and political resources here, for in some ways the playing out of this conflict involves a certain encirclement of black intellectual thinking. Conservative educators such as Diane Ravitch join conservative ideologues such as George Will in insisting, for instance, that our country, the United States, is a branch of European civilization. Eurocentricity is right, says Will, in American curricula and consciousness because it accords with the facts of our history and we, and Europe, are fortunate for that.

Europe, through this legerdemain, is collapsed into the United States without any difficulty. Here, I'm suggesting that Europe is being ethnicized in very interesting ways, and you can see this, for instance, in what I call "multicultural ads," like the one for Mueslix, in which Europe occupies this pre-industrial space where Europeans are picking up grains to put in boxes to ship off to the United States so that you can have your breakfast cereal. History and tradition in this country is seen as interchangeable with that of Europe, or as they might say in England, ask Fergie. On the other hand, Afrocentric theorists such as Molefi Asante argue for the panethnic unity of all black people of the diaspora, pointing to the origins of African people in the spatial reality of Africa. Of course it is important to emphasize here that Afrocentrism is a liberatory discourse. When one reads the works of Asante, Jawanza Kunjufu, and others, one recognizes immediately a sustained effort to connect to an intellectual and political history of struggle waged by racially subordinated groups within the United States. But Afrocentrism also contains within its discourse a language that masks issues of contradiction and discontinuity within the diaspora, between the diaspora and Africa, between different economically and socially situated African-Americans, and other minority groups, and between differently situated men and women. (I was in Toronto recently giving a talk related to this topic, and I was sneered at by some Afrocentrics: the new position is that there is a polycentrism, which is a considerable variation on this framework, and it includes a wider range of intellectual moves and people that I would not normally associate with Afrocentrism, people like Aime Cesaire, Wole Soyinka and so on.)

Beyond these concerns is the issue of the intellectual and cultural worker and his or her problematic relationship to anything that begins to sound like the singular cultural heritage or cultural stream. It is a necessary

condition of dynamic, intellectual, cultural work that the intellectual worker has the flexibility to draw on the wellspring of history, to draw on the variety of resources that fan out across the myriad groups that make up this society and the world. In this sense I'm referring to an ongoing dialogue that I think exists between "Third World" writers and the so-called canon. There is a process of rewriting, there is a process of encounter, there is a process of conversation. One cannot think of Derek Walcott's work without thinking of the role that T. S. Eliot plays in it, that Ezra Pound plays in his writing, functioning as critics in a context in which a written critical tradition doesn't exist. And there are all kinds of reasons to explain this in the context of the Caribbean. Of course, the Afrocentrics would point out to me that there was an oral tradition, and that this works through Walcott's work as well, and one has to take this into account. In fact, from that perspective, I think you can say that English has been occupied and taken over by the postcolonial writers, so it is impossible to continue to maintain the notion that an English language exists that can be embodied in the small space of England and that could fit into Guyana, on the coast of South America, without changing its shape. I really think that we need to clarify that. And the fact that the most extraordinary writing that is taking place in our time is coming out of postcolonial writers, whether you look at the great Hispanic-American writers like García Márquez or Fuentes, whether you look at Toni Morrison, whether you look at somebody like Jamaica Kincaid, whether you look at Ondaatje, coming out of Toronto, out of Sri Lanka. I think this is important literature to deal with and to engage with, and there shouldn't be too much debate about whether it belongs to any serious curriculum of contemporary schooling and contemporary higher education.

Culture, as writers such as Coco Fusco, Cornel West, and Stuart Hall suggest, is a hybrid. For that matter, race is a hybridizing process as well. In any one group or individual, there are always competing identities, possible selves, competing interests, needs, desires, wrestling to the surface. In saying this I'm not denying that there are certain stabilities associated with race; I'm not denying that there is a persistence of what Hall calls continuities between the peoples of Africa and the people of the Afro-New World Diaspora. Neither am I trying to contest the fact that there are brutal realities associated with the patterns of racial exclusion that affect minorities in the United States. What I am saying is that racial difference is the product of human interests, needs, and desires, human strategies, human capacities, forms of organization and forms of mobilization, and that these dynamic variables, which articulate themselves in the form of grounded social constructs such as identity, and inequality, and so forth, are subject to change, contradiction, variability, and revision

within historically specific and determinant contexts. Racial identities are, therefore, profoundly social-historical categories. Thus the concept of Asian-American, a particularly recent concept, pastes over extraordinary kinds of contradictions. Or if, for example, you look at the relationship of Korea to Japan, you see Koreans as an oppressed minority, with educational patterns of underachievement that approximate blacks and Hispanics in this country.

Against the grain of this historical and social variability, Afrocentrics and Eurocentrics now argue for school reform based on the narrow limits of ethnic affiliation. For Afrocentrists, the intolerable level of minority failure in schooling has to do with the fact that minority—particularly African-American—cultural heritages are being suppressed in the curriculum. Now, that's not inaccurate, but the point after is problematic: black students fail because schools assault their identities and destabilize their sense of self and agency. A good example of this thesis is to be found in *The Conspiracy to Destroy Black Boys,* by Jawanza Kunjufu. For the proponents of Western civilization, by contrast, the Western cultural emphasis in the curriculum is color-blind. Black students fail, when they fail, because of the cultural deprivation that exists in their homes and in their communities. Literacy and grounding in the tenets of Western civilization would be the best antidote for failure among the black poor, as E. D. Hirsch suggests; broad cultural literacy would help disadvantaged black youth enter the mainstream.

My argument comes basically in response to these kinds of positions on inequality in American education, each of which relies on a diagnosis of inequality based on race and ethnicity. And in both positions, race and ethnicity are conceived in strangely similar terms: educational theories of racial inequality, specifically, are at bottom still informed by notions of essences—not necessarily innate biological essences, to be sure, but notions of nearly indelible characteristics in culture, linguistic styles, cognitive capacity, family structures, and the like. What I want to do, then, is to offer a critique of the tendency toward essentialist or single-cause explanations of racial inequality and racial identity in education. I argue that these essentialist or origins-oriented explanations of racial difference in education are deeply flawed and that, more to the point, they constitute an inadequate basis for conceptualizing educational reform.

By "essentialism," I am referring to the tendencies in current mainstream and radical writing on race to treat social groups as stable or homogenous entities, whereby racial groups such as Asians, or Latinos, or blacks, are discussed as though members of these groups possess some invariant (or insignificantly variant) set of characteristics that mark them off from each other and from whites. It is my contention that current

tendencies towards essentialism in the analysis of race relations significantly inhibit dynamic understandings of the operation of race in daily life, and race-based politics in education and society. I argue, further, that essentialist thinking about race contributes to the ever-increasing Balkanization of cultural and public spaces in education and society.

Debates on multiculturalism are currently preoccupied with issues of curricular content, but I think the more radically crucial issue—and this is raised by the Afrocentrists to some degree—is a debate around the distribution of knowledge, and the debate around the alienation and the virtual exile of black and Hispanic kids from an academic experience in schooling. This, to me, is the radical issue. I am therefore interested in the ways in which moral leadership and social power are exercised in the country, and the ways in which regimes of racial domination and subordination are constructed and resisted in education and popular culture. In most cases, students get their understandings of what black people are like and what the inner cities are like by way of mass media—and, unsurprisingly, school textbooks, too, reproduce a certain kind of glossy abridged history of different contending groups in the United States. So popular culture shapes, in very profound ways, what people understand about Africa, how people even understand the mapping and spatial orientations of the world.

The theoretical and methodological issues concerning race are complex, and therefore require comparative and relational approaches to analysis and intervention in unequal relations in schools. Such analysis and intervention must pay special attention to contradiction, discontinuity, and nuance, within and between embattled social groups. Rather than treating minority groups as homogeneous entities, I point to the contradictory interests, needs, and desires that inform minority education, cultural and political behavior, and that define minority encounters with majority whites in educational settings in society. By invoking the concepts of contradiction and nonsynchrony, I wish to advance the position that individuals or groups, in their relation to economic, political, and cultural institutions such as schools, do not share identical consciousness and express the same interests, needs, or desires at the same point in time. These discontinuities in the needs and interests of majority and minority groups are, for example, expressed in the long history of tension and hostility that has existed between the black and white working class in this country. Also of crucial importance within this framework is the contradictory location of the new black middle class within the racial problematic, and the role of neoconservative black and white intellectuals in redefining the terrain of contemporary discourse about racial inequality in terms of how identity politics undermine the ideal of a color-blind society.

Just as important for any relational and nonessentialist approach to race and curriculum is the fact that minority women and girls have radically different experiences of racial inequality from their male counterparts because of the issue of gender. I believe that any strategy for educational reform in the area of race relations must take this complexity into account. As Michael Burawoy and Mokubong Nkomo make clear with respect to South Africa, economic divides that exist between the black underclass in the Bantustans, and their more middle-class counterparts working for the South African state, the police, nurses, Bantustan bureaucrats, and so on, often serve to undermine black unity in the struggle against apartheid. Similar examples exist in the United States, where some middle-class minority intellectuals, such as Shelby Steele, have spoken out against affirmative action and minority scholarship programs in higher education. A case in point is the 1990 ruling by the U.S. Department of Education's former Assistant Secretary for Civil Rights, Michael Williams, that maintained that it was illegal for a college or a university to offer a scholarship only to minority students. The irony of this situation is underlined by the fact that the former Assistant Secretary for Civil Rights is a black man, and the fact is that without these scholarships a number of very talented minorities would not be able to pursue higher education. Here, as is so often the case in 1990s cultural politics, on a reactionary Republican policy that effectively undermined the material interests of African-Americans and other minority groups, the point man was a neo-conservative member of the emergent minority middle class.

One should not, however, draw the conclusion that contradictions associated with race, and specific social policies such as affirmative action, affect blacks only. These dynamics are also reflected in the politics of identity formation among Asian-Americans. Look, for instance, at two examples of the contradictory effects of inclusionary and exclusionary ethnic practices among Asian-Americans and Pacific Islanders. In order to consolidate their political clout and benefits from land-trust arrangements, native Hawaiians voted four to one in January, 1990, for a highly inclusionary definition of their ethnic identity, one that expanded the definition of their people to anyone with a drop of Hawaiian blood. According to Omi and Winant, previously only those with at least fifty percent Hawaiian blood—whatever "blood" is—were eligible for certain benefits. They also point to a second example, this time of the exclusionary effects of intraethnic contradictions in the politics of Asian-American identity formation and affirmative action policy: in June, 1991, in San Francisco, Chinese-American architects and engineers protested the inclusion of Asian-Indians under the city's minority business enterprise law, citing a Supreme Court ruling which requires cities to define narrowly those

groups which have suffered discrimination in order to justify specific affirmative action programs. Chinese-Americans contended that Asian-Indians should not be considered Asian—in a situation, needless to say, where obvious economic benefits accrue to minority businesses that are designated as such.

The contradictory phenomenon of racial identity formation in this post-Civil Rights Era also manifests itself inside schools. Linda Grant calls attention to these discontinuities in the operation of gender at the classroom level. Based on the findings of a study of face-to-face interactions in sixty desegregated elementary school classrooms in a Midwestern industrial city, Linda Grant concludes that black females' experiences in desegregated schools differ from other race/gender groups, and cannot be fully understood by extrapolating from the research on females or research on blacks. Among other things, Grant contends that the teachers in her study did not relate to their black students in any consistent or monolithic way. Grant places particular emphasis on the way in which black girls were positioned in the language of the classroom and in informal exchanges between teachers and students. She notes the following. Although generally compliant with teachers' rules, black females were less tied to teachers than white girls were, and approached them only when they had a specific need to do so. White girls spent more time with teachers, prolonging questions into chats about personal issues; black girls' contacts were briefer, more task-related, and often on behalf of a peer rather than oneself. Although these teachers tended to avoid contacts with black male students, they were inclined at times to identify at least one black male student in their classroom as a superstar. In none of the sixty segregated classrooms was any of the black girls identified as a high academic achiever. Instead, Grant maintains, black girls were typified as average achievers, and assigned to average or below average track placements and ability groups. Gender differences partially influenced and modified the racially inflected ways in which teachers evaluated, diagnosed, labelled, and tracked their students. Grant therefore points to a hidden cost of desegregation for black girls. Although they are usually the top students in all-black classes, they lose their stature to white children in desegregated rooms. Their development seems to become less balanced, with considerably more emphasis being placed on their social skills. Black girls' everyday schooling experiences thus seem more likely to nudge them toward stereotypical roles of black women than towards academic alternatives. Of course, the early work of Ray Rist in the late 1960s and early seventies, pointing to self-fulfilling prophecies and expectation research, is another point of affirmation of this kind of line of analysis.

So let me conclude. The point that I want to make here, then, is that you cannot read off the educational, cultural, or political behavior of minority and majority youth or adults based on assumptions about race pure and simple. Different gender and class interests and experiences within minority and majority groups often cut at right angles to efforts at racial coordination and affiliation. In each of the examples of nonsynchrony that I have discussed—the case of black, middle-class bureaucrats versus Bantustan peasants and workers in their struggle against apartheid in South Africa, or black girls' differential academic experiences in a desegregated classroom, or the cases of intraethnic conflict and instability among Asian-Americans and among white youth—dynamic variables of gender, class, race, and ethnicity seem to confound rather than simply reinforce one another. I want to argue, therefore, that to predicate race relations reform in education on the basis of static definitions of what white people are like and what minorities are like can lead to costly miscalculations that can significantly undermine the goal of race relations reform in education itself. I also want to emphasize the need to pay attention to the differential patterns of historical and contemporary incorporation of minority and majority groups into the social and cultural relations that exist in educational settings.

Of course, in affirming the positive moment in history and culture, we should not rush headlong into the politics of cultural exceptionalism or the celebration of cultural diversity for its own sake, for, as Abdul Jan Mohammed and David Lloyd argue, such contentless pluralism tolerates the existence of salsa, it even enjoys Mexican restaurants, but it bans Spanish as a medium of instruction in American schools. Rather than taking the easy path to exceptionalism, I maintain that critical and subaltern educational activists must begin to see racial difference as one—but not the only one—of the starting points for drawing out various solidarities among subordinated minority youth and adults, and working-class women and men over separate but related forms of oppression. And in some ways I share some of the anxieties raised by Todd Gitlin, except that I think there is a different discourse to use instead of the languages of universalism and identity politics. Here I'm thinking of people like Linda Nicholson and Donna Haraway in postmodernism, who point to a language of alliances, or Chela Sandoval, who talks about "strategic coalitions" and "differential consciousness," and I think that one has to struggle over how we begin to work through—both within and beyond—issues of difference. (Indeed, it was the failure of progressive groups to see the limitations of a calcified position on racial identity that contributed to the paralysis around the recent nomination of the ultraconservative black judge, Clarence Thomas, to the Supreme Court.)

In this respect, the struggles over racial inequality in education cannot be meaningfully separated from issues such as police brutality in African-American and Latino neighborhoods, or the sexual or mental harassment of minority women on the shop floor. Nor can oppression and inequality be meaningfully confronted simply by adding more sensitive curriculum materials to, or including new voices in, the school syllabus. We have to come to recognize that examining race relations is critical, not simply for an understanding of social life as it is expressed in the margins of American society, but ultimately for an understanding of life as it is expressed in its very dynamic center. For as Stuart Hall reminds us, if you try to stop the story about racial politics, racial division, racist ideologies, short of confronting some of these difficult issues; if you present an idealized picture of a multicultural or ethnically varied society which doesn't look at the way racism has acted back inside the working class itself, the way in which racism has combined, for example, with sexism, working back within the black population itself; if you try to tell the story as if somewhere around the corner some whole, constituted class is waiting for a green light to advance and displace the racist enemy—you will have done absolutely nothing whatsoever for the political understanding of your students.

As a further corollary to this, I think we should by now be disabused of the idea that the contradictory politics and practices associated with racial identity formation only express the experience of minority individuals and groups. In this paper I have sought to draw attention to the fact that these discontinuities and contradictions also apply to whites. Much work needs to be done to understand and intervene in the ways in which whites are positioned *as white* in the language, symbolic, and material structures that dominate culture in the West and the U.S.—and, of course, we need to move beyond the static definitions of whites and blacks as they currently pervade existing research in education. This means, for example, that we should not continue to position all whites as the "other" of multicultural curriculum reform or other transformative projects in education. It means that in every local setting, particularly the urban setting, we must find the moral, material, and political resources for generalized affective investment in schools. Such an investment must be grounded in a critical reading of the differential needs of embattled urban communities and the particular needs of inner-city schools; and such a differential consciousness must constantly challenge individual constituencies to think within, but at the same time to think beyond, the particularity of their experiences and interests.

Contesting Racial Amnesia:
From Identity Politics Toward Post-Multiculturalism

Michael Dyson

I'm going to tell a story about the rise of identity politics and the background assumptions against which it is articulated. After telling this story—without knowledge of which it makes no sense to criticize identity politics—I'll then move toward what I'm going to call post-multicultural politics. There are three features that I want to highlight at the outset, to which I'll return throughout in discussing universalism, memory, and traditions, which are key concepts in discussions of historicizing the rise of identity politics as a symptom of the collapse of insightful dialogue about race in the United States. These three things are the moral hinges of my cautionary tale about rushing too quickly to de-essentialize without trying to account for the rise of—and the impulses for—essentialism. We've got to get beyond essentialism, but we've got to understand what produced essentialist impulses and how they were elaborated within African-American culture specifically, and how people have taken these issues as a defense mechanism against white racist hegemony and dominance, which is itself undertheorized because it's so often assumed to be universal.

The first hinge of my cautionary tale comes from Alastair McIntyre. In his book, *After Virtue,* McIntyre talks about the dissolution of a common vocabulary within which concepts like "the good" and "virtue" make sense. McIntyre is trying to argue, of course, against a kind of rule-governed conception of morality derived from rational principles, arguing against utilitarian calculuses, and so on. He's trying to get to a conception of the moral life that depends on the revival of a neo-Aristotelian sense of community, because he's seen the dissolution and unravelling of this

336

vocabulary—a vocabulary in which "the good" and "the virtuous" make sense—insofar as there's been a shattering, a fragmentation, of our own lives as moral beings. So "the good" means one thing to one community and another thing to another community; we no longer have a unitary sense of what "the good" means, or what constitutes "the good." And as a result of that, he sees a return to what has been characterized as communitarianism—a return to sustaining virtues, habits, forms of thinking and life, within a community, such that it makes sense to claim those virtues as something relevant to be pursued. So, in his understanding, the status of the universal was buffetted by fragmentation; the solution is a kind of reconstitution of community within these neo-Aristotelian pockets that sustain habits of life and thought that instantiate coherent beliefs about the common good. It's very important to remember McIntyre's argument as we discuss the various enticements and dangers of pursuing a notion of universality.

Second hinge. Michael Kammen, in his book, *The Mystic Cords of Memory,* speaks about the notion of selective memory. The selective memory is employed, in his understanding, for the aims of reconciliation, because it preserves dimensions of traditions that unify, versus traditions that are fragmented. And what he says is that selective memory is employed to reconcile this fragmentation precisely because it has the explicit and implicit need and desire to depoliticize and to cause amnesia, at which expense it maintains its tradition. So to criticize and to remember, for Kammen, is to confront uncomfortable aspects of traditions, forcing confrontation with precisely those hidden, obscured, denied features of the tradition that constitute alternate memories. To politicize is to problematize the tradition, and to remember is to recall the very elements that would undermine the possibility that the tradition could be sustained in the way in which it currently operates. Hence the need for selective memory, which reconciles the tradition, consolidates it by forgetting and depoliticizing.

Third and last hinge: Michael Rogin's notion of political amnesia, where he tries to combine certain aspects of Jameson's work in *The Political Unconscious* with Jacoby's work in *Social Amnesia.* The creation and reproduction of structured forgetting sustained by mechanisms of invisibility gives us as a paradigm Edgar Allan Poe's "Purloined Letter": it is rendered invisible precisely because it is hidden in common view. And then, at the boundary of my cautionary tale, a word from Henry Kissinger, who says that the politics of the academy are so vicious because there is so little at stake. That is worth remembering, because when we have all of this fuss about the academy, and we feel a sense of crisis, when you think about McIntyre narrating the dissolution of this vocabulary in which the crisis

has arisen, the point is to remember that people whose lives are really desperate can rarely afford the luxury of pessimism; they're too busy living on the surviving fragments of hope. This is a powerful caution for us to remember, and use to interrogate our own subject positions. As academics and public intellectuals trying to rethink and reconceptualize the prevailing forms of oppression in American culture, we have got to understand that people who don't speak the kinds of languages that we speak are already giving us evidences of their survival beyond the crises that we've imagined.

With these three frontispieces (or four, with Kissinger) operating, I want to narrate the following story. The civil rights struggles were, in a broad sense, about the sacred trinity of social goods: justice, equality, and freedom. When we look at the quest for civil rights, then, there are three things that have to be kept in mind as we try to rethink higher education and its relationship to a so-called Balkanized academy.

First, the "bloodless" revolution in civil rights legislation was achieved through a coerced adherence to declared principles of democracy. The Civil Rights Movement was a long-deferred elaboration of egalitarian tendencies in American political culture, and it was not simply the reorganization of American life in a linguistic sense, such that the language changed, and people's conceptions and self-understanding were mobilized in different directions. It was actual political practice that *forced* the rearticulation of certain conceptions of justice, and freedom, and equality to take place. There were bodies on the front line in Birmingham and Selma, in Georgia; there was actual, sustained, concrete, political resistance and opposition that forced the academy and the larger American society to rethink its relationship to conceptions of race.

Second, the Civil Rights Movement was about the casting of the historic quest for freedom in the modes of behavior and the language of civic piety that linked the black freedom struggle to the ideological center of democratic culture. So when we talk about the exhaustion of the language of rights for articulating black concerns, we have to pay attention to the way in which what happened in the Civil Rights Movement was the appropriation of the language of civic piety, which was quite resonant in American traditions of civic response and contestation; likewise, when we talk about notions of civil religion, we also have to understand that Martin Luther King, Jr. was an enormously dextrous and skillful manipulator of both the rhetoric and the means of civil religion. He articulated his specific subject position as a black Baptist preacher, whereby he supposedly awoke from his dogmatic slumber at Boston University, and he linked his specific appropriation and understanding of freedom to a larger culture which was already in place. The language of rights is already in

place, and so what he does is appropriate this language and use it. In one sense the argument can be made that what King was doing was showing the ideological flexibility—although I think we ought to contest that—he at least showed the interpretive flexibility of documents like the Constitution and the Declaration of Independence to accord with notions of freedom, justice, and equality that were produced by concrete political praxis and opposition.

But we've got to get the order right here. It's not that people in the academy were having discussions at the Unit for Criticism and Interpretive Theory about what we're going to do about these black people. They were out there being bitten by dogs, bicuspids and incisors were tearing into their flesh, and that rearticulated and reorganized conceptual practices and discursive formations. That's what went on—actual political practice. I was thinking, during Todd Gitlin's presentation, what difference does it make when we tell that story? And the difference it makes is that you not only understand the priority of certain forms of praxis to theory, but you understand the ways in which, unless we can theorize them in adequate ways, the practices don't even make sense.

Thirdly, there was the fusion of the pursuit of racial reconciliation with the concomitant rejection of narrow interpretations of racial equality, distancing both black nationalists on the one side and white racialist/ nationalists on the other side. This, then, in my understanding, put in place the realization of certain features of democratic equality—that is, the realization of access to social spheres and social goods, the more equitable distribution of social goods like education, employment, transportation, and so on. But it failed to fully satisfy the cultural and even the psychic demands embodied in the quest for freedom, equality, and justice. So when we talk about the social structure of realities, we must see as a background the immediate foregrounding of certain narratives of self-esteem that only make sense in relationship to these larger social structures and economic realities. When we talk about notions of self-esteem, then, they are never depersonalized realities; they are always linked to larger social realities. For instance, if you live in a culture that mediates conceptions of negative black identity to you through television, media, theological tracts, discourses from centuries before until now, in an uncontested, unproblematized, unitary fashion, then it is fundamentally disingenuous to problematize and conceptualize essentialism, and theorize about it in the context of African-Americans who have appropriated these identities, without talking about those forces to which they had to respond. And it is disingenuous precisely because the very problem to which they were responding in the Civil Rights Movement was the problem of the bourgeois liberal opposition, which did not pay attention to the psychic de-

mands of the movement. Of course, King picked up on this right near his death. He sounds like a nationalist when he says that the problem is to revive the Olympian manhood of black people. That's a page right out of Asante, in one moment, and Malcolm X in a certain sixties black nationalism. Hence the prominence of sixties black nationalism centered on a crucial question of life's identity.

"Identity"—for several reasons. First of all, there was the devalued African past, constructed such that narratives of recovered racial identity became crucial precisely because this element was most obscured, distorted, and elided. Not only social goods were at stake; there was also an explicit appeal to the centrality of the quest for identity, because people were trying to figure out, are there Africanisms, are they being continued over in American culture, how should we understand the debate between Frazier and Herskovitz, what is all this history about? It is about the quest for identity that was deliberately withheld from people of color. Linked to this, then, are narratives of self-esteem that are crucial to people whose denial was predicated on their supposed intellectual and personal inferiority, not simply as individuals, but collectively as blacks. The uncritical notion of blacks being evil, and inferior, and unintelligent informs personal perceptions and how people feel about themselves.

This third feature played on the desire to be liked by people who formerly—or formally—despised African-Americans. To be accepted as intelligent, as beautiful, as worthy. White validation and legitimation, all signified partially in the Civil Rights Movement's quest for inclusion, which also included elements of reconciliation that undercut its own racial memory, was being almost avoided. So we get the phenomenon of black intellectuals who, after a quest for white legitimation and validation in the academy, continually seek the validation of white people in order to say "I'm OK—and if I'm OK and you like me, then I'm *really* all right." And this is part of the engine that drives the revival of a certain category of racial formation that *is* essentialist, and a kind of identity politics that is central to various forms of black nationalism. It may distort the social, political, and economic structures that make it possible, but black nationalist politics also provided an important check to the fantasies of unproblematic reconciliation and inclusion. It focused on identity, both civil and personal, as a crucial pillar of racial advance. It rejected the premise of "I'm OK because you like me" not simply because it was personal, but because it was the basis of group ambition and achievement. Thus there was a tension between the quest for inclusion and reconciliation, on one hand, and autonomy and recognition on the other.

This is one of the central tensions between the black bourgeois liberal response and opposition to white racist dominance, and the black nation-

alist upsurges in the sixties. In part, then, the politics of racial essentialism arose as a defense mechanism against the ominous gaze of white authoritarian regulation of black being. That mechanism doesn't acknowledge the flexible, fluid boundaries of race, the socially constructed means by which race is reconstituted over space and time that is both a source not only of irreducible categories for social theorizing, but of the stakes of "personal" identity as well. Therefore, what arise are rhetorics of authenticity that are reasserted—especially in times of crisis of identity precipitated by white racist attack, whether in Alabama and Georgia, or in the narrowing of boundaries of political meanings in the Reagan-Bush era. Racial essentialism is linked to the assertions of identity politics precisely because this era has erased the memory of the context of struggle that helped, in one sense, determine this present historical moment. Depoliticization and amnesia have created, then, an artificial legacy that obscures the real problems, and encourages the circulation of stories that are only half-true. Identity politics is not, for instance, a "private" politics of special interest. What constitutes identity, personal or collective, is quite public—socialization processes, ranges of images that create and reinforce perceptions that are the basis of self-identity, and so on—and the critics of identity politics often miss that point. We can say that if racial essentialism and identity politics are linked, not naturally but by social choices and imposed constraints, then their advocates are not the sole owners of the means of reduction.

On the other side, the critics of identity politics and essentialism (myself included in certain ways) who appeal to conceptions of unity and universality, mask their roots in particular and specific traditions which masquerade as universal. Thus universality and unity are often achieved by racial amnesia, because the goal of unity is the reconciliation of difference and oppositional discourses at a certain level, even though the discourse of multiculturalism ostensibly concedes space to oppositional practices within an environment. But again we run into the operation of depoliticization and amnesia, and in regard to race, critics of identity politics rightly criticize a narrow focus on authenticity and loyalty to the race that are the governing tropes of identity politics. In one sense you can never adequately answer Billy Paul's question: Am I black enough for you? And when you start down this slippery slope, you can never determine who is really black. As a result, you come up against a perennial contestation over an increasingly narrow sphere of racial identity that is up for grabs in interpretive warfare.

So, against an uncomplex criticism of identity politics that fails to understand why blacks are suspicious of such criticism, I want to try to pose a few plausible explanations about why some people, in this case

African-Americans, but also other so-called minority peoples, may be sus-
picious of the de-essentializing impulses that persons like myself and Cam-
eron and others want to press. Then we can try to figure out how we can
move beyond these essentialist impulses to this radical post-multicultur-
alism that I want to imagine.

First of all, this notion of de-essentialized racial politics tends to
mask the reasons for differentiation, and to rearticulate blacks and others
as special interest groups. Over the last twelve years, we've seen the col-
lapse of the will to undo the legacy of past racism with immediate in-
tervention, both in the private and public spheres. And what is often not
talked about, even by Bill Clinton, is that the fierce rivalry among pre-
viously denied groups for the politics of public attention masks the anx-
ieties of the real source of that contestation, because one rule seems to
prevail: One at a time. Not Latinos and African-Americans, and gays and
lesbians and so on, we can't have all of them competing for the politics
of public attention. One at a time. What seems to apply is an implicit
rule that the distribution and regulation of social goods can only be gov-
erned by this zero-sum thinking, to which the system is hostage. Moreover,
there is a deep suspicion among many people that it is the height of
hypocrisy to caution and chasten African-Americans about identity politics
in a land that has continually witnessed the appropriation and commo-
dification of black identity for its own uses. We don't have to talk about
slavery under this heading, we can see this in terms of black popular
culture. We can see the commodification and appropriation of black gay
identity, so that it's not that Sylvester becomes the famous person nec-
essarily, it's K.C. and the Sunshine Band. It's not the black agrarian blues
of Little Richard that gets the play, it's the rock 'n' roll of Elvis Presley.
It involves the commodification of black cultural imagination at the site
of the hip, the chic, and the cool. And even though Michael Jordan gets
paid big-time, funky-fresh, dope, stupid money, most people do not realize
the benefits of it, particularly those black kids who look at Chicago Stad-
ium and who can never buy a ticket to get in to where Michael is doing
his air time, even though his will to spontaneity, his will to edifying
deception, and his notions of deifications of accident, as Herskovitz talks
about, are all beautiful, and I love to see them. But when black people
then reappropriate notions of cultural identity, all of a sudden it becomes
an off-limits game—after their very identity has been appropriated and
domesticated and diluted and commodified for the interests of American
capital and the larger society.

Now that I've said all of that, I want to move toward what I consider
a post-multicultural politics. First of all, I'm aware of the kind of faddish
title that this represents—post-everything. I think, though, that we have

to find some way of problematizing the implied consensus that places unitary conceptions of multiculturalism with discourses of pluralism and diversity at the center. First of all, my conception of post-multiculturalism would dismiss the quest for legitimacy that strangles so-called minority cultures from within and without. Part of the problem that has not been addressed in a serious way by the left—and again I refer to Todd Gitlin's provocative paper, which I'm trying to argue with him about, because I do think we have to transcend identity politics somehow—is that we've got to find a way of respecting the integrity of particularity, and to understand what forces drove the engine of quests for and rhetorics of authenticity, legitimacy, and loyalty. I have tried to narrate a bit of that. But in my own post-multicultural sense, we would dismiss the quest for legitimacy that strangles not only from without but from within. I think of my students at Brown, who try to say that certain people can rap and certain people can't rap, black people can rap and white people can't rap, white rappers can't criticize black rappers as being inauthentic because they're not black. And I say, what's the problem? Then they invoke Malcolm X and they say that if Malcolm X were here today he might call you the biggest sellout because you're attending an elite, white institution debating forms of black culture and consciousness and not being linked to progressive forms of realization of that within the larger society. So you can never stop it. The quest for legitimacy is perennial precisely because nobody has the markers and boundaries, and they're always slippery and sliding, which teaches us profound lessons about the nature of race to begin with.

Second, we have to move beyond modified universalisms, glimpsed in a multiculturalism that buys into consensus and a notion of wholeness, and link particularity to the possibility of reconceiving the whole so that *coherence,* and not unity, is the operative category. Now, this could be splitting hairs, but I think there is a difference between talking about notions of coherence and notions of unity. Some might see one as predicated on the other, or claim that they're synonymous, but I disagree. I think unity designates an uncontested terrain where people are brought together, whereas resonant notions of solidarity imply that these diverse coalitions can be brought together with a coherent conception of opposition to forms of practice within higher education and larger American society. Third, I think we can have this coalition of interests that respects the integrity of particularity, while seeking, in this case, race-transcending grounds of common embrace, so that we move beyond pluralism to a concrete interpretation of what diversity really means, of what Cornel West and Henry Louis Gates talk about in terms of interrogating the moral content of our identities. And when we interrogate that moral

content, what we begin to do is then automatically link them to other like-minded people, whether they be gay or lesbian, whether they be environmental activists, whether it be white men and women who are interested in resisting forms of oppression, and so on. The moral content of our identities is not merely shaped by our own historical and personal experience, but we refer to them as we make expansions across the barriers that divide us.

And finally, and most forcefully, I think that what this forces us to do in a post-multicultural moment is to move beyond the academy, which is why I opened up with Brother Kissinger. Kissinger is right on very few things, but I think he's absolutely right that, in one sense, the university is an artificial environment. And of course, we want an artificial environment to protect young seekers after truth, those who are obeying the Delphic oracle's injunction to know thyself. We want to have a protected environment, but we want to contest who those selves are, how they get constructed, who has a say in making them who they are, so that the narrow, militaristic conception of "be all you can be" gets problematized, and so that when we begin to expand the range of understandings about *what* persons are and *who* persons are, a post-multicultural moment moves that range of understandings beyond the academy. Because the university is necessarily an artificial environment, and an insufficient environment within which to test the greatest ideals that we can generate within the academy. So I am arguing for a public intervention that is not simply predicated upon an elitist condescending stance, but a stance that takes seriously the actual people for whom we seek to speak, and on whose behalf we speak, so that our own understandings will not only be rooted in a provocative theoretical base, but linked to understandings of people's actual, everyday lives.

Discussion

JIM HALL: I teach in the African-American Studies department at the University of Illinois at Chicago, and I'd like to ask Cameron if he could suggest what kind of pedagogy this critical stance on essentialism might translate into.

CAMERON McCARTHY: A fundamental issue is the intellectual autonomy of kids and teachers in the classroom. I mean the centering of kids as knowledge producers in the world, recognizing that they stand in the world as writers in relation to all the great literature they might ever read; that must be a central informing element of the way we think through these questions of educational change. What educational multiculturalism

really raises, then, is a very dynamic issue, one that can potentially liberate the classroom from the hegemony of textbooks and the textbook industry. That is, to open up the possibility that kids might have access to multiple resources, that they are able to do their own research and come to conclusions about the world.

There are also things about the relationship of the community to the school that need to be explored. Look at the practice of Afrocentricity on the ground. What you see for the first time is an effort to interpret urban communities, which schools don't. Schools exist as armies of occupation in urban communities. Teachers come in and they go out, and this is true of black teachers as well as white teachers. And the participation of the urban communities in what becomes the agenda of schools is not encouraged, or worked through, or thought through.

Finally, there are things about the actual labor process of teaching that we're not thinking about. Teachers are severely underpaid in systems in this country, and there's a whole instrumental relationship and corporate organization of schooling in which principals are not instructional leaders but administrators on site. Consider as well, for example, the way something simple like off-periods is organized, in this case such that people in the same department don't have the same time off to collaborate. These are some of the very concrete things that have to be talked through.

MICHAEL DYSON: I want to echo what Cameron has said. However much we may criticize Afrocentrism in theory, we need to look at how it responds to local communities. One of the attractions of people like Leonard Jeffries is that he is trying to address the absurdity of the everyday forms of capitulation to despair that he views around him. And part of that has to do with style, of identifying with people and then saying, "Yes, I know what that means." And even though I've been quite critical of Jeffries, and of people like him, one of the things we have to understand about him is that what he says to people empowers them. He's trying to translate what he's thinking about to what people are doing, and how they actually live. So I think one of the things we can do is embody, as teachers, our politics of style and encourage our class, our people, who engage with us in the process of learning, to be empowered, to become—I'm a radical traditionalist in this sense—seekers after truth, problematizing what "truth" means.

KAL ALSTON: In looking at the academies for African-American boys, one of the paralyzing problems has been what to do about the girls. The same discourses that empower boys don't necessarily empower girls. It is as though the girls don't live in the same houses, as though they don't walk

through the same streets, as though they don't live in the same communities, and as though mothers and female teachers all of a sudden have become inadequate. There was a political problem with this line of critique because, as things fell out, the people who charged the cities with inequity—NOW's legal and educational defense fund, and the ACLU—were groups that are not inside those communities, so the critique went nowhere. But in fact, there were mothers of daughters and teachers of girls who were resistant to the notion that boys were in crisis, if that meant that now all of our energy was going to go to the boys. I think you reach out for the solution that makes the most sense at the moment, because of this paralyzing sense of being besieged. You don't stop to contextualize and say, "unless we fix the things in our communities that are wrong for both our boys *and* girls, we won't *have* a community for those boys to thrive in." There are profound educational and moral implications to the educational decisions being made now, but city school districts probably don't have much stake in them, and so aren't interested in pursuing them. It's important to bring those issues into the schools and into teachers' and parents' minds.

BRUCE WILSHIRE: Cameron's and Michael's talks helped me think about my own life and teaching, and think about the whole history of essence and essentialism and how difficult it is to escape its most stultifying forms and see the world afresh. But if you go way back in the history of philosophy, for Plato and Aristotle the essence of something was just that set of characteristics essential for X being X, that's all. It was a showcase of finished forms. Later, William James had a chapter in the *Principles of Psychology* entitled "On 'Essence.' " But notice, he puts the word "essence" in quotes. So why did he use the word "essence" at all? The fact of the matter is, in any mode of interaction with the world, certain features are essential for identifying a thing of a certain sort, essential for identifying any X. But it's such a short, slippery step from that to inferring that those features are essential for X being X; so you get that slippery slide from "features essential for identifying X" to "features essential for X being X," and then we're back into essentialism. So he used the word because we've got to keep identifying things. There's no civilization without identifying things, and of course we're in a corporate body, or bodies, that are constantly identifying things. Yet we must constantly struggle against essentialism, and struggle against that slippery slope back into essence in the most stultifying form. This demands of us what I would call a kind of phenomenology of a grass-roots sort—fresh perception of the actual situation in front of us. My own feeling is that this is extremely urgent;

it's like an ongoing revolution. We must repeatedly escape the snares of essentialism. We just have to keep at it.

DYSON: I love this term "grassroots phenomenology." I got to rip that off. No charge? I think that you've put your finger right on the pulse: the paradox for those of us who want to resist certain essentializing tendencies is how, then, do you maintain identity, because you've got to have identity. In a sense, you've got to say both what something is and what it isn't, so that some things do remain constant.

I mentioned in passing Herskovitz's notion of the deification of accident. Now Herskovitz says this is something we can find in African and African-American cultures; it's a preoccupation with living on the slippery edge, with constantly trying to mobilize passions and energies against perceived limits, whether this is Michael Jordan, or a preacher on Sunday morning, or a rap artist. These are common features, but they are also *historically produced* features that have been transmitted culturally over space and time. That's different from a notion of essential identity, one that says, "without this category or without this element, this person no longer qualifies as being—in this case—African-American." That wrongheaded approach to the whole notion reveals the worst features of essentialist thought. On the other hand, we can employ the term bell hooks uses, the "privilege of familiarity." For if we abandon essentialism altogether, and pretend that everybody has equal access to notions of what it is to be black—pull this leg and it plays "Jingle Bells!"—that ain't how the whole thing works either. You have to have familiarity. It's hubris to assume that anybody can go in and say, "I can identify the properties of what it means to be African-American," or talk about "African-American expressions of music or jazz." You want to chasten the defiant hubris that assumes everybody is equally accessible, that all cultures and understandings are accessible in a certain way. So I think you're right. The slippery slope is that, on the one hand, we don't want to think of humans in terms of essences, but on the other hand, we don't want to erase the notion that we have to identify properties, notions, human beings, thoughts, and constructions.

STEPHEN DAVID: I have three questions. First, I'd like to know to what extent is the de-essentializing of notions of race an attempt to maintain the politics of race, while at the same time moving beyond the reproduction of race? My concern here is whether it is possible or desirable to move beyond race when we talk about multiculturalism, various kinds of culturalisms and culture, or whether we're not simply substituting something else for race and calling it "culture." Second, in Michael's notion of post-

multiculturalism, will we ever get to a time when it's possible for black or non-Western entities to be admitted into this subjectivity called Western subjectivity? And third, I'd like to raise a concern, perhaps to everyone. Even in the papers you've presented, and those that have been presented here both by black and white speakers talking about marginalized groups or minority groupings, we've talked of African-Americans, we've talked of Latinos, we've talked of that indistinct group called Asian-American, but at no time in this place have I heard people mention Native Americans. And in the one year and nine months that I've been here in the United States, I've hardly ever encountered discussions of Native Americans. In fact, on this campus the only time it has come up is in the controversy over the mascot of the football team, the Illini. The other times I've encountered "Native American" are when I go to the museum. It seems as if you only encounter the Native American in the museum or on the reservation.

MCCARTHY: If I could start with your last observation first, that is, not talking about Native Americans: I think that this is why I stress the notion of dialogue, why I stress being humble about your perceptions of the world and your theories, while remaining, as much as possible, open to other possibilities, other points of view. Because there is always a blind spot in the way one formulates things. As Stuart Hall points out, even the most liberatory or emancipatory discourse has a kind of figured masculinity, a kind of class identity in operation, so that it blocks certain issues. So I inevitably stand to be criticized on this score.

Now, the "Western subject" is very much the silence against which I speak. "Westernness" is not typically problematized; who is in "the West" is not problematized—specifically in relationship to the United States. That's why I call attention to the easy collapsing of Europe into the United States; I want to identify this as a strategy and a set of strategies, not only in intellectual discourse, but in popular discourse and in the institutional apparatuses of the state as well. There is a problem with "the West" as soon as you take any historical perspective on the thing that centers it; "the canon." At the beginning of this century there was no American literature—white, black, or green—being read in university "canons." Today there is no Canadian literature, or Australian literature, or any other "foreign" literatures in English, seriously being read in American schools. Once you begin to examine what is taken as "Western civilization," you find that Western civilization as a course of study is something that starts in the United States; it's not taught in England or in France. I certainly didn't do it in high school in the Caribbean. It is a

construct, like the idea of "free enterprise." It's a construct, not a given, so we need to problematize it.

In looking at essentialism, it is very useful to have the history Michael set up for us. But what we have to do now, whether we like it or not, is engage with the politics of difference as it exists in our time. Despite its negative elements, I think that implies grappling with essentialism's creative dimensions, which are not being acknowledged. Some of the most vitalizing discourses we've heard in the universities are being spoken now; we need to accept that. At the same time, and this is my last point, we want to move to a place where communities disempowered in the past can speak with voices, and have effects in the world, in a setting that informs any new dispensation, any new disposition. That is the key to identity politics in our moment: we want to sit down as equal voices to determine what the resolution or dispensation is going to be.

JERRY WATTS: I just want to say something real quick. I think both your talks are basically wrong on many things, and I'm going to tell you why. You describe essentialism very well, but it seems to me that you mislabel a lot of what's going on with these black folks. What *is* going on is not who constitutes blackness, or what's authentically black; it's a relationship. The notion comes from a valorization of victimization and the belief, given Judeo-Christian discourse, that victims occupy a particularly high moral status in the culture. So why is it one victim at a time? It's because at any given moment there's contestation over who's going to monopolize the status of the victim. We've got two problems here. One is that we are in a situation where "identity politics" arises, and I think you're right, Dyson, about how it arises originally, where it comes from, and why it developed the way it did. But at some moment there arises a myth that subjugation breeds ethics, and then that becomes infused with a lot of academic discourse; that's a canard we've got to reject. On top of that, the idea that identity politics is a primary form of politics now presupposes that guilt is, in fact, very operative in this culture. And guilt is a social relationship. You can't have guilt unless somebody's granting you this status of being guilty and so forth, and identity politics around guilt arises at precisely the moment where I can empirically show Americans have least concern for the subjugated. What's going on in identity politics is precisely a response to the absence of blacks now occupying a victim status, because blacks in some sense, in the popular media, are being portrayed as victimizers. So, we're now conflating the authentic materiality of subjugation with the ideological cover called "victim." What Stephen David's talking about is that the Indians do not occupy victim status. They're subjugated, but they don't generate mass guilt in American sensibilities.

You've got to have a certain kind of political power even to occupy the status of victim, which they don't have. There is no other primary moral discourse that we've invented yet in this culture for dealing with questions of subjugation. And this cuts across lines of identity politics and discourses of black unity, Leonard Jeffries and Martin Luther King. For instance, neither integrationists nor nationalists can deal with the critique of black female victimization *vis-à-vis* black men; that undermines in their mind the ability to generate a black victim status, since you cannot have a victim status if you are simultaneously occupying the status of victimizer. So the "victim" always wants to be singular in the appeal it makes, and it doesn't allow for any kind of multiplicity of identities. The problem's not nationalism. Black nationalism is bound up in discourses of economic solidarity, we know that. The problem is that the dominant ideology allows for the articulation of subjugated folk, but only in a discourse that's linked to the assertion of one's status as victim. Now, how do you create a democratic discourse around that?

DYSON: You done said about eight million things, man. I want to return the compliment because I think you're fundamentally wrong, but I think that in your hyperbolic overstatement you're absolutely right. You're right in the sense that your analysis of victimhood and victimization is quite accurate in many senses, but I think you set up a straw man. My narrative didn't have anything to do with guilt. Still, your point is well taken insofar as Gandhi, for instance, couldn't have made the moves he might have made if he were agitating for independence in South Africa; they would have just killed him. End of conversation. Ain't no mass movement going on. And had Martin Luther King, Jr. *not* been a political actor within an environment that allowed him to appeal to certain beliefs resonant in the Judeo-Christian heritage, you're absolutely right—they'd have shot him, another dead nigger, case closed, move on. Whereas the reason King is able to talk to his antagonists, to people in Birmingham beside Bull Connors, to people who are Senators, and to Americans who watch the news at night and see dogs tear into people's flesh, the reason he's able to appeal to them is not simply guilt; it's a shared conception of what it means to be good—despite what McIntyre says about the dissolution of that vocabulary. At a certain gut level, people are incensed at this, not simply because of guilt, but because they share a certain consensus about what it means to be human and to participate in the public good. So I think in one sense, Jerry, even though you've got a powerful analysis of the discourse of the "victim," that's a straw man argument, because you make a distinction between the ideological cover on the one hand and victim status on the

other, when sometimes that status is real and contains an appeal to a common sense of the social goods of freedom, equality, and justice.

TODD GITLIN: I approve of disassembling terms like "identity." Now I'd also like to start disassembling the one called "empowerment." I was troubled, Michael, and surprised to hear you talk about Leonard Jeffries empowering the people that he talks to.

DYSON: Well, that's not all he does.

GITLIN: Well, no, but you did say that. Empowerment has a very good rep these days, you can't find anyone who's against it, from management training sessions to insurgent groups on campus. For that matter, Colin Powell is enjoying a spurt of empowerment and liking it quite a lot. It's perfectly evident why this is problematic. The Serbs love the kind of empowerment they're getting, and the cops, Stacy Koons and his friends, got a big empowerment rush, and so did the guys who kicked the shit out of Reginald Denney, and so on. And this is not just a nitpick, because it points to a fundamental problem in privileging any category, and then assuming that any instance of it is automatically a good thing. So empowerment becomes virtuous, without regard to the question of empowerment over whom with respect to what.

DYSON: That's well taken. I wrote a piece for *Emerge* magazine on Leonard Jeffries, which they called "Melanin Madness," and I got all kinds of hate mail from black folk. Then I was on radio programs and they'd call me Uncle Tom, handkerchief head, sellout, negro that white folk love, you know, things like that. And I was quite critical of his romantic impulses and his—more than romantic, I think, problematic—valorization of certain conceptions of racial privileging that, left unchecked, dead-end in all kinds of false readings of politics that don't empower the very people that he seeks to empower.

JEFFREY HERF: You're right, in a sense, that Leonard Jeffries does empower people, but what Todd was saying was that . . .

GITLIN: They get off on it. Lots of people got off on Hitler.

HERF: There are a lot of people who could empower other people for terrible purposes.

DYSON: Of course; that was Todd's point, and I agree with it. But let me clarify. That is why I tried to describe the background of identity politics by paying whatever attention to historical detail I could in thirty minutes: I want to try to specify these background assumptions so we can understand what people are being empowered against. Now, Shelby Steele takes a different tack on these things. He talks about subjugation and victims—ironically, in ways similar to Jerry, not that I want to leave Jerry connected with Shelby—but he's not talking about just any kind of subjugation. Shelby Steele says that people use racial rhetoric as points of privilege and power. He says that on campuses that he knows about, black students appropriate the language of victimization, and then use it like a club to beat white students over the head. So you have tension between white students who feel clubbed over the head because they're not black—as in the statement Cameron read from those students: well, I don't have an ethnicity, boy, everybody else has one, I need to get one. And on the other hand you've got resentful black students who are saying nobody wants to take responsibility. For instance, when I graduated from Carson Newman College, where I went to study philosophy, I graduated with straight A's in philosophy, mastered all this stuff, got this fellowship directly to go to Princeton and study, Ph.D. program, and a white man who never met me before in his life told me, "You know, you're not going to Princeton simply because you're black." Now, I didn't want to get *ad hominem* on him or use the old strategy of just talking about his family. But I didn't know. I said, well, I didn't realize that was the case. So what do I have a choice of doing? I have a choice of thinking, well, I can now view myself through the prism of white authoritarian regulation of who I am, through white descriptions of myself. To me, the Shelby Steele narrative gives you a life where you're always worrying about what white folk think about you. Oh my God, I'm at a school now, at Princeton, where white folk think I'm here because of affirmative action. Well, so what? I'm still getting educated. I'm still trying to think, I'm still trying to reflect on the very problem of what that means. The point is that it makes a difference, but you've got to narrate those background assumptions. Then when you take stock of Leonard Jeffries in that context, you get to what I meant about empowerment. And it is—I think Todd is right to point to this—it's a seductive empowerment that's ultimately unsatisfying. But we can't deny that people get surges and charges and empowering feelings and reinforcements, in the negative sense of that word, and that they also get connected to a narrative that tries to tell the story about what they feel and why they feel it, and what their actually existing subjugated status is, even though I think it's wrongheaded and it misses the point. But *that's* what's going on, too.

Identity and the Status of Afro-American Intellectuals

JERRY WATTS

I want to start with a quick story. Recently I received a request from the Anti-Defamation League asking me to respond to a book that was published by the Nation of Islam, *Secret Relations between Blacks and Jews,* a book that has gotten quite a bit of publicity as a result of a prominent op-ed piece that Henry Louis Gates wrote for the *New York Times.* I received this text from the Anti-Defamation League with a note indicating that they wanted me to respond to it, that they were going to compile a collection of responses, and that Eugene Genovese and C. Vann Woodward and other historians were also replying. What is interesting about this book is that the individuals who wrote it for the Nation of Islam mention very early in the introduction that the sources of the material used are publications by Jewish authors, and they said, more or less, that this is a study based on what "they" say about "themselves." In the text, the primary sources are articles from journals published by the Jewish Historical Society. Now the book contains lists of many Jewish slaveowners on many of the Caribbean islands, Barbados, Antigua, and so forth, and they list Jewish participants in the Dutch West Indies company.

On one level this was hilarious to me, because what the Nation of Islam people had found was a generation of ethnic celebration literature; they had found a body of ethnic celebration literature around the 1890s and early 1900s, where Jewish writers were *celebrating* Jewish participation in the slave trade. They had quotes like, "there couldn't have been slavery in Antigua without Jewish participation," just phenomenal things. Whoever did this research went and found this material. Now, what struck me, besides the weirdness of finding this ethnic celebration literature that made all these overstated claims, giving the Nation what they wanted to

say about Jewish participation in the slave trade (though, of course we know there were Jews who participated in the African slave trade), was that the ADL was asking me to write a response to this even though I had no expertise in this area. They listed Genovese, listed Vann Woodward, Curtin, and so forth, and I said, well, why the hell would they ask me? And of course it had to have something to do with being a quote-unquote Negro; it dawned on me that I was supposed to participate in my own commodification, to participate in what was supposed to appear as some democratic response that would include me. The irony is that I was supposed to participate in this commodification in response to a text based on a similarly crazy reification: remember, *this is what they say about themselves.* And I was supposed to say, well, what they say about themselves, according to me as a black person, is insufficient. Which it is, but that's not the point.

Second story. As a graduate student, I did a lot of work studying the politics of Jewish-American intellectuals in the United States. In subsequent years I have gone back and tried to work on different texts and so forth, and I must say that I had, on one occasion, submitted a critique of neoconservatism, focusing on the New York Jewish intelligentsia, to a major democratic-socialist journal. I called it "The Americanization of the New York Intellectuals." What my thesis was, essentially, was that the avenue to mainstream authority in the United States among intellectuals always comes through the right. The right has the authority to endow cultural legitimacy in ways the left does not. The primary way, it seems to me, that outsiders become legitimate is to participate in defining others as illegitimate. By being able to do that, you back-door yourself into a position of authority. You cannot begin to think of the possibility of a John Kennedy without an Irish-Catholic-led Father Coughlin and McCarthyism. Those people and movements helped to generate notions of authentic Americanization for Irish Catholics, who built Irish-American authenticity by finding other Americans inauthentic. What I was claiming was that part of the currency the New York intellectuals gained in their attempt to become authentically American involved delegitimating some of the claims made by Afro-Americans. And I argued that part of the cutting edge of the acceptance of Kristol, Glaser, and so forth within traditional conservatism, which historically had been deeply imbedded in anti-Semitism, had been their ability to level a certain kind of critique of Afro-Americans, and to have that critique be viewed as something less than racist.

An eminent democratic-socialist wrote me back and told me—he did not comment on the subject matter of the article—that I should stick to what I knew best. I had published in the journal before, and have published

there since, and I understood that I was supposed to stay within the confines of a racial discussion, and that if I stepped outside of that I would become an interloper. I was a little bit shocked by this, but it reminded me that, after all, my race is a commodity. It generates more authenticity for me to appear in certain places, not necessarily to be heard, but to be seen. But by the same token, the mere act of trying to speak about certain issues, because of who I am as a black intellectual—and other black intellectuals have had this problem—delegitimates my ability to participate in other dialogues.

This remains a widespread problem in the Afro-American academy. One irony is that it leads to an intellectual self-definition forcing one always to be very conscious about devising strategies around which to navigate the ways in which race circumscribes what we can say and the validity granted to what we get to say. We know, for instance, that Afro-American Studies is one of the most frequently attacked arenas of study within the current debates around higher education. The question of the legitimacy of Afro-American Studies is deeply imbedded in the contemporary American academy, structurally and culturally. From their inception in the late 1960s, Afro-American Studies programs were deeply stigmatized. In part, the stigmatization stemmed from the devalued status of all things black, even including creative artifacts like music and literature produced by black people, but it also stemmed from the fact that black people were often housed in these programs.

The second major source of the stigmatization stems from the fact that these programs arose as an academic concern on the wings of political protest. So unlike other departments, which were dropped from heaven, Afro-American Studies programs were seen as a political trade-off which supposedly undermined their intellectual legitimacy, a trade-off to loudmouth black students and progressive white ones. This was the case at places like Wesleyan, Harvard, and so forth. The initial politicization of Afro-American Studies, I would argue, could not have been avoided. These departments did not arise, as Michael Dyson mentioned earlier in another context, after quiet faculty meetings where someone got up and said "I think we should have an Afro-American Studies program. It's only befitting of Amherst College and so forth that we study these Negroes or let them speak or whatever." But Afro-American Studies arose, and was viewed as, a constituency service, and this has always been deeply imbedded in the idea that Afro-American Studies is part of the parochialism attributed to blacks, that we only have Afro-American Studies because we have black students. We know that there were individual scholars working in the arena of Afro-American Studies long before it was codified into a department or discipline. These individuals were, by and large, devalued as

scholars. In some sense the subject matter that allowed Afro-American Studies to occur was a subject matter that was inherently devalued. For instance, the major place where black people were studied, of course, arose in hand with history and in the area of anthropology. Anthropologists studied less-developed people, and Africa was therefore piggybacked into the academy on the basis of anthropology, following these Harry-Johnstone-type narratives of people journeying through Natal and so forth, but it emerges within anthropology. It has been challenged in anthropology, of course, when Boas, Herskovitz, and others emerged in the early decades of the twentieth century. This work, in fact, opened up spaces for the beginning of a perception, at least within anthropology, of Africa as bearer of something other than deficit and inequality within the dominant social sciences. Within social sciences, the dominant paradigms had always been centered around traditional modernization theories—Marx, Weber, Durkheim and so forth—and these theories, again, inevitably left Africa in a state either of prehistory or on its way to becoming like us.

These traditions were permeated by the explicit attempt to universalize European societies as the most advanced and the norm for all aspiring, would-be civilizations, teleologies of development, and so forth. This line of argument comes and goes, and actually makes up the dominant strain of political science that I was trained in during the early 1970s, when political development literature was still operating under modernization paradigms. In effect, the study of Africa is negotiated through either modernization theory or anthropology, and it was clearly an Africa which existed as a negation, or as a historically earlier moment in time, of Europe. On the domestic front, we had the same type of discourse out to define and construct a perception of Afro-Americans that would also lead to and legitimate inequality. This runs right from the prevailing Social Darwinism in the States at the turn of the century, which Du Bois confronts and tries to rescue a notion of Afro-American humanity from, through the beginning—and it is a strange moment here—of something we call the Chicago School of sociology, where Robert Park begins to bring blacks themselves into certified positions within academic sociology. Du Bois had been there earlier, but his work in *The Philadelphia Negro* had not been adequately recognized. Park brings Franklin Frazier, Charles Johnson, Horace Mann Bond through the University of Chicago program, and we begin to see a counter black discourse emerge, again, trying to perceive Afro-Americans as existing in something other than a deficit to white folks. But Afro-American scholars were burdened with the fight to reconstitute and define a new vision of Africa, and to do so with a new vision of Afro-Americans as well, because the perception of Africa and

African-Americans as part of the African diaspora certainly stigmatized the Afro-Americans.

You can see this in the work of Ralph Bunche, early on in the thirties, where he explicitly views a counterracist historiography and antiracist historiography around Africa as naturally increasing the cultural status of Afro-Americans. It doesn't take much to perceive that. Yet regardless of the quality of the work they produced, it was who they were, and their very subject matter, that would hinder their material mobility within the American academy. Regardless of what Du Bois was writing, he was not even going to get a job at a place like Trinity College, much less Harvard or Yale. We get the supreme irony of the American academy when, in 1948, we get Franklin Frazier as president of the American Sociological Association when he can't get a job in a predominantly white institution; sociology's holding meetings in places where he can't even come in the damned front door. So we get some phenomenal contradictions in the American academy, and when we start talking about meritocratic norms, we know this whole narrative becomes very ironic. Black academics working in supposedly deracialized, nonracial arenas are constrained. David Manning's excellent biography of biologist Ernest Just shows that often he would not be allowed to enter the scientific debates in his field because he was black. He could get maybe a fellowship up at Woods Hole, but usually, to the extent that people felt they even had to respond to him, instead of giving him money or a job they would tell him he needed to go back and be a leader of his people.

The problem is that the whole Afro-American intellectual project in the twentieth century has been a project of vindicating Afro-American or African life, and this is a profoundly problematic matter because, although historiography based on reconstituting a different idea of Africa, reconstituting a different idea of Afro-Americans, is an antiracist enterprise, still, it is a deeply parasitic intellectual project. My claim here is that the primary problem confronting Afro-American intellectuals has been the way racism has been inscribed through American intellectual life, and the structure of the American academy has necessitated intellectual projects that ultimately deny the ability of Afro-Americans to function as more "authentic" general critics of American society. People are caught, instead, trying to defend the value of Afro-American life. We saw this when Du Bois had to stake his claim against William Graham Sumner. He had to argue that Afro-Americans at the bottom of the ladder were not evidence of a natural social order, but that these black folks were subjugated, and he had to prove or try to document oppression. We get Carter Woodson, the second black to get his Ph.D. from Harvard—in fact, Woodson was naive enough to think Harvard was going to keep him around, and they

would have kept him around if he had picked up a broom or something—who comes out of Harvard with his Ph.D. and actually puts Afro-American historiography on the map. He sets up the Society for the Study of Negro History and Life, publishes *Negro History Bulletin*, the *Journal of Negro History*, basically out of a one-room operation above the Y in D.C. Woodson is a major figure locked within this tradition of response.

One of the ironies of this tradition is that, in the contemporary arena, we now have all these Afrocentrists on the scene, and I would claim they are just a modern-day variant of the same phenomenon. What is always striking to me about the Afrocentrists is that they are fighting an antiracist fight to the extent that they're trying to correct the historical record, but to the extent that they are reading the correction of the historical record as the source of claiming the validity of Afro-American lives, they're caught in the vindicationist project. That is, the Afrocentrists concentrate on ancient Africa's greatness, on the European robbery of African knowledge, on the unacknowledged European plunder of Africa, and then argue that the explicit origins of the West lie in Africa. The Afrocentrists are deeply imbedded in essentialism, there is no doubt about that, but what's always striking to me is that they valorize that part of Africa that Europe supposedly stole from. I have always been shocked that the claims for black equality within Afrocentric thought never go to any folk living in the jungle. What makes Egypt valuable is that it produced Greece, Rome, and so forth. They're still working within the logic of a hierarchy that they attack. What's so funny—or pathetic—about this is that they are caught in the same project. The other phenomenon, by the way, given the reifications they work within, is that if, in fact, Egypt lies at the origins of the West, then you can claim the West is yours too, and you don't even need to be opposed to it. Afrocentricity is caught in this.

I take this notion of vindicationist thinking from Afro-American scholar St. Clair Drake; he discusses a lot of this in his notion of "black folk here and there," a play on Du Bois' important text. At the same time, we know that this first generation of Afro-American studies programs were illegitimate in part because they hired people who were supposedly more politicized than intellectual. That was often the case. I saw a lot of charlatans running around these Black Studies programs early on. We do not have to hide from that. But, nevertheless, we know that what happens in response to that is that we develop a cadre of Afro-American intellectuals, within the academy's contemporary dominant mode, who view the quest for respectability as the primary governing ethos of contemporary Afro-American Studies. What this means, this quest for respectability, is that Afro-American Studies is to become hyperprofessionalized and depoliticized, and that all of the most innovative sides of Afro-American Studies

are scuttled. Early on, the politicized first generation of Afro-American Studies folk often had community college interactions, outreach programs and so forth, and all those things are put by the wayside, precisely because white folks in the academy are not doing them. So this quest for respectability is the result of a new generation of more professionalized Afro-American scholars emerging, but these people are still operating under, and, in fact, locked into, a fear of the white gaze. In the meantime, in order to win increasing respect, Afro-American Studies programs begin to "deracialize," to hire more white folks to teach, out of the notion that, if they can show that it's not only black people who are interested in studying or teaching Afro-American Studies, the rest of the college may grant it a higher status. What you have is a logic where, in the name of expanding Afro-American Studies, you want black folk to disappear.

The fight around Afro-American Studies, and the way in which it has been incorporated into the campus, has also, in some sense, hindered the fight for making the curriculum racially more cosmopolitan. Not only does it give a certain tier of academic intellectuals a vested interest in protecting their material fiefdom; inevitably, it also makes Afro-American Studies programs the depository, in many instances, of the campus's whole notion of everything worthy of being taught concerning Afro-Americans. When I was at Wesleyan, if we didn't teach it in Afro-American Studies it was deemed not worthy of being taught. And deans and academic figures in the college, who would sit back and make you coordinate, who would make the History department hire a Russian historian, or the Political Science department hire a political scientist in Japan, would never do that around Afro-American Studies, precisely because they would claim not to know what constituted sufficient expertise, but also because they relinquished that fight to nebulous faculty lines thrown into the corner called Afro-American Studies. Anybody who was in Afro-American Studies will also tell you that they became *de facto* affirmative action hiring mechanisms. That is, those of us who were in these programs inevitably were given the task of bringing more black faculty into the school. This not only presupposed a certain parochialism for Afro-American intellectual interests—black folks who didn't study things related to blacks were not viewed as something to be sought after—but it eliminated the need for entrenched departments to have their own outreach to try to integrate their faculties. We became the affirmative action wing of the faculty, as well as the grab bag for where you put Afro-American subject matter in the absence of the college's attempt to make the curriculum more cosmopolitan.

As for the fight to make the curriculum more cosmopolitan, or, as I would argue, to make the curriculum reflect the authentic complexity of the world—Gates writes about how Comp-Lit programs rarely have

African literature—and the extent to which this fight has not been fought *is* the extent to which Afro-American intellectuals were disproportionately housed in Afro-American Studies programs, which carry the torch for all things nonwhite. We have to keep in mind, though, at Harvard University today, what happened upon the hiring of Henry Louis Gates (we have to celebrate our success models): as the result of hiring Gates, Harvard University overnight doubled the size of its black tenured faculty in Arts and Sciences, because Gates brought with him Appiah, and now with Martin Kilson and Orlando Patterson in there, there are all of four black people in the university's grad program in Arts and Sciences that are tenured. University of Chicago isn't any better, Columbia is the same way, so is Yale. The scarcity of a black presence in elite institutions is far more severe than you would think from the rhetoric used by the right, for whom these black faculty are supposed to embody a decline of standards. Folks just aren't there in the numbers necessary to make that argument. I don't know about Brown, Dyson, you-all might have a whole lot of Negroes running around there, but I know Harvard only has four. With Cornel West, they'll have five, and Princeton will have one less. That's out of an Arts and Sciences faculty of hundreds. It's just incredible. One of the things that's striking is that our presence so exceeds our numbers; it's like when Primo Canera once talked about being knocked out by Joe Louis, and he said "I looked up and Joe Louis hit me, and I became dizzy, and the second time he hit me I thought I saw all of Harlem." That reminds me of this current debate around the black presence and affirmative action. You see one Negro, you see an army. I don't know how many times I've been counted psychologically, but I can tell you the presence just isn't there.

The point I'm making here is that our ability to gain mobility in the elite academy is inextricably linked to our ability to master this issue, this politics, this intellectual project of respectability. The very thing that generates mobility for Afro-American intellectuals is also the very thing that undermines us and makes our intellectual project so thoroughly, and so often, parasitic. One occupies a certain kind of dependency within the eyes of one's white peers precisely because they are white and, through that, one grants one's own projects intellectual validity. Baraka notes that when he was at Howard University, Howard refused to have any offerings in jazz. He says how ridiculous this was, a black institution that couldn't have any courses on jazz. Sterling Brown, literary critic and poet, would bring students to his house and teach on the side about jazz, but it wasn't until jazz started appearing at predominantly white institutions that Howard felt it could bring jazz in, and Baraka points out that the first jazz guy they let in was Stan Kenton. A statement in itself.

So, then, on the issue of Afro-American vindicationism and its modern-day variants, this quest for respectability right through to Afrocentricity to this debate between Molefi and Gates and so forth—is a debate on the same axis. These folks think that they're speaking radically different languages, but they're actually caught in the same fundamental project. And that project has everything to do with the inability of subjugated folk to existentially declare themselves as equal, and to proceed from there. Now, I don't want to claim that is an easy project, but at the same time we know the limitations of this kind of vindicationist project.

One last point. The vindicationist project intellectually is but the intellectual side of a dominant mode of political discourse among the black elite in the twentieth century, which has been an appeal to an Afro-American victim status. The victim status is a social relationship. It cannot be acquired unless the victimizer grants it. To the extent that all subjugated people do not occupy victim status, and some of the people that do occupy victim status are not necessarily subjugated, we have to understand that victim status is an ideological discourse that can be acquired. We know, for instance, that American Jews occupy at some times the victim status in the context of American society, precisely because of the wretchedness and horror of the Nazi Holocaust. But it is not necessarily related to the political, social, or economic conditions of American Jewry. In the same way, one of the fights in these debates, between Chicanos and Afro-Americans—when I was teaching at Davis I used to see this—is that Chicanos always argued with me that they were caught, they could not acquire victim status because they were suffocating under Afro-American victim status. They were subjugated but there was no discourse. America did not view Chicanos as subjugated in the same way it viewed Afro-Americans.

Thus when Du Bois is writing a historiography, a sociology that attempts to document Afro-Americans as humans, it's understandable, it's clear that he means equal humans. At the same time, Du Bois might do something like he did around the First World War, and tell Afro-Americans to stop protesting and to close ranks with the war, because by dying, he says, by shedding your blood for America, you might be able to convince whites that you are worthy of full citizenship rights. Of course, Du Bois was out of his mind on this, because folks were dying left and right all the time; that was never the question, the question was how they were going to live. We know that ultimately what happens in *that* story is that the U.S. Army doesn't even let blacks fight under the flag in the First World War, they have to fight under the French flag, and these people aren't even treated equally as U.S. veterans, they're segregated out of the U.S. Army entirely. That political project is similar to, but different from, Du Bois' intellectual project, and there comes a moment when we have

to divorce these, and that moment is now. In the contemporary academy, we have more ability to gain mobility through this quest for respectability in the academy than we have in terms of what could translate as a general political program in the broader society at large. To the extent that Afro-American intellectuals have been able to generate a certain respectability ethos linked to notions of competence and being quiet, not laughing out loud in public, not raising any troubling political issues, to the extent that they have done this, they have earned increasing academic mobility—and that mobility is not necessarily linked to the quality of one's mind and/or one's publications. But the same effort, the same strategy in present society, doesn't reap the same benefits for the broader black community. And that's one of the major reasons we have such severe fissures between segments of the Afro-American elite, and between the Afro-American elite and the Afro-American everybody else.

Discussion

JEFFREY HERF: I have a response to Jerry Watts. I think you want it both ways, and I think you know what I mean. I think it's awful that people expect you to do African-American studies if you don't want to. You should be able to do whatever you want; that's what I've always believed. I have no patience for those administrators who assume you should be doing that because of who you are; I have no patience for that kind of attitude, but then I'm an old-fashioned conservative, and I don't think you should be judged by the color of your skin—I have one of those reactionary notions. But you want it both ways. I think—and if I'm wrong, please let me know—that when the ADL wrote you, of course they wrote you because you're black. They also wrote you because you've written about race issues. They wrote you, I'm guessing, because they thought your heart was in the right place, that you were opposed to racism. And they probably assumed that what the Nation of Islam was doing was racist and anti-Semitic. They weren't interested in a disinterested scholarly examination of the role of Jews in the slave trade. The Nation of Islam had published something which was an attack on the Jewish people, it was an example of Jew-hatred, and maybe the ADL knew that you had written intelligently about Jewish intellectuals in New York, and they thought this was something that you'd be outraged about. But then, at that point, you said—I'm interpreting what you said—"Now I'm not going to act as a general intellectual who deals not only with black people but with racism in general, or intolerance or hatred in general." You stepped back from it, which I was very disappointed about, because when I got up that morning and I read Henry Louis Gates's article, it really brought tears to

my eyes. It really pains me, because I sense, in terms of our ages and our experience, that we have a lot in common, and I was hoping for . . . well, I was disappointed.

JERRY WATTS: OK. It bothers me when deans assume that I want to do African-American studies, but that's not the problem I was worried about. I wasn't worried about someone white assuming I would do African-American studies as much as I was worried that, once I made that decision, what I studied would be devalued. I mentioned that problem in order to say that I also wanted universities to open up space for Afro-American intellectuals and scholars who were doing non-Afro-American studies stuff. As for the ADL and the Nation of Islam, I wrote the Anti-Defamation League back and told them that I would participate in anything they wanted to do around black anti-Semitism, provided I could put Jewish racism on the table. And they wrote me back and told me, "bullshit." And I explicitly said to them that one of the *least* effective ways of generating a basis, in African-American communities, for an honest confrontation with anti-Semitism is to renege on, and not deal with, the question of Jewish racism, because that, in this case, is what's going to legitimate me to expand this other dialogue. That's precisely what Gates's piece didn't do. And when Killson and all these other folks wrote in and said the *New York Times* should have a broader dialogue around the flip side of this, it disappeared. By the way, if I called on you to respond publicly every time a white person in this society said something vulgar, brother, you'd be writing at your typewriter every damn day, yet you expect me to play that role. White intellectuals don't assume that kind of responsibility. But I'm part of the collective horde, you see; it's precisely the reification of me as black that makes me have to participate, to speak out. But you all can sit back and say "Hey, well, that's Joe Johnson over there in Saint Louis saying all this racist stuff, that ain't got nothing to do with me." So let's be real when we say we have these expectations about speaking out about vulgarity.

MICHAEL DYSON: Jerry, I think you gave us a set of brilliant insights into the nature of black political life, kind of an informal ethnography, both relating to your own life and stories you've heard, but I want to focus on your suggestion that mobility was available to black intellectuals who essentially engaged in a process of mimesis. That's what we're really talking about—mimicking white standards, or trying to, because black scholars were subjugated people who could undermine or mitigate that subjugation to the degree they were willing to imitate the larger white culture. Well, two things are important here. First, to what degree does white mediocrity

in the academy play into your own conception of mobility for black in-
tellectuals? And second, in regard to the victim status you talked about
earlier: If, for black intellectuals, mobility can be energized by mimesis,
what are the alternatives for victims in the world outside the academy?
That is to say, at least there's mobility for black intellectuals by way of
mimesis. What are the strategies, other than the appropriation of victim
language, for other people?

WATTS: I don't know. In some sense there's largesse that comes with
operating within a victim status. I mean, you can get benefits out of it,
but you can never get equality. That's the point I'm making. It's a de-
pendent relationship, and it's based on recognizing a hierarchy of rela-
tionships. But there are benefits. To get past victimhood, you have to
generate notions of agency that are not necessarily rooted in particularity,
and nationalism, and so forth. Your first question was on, what, Afro-
American intellectuals? Yeah, see, one of the baffling things is that, when
you look at some of these Afro-American intellectuals historically, you
find some actually fairly brilliant individuals deferring to the recognition
of some really mediocre white folks. And this had nothing to do with
anything except differences in power, and who controlled the funding of
the foundations. One of the particular problems that Afro-American in-
tellectuals are caught in is that, of all the folk in the diaspora, we are the
most schizoid because we are, in some sense, the most Western—bastar-
dized Western, Westernized folk—and don't, in fact, have certain kinds
of outsider cultural traditions that can sustain an oppositional identity
around culturalism. We're cultural insiders, political outsiders. Economic
outsiders. But you see that Afro-American culture is very much American.
Not all of it is, but you understand my point. And, all too often, you
don't run the risk of recognizing that if you simply extrapolate from your
own cultural situation. You may not get institutional reinforcement for
recognizing it, but what the hell, let the chips may fall where they may.
But that's a very different strategy from trying to get to Princeton.

ADAM STEPHANIDES: I didn't really have a question. It's more of a comment.
From what I've heard of these exchanges, the magic phrase seems to be
"the politics of alliance." That's what is somehow going to get progressive
politics out of the stalemate it seems to be in, but I think, Professor Watts,
that you inadvertently revealed one of the problems with alliances, or one
of the roadblocks to achieving them, in your response to the question
regarding *Secret Relations Between Blacks and Jews*. You said that you were
unwilling to make a statement against black anti-Semitism unless you were
also allowed to bring up the question of Jewish racism. You asked how it

would look to the African-American community if you only condemned black anti-Semitism, and failed to bring up the question of Jewish racism. But you either seemingly didn't know or didn't care how this would appear to Jews. It appears to me that anti-Semitism is a matter of indifference to you. I hope I'm wrong, but I was disturbed by the tenor of your remarks, and I felt this was something I had to say.

WATTS: I hear you, brother. This is very interesting. The question is— well, it's a question you can't win on—but I'll say this. The way they got my name, I think, was from a story in the *Times* that said that I participated in a lot of stuff related to confronting black anti-Semitism, and I will do that in a black audience very easily. I don't have any problem with that. What I don't want, and I'm always very concerned about this, is to occupy the status of the unique negro, the one unlike the others. But I wrote the ADL a letter and said look, I'll help you-all design a whole black anti-Semitism program, but you're going to have to put Jewish racism on the table. Those cats came back to me like I was crazy. But if we're going to play universal politics, let's put everything on the table, let's play universal politics. And if we're not going to play it, then we're not going to play it. And we're not going to build any coalitions around it. That's precisely the issue. Coalition-building is by fits and starts, I agree, but I'm not going to be staged as someone who's unlike those other bad black folk. That's a *cul-de-sac* for me, intellectually.

TODD GITLIN: I'm afraid I'm going to march up the same *cul-de-sac*, Jerry. I have to be personal here. When I was deeply involved in the movement against the Vietnam War, my father, who was an embittered liberal, a Jewish liberal, said to me one day, "What did the Vietnamese ever do for the Jews?" I don't remember what I said. I doubt I could say anything. But I do know that many years later, when I first went to Europe, I was walking in Père Lachaise cemetery, and I saw a monument to a group, probably a Communist resistance group, who had died in the effort to liberate a French detention camp. One of the names on the monument was Vietnamese. I broke down in tears and sent my father a letter telling him about it. I hope he got the point.

WATTS: I don't understand the point of what you're saying to me *vis-à-vis* what I said.

GITLIN: Why does one demand for rights become contingent on another?

WATTS: What demand for rights?

GITLIN: The demand that you oppose this awful document. Why should it be contingent?

WATTS: I was asked to oppose this document for what I think was a reification of my racial identity, and in fact implicitly . . .

GITLIN: So what?

WATTS: . . . What do you mean "so what"? The ADL doesn't send me any goddamn thing else to sign on for. And that's not unimportant. It ain't just happenstance I got this. I don't have any skill here, I'm not a historian of the slave trade. I can't critique a document on the slave trade, my good man. You are missing the point. You're acting like what's on the table is an uncontested moral position of the ADL, and that's not the only thing on the table. They could have said all kinds of things, they could have said, yes, Jews were participating in the slave trade, and what does that have to do with the validity of anything? I mean, you don't have to prove whether or not Jews were in the slave trade, that's no justification for black anti-Semitism. However, if you want to make a claim against black anti-Semitism, go ahead and make the claim. You don't have to run that past me. With the ADL, I'm just a tag-on to be objectified so as to legitimate a certain kind of fictitious dialogue. It's a false sense of community. We understand that. Why are you playing me? The ADL isn't coming to me out of any dialogue around black-Jewish relations; in fact, when I asked them to get into dialogue they told me to go to hell. Wasn't about any dialogue.

GITLIN: Just one last thing. Fine. I wish you had signed the statement and written a diatribe against the ADL because, while they're so concerned about Jewish defamation, they're not so concerned about Jewish racism. But I would wish for both/and.

DYSON: One *more* last thing. In regard to the question about black-Jewish relations, I think it's quite crucial. I was involved at Brown University, maybe three weeks ago, with Henry Louis Gates and Michael Behrenbaum, from the National Holocaust Museum in Washington. And in defense of what I heard Jerry saying, and given the real concerns that Jeffrey and Todd have eloquently expressed, I just want to relate that when Gates reproduced his argument from the op-ed piece about black anti-Semitism, a Jewish student stood up and asked him, "Why don't you speak not only about black racism but also about Jewish racism, and in that way place it in a larger context, so that we can understand the moral nature of this

debate." I think Professor Gates responded by saying, "Well, I'm black, I make my living dealing with black people, I make my whole life in an Afro-American studies department, I'm interested in what black people do." That's one take on this problem, and for some people that's satisfying, but I wanted to say that I think Jerry at least wants to carve out the space to discuss that larger context. If we're going to have precisely the thing we're aiming at here, which is serious, rigorous, honest debate all around, I think the only way we can do that is to try to put all the discussions we have clearly above the board so that for both sides, or either side, or all three sides, or whatever, the competing interests in our own selves can be negotiated and adjudicated in some way. The only way we can do it is with explicit honesty. I think that's the only way forward, not only for black-Jewish dialogue, but for the whole series of problems we've been taking up.

Contributors

MICHAEL W. APPLE is John Bascom Professor of Curriculum and Instruction and Educational Policy Studies at the University of Wisconsin-Madison. He is the author of numerous books on the politics of schooling, including *Ideology and Curriculum* (1979, 1980), *Education and Power* (1985), *Teachers and Texts: A Political Economy of Class and Gender Relations in Education* (1986), and, most recently, *Official Knowledge: Democratic Education in a Conservative Age* (1993).

ERNST BENJAMIN, General Secretary of the American Association of University Professors, taught political science and humanities at Wayne State University from 1965 to 1984. He has a Ph.D. in Political Science from the University of Chicago, did postgraduate work at the Institute of African Studies and the University of Ghana, and now writes on labor relations and higher education. He has served as chair of the Washington Higher Education Secretariat Committee on Minority Participation in Postsecondary Education and as a member of the national TIAA-CREF Advisory Council.

MICHAEL BÉRUBÉ is a professor of English at the University of Illinois. He is the author of *Marginal Forces/Cultural Centers* (1992) and *Public Access: Literary Theory and American Cultural Politics* (1994).

LINDA BRODKEY is a professor of English at the University of California at San Diego and the coordinator of the Warren College Writing Program. She is the author of *Academic Writing as Social Practice* (1987) and articles on interpretive theory, literacy, and the teaching of writing. At the University of Texas she was active in the widely debated effort to revise the required introductory course in writing.

TROY DUSTER is Professor of Sociology and Director of the Institute for the Study of Social Change at the University of California at Berkeley. His books include *The Legislation of Morality* (1972), *Backdoor to Eugenics* (1990), and the coauthored *Patterns of Minority Relations* (1967).

369

MICHAEL ERIC DYSON is a professor of Communications at the University of North Carolina. He is the author of *Reflecting Black: African-American Cultural Criticism* (1993) and has contributed articles on race, multiculturalism, and presidential politics to *The Nation* and *Social Text*.

JUDITH FRANK, a professor of English at Amherst College, has written on New Historicism, the novel, and gender studies; her work has appeared in the *Yale Journal of Criticism* and *Wild Orchids and Trotsky: Messages from American Universities* (1993).

HENRY GIROUX is Waterbury Chair Professor of Secondary Education at Pennsylvania State University. His books include *Schooling and the Struggle for Public Life* (1988), the coauthored *Postmodern Education* (1991), and *Border Crossings: Cultural Workers and the Politics of Education* (1993).

TODD GITLIN is Professor of Sociology at the University of California at Berkeley. He is the author of numerous books, including *The Sixties: Years of Hope, Days of Rage* (1987) and *Inside Prime Time* (1983), both of which appeared in revised editions in 1993, as well as *The Whole World is Watching* (1980). His first novel, *The Murder of Albert Einstein*, was recently published by Farrar, Straus & Giroux. He has written on speech codes, social activism, and conservative attacks on higher education, and is currently writing about multiculturalism and national identity, and researching the mass media's role in American foreign policy.

GERALD GRAFF is George M. Pullman Professor of English and Education at the University of Chicago. He is the author of *Poetic Statement and Critical Dogma* (1970), *Literature Against Itself* (1979), *Professing Literature: An Institutional History* (1987), and *Beyond the Culture Wars: How Teaching the Conflicts Can Revitalize American Education* (1992). He is also coeditor of *Criticism in the University* (1985) and cochair of Teachers for a Democratic Culture.

BARRY GROSS is Professor of Philosophy at York College, City College of New York, where he teaches philosophy of science, philosophy of law, and practical ethics. He is also Treasurer of the National Association of Scholars and President of the New York Association of Scholars. He is the author of *Discrimination in Reverse: Is Turn About Fair Play?* (1978) and *Analytic Philosophy: An Historical Introduction* (1970). He has edited *Reverse Discrimination* (1977) and *Great Thinkers on Plato* (1986). He was a consultant on the creationist law suit *McLean v. Arkansas*.

JEFFREY HERF has been a fellow at the German Historical Institute, a Bradley Fellow at the School of Advanced International Studies at Johns Hopkins University in Washington, D.C., a George Marshall Fund Fellow and a Fulbright scholar at the University of Freiburg, and, most recently, a fellow at the Institute for Advanced Study in Princeton. He is the author of *Reactionary Modernism: Technology, Culture, and Politics in Weimar and the Third Reich* (1984) and *War By Other Means: Soviet Power, West German Resistance, and the Battle of the Euromissiles* (1991). He has published essays on American politics and culture in *Partisan Review* and elsewhere, and is now writing a history of politics and memory in the two Germanys from 1945–89.

GREGORY JAY, cochair of Teachers for a Democratic Culture, is professor of English at the University of Wisconsin at Milwaukee. He is the author of *T. S. Eliot and the Poetics of Literary History* (1983) and *America the Scrivener: Deconstruction and the Subject of Literary History* (1991), and the coeditor of *After Strange Texts: The Role of Theory in the Study of Literature* (1985).

PAUL LAUTER is Allan K. and Gwendolyn Miles Smith Professor of Literature at Trinity College. His most recent book is *Canons and Contexts* (1990), essays on curricular and administrative reform in higher education. He is also the editor of *Reconstructing American Literature* (1983) and the coordinating editor of the *Heath Anthology of American Literature.*

CAMERON McCARTHY is a professor of Curriculum and Instruction, Educational Policy Studies, and Communications at the University of Illinois. He is the author of *Race and Curriculum* (1990) and the coeditor of *Race, Identity, and Representation* (1993).

CARY NELSON is Jubilee Professor of Liberal Arts and Sciences at the University of Illinois. He is the author of *The Incarnate Word: Literature as Verbal Space* (1973), *Our Last First Poets: Vision and History in Contemporary American Poetry* (1981), and *Repression and Recovery: Modern American Poetry and the Politics of Cultural Memory* (1989). His edited or coedited collections include *Theory in the Classroom* (1981), *Marxism and the Interpretation of Culture* (1988), *Cultural Studies* (1992) and Edwin Rolfe's *Collected Poems* (1993).

LINDA RAY PRATT, President of the 43,000-member American Association of University Professors, is a professor of English at the University of Nebraska-Lincoln. She served previously as first vice president

and, among other activities, chaired the AAUP's Committee on Part-Time and Non-tenure-track-faculty. She has a Ph.D. in English from Emory University and publishes on Victorian and Early Modern poetry, and on higher education.

JOAN WALLACH SCOTT is Professor of Social Science at the Institute for Advanced Study in Princeton. She is the author of *The Glassworkers of Carmaux: French Craftsmen and Political Action in a Nineteenth Century City* (1974) and *Gender and the Politics of History* (1988), and the coauthor of *Women, Work and Family* (1978). She has recently edited, with Judith Butler, *Feminists Theorize the Political* (1992).

CAROL STABILE teaches in the Communications Department at the University of Pittsburgh. She is the author of *Selling Futures: Feminism, Postmodernism, and the Technological Fix* (1994).

MICHAEL WARNER is a professor of English at Rutgers University, author of *The Letters of the Republic: Publication and the Public Sphere in Eighteenth-Century America* (1990), and coeditor, with Gerald Graff, of *The Origins of Literary Study in America* (1988).

JERRY WATTS is a professor of American Studies and political science at Trinity College. He writes regularly about progressive politics and about the intersections of race and politics in America for journals like *Dissent, Social Text,* and *The Boston Review*. He has recently completed *Heroism and the Black Intellectual: Reflections on Ralph Ellison, Politics, and the Dilemmas of Afro-American Intellectual Life.*

Index